Daring to Look

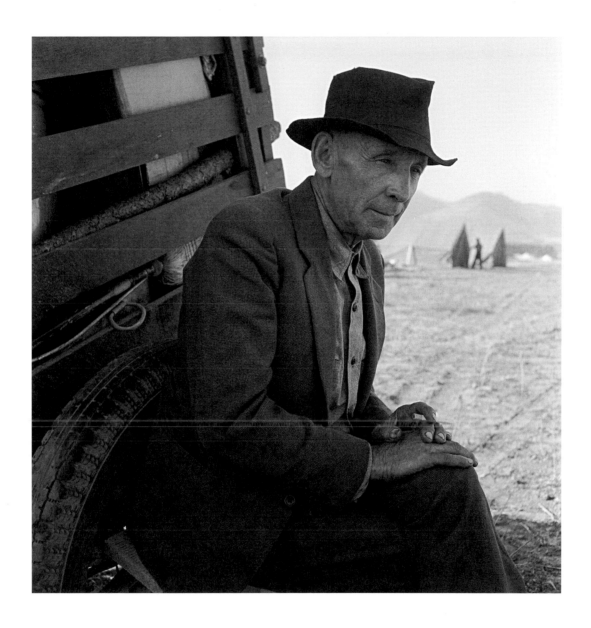

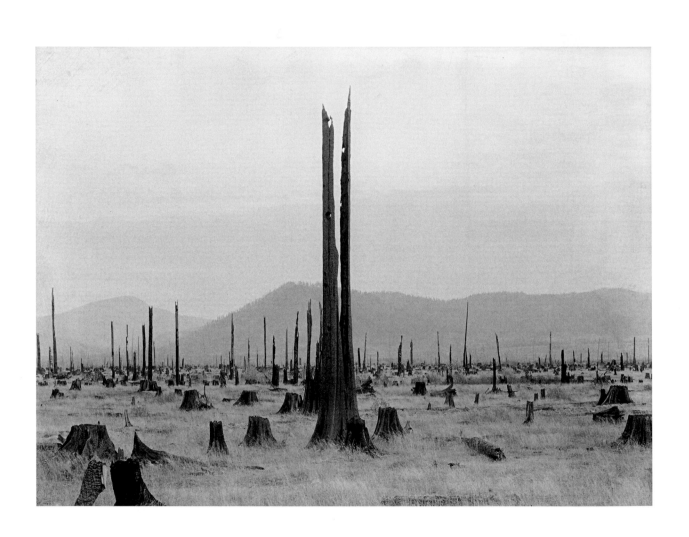

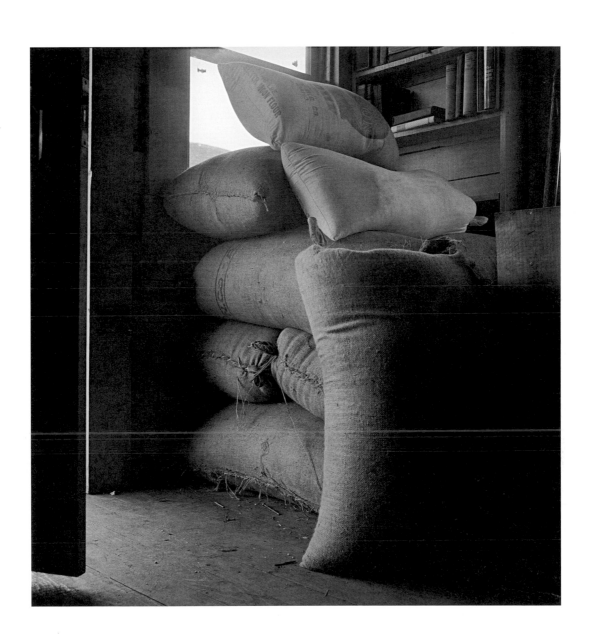

OTHER BOOKS BY
ANNE WHISTON SPIRN

The Language of Landscape
The Granite Garden: Urban Nature and Human Design

ANNE WHISTON SPIRN

Daring to Look

DOROTHEA LANGE'S PHOTOGRAPHS
AND REPORTS FROM THE FIELD

THE UNIVERSITY OF CHICAGO PRESS · Chicago & London

ANNE WHISTON SPIRN is professor of landscape architecture and planning at the Massachusettes Institute of Technology. A photographer herself, she is the author of *The Granite Garden: Urban Nature and Human Design* and *The Language of Landscape.*

The University of Chicago Press, Chicago 60637
The University of Chicago Press, Ltd., London
© 2008 by Anne Whiston Spirn
All rights reserved. Published 2008
Printed in the United States of America

17 16 15 14 13 12 11 10 09 08 1 2 3 4 5

ISBN-13: 978-0-226-76984-4 (cloth)
ISBN-10: 0-226-76984-4 (cloth)

Digital scans of Dorothea Lange's photographs were produced with support of the Publishing Office and the Prints and Photographs Division, Library of Congress, Washington, D.C.

Library of Congress Cataloging-in-Publication Data

Spirn, Anne Whiston, 1947–
 Daring to look : Dorothea Lange's photographs and reports from the field / Anne Whiston Spirn.
 p. cm.
 Includes bibliographical references and index.
 ISBN-13: 978-0-226-76984-4 (cloth : alk. paper)
 ISBN-10: 0-226-76984-4 (cloth : alk. paper)
 1. Agricultural laborers—United States—Pictorial works. 2. Depressions—1929—United States—Pictorial works. 3. United States—Economic conditions—1918–1945—Pictorial works. 4. Lange, Dorothea. I. Lange, Dorothea. II. Title.
HD1525.S66 2008
331.7'63097309043—dc22
 2007038592

CONTENTS

PREFACE

SEEING IS FOR ME A WAY OF KNOWING, photography a way of thinking. A photograph can embody a complete thought or an entire story; a series of photographs can shape a narrative or make an argument. Words tap the ideas that the visual holds and carry them further. My book *The Language of Landscape* emerged from a process of seeing, photographing, and writing, beginning with the sorting of my own photographs of landscapes. As I culled, compared, grouped them in twos, threes, fours, then sequenced the groups, ideas took shape: landscape is pragmatic, poetic, rhetorical, polemical; landscape is the scene of life, a cultivated construction, a carrier of meaning, a form of language. Writing, in turn, transformed what I saw and how I photographed. Photography became a way to test ideas, places my primary sources, and photographs and field journals my primary data. Working in this manner led me back to Dorothea Lange, to wonder about the interplay between her photographs and captions and the role of her field notes.

I had first encountered an example of Lange's "typical field documentation" in 1969, in *Dorothea Lange Looks at the American Country Woman*. Entranced by the significant detail of that text, I longed to read the others promised by the word "typical" and was disappointed not to find them in books of Lange's work. A quarter century later, my interest in her field documents was more pragmatic: I wanted to learn from her methods. My hunch was that Lange employed images and words, together, not merely to record conditions, but also to discover and to explore ideas. After the publication of *The Language of Landscape* in 1998, I sought and found Lange's "field documentation": the typewritten texts, which she called "general captions," and her handwritten field notes, the raw material for the longer, more formal reports as well as for the captions to individual photographs. The general captions proved to be more than texts, for Lange appended to each a list of the relevant negative numbers, thereby mapping relationships among photographs. The photographs are not illustrations, nor are the texts explanatory footnotes to the images. Coequal, they correspond.

Despite my excitement on recovering these remarkable documents, I put them aside, for by then I was writing *The Eye Is a Door*, a book about photography and the art of visual thinking. Lange was not the protagonist, but I planned to weave into that book the story of her general captions. In fall 2004, the manuscript of *The Eye Is a Door* was all but finished when it seemed to split in two, the voice of one part at odds with that of the other. To gain perspective, I took

a "short" break from that project to edit a book of Lange's general captions. The break would last two years, a detour that became a journey in its own right.

Daring to Look began with a simple idea: to bring together a selection of Lange's photographs and her reports from the field. A brief introduction would sketch the context of Lange's life and work, an epilogue would bring the story back to the present. Not so simple, as it turned out. The book expanded into a more complex work whose shape emerged from the material, material that posed perplexing questions that demanded answers. First, there were Lange's reports from the field, her general captions, which she wrote from 1939 to 1944. I chose not to include those from 1940, written for the Bureau of Agricultural Economics, or those from 1943–1944, for the Office of War Information: the former, on shacktowns, have an academic tone and include no quotations from the people photographed (probably they were written by Lange's husband, the economist Paul Taylor); the latter describe the community life of ethnic populations in California, but the OWI lost the photographs. I decided to focus on 1939, for those texts and photographs are a window on an entire year's work and show the evolution of Lange's method. Reading the texts, I encountered unfamiliar terms and puzzling contradictions. What were Bang's disease, a plug mule, the Townsend Plan? And why did some people tell Lange that the Works Progress Administration had "ruined the working man" while, for others, a WPA salary seemed to be the only thing between them and the wolf at their door? Matching photographs to the negative numbers Lange had appended to her reports from the field, I found wonderful images that I had never seen before. I was astounded by how many were of landscapes and of the interiors of homes with no people visible, for Lange is famous for her iconic portraits of people in trouble, their states of mind captured eloquently in posture and gesture. But Lange's trees, fields, and barns have an eloquent posture too, and her domestic interiors are expressive human gestures. Why, then, is Lange typecast as a photographer of people, her landscapes neglected? Then there were the people and places Lange described. What had happened to them? Did the government programs that Lange portrayed succeed? Did they have lasting effects?

And there was Lange herself. The introductory essay, initially, was to be a brief recounting of Lange's importance and the significance of the general captions for her own work and for documentary photography. But there were mysteries. Why did Lange begin to write long field reports in 1939? How was that year significant? Why were the texts not published long ago? The search for answers produced further mysteries. Why was Lange fired at the end of 1939? Why, when her photographs and captions are sharply intelligent, critical, witty, and often understated, do so many critics describe her work as heavy-handed and emotional? Why are there so few statements of unequivocal praise, and why do so many critics and scholars disparage her work or ignore it?

Where Lange led, I followed: from field notes to general captions to photographs; from the research reports, memoranda, and newspaper clippings she collected to other publications of the 1930s; from Lange's letters to her boss, Roy Stryker, to his responses; from her 1935 booklets to "Death of a Valley" in

1960; from her articles of the 1940s and '50s to her interviews of the '60s; from the California, North Carolina, and Pacific Northwest of 1939 to the places they had become in 2005–2006.

Each step exposed a story, and one story led to another, the collection a conundrum of what to include and what to leave out. Ron Partridge, a friend of Lange's, urged me to describe her more fully as a person, the difficult choices she made about family and work and the consequences. But these are best treated in the context of a biography. My focus is on her work, what she did and how, and particularly on the work of a single year, 1939, what led up to and followed from that year, and its significance. Some may feel that I have exaggerated Lange's undervaluation and neglect. Three years ago, I myself would have regarded such an assertion with skepticism, but the evidence of disparagement of Lange, in comparison to Walker Evans, for example, is pervasive and blatant. Lange has her admirers, but their claims for her importance are less sweeping than those of Evans's champions.

Daring to Look opens with a prologue composed of Dorothea Lange's own words, drawn from interviews in the 1960s and also from tape recordings of her conversations during the same period. Part One, my essay "Dorothea Lange and the Art of Discovery," describes the Lange I discovered, the person and the photographer, her process and her purposes, her art, the context of her work, and her professional relationships, and considers the importance of her lasting contribution to photography. Lange's photographs and notes from the field of 1939, in Part Two, are at the heart of the book. An editor's headnote introduces each section of Lange's texts and photographs and provides contextual background, drawing particularly from publications of the 1930s, many of which Lange herself would have read, and from Lange's own field notes and correspondence. Part Three, "Then and Now," recounts my own journey to the places Lange photographed in 1939, with reflections on what I found there, what Lange had missed in the landscape, what has and has not changed over the intervening decades, and what significance Lange's work of 1939 holds for the present day.

Nearly forty years ago, Lange's work revealed the synergy between what had seemed, in my own life, to be conflicting interests—the study of art and the making of art, the observing and portraying of the world and acting to change it. In Lange I found an ethnographer's eye, a writer's ear, an artist's vision. In Lange, the word and the image, the documentary and the work of art, are one. She inspired me to integrate my own passions rather than to elect one and exclude others, and I moved from art history to landscape architecture, a profession that gave scope to history, ecology, and anthropology, to design, planning, and photography, and to practice as well as scholarship. In the years since, I have come back again and again to Lange's *American Country Woman* and to her 1939 work *An American Exodus*, written with Paul Taylor, as models for how to capture in photographs and extend in words the meanings of visual images, with the camera as instrument of discovery.

Two years after embarking on *Daring to Look*, I return to the manuscript for *The Eye Is a Door* and see the shape of the whole, the two voices one.

*

To Dorothea Lange, I owe a great intellectual and artistic debt. My decision to produce a book of her unpublished texts stemmed from a desire to repay that debt, but I now owe her far more. Lange once said, speaking for the Farm Security Administration's photographers, that "the government gave us a magnificent education." Dorothea Lange's photographs and words, the places they led and the people I met there, gave me a magnificent education.

In the Dorothea Lange Collection at the Oakland Museum of California, I encountered Lange directly in taped conversations, field notes, fellowship proposals, and sketches of ideas for projects. Drew Johnson provided access to the archives, helped me find Lange's carbon copies of the general captions she submitted to the FSA, arranged for me to hear audiotapes, and introduced me to Henry Mayer, an extraordinarily generous scholar who shared my enthusiasm for Lange as an author, artist, and discoverer. Henry's death in 2000 left an unfinished project, what would surely have been a wonderful biography of Lange. Meg Partridge, author of *The Visual Life*, a film on Lange, gave me a treasure, the transcript she had made of the tapes recorded in the 1960s by KQED, in which Lange speaks of photography, writing, art, and life.

In the Library of Congress, I met Lange the consummate professional through the work she produced on assignment for the Farm Security Administrations and her correspondence with "the boss," Roy Stryker. I am grateful to Jeremy Adamson and the staff of the Prints and Photographs Division for their support, particularly to Beverly Brannan, curator of photography, who shared her extensive knowledge of FSA photographers, showed me Lange's 1935 reports and Walker Evans's 1936 portfolios, and provided important clues to solving the mysteries surrounding Lange and her 1939 work. W. Ralph Eubanks, director of publications at the Library of Congress lent his support and counsel throughout the process of publishing.

Lange's friends added an intimate dimension to archival encounters. Rondal Partridge described Lange's darkroom techniques, instructed me in the use of her 1939 equipment, from film holders to exposure meter to the hefty Graflex, showed me the many photographs he had taken of Lange, and told stories of working with her in the 1930s and of his friendship with her and her family. He reviewed all the photographs I had printed from digital scans of Lange's negatives, discussed nuances of her approach to printing, suggested refinements to a few, and bestowed his approval; from these discussions, I learned immeasurably. Christina Gardner shared her experiences as Lange's client, assistant, student, and friend, gave me an intimate view of Lange's relationships with family and colleagues (like Ansel Adams), and showed me the portraits of Christina's family that Lange made in the 1920s and '30s. To Dyanna Taylor, photographer-filmmaker and Lange's granddaughter, I owe the introduction to Ron and Christina and a frank discussion of Lange's family life.

Others opened my eyes to aspects of Lange's photographs and texts. Richard White and Bill Cronon read every caption and photograph and responded with their deep knowledge of American environmental and social history. Paul Groth, Paula Lupkin, and Daniel Abramson reviewed the photographs from the perspective of the history of art and architecture, and Paul told me how to find one of the labor camps Lange had photographed. Ellen Lorentzson, photojournalist and editor, pointed out Lange's storytelling techniques. Randy Hester and Walter Hood recounted stories of growing up in rural and urban North Carolina. Ralph Cammack, Glen and Mary Wardlaw, Ruth Hull, Harold Soper, and Ruth Soper Miller showed me significant details of agriculture and daily life in Lange's photographs of the Northwest and reflected on their own lives and experience.

The Doe and Bancroft Libraries at the University of California in Berkeley, and the libraries of Harvard and MIT in Cambridge, Massachusetts, provided indispensable access to literature on and by Dorothea Lange, Paul Taylor, and contemporary authors, and on American culture and politics of the 1930s. I am grateful to Thomas Oles for his assistance in tracking down books, articles, and maps.

A leave from MIT and a fellowship at Harvard's Charles Warren Center for Studies in American History in 2004–2005 provided the time and resources to finish the manuscript. Director Lizabeth Cohen and Warren Seminar co-chair Margaret Crawford encouraged me to write the Lange book rather than the project I had originally proposed. A grant from the Graham Foundation for Advanced Studies in the Fine Arts provided funds for photography and for travel to archives and to the places Lange worked in 1939. I am grateful to those institutions and to Michael Katz, Tom Hughes, Bill Cronon, and Richard White for their support of my Warren fellowship, and to Dolores Hayden, Alex MacLean, and Kenny Helphand for theirs of the Graham Foundation's grant.

Beverly Purrington and Richard White, Clare Cooper Marcus, Anne Vernez Moudon, Kenny and Margot Helphand, Mike Houck, Randy Hester and Marcia McNally, and Joyce Shaw provided a home base on my journeys to Lange's 1939 destinations. I had many excellent guides in the field: in North Carolina, Reuben Bowes; in Imperial County, California, Andy Curiel, Kevin Kelley, and Leonard Knight; in Carlton, Oregon, Mel and Dollie Wasson; in Yakima, Washington, Lorene and Carl Walker; in Bonner County, Idaho, Scott Hill and Ann Ferguson; in Ola, Idaho, Amy McBryde; in eastern Oregon, Ralph and Charlotte Cammack, Jay Chamberlin, Virginia, John, and Cody Cleaver, Monty Culbertson, Nancy Deboer, Cleta deBoer, J. L. Eldred, Minard Hart, Elmer King, Ruth Soper Miller, Shelli Monroe, Betty, Terry, and Sue Oft, Bob and Imogene Peterson, Clarice Poor, Gene de Rock, Kris Ward, and Larry White. Allen Brown, an extraordinary guide and researcher, choreographed my education in irrigation, unearthed old documents, located people and places.

To challenge, confirm, and refine my selection of Lange's 1939 photographs, I enlisted the eyes of fellow photographers Paul Caponigro, Wendy Ewald, Ellen

Lorentzson, Alex MacLean, Ron Partridge, Will Steacy, Leslie Tuttle, Camilo José Vergara, and Lewis Watts.

Friends and colleagues read the manuscript and provided invaluable criticism, information, and advice. Beverly Brannan, Kenny Helphand, Martha Sandweiss, and Richard White read an early draft of the manuscript, Finis Dunaway, Mary Renaud, Paul Spirn, Leslie Tuttle, and Isabel Whiston, a later draft. Rondal Partridge and Christina Gardener reviewed my essay on Lange. Allen Brown, Walter Hood, Randy Hester, and Larry Susskind read the final chapter.

I am grateful, too, to Helena Zinkham, Barbara Natanson, and Lewis Wyman of the Library of Congress Prints and Photographs Division for facilitating the digital scans of Lange's photographs and to John Paul Caponigro for his advice on preparing the files and producing the prints. Timothy Terway produced the maps of Lange's 1939 journeys and created a wonderful Web site for the book with additional photographs and texts, animated clips, and recorded interviews (http://www.daringtolook.com).

My agent Jill Kneerim, in her former life as a publisher, was the Jill Grossman with whom Lange discussed a book on "freedom," which Lange was forced to abandon after she was diagnosed with cancer. Jill greeted my proposal with enthusiasm, offered wholehearted support throughout the writing, and found the book an auspicious home at the University of Chicago Press, where Robert Devens provided wise guidance, Joel Score deft editing, Matt Avery a wonderful design, and Levi Stahl enthusiastic promotion.

Jeannette Hopkins, my editor for nearly three decades, initially was dismayed by this project, which she saw as a distraction from my own work, then challenged me to write a "real book," insisting that the proper way to honor Lange as author was to be true to myself as an author. No writer could have a more gifted editor or a better friend.

To read and reflect on Dorothea Lange's 1939 photographs and texts is to understand the fundamental importance of family. To my parents and sisters, and to Paul and Sam, who are the foundation of love and life, thank you.

Anne Whiston Spirn
Nahant, Massachusetts, 2007

Daring to Look

1. Dorothea Lange, 1960s. Rondal Partridge.

PROLOGUE

"A Discoverer, a Real Social Observer"

Reflections by Dorothea Lange in the 1960s

THERE IN MY STUDIO ON MONTGOMERY STREET [in San Francisco] I was surrounded by evidences of the Depression. . . . I remember well standing at that . . . window and just watching the flow of life. Up from the waterfront it came to that particular corner, that junction of many different things. There was the financial district to the left, Chinatown straight ahead, and the Barbary Coast and the Italian town. The unemployed would drift up there, would stop, and I could just see they did not know where next. . . . The studio room was one flight up, and I looked down as long as I could, and then one day said to myself, "I'd better make this happen."[1]

I was just gathering my forces. . . . I wasn't accustomed to jostling about in groups of tormented, depressed and angry men, with a camera. Now I could do it much more easily. . . . I've confidence in people that they will trust in me.[2]

My most famed photograph . . . I made . . . on the first day [in 1933]. [I] went out in an area where people said, "Oh, don't go there." . . . I made the old man with the tin cup first, but that was life [figure 5]. . . . I saw something, and I encompassed it, and I had it. . . . I put it on the wall of my studio, and customers . . . I was making portraits of would come in and just glance at it. The only comment I ever got was, "What are you going to do with this kind of thing? What do you want to do this for?" . . . That was a question I couldn't answer. I didn't know. . . . But I knew my picture was on my wall, and I knew that it was worth doing.[3]

Now, I have many visitors, young photographers with portfolios under their arm, . . . confronted with, "What are you going to do with it?" And remembering that, I feel justified in saying, "Don't let that question stop you, because ways often open that are unpredictable, if you pursue it far enough. Don't relinquish it." Most young photographers . . . want too quickly to make a name for themselves. . . . But the way it happened with me, I was compelled to photograph as a direct response to what was around me.[4]

*

I went down to Imperial Valley, California, to photograph the harvesting of one of the crops . . . the early peas or the early carrots. The assignment was the beginning of the migration, of the migratory workers as they start there in the early part of the season. . . . It was a very rainy afternoon. I stopped at a gas station to

get some gas, and there was a car full of people, a family, there.... They looked very woebegone to me.... I looked at the license plate on the car, and it was Oklahoma.... I approached them and asked ... something about which way they were going, were they looking for work.... And they said, "We've been blown out." ... They told me about the dust storm. They were the first arrivals I saw. These were the people who got up that day quick and left. They saw they had no crop back there. They had to get out. All of that day, driving for the next ... three or four hundred miles, I saw these people. And I couldn't wait, I photographed it.... Luckily my eyes were open to it. I could have been like all the other people on that highway and not seen it. As we don't see what's right before us. We don't see it till someone tells us.[5]

This thing they call social erosion. I saw it.... That was the beginning of the first day of the landslide that cut this continent, and it's still going on. I don't mean that people haven't migrated before, but this shaking off of people from their own roots started with those big storms, and it was like a movement of the earth, you see, and that rainy afternoon I remember because I made the discovery ... up to that time unobserved.... I went home that day a discoverer, a real social observer.[6]

We have, in my lifetime, changed from rural to urban. In my lifetime, that little space, this tremendous thing has happened. These people on that rainy afternoon in April were the symbol, they were the symbol of this tremendous upheaval like an earthquake.[7]

*

I think that the visual life, the truly visual life, must be a very great illumination; I have never doubted it. I wonder how many photographers are even aware that there is such a thing.... The discipline and the difficulties of attaining this— because really it's exploring another world—are so immense that I back up from it. I have had a few ... short periods when I came close to it. Those are my best periods.... You wake up with it in the morning and you sustain it. And you live it. You breathe it. You don't read a newspaper. You're cut off from the moorings of the people around you ... you actually are nourished and sustained by your eyesight. You look into everything, not only what it looks like but what it feels like. That's the consuming thing, tremendous thing. Out of that sort of attention great photographs will be made, and the best ... photographers have it once in a while.[8]

One should really use the camera as though tomorrow you'd be stricken blind.... To live a visual life is an enormous undertaking, practically unattainable, but when the great photographs are produced, it will be down that road.... I have only touched it, just touched it.[9]

[To] come back ... having observed something that you didn't know was there, [or] ... having seen something that you have seen many, many times and never realized ... [is] a great discovery. There is an element about such photographs that makes you say (it comes out of Dostoyevsky ... a photographer who

is really at work...surely understands this one), "There are moments when time suddenly stands still and gives place to eternity"...moments where all seems to fall in its place, for anyone to understand—if it's a really good photograph.[10]

Artists are controlled by the life that beats in them, like the ocean beats in on the shore. They're almost pursued; there's something constantly acting upon them from the outside world that shapes their existence.[11]

The secret places of the heart are the real mainsprings of one's action.[12]

I believe that everything, every human action, has consequences, every human endeavor. And to get that element into the photograph, the projection of that... if you can come close to the truth, there are consequences from the photograph.... The good photograph is not the object. The consequences of the photograph are the object, and I'm not talking about social work. It can be... something that is extraordinarily beautiful for its own sake.... The consequence of its beauty is the transmission of it; so that no one would say, "How did you do it? Where did you find it?" But they would say, "That such things could be."[13]

The subject of poverty has to be unearthed and looked at again. What is this, who are the poor, who really are the poor?... Real poverty is when life doesn't meet the human needs, when the circumstances just simply don't yield it, and can't, no matter how the people struggle.[14]

The world is not being photographed at all...only the spectacular, the sharp, and...the bizarre episode.... The underpinnings, the human condition...is lacking.... The circumstances out of which our civil rights struggles come. What has produced the thing...we call poverty. Not the plight of the people who endure it, but out of what it comes, and the many kinds of poverty that there are.... No one has photographed, so far as I know, the social phenomenon of prosperity. It is unrecorded.[15]

No country has ever closely scrutinized itself visually that I know of.... I know what we could make of it if people only thought we could dare look at ourselves.[16]

ONE

Dorothea Lange & the Art of Discovery

ANNE WHISTON SPIRN

DOROTHEA LANGE IS A MASTER of photography, one of the great pioneering artists of the twentieth century. Some of her images, such as the renowned "Migrant Mother," are icons of American culture. Dorothea Lange is to photography what John Steinbeck is to literature. Her work inspired Steinbeck as he conceived and wrote his powerful novel *The Grapes of Wrath*, and he used some of Lange's photographs as illustrations in *Their Blood Is Strong*, his 1938 nonfiction booklet about migrant workers. Filmmaker Pare Lorenz claimed that Lange's images of migrant workers, which appeared in thousands of newspapers, magazines, and Sunday supplements, and Steinbeck's *The Grapes of Wrath* did "more for these tragic nomads than all the politicians in the country."[1]

"No country has ever closely scrutinized itself visually," Dorothea Lange said at the end of her life. "I know what we could make of it if people only thought we could dare look at ourselves."[2] Lange did dare to look. She dared to go places others feared to go. She moved freely and openly among migrant workers in squatter settlements, and in the camps of labor contractors in regions torn by violent labor conflicts. She traveled thousands of miles down back roads, to remote stump farms near the Canadian border, to sharecropper's cabins in the South, and to small government-sponsored farmsteads in the high desert. She discovered "what had been either neglected, or not known... things that no one else seemed to have observed in particular, yet things that were ... important," and she held up her mirror that we might see who we were, how we came to be, and what we were in the process of becoming. Daring to look, she raised questions that demand answering, still.[3]

Daring to Look presents 149 of Lange's photographs and her accompanying reports from the field from the year 1939, when, at forty-four, she was at the height of her powers. Few of Lange's superb 1939 photographs—portraying America's massive upheaval and resettlement, its private greed and environmental degradation, its public miscalculations, and its efforts to restore hope— and, as of 2006, only four of her seventy-five seminal texts from that year have previously been published. Her artistic documents from that pivotal year, "lost" and now "found," appear for the first time in this book, almost seventy years after they were produced. Why, with Lange's work among the most celebrated and influential in American photography, have these photographs and texts been so neglected? And why has the handful of photographs that have been published been limited to those of people, when almost half of her three thousand photo-

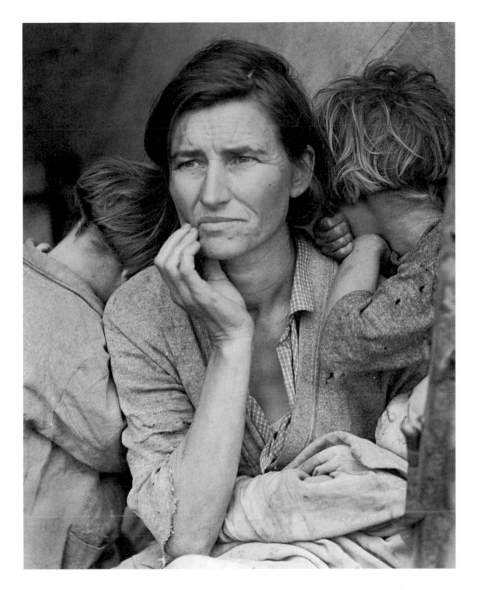

2. Migrant Mother. Nipomo, California, 1936. Lange's original caption: "Destitute peapickers in California; a 32 year old mother of seven children. February 1936."

3. "America Survives the Depression." "Migrant Mother" on U.S. postage stamp commemorating the 1930s. 1998.

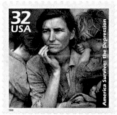

graphs from 1939 are of landscapes and buildings, with no people at all? The answers I found pose even larger mysteries about Lange's work and her identity. *Lange herself was missing.* This book is a story of discovery and recovery of what had been lost or overlooked or misinterpreted, a process of retrieving and recapturing Lange, the person and the artist.

The "lost" documents and other mysteries

In 1969, a senior in college, I took a slim book from a shelf in a bookstore's photography section and looked into the faces of fifteen women, from an "ex-slave with a long memory" to a pioneer who "crossed the plains in 1856." The book was *Dorothea Lange Looks at the American Country Woman*.[4] One of Lange's American country women, her face framed by the deep visor of a "do-up" bonnet, was "Queen." I encountered Queen again at the end of that book in a text

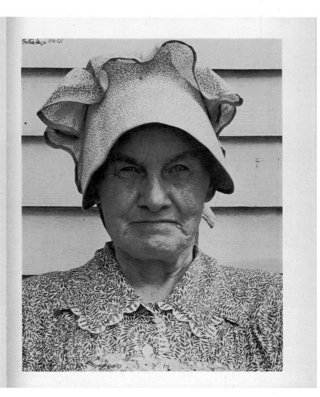

The woman called "Queen"
on a Sunday morning
at church-time.

Note
that she wears her "do-up" bonnet,
typical sunbonnet
in this part of rural America.

NORTH CAROLINA. 1939

4. Queen, *American Country Woman.*

headed "Typical Field Documentation," describing "Annual Cleaning-up Day at Wheeley's Church" on July 5, 1939. The vivid detail of Lange's words compelled me to look at the photograph itself in a new light. Lange indicated that she had gotten permission from the deacon to return on July 9, "preachin' Sunday," to make pictures of the congregation. Did she return, I wondered, and, if so, what did she see? To find an answer to that question and to learn more about the photographer and her work, I sought out books on Lange and studied her photographs, but over the next thirty years, I found no further "field documentation," despite the "typical" in the title of the example I had read. In 1999, I began a search—and I found the answer. Yes, Lange did go back to photograph Wheeley's Church on "preachin' Sunday." And, yes she did write many other reports from the field.

After Lange's death in 1965, her husband, Paul Taylor, a professor of economics at the University of California at Berkeley, gave her photographs and papers to the Oakland Museum of California. There I found carbon copies of the field documentation Lange had written years before, on assignment for the Farm Security Administration (FSA). (Both the original texts she submitted in 1939 to the FSA office in Washington, D.C., calling them "general captions," and the photographs themselves, are in the Library of Congress.) Each of Lange's seventy-five general captions from 1939 stands as a portrait of a moment, a place, a group of people, a theme; together, they paint a portrait of rural land and society in America and of the forces transforming them at the height of the Great Depression. These reports from the field appear in this book. The "lost" words and photographs from 1939 reveal starkly contrasting Americas: in California,

the spread of large-scale industrialized agriculture and new highways, with the arrival of a migrant population from the Midwest, South, and East; in North Carolina, traditional agriculture centered around the seasonal cycle of harvesting and curing tobacco and the daily lives of white and black tenants and sharecroppers, scarcely changed from the Reconstruction era after the Civil War; in the Pacific Northwest, the irrigation of sagebrush desert, the resettlement of farm refugees from the Dust Bowl, and the abandoned lumber mills and vast acres of cutover forest peopled with pioneers who settled these stumplands. Lange was piecing together the "big story" behind the many personal and local stories of poverty and despair, generosity and hope.

That big story cannot be told in a single photograph or even in multiple photographs. To tell the story of "people in their relations to their institutions, to their fellowmen, and to the land" many photographs need to be grouped by subject, arranged, cross-referenced, and "buttressed" by words.[5] So Lange believed. To accomplish this, she developed the general caption to define a topic, place, or people, to cross-list individual photographs and captions by negative number, and sometimes to include documentary evidence from newspaper clippings, articles, and office reports. Her "Hop harvest in Oregon," for example, is a group of thirty-five photographs (each with its own caption) and accompanying text that sketches how hops are "stripped from the vine," "weighed in the yard and hauled to the kiln in sacks," as well as who the pickers are ("locals and migratory families") and how much they earn ("1¢ per pound of picked hops...about $1.50 per day") (see general caption 45). Lange attached a pay envelope with rules for hop pickers and an article on children in the hop fields as supporting evidence (figure 16). Her photographs, and their individual captions, are episodes in this cumulative, nonlinear story: a tree arching over a road with a sign advertising for hop pickers ("But they don't say what they pay!"); a boy in the field ("Started work at 5 a.m. Photograph made at noon. Temperature 105 degrees"); a deputy sheriff leaning on the shelf of the paymaster's window ("We have him ... to keep them scared as much as anything"). Although a few of these photographs have been published separately, "Hop harvest in Oregon" has never been considered as the narrative that it is. Now, framed by the general caption, the images and words acquire multiple layers of meaning, embodying what anthropologist Clifford Geertz, much later, would term "thick description."[6] For Lange, the photograph was not the goal; her primary purpose was to discover and to understand. And to share that knowledge. The end product was not the individual photograph but the pair of image and caption, and the group of images with accompanying text.

Lange's words and images, seen together, are more than documentary records; they are an art form. Her best photographs are neither pure art nor mere fact but a marriage of the two that "carries the full meaning and significance of the episode or the circumstance or the situation." She does not trust a visual image to tell the story by itself. For Lange, "writing was the equivalent of the photographs, or even more important," says Rondal Partridge, Lange's assistant and friend. Her strongest captions direct the eye and the imagination beyond the

obvious or picturesque or grotesque. At times they focus on the merely factual, at other times they are rhetorical, complex or ironic; sometimes they point to what is *not* in the photograph. The words are often a punch line to the "photographic statement." As Lange put it, a caption should "enhance and fortify" a photograph; it should not be text "that tells a person what to look for, or that explains the photograph." It should "give you a different look."[7] To give that "different look" to her photographs of U.S. 99 in California, Lange, in 1939, produced her first "general caption." By the end of the year she had developed the form fully, and she continued to use it thereafter. For Lange, those general captions of 1939 were a key step linking her experiments with words and images in the mid-1930s to her photo essays for *Life* magazine in the 1950s and her work of the 1960s, which freely combined photographs with spare prose. These late works are among her greatest.

If Lange's texts and photographs of 1939 are so important and compelling, why have they not been published until now? Has her work of 1939 for the New Deal's Farm Security Administration simply been buried among the tens of thousands of images and texts by other photographers in the FSA's vast collection, housed since 1943 in the Library of Congress? No—the photographs are posted on the library's public Web site, and the general captions are accessible on microfilm.[8] A 1985 Library of Congress guide for scholars, which noted that FSA photographers had produced both "individual and general captions," included one of Lange's 1939 general captions as an example. A few scholars have mentioned these texts, but none has treated them in depth.[9] If this is not a case of an unknown treasure, then what is the reason for such neglect? Did these authors think Lange's grouping of photographs and her words themselves were of little importance? As Beaumont Newhall wrote, in his 1967 foreword to *The American Country Woman*, "Dorothea had a sense of words as acute as her sense of the picture. Not enough has been said of it." Forty years later, not enough has been said of it, and too little has been published.[10]

A great many books have reproduced Lange's photographs with captions someone else wrote, apparently unaware or not caring that, to Lange, visual and verbal images are a unity. Without Lange's own words, the intended impact of the photograph is often lost. Further, the words others have substituted for Lange's have often been misleading or wrong.[11] In the 1971 Time-Life book *Great Photographers*, Lange's photograph of a woman and her children "just arrived from Deadwood, South Dakota," taken in Tulelake, California, is incorrectly placed in Tulare, some five hundred miles away. What's more, the caption asserts melodramatically that they "stare into a bleak future," that their "gaunt eyes and clutching hands tell the tale of misery and hunger" (figure 103).[12] Not Lange's words, and the impression they leave is false: in another photograph the mother is smiling, not bleak at all, her expression not gaunt (figure 104). Lange knew that people tend to look at photographs and read into them their own stories, stories that are often at odds with the circumstances recorded. Her 1937 photograph of a black couple, "Ex-slave and wife who live in a decaying plantation house" from Greene County, Georgia, where they were scratching out a

living, was featured in an FSA exhibit of 1940, "New Start on the Land," the caption claiming that FSA programs had doubled the incomes of borrowers, a mockery.[13] Scholars have taken similar liberties with Lange's work, like the historian who misrepresented Lange's photograph of a black tenant farmer from North Carolina with a caption describing how "agricultural programs implemented during the depression not only helped a great many farmers to overcome personal hardships but also taught them new skills and introduced them to new crops" (figure 60). Lange's own documentation suggests no such thing (the man's crops were the standard, tobacco and cotton), and her North Carolina captions cite no helpful programs.[14] To delete Lange's captions is akin to cropping her photographs.

A handful of Lange's 1939 photographs have been published repeatedly without the evidence she provided of their context. A young girl leaning on a wire fence is referred to as "one of Chris Adolf's children, near Wapato, Washington." This is Lange's caption for the individual photograph, but her general caption provides the backstory: this one child is one of eight, all uprooted from the high plains of eastern Colorado by drought ("The dust got so bad that we had to sleep with wet cloths over our faces") and resettled with their parents on "Indian land" (figure 122). In other instances, the descriptions are simply inaccurate: a photograph of a North Carolina country store, made in 1939, is frequently dated to 1937 and the store transplanted to Alabama. Lange's original caption for another image of the store describes it as a meeting place down the road from a tenant farmer's house; Lange had gone to the store with the farmer and his daughter and returned a few days later to take this photograph (figure 177). The photographs reproduced in this book are presented in Lange's own contexts, now restored.

Some curators and critics may argue that a photograph should stand on its own, with no need for explanatory text. To call a photograph "text-dependent" is, in their view, derogatory. An artist should be seen and not heard. But knowledge ought not to be so readily dismissed. Lange's joining of words with images counters the prevalent prejudice that verbal intelligence diminishes visual artistry. The verbal and the visual *are* distinctly different ways of thinking and knowing, but in those rare instances when one individual practices both arts, that whole should be celebrated, not suppressed. To divide the visual from the verbal, for Lange's work, is to miss the whole that it represents.

Iconic images are by nature archetypal, but Lange's works are also documents of lives and places: where the people came from, how they are making out, what they hope for, and the conditions that shape a person, a homestead, a town, a region. Thus, her captions are as important to her work as the images themselves, providing details, often with direct quotes from the persons depicted, expanding the images, grounding them in time and space. The general captions supply the larger context of event and circumstance and place. To read Lange's photographs and captions together, as she meant that we should, is to sense the necessary tension between the universal and the particular.

Lange's general captions are not all that has been missing. I was startled to

discover Lange's rich landscape material. She is known almost solely as a photographer of people, but in almost half of the photographs Lange took in the Pacific Northwest in the fall of 1939, there are no people. Instead, there are lonely farms amid stumps and sagebrush, log cabins and dugout homes, one-room schools and railroad stations. There are intimate landscapes too: sacks of seed piled against a bookcase, houseplants brought from Montana to a one-room cabin in northern Idaho. Her lens and pen convey the significance of the inanimate object: the sack, the step, the path, or the mailbox. Indeed, her intuitive and metaphorical approach sometimes invests these subjects with a sense of the animate, as if she believed, with Henry James, "that objects and places, coherently grouped, disposed for human use and addressed to it, must have a sense of their own, a mystic meaning to give out."[15] And yet, in an overwhelming and consistent trend, books purporting to offer an overview of Lange's work have principally featured her photographs of people.[16]

Lange's work cannot be separated into conventional categories of landscape or portraiture. The absent people are implicit in the landscapes and buildings they shaped, and the landscapes implicit in people's bodies and the details of their clothes, homes, and tools. "She seemed to see the people as part of the landscape, living, breathing parts of the landscape," her son Daniel Dixon has observed. When, in the 1960s, Lange speaks of her photograph of an Irish countryman, she could be describing a wind-pruned tree: "That face that the wind of the Atlantic Ocean—blown over all his life, never been out of it."[17] The faces of the farmers she photographed in 1939 were like that, weathered. Landscape was in those faces. Lange photographed landscape in the original and most profound sense of the word, the mutual shaping of people and place, her sense of landscape as acute as her sense of person.[18] "Nobody ever gave me any credit for making any landscapes," she declared in 1964. "I did make landscapes, loads of them!" Why, then, have critics failed to see or acknowledge that?[19] Perhaps it is because the full body of her work has not been seen at all, a fact that is, in itself, telling.

Also, despite the evidence of Lange's own work, critics often focus on her gender and on her emotion, not her intellect. One critic said that "no subject was beyond her woman's sense of care and tenderness," that with "maternal concern for things of this world" Lange created "universal forms of human feeling."[20] In his 2002 book, Pierre Borhan observed that Lange's choice of photographs for *The American Country Woman* "confirmed, if it was ever in doubt, that she appreciated women who were essentially domestic and devoted to their families." Yet families are mentioned or implied in Lange's text for only eight of the fifteen women in that book, and none is shown with a husband or a child. Rather, they are presented as individuals to be respected and admired for themselves and, at the same time, as emblems of a tradition to be celebrated, one portrayed not only by each woman herself, but in a paired photograph of her home, landscape, church, or town. In an earlier version of the work, Lange had written of the American farm woman that "she bears the imprint of the land around her, leaves her stamp in generations after her.... Her portraits are everywhere around her.... She has always been a mirror of the land she lived on."[21]

When a retrospective exhibit of Lange's life's work opened at the art museum in Worcester, Massachusetts, in the fall of 1966, a year after her death, the *Boston Herald* avowed that Lange "belongs with the great artists of America" but said "she was as little known outside professional circles, as the photographs were well known."[22] This is still true four decades later. When I told people about my book in progress, many asked, "Who is Dorothea Lange?" You have seen her work, I would say. You know, the photograph of a mother and her children from the Great Depression, the most reproduced photograph in the world, according to one source. I would hunch my shoulders, raise my hand to my cheek, bend the other arm as if cradling a baby. By then, everyone nodded in recognition. But they knew nothing of Lange herself or of her contribution to photography, to art, to American culture, as one of the most important American artists of the twentieth century.

"I went home that day a discoverer, a real social observer"

Who was, who *is*, Dorothea Lange? Lange was forty years old when she made the photograph "Migrant Mother." She had recently reinvented herself professionally. She had been a portrait photographer in San Francisco, her clients from wealthy families, the direct opposite of the "people in trouble" whose photographs were to make her famous. Not until she was thirty-seven, in 1933, did she take her camera down from her upstairs studio on Montgomery Street into the gritty city, where the Depression was "beginning to cut very deep."[23] And on that first day, she made a photograph that was to become one of her most celebrated, "White Angel Breadline." (Her print of that photograph sold in 2005 for $822,400 at Sotheby's in New York, at the time a match for the highest price ever paid at auction for a twentieth-century photograph.)[24]

When Lange made "White Angel Breadline," she was the mother of two small sons and the principal breadwinner for her family, living apart from her husband, Maynard Dixon, painter of the American West and a well-known figure in San Francisco's art colony. Her friends were artists and photographers, among them, Imogen Cunningham, Edward Weston, and Ansel Adams. She had come to California in 1918, after one year at a teacher's college and a series of apprenticeships in New York with portrait photographers. As World War I reached its climax, she embarked on a trip around the world but ran out of funds and got no farther than San Francisco, where she opened a portrait studio and, in 1920, married Dixon. When, soon after, Dixon quit his job as a billboard artist to devote himself to painting, he took long trips to the Southwest, usually leaving his wife behind in San Francisco. Lange had been left behind before: her father, a lawyer, had abandoned his wife and children during the Depression of 1907; her mother, a librarian left alone to raise their two children, moved back into her own mother's house in Hoboken, New Jersey.

When exactly, and why, did Lange decide to photograph "people in trouble"? Her own accounts vary, though all entail a struggle to redefine her professional identity. In an interview during the 1960s, she tells of watching from the up-

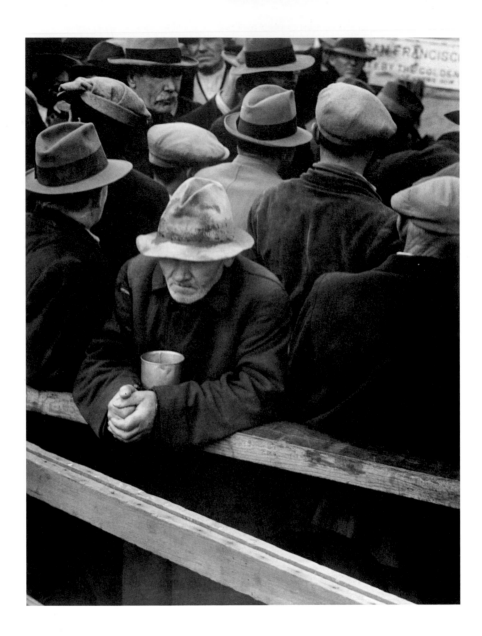

5. White Angel Breadline. San
Francisco, California. 1933.

stairs window of her studio as the unemployed drifted past in 1933, and of de-
ciding to take her camera to the street. But, in an account from the 1950s, she
reports that the decisive moment occurred earlier, in a clap of "thunder bursting
and . . . wind whistling" in the summer of 1929, as if foreshadowing the stock
market crash a few months later. She decided then to "concentrate upon people,
only people. All kinds of people, people who paid me and people who didn't."[25]
Whether or not the conversion was really so melodramatic, Lange's transfor-
mation from portrait photographer of the urbane wealthy to "field investigator,
photographer" (the title of her first job with the federal government in 1935),
was life-changing.

 As Lange went down to the streets of San Francisco in 1933, Franklin Delano
Roosevelt was launching the New Deal to address the national economic emer-
gency. Urgency, fear, and hope were in the air. In his first Hundred Days, FDR

issued executive orders establishing a host of programs and agencies to provide relief and create jobs for the poor and the unemployed. Lange, on San Francisco's skid row, was photographing men sleeping on sidewalks, leaning against storefronts; one man sat slumped, head bowed, next to an overturned wheelbarrow. In 1934, Lange and Dixon, though living apart, were portraying similar scenes, Dixon's paintings of a man sitting on a curb and men leaning against buildings echoing Lange's photographs. Or perhaps her work echoes his, framing views from the same low perspective. Probably the influence was mutual.

Before the San Francisco general strike broke out, on July 16, 1934, Lange had already photographed demonstrations: men with fists raised, mouths open, shouting. When the strike erupted among longshoremen, she entered the crowds to make portraits of participants and spectators: men gripping placards; a policeman in the street, with gleaming badge and buttons; a crowd of men in fedoras and overcoats, shirts and ties. When she put up on the walls of her studio prints of the demonstrations, the general strike, and the unemployed men on San Francisco's streets, her privileged clients asked, "But what are you going to do with it?" She did not yet know and could not answer.

That summer, Willard Van Dyke exhibited Lange's street photographs at his gallery in Oakland. Paul Taylor, who was teaching economics at Berkeley and saw the exhibit, phoned to ask whether he might use a photograph for *Survey Graphic*, a leading social science journal of the day. Lange said yes, and her photograph of a man shouting into a microphone appeared with an article by Taylor and Norman Gold.[26] Taylor, who had known the *Survey Graphic* editor, Paul Kellogg, for many years, had written for the journal previously, including an article on migrant workers from Mexico with photographs by himself and by Ansel Adams. "My method in the field is to observe, then select," he said later. "By the time you statisticians know the numbers, what I'm trying to tell you about in advance will be history, and you'll be too late."[27] When the California Emergency Relief Administration (SERA) appointed Taylor as field director for rural rehabilitation and charged him to assess the situation of agricultural laborers, Taylor decided that "words alone could not convey the conditions"; he must show "what the real conditions were like," and to accomplish this he hired a photographer—Dorothea Lange. Ten months later, they were married.[28]

In January 1935, Lange, on her first trip for the new job, accompanied Taylor to California's Imperial Valley to observe and report on farm laborers living in hovels made of cartons, branches, and scraps of wood and cloth, with primitive privies, no waste disposal, no potable water. Lange began to write as well, impressed by the "life histories" a young Mexican woman on Taylor's team of researchers was bringing back, and from then on she asked questions or listened and wrote down what people said about the hardships they faced ("Pretty hard on us now/Water standing on the quilts when we got up this mornin'"), what they earned ("15¢ a hamper"), where they came from ("Born . . . raised in the state of Texas—farmed all my natural life"). Thirty years later, the excitement of that early fieldwork was still fresh for Lange, particularly the memory of the rainy afternoon when she met the first Dust Bowl migrants. "We've been blown

out," they told her. "That was the beginning of the first day of the landslide that cut this continent," she recalled. "I went home that day a discoverer, a real social observer."[29]

Lange's photographs and her field notes provided the raw material for a new sort of government report: essays comprising photographs with handwritten captions, many with quotations from the people she photographed.[30] For that first assignment, she combined, in a spiral-bound document, Taylor's longer texts (including statistics) with her own hybrid essays, and maps drawn by Maynard Dixon. That first report by Lange and Taylor, "Establishment of Rural Rehabilitation Camps for Migrants in California," requesting federal funds to build twenty to thirty camps with "decent housing," could not have been more effective. At the meeting of the SERA commissioners, Taylor's boss (who had been skeptical about hiring a photographer) pulled out Lange's sheets of captioned photographs and passed them around the table, whereupon the members voted to fund the camps. Later, though, someone challenged the state commission's authority to allocate federal money, for the camps were controversial. After the general strike of 1934, conflicts between growers and workers became increasingly violent, growers fearing that workers in government camps would organize and labor organizers fearing that the camps would stifle such collective action. Not until a federal official went out into the field with Taylor and Lange to observe living conditions firsthand were funds allocated to construct two camps, the first federally funded housing in the United States, Taylor said. Taylor has been called the father of the migratory camp program in California.[31] If he was the father, then Lange was the mother.

Taylor and Lange's first report described the situation faced both by Mexican and Filipino farm workers and their children and by "white Americans." "On these workers the crops of California depend," reads the first caption. "All races serve the crops in California," says another.[32] Lange produced at least three other reports that spring of 1935, one more with Taylor and two on her own. By April, she was photographing "drought refugees" from Texas, Oklahoma, and Arkansas. The photographic essay she composed later that month was more than a collection of photographs (figure 6). It was a story, beginning at the bridge from Yuma, Arizona, the gateway to California, introducing the migrant families and their "worldly goods," relating their histories and hopes, describing their sense of disorientation. "I'm havin' trouble with my bearins," a man from Arkansas told Lange. "Where is Tranquility, California?" asked a pregnant mother from Oklahoma.[33] "First Rural Rehabilitation Colonists, Northern Minnesota to Matanuska Valley, Alaska," Lange's story of resettled farmers en route to Alaska in eleven pages of deftly-sequenced photographs and no captions is an artist's book. From the first pairs (a young father, mother, and baby on a train; empty train tracks stretching into the distance) to the last pair (a woman leaning on the ship's rail, looking out; the steamship sailing off), Lange captures hope, apprehension, regret—the mixed emotions of resettlement (figure 7).[34] With these "books," Lange had moved from studio portraitist and street photographer to investigator and storyteller.

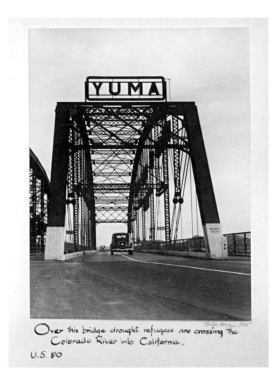

Over this bridge drought refugees are crossing the
Colorado River into California.
U.S. 80

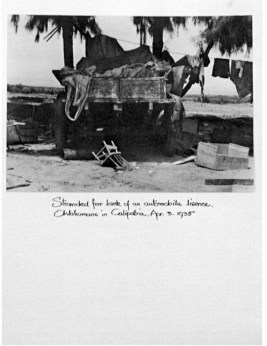

Stranded for lack of an automobile license.
Oklahomans in California. Apr. 3. 1935

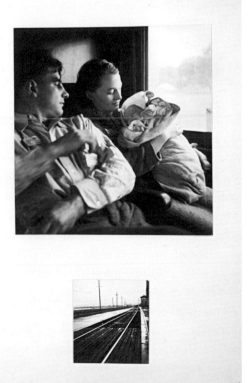

6. "Migration of Drought Refugees to
California." April 1935.

7. "First Rural Rehabilitation Colonists,
Northern Minnesota to Matanuska, Alaska."
First and last pages. May 1935.

Two years into FDR's first term, the nation's capital was on fire with new executive orders and new legislation. The Works Progress Administration was creating jobs for unemployed workers, from laborers to artists. Roosevelt had signed the Social Security Act to provide pensions and unemployment insurance, a sea change in American society. Agencies created two years before were now being revised, moved, and reformed under new names within new structures, their staffs reshuffled and expanded. One of these was the Resettlement Administration, consolidating several existing programs, including a low-interest loan program to help poor farmers buy land. Among those recruited to go to Washington, D.C., to staff the new Resettlement Administration was Lewis Hewes, who had authorized Lange's original appointment to work with Taylor.[35] Hewes took along to Washington copies of Lange's and Taylor's reports to show to his new boss, Rexford Tugwell, and also to Secretary of Agriculture Henry A. Wallace, Secretary of the Interior Harold Ickes, and Eleanor Roosevelt. Lange's photographs had a "powerful effect" in Washington, Hewes told one of Lange's biographers: "She was about the most important thing in the whole show." He arranged for her to be hired as "field investigator, photographer" in the agency's Information Division, based in California and with responsibility for five states.[36] Two years from the time Dorothea Lange stepped down from her studio in San Francisco to take her camera into the streets, she was ready to photograph the New Deal. She knew what she wanted to do, and what she would do for the rest of her life.

"We unearthed and discovered what had been . . . neglected, or not known"

"Open yourself as wide as you can . . . like a piece of unexposed, sensitized material," like film itself. That was Lange's way of working. "It is often very interesting," Lange noted in the early 1960s, "to find out later how right your instincts were, if you followed all the influences that were brought to bear on you while you were working in a region. . . . It did happen more than once that we unearthed and discovered what had been either neglected, or not known, in various parts of the country, things that no one else seemed to have observed in particular, yet things that were too important not to make a point of." Lange would prepare for a trip to a new area by consulting knowledgeable peers and "looking up data," believing that "it is not enough to photograph the obviously picturesque." She did not delve deeply into books before a trip, instead reading in the field or after returning, to make sense of what she had seen and to put the photographs in context. "To know ahead of time what you're looking for means you're then only photographing your own preconceptions, which is very limiting, and often false."[37] Too much reading in advance prejudiced the eye.

"Ron, go slow, slow!" Lange would urge her driver and assistant, Rondal Partridge. "And her eye would go from one side to another," he remembered, "taking in everything, every little thing, and when we saw something—a broken car, a camp of migrants, a farm machine, a boss—she would stop and ask questions.

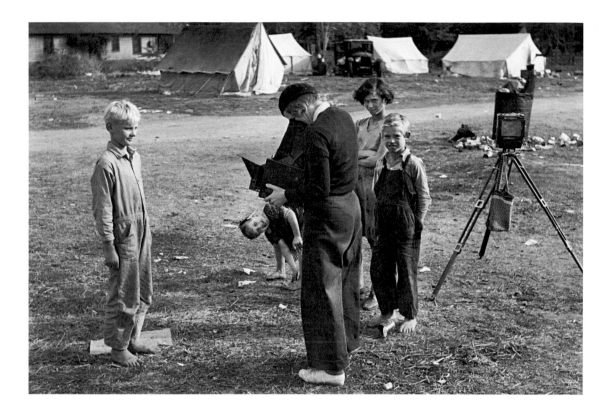

'I'm from the government. What's going on here?'"[38] "This tells the whole story," Partridge told me, pointing to his photograph of Lange in a migrant camp during the late 1930s (figure 8). "With the Rolleiflex around her neck, she would set up another camera on a tripod. The camera on the tripod was a come-on. The kids would gather round and ask for their picture to be taken. Then they would run to tell their parents, and she would follow. That's how she met the adults."[39] A series of Lange's 1939 photographs records this process (figure 9).[40] In Partridge's photograph, Lange is surrounded by children; one tall boy, shoulders thrown back, smiles into the lens. Lange looks down through the viewfinder of her Graflex, the lens at the level of his chest. It was her practice to point her camera up toward the faces, not to look down on them; that perspective made her subjects seem monumental. It was also a consequence of her own short stature and of her choice of cameras, some of which required her to look down through a viewer rather than straight ahead.[41] To get an overview of a camp or a field, Lange would climb up onto the roof of her car (figure 10).

On assignment for the FSA, Lange usually photographed every day, from early morning into the evening. At night, she wrote letters and prepared for the next day's work: "Have just finished loading and unloading the films. It's late, I'm tired. Had a good day today but I'm done up—and there are all those notes and explanations, essays on the social scene in California is what they should be—still to be done."[42] To supplement her notes, Lange clipped stories from local newspapers and gathered research reports, pamphlets, and memos written by local FSA staff (figure 16). Although she sometimes stayed in one place for

8. Dorothea Lange photographing at a migrant camp. 1937. Rondal Partridge.

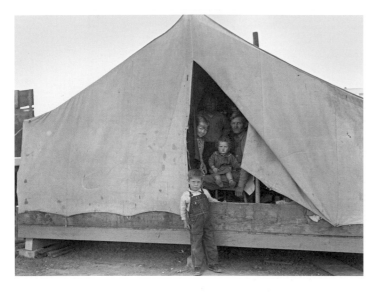

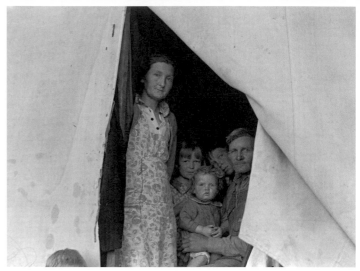

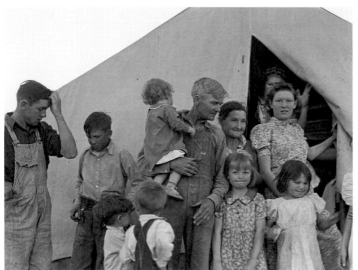

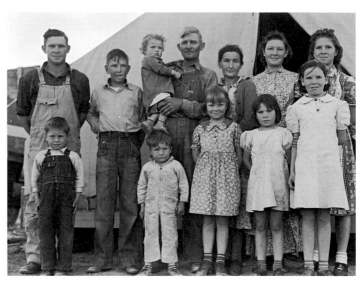

9a–e. The encounter: photographing a family.

"Brawley, Imperial Valley, Feb. 23, 1939. In FSA migratory labor camp. Family, mother, father, and 11 children, originally from near Mangrum, Oklahoma, where he had been a tenant farmer. Came to California in 1936 after drought. Since then have been travelling from crop to crop in California following the harvest. Six of the 5 children [*sic*] attend school wherever the family stops long enough. Five older children work along with mother and father. Feb. 23rd, two of the family had been lucky and 'got a place' (a day's work) in the peas on the Sinclair ranch. Father had earned $1.73 for ten-hour day. Oldest daughter had earned $1.25. From these earnings had to provide their transportation to the fields, 20 miles each way. Mother wants to return to Oklahoma, father unwilling. She says, 'I want to go back where we can live happy, live decent, and grow what we eat.' He says, 'We can't go fixed the way I am now. We've got nothing in the world to farm with. I made my mistake when I came out here.'"

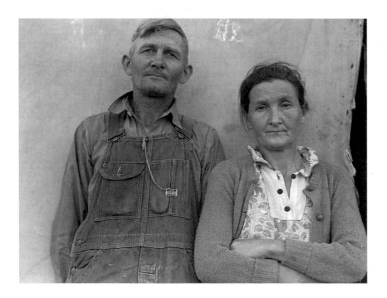

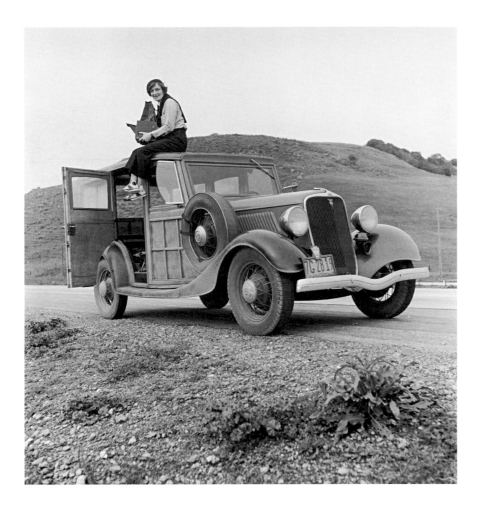

10. Dorothea Lange, Resettlement
Administration photographer.
February 1936.

several days, she often had to travel several hundred miles in a day. If an assistant was along, they might travel all night, taking turns driving and sleeping, or sleeping in a single room in an auto court, like those in California's Central Valley between U.S. 99 and the railroad tracks, where the roar of trucks and the clanking of trains resounded throughout the night. "[It] was hard, hard living," Lange recalled, ". . . not too far away from the people we were working with."[43]

Open herself, Lange found it easy to get people to open up to her. She would ask for directions as a way into a real conversation. She might speak to someone standing at the opening of a tent, on a doorstep, in a field, beside a car: Where had they come from? Where were they going? Who was living or traveling with them? How were they managing? What were their plans? There was no emotional distance between Lange and her subjects. Ben Shahn, in contrast, sometimes used an angle-finder on his lens so that people did not know he was photographing them. It is hard to imagine Lange's employing such a technique. "I never steal a photograph," she told Partridge. "Never. All photographs are made in collaboration, as part of their thinking as well as mine."[44] She wanted rapport with those she photographed, and she sensed when she had it; she considered her subjects complicit in the creation of their own portraits. Many of the individuals she photographed are shown speaking to her or pausing to reflect, their

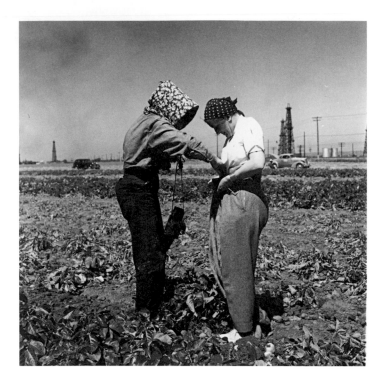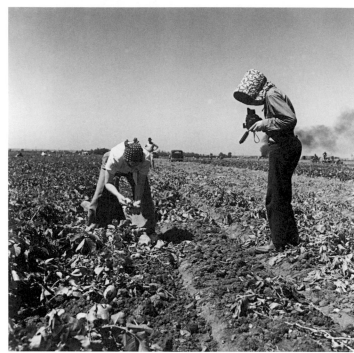

11. Dorothea Lange, changing places with an agricultural worker. 1937. Rondal Partridge.

expressions revealing. She usually took more than one photograph of each person; in one an expression may be grave, in another a smile flashes.

Lange was patient:

Often it's just sticking around and being there, remaining there, not swooping in and swooping out in a cloud of dust; sitting down on the ground with people, letting the children look at your camera with their dirty, grimy, little hands, and putting their fingers on the lens, and you let them, because you know that if you will behave in a generous manner, you're very apt to receive it.... I have asked for a drink of water and taken a long time to drink it, and I have told everything about myself long before I asked any question. "What are you doing here?" they'd say. "Why with your camera? What do you want to take pictures of us for? Why don't you go down and do this, that, and the other?" I've taken a long time, patiently, to explain, and as truthfully as I could.[45]

Lange listened to the people she photographed and tried hard to remember their exact words until she could write them down, "often with great excitement…just hoping that I could hold onto them until I got back to the car." "The words that come direct from the people are the greatest…. If you substitute one out of your own vocabulary, it disappears before your eyes." "I'd turn around," Partridge recalled, "and there would be Dorothea, back in the car writing down what she had heard."[46] In her looseleaf "daybook," small enough to fit in the palm of her hand, she recorded the location and date, remarks made by people she met, and statistics that described their lives (what they earned, how much they paid for food and rent, the number and ages of their children). Some of her

notes are scrawled; others are written more carefully. Most are in her own hand-writing, with its distinctive upright, rounded letters; some are in another hand (occasionally a stenographer from the local FSA office accompanied her). The comments Lange wrote are never critical or condescending, though some notes in others' handwriting are—"rather shiftless," wrote one note taker about a family. In all the many daybook pages I examined during my research, I found not a single denigrating comment by Lange about any person.[47]

Lange turned others' hostility to advantage: "You go into a room and you know where you're welcome; you know where you're unwelcome.... Sometimes in a hostile situation you stick around because hostility itself is important.... The people who are garrulous and wear their heart on their sleeve and tell you everything, that's one kind of person, but the fellow who's hiding behind a tree and hoping you don't see him is the fellow that you'd better find out why."[48]

When Paul Taylor accompanied Lange in the field, he too engaged people in conversation and took notes while she photographed; the two paused at intervals to confer and record what Lange had heard. "Her method of work," he recalled later, "was often to just saunter up to the people and look around, and then when she saw something that she wanted to photograph, to quietly take her camera, look at it and if she saw that they objected, why she would close it up and not take a photograph, or perhaps she would wait until...they were used to her.... Then she would take the photograph, sometimes talking with them, sometimes not.... My purpose was just to make it a natural relationship, and take as much of their attention as I conveniently could, leaving her the maximum freedom to do what she wanted.... But you can see on how many great occasions she didn't need my help."[49] Entries in her daybooks for August 1939 in both Taylor's handwriting and hers reflect their easy, cooperative working relationship; they passed the daybook back and forth (figure 12). "A good deal of the discipline that I needed in order to get hold of such an assignment—some of them had a very broad base—he gave me on those trips," said Lange. "I learned a good deal from Paul about being a social observer."[50]

"I am writing captions until my fingers ache to say nothing of my head," Lange told Roy Stryker, her boss at the FSA, in 1937. "This is no small job.... Am not sending it on to you in sections, as I had originally planned because I am making cross-references.... It's not the individual captions that [take] the time but it's the arrangement and grouping. If this is not done I believe that half the value of fieldwork is lost." And two weeks later: "I am not yet through with this g-d-captioning job by any means although I'm working on it just as hard as I can. Sometimes it goes fast but sometimes I get stuck and have to go walk around the block or dig in the garden. I write 'tenant farmer' and 'Mississippi' in my sleep."[51]

Lange began to formulate what became her general captions in the spring of 1939. Initially, they provided context and consolidated individual stories, but they came to be more than organizational—they were catalytic. "U.S. 99," her first general caption, describes the "arterial highway which serves the San Joaquin and Sacramento Valleys of California. Over it moves a stream of vehicles of

Aug 13 - Sunday
1939
Abandoned farmhouse
1 mi. E of Quincy, Wash.
in Columbia Basin.
The land of this farm is
still used for
dry land grain farming -
But the original homesteader
has left. the land
has reverted to a bank or
insurance co. & is operated
on lease from town for grain
only on a large-scale.
Most of the Basin was
homesteaded in the 90's.

across highway
Ament Chris - German Russian
He stayed
White House and red barn.
Came from Volga in '99 to
Nebraska. Heard of free crops and
R.R. land and came in 1906,
have has 320 + 480 acres.
His neighbors left and went to Canada.
From one of his pieces he sledged
21 bu to the acre (from the high land)
If he had it to do over he wouldn't
have come. Raised 9 children,
all born in state.
I'm 67 years old and won't live
to get the benefits of the water,
but I hope to be able to see it.
If it govt handle it right it will
be a good thing, but my boy has
a good piece of land down in Yakima,
plenty of water, good soil, and he
can make a go of it.

12. Dorothea Lange's daybook. August 13, 1939. Quincy, Washington. Paul Taylor's handwriting on left, Lange's on right.

commerce—oil tank trucks, loads of pipe for oil wells, groceries in bulk, household goods, freight of all kinds." After she conceived "U.S. 99," Lange began to focus more on the landscape of road and roadside: "the fields and labor houses of large growers, orchards of small and large farmers, ragged camps of squatters, fruit and vegetable markets, hot dog and cold drink stands, auto camps, gas stations, billboards, and stringy towns." By the end of the summer, she was formulating her general captions in the field, and this guided her picture and note taking. Although Lange did not invent the idea of the general caption—Ben Shahn, the previous summer, had grouped his photographs of rural Ohio thematically, under "general captions"—by the end of 1939, she had set the standard.[52]

"It was a revelation, what this woman was doing"

Between 1935 and 1939, on assignment for the Resettlement Administration and its successor, the FSA, Dorothea Lange made "Migrant Mother" and many other celebrated photographs, her work being among the most widely used and recognized of that of all the FSA photographers. Yet Lange's boss, Roy Stryker, fired her, and not just once but three times; first in October 1936, next

Pacific Northwest
November 13, 1939

GENERAL CAPTION NO. 46

DATE: August, 1939

PLACE: Marian County, Willamette Valley, Oregon

SUBJECT: String bean harvest

The bean crop requires a large number of harvesters for a few weeks in August of each year. Beans are trained up strings attached to cross wires similar to those in hop yards, only lower. Crops are grown mostly by small farmers. Pickers are partly local people, partly from nearby portions of Oregon, who work seasonally only in the bean crop, and partly migrants who follow the crops from harvest to harvest. Many of these have come originally from outside Oregon, principally from Kansas and other states of the northern Great Plains. Some have come from Oklahoma and other states of the Southwest. Most of the pickers camp on the land of the growers. Small farmers do not maintain organized, well-equipped camps. There is less formality and freer more intimate relationship between small farmers and pickers than between the large growers and workers in California. There are one or two large camps which charge rental. 1939 pickers' wages are $1 per 100 lbs.

A Small Farmer: "We watch all the time for agitators. An agitator will turn the whole yard upsidedown in two hours."

Refer to negative numbers;
20472 E
20476 E 20585 C
20478 E 20586 C
20481 E 20589 D
20482 E 20591 D
20490 E 20599 D
20495 E 20901 D
20497 E 20903 D
20500 E 20904 D
20501 E 20907 D
20530 E 20908 D
20531 E 20909 D
20532 E 20910 D
20534 E
20535 E This is a region where Region XI plans to send *one of its four*
20575 C ~~lbs~~ mobile camp units for the season of 1940.
20579 C
20580 C
20581 C
20582 C
20583 C
20584 C

13. General caption 46.

in November 1937, and finally in October 1939, at the end of that brilliant year in which she produced the extraordinary photographs and field documents reproduced in this book.

Unraveling the mystery behind Stryker's repeated and successful efforts to dispense with Lange reveals much about her character and standards, and his. Stryker had begun work at the Resettlement Administration in mid-July 1935, only a few weeks after Lange's own appointment.[53] When his mentor, Rexford Tugwell, director of the Resettlement Administration, decided that photographs could expose the desperate conditions of lives and land that his agency was set up to remedy, he had asked Stryker, whose doctoral work in economics he had supervised at Columbia University, to organize the Historical Section within the agency's Information Division to produce such photographs.[54] Tugwell had

been extremely impressed by the Taylor/Lange reports, and Lewis Hewes, who wrote Stryker's job description and was responsible for Lange's own appointment at Tugwell's agency, undoubtedly had those same reports in mind as a model for the sort of work he expected Stryker's section to produce.[55]

The scope and scale of the photographic mission of the FSA was unprecedented, and the work it produced "remains the largest documentary photographic project of a people ever undertaken." So the Franklin D. Roosevelt Presidential Library at Hyde Park, New York, describes it. But, in 1935, Stryker did not start off with the vision and sense of purpose that ultimately made the work of the Historical Section so unique and valuable. He began by consolidating all of the agency's photographers under his direction and arranged for Lange's transfer to the section as a "photographer-investigator." From other sections of the Resettlement Administration, he inherited Walker Evans and Ben Shahn, both established photographer/artists, as well as Carl Mydans, a journalist. He hired Arthur Rothstein, a former student of his from Columbia and put him to work photographing sheets of typed memoranda and clumps of dirt. Ben Shahn made fun of Rothstein's assignment. "No one is going to be moved by a lump of soil," he told Stryker. But then someone brought in Lange's photographic essays, and "Roy's whole direction changed," said Shahn. "He abandoned all this documentary stuff he was doing; documents of documents and stuff."[56] And when Shahn and Walker Evans first saw Lange's photographic essays, Shahn recalled three decades later, "It was a revelation, what this woman was doing." According to Bernarda Bryson Shahn, Shahn's wife, her husband and Evans talked incessantly about Lange's work.[57] Shahn, apparently, has been the only one of the three to acknowledge the extent of Lange's early influence on his own work; Evans and Stryker were not so forthcoming.

On December 31, 1935, Lange wrote Stryker that she and Paul Taylor "were married in early December" and had gone on a "working holiday." Taylor was a friend of Stryker's superiors and an expert in the subjects that Stryker's section was supposed to document, and his marriage to Lange introduced an unforeseen element into the situation, one that was no doubt unwelcome to Stryker. With Lange now taking on primary responsibility for running a new household, with children from her and Taylor's previous marriages, long field trips outside California were difficult, and she confined them mainly to summers, when Taylor was on vacation and could travel with her.

Stryker had begun to develop "shooting scripts" for his photographers, the first coming in 1936 following a meeting with noted sociologist Robert Lynd in which the two discussed the use of "the camera as a tool for social documentation." But, although Stryker wrote long and detailed shooting scripts for the younger photographers, he seldom did so for Lange; indeed, he sometimes used her work as a model, suggesting to Rothstein, for example, that he take "pictures emphasizing the feeling of geographical spaciousness and desolateness. e.g. Lange's mail boxes."[58] Typically, he simply assigned Lange to a geographic area, told her which topics to work on, and left the details up to her. Lange would outline her plans, ask Stryker, whom she called "the Boss," for comments and

approval, and either send her exposed film directly to Washington, D.C., or develop it herself, mailing the negatives to the FSA staff, who numbered them and made proof prints. Stryker would review the prints and send them to Lange to write captions. The process was, for Lange, a constant source of frustration, as months went by while she waited for proofs. In addition, she was critical of the FSA photo lab's technical performance, not trusting it to produce high-quality work ("Many of these prints are very poor and must be reprinted").[59] In September 1936, when "Migrant Mother" was slated to be in a major exhibit, Lange was horrified to discover that the D.C. office would not return the negative so she could print it to museum standards. "The Boss" planned to have the FSA lab provide the print. Lange wrote in dismay to Stryker's assistant:

Dear Mr. Locke:

In a hurry. Please send me the negative of the mother and children. Pea-pickers of which I wrote. Miss Slackman said in her letter that you were making the prints for me. Please mister that idea is no good. This show is the most important photographic show we have. It tours the country. It tours Europe. I couldn't afford to show prints, unsigned, which I have not even *seen*. I'll send the negative right back....Am writing to you because the Boss may still be away.

LANGE[60]

Edwin Locke did send the negative, and Lange returned it promptly. But a month later, in October 1936, Lange was terminated. Only weeks before, Stryker had assured her that she was "still secure with us."[61]

Stryker blamed the budget for firing Lange; he was, so he said, reduced to two photographers, Mydans and Rothstein.[62] But in fact, Stryker had just hired a new photographer, Russell Lee, information he withheld from Lange for months. Perhaps the firing was ordered by his boss, a Mr. Gilfond, as Stryker implied in a later letter, because Lange irritated Gilfond, who wanted the photographers to be based in the East, not the West. Or perhaps Stryker himself found Lange hard to take. Her letters to him were certainly direct and without diplomatic embellishment: "Listen Mr. Stryker," she would say, although she often praised him for his dedication to their shared cause: "You are on your big white horse and once more engaged in heavy battle with our enemies, the publicity boys."[63]

It is true that Lange was exacting; her standards were high. But if she was hard on others, she was hardest on herself. "Not good enough, Dorothea," she would say, looking at her photographs. Her son John remembers her saying that "over and over," "all her life."[64] Lange's letters to Stryker and notes on captions take note of her flaws and explain them. "Taken in the rain," she would say, or note that the regional staff insisted on going out at noon (when the light is bright and flat).[65] "I took long chances," she wrote to Stryker on February 24, 1936, "and they are probably failures ... made other mistakes too, which will be very apparent to you.... I make the most mistakes on subject matter that I get

excited about and enthusiastic. In other words, the worse the work, the richer the material was." If her candor, like her standards, made her vulnerable, this could also be misleading, for in fact, while humble, she was self-confident. Certainly her acknowledgment of imperfections misled Stryker; from then on, he began to point to deficiencies, saying, for example, "I can't understand why so many of your pictures have such a gray appearance in the print." When Lange cited heat or humidity and such, Stryker would retort that no one else had that problem.[66]

Lange was reappointed in January 1937, two months after losing her job, perhaps as a result of intercession by Jonathon Garst, who was regional director of information for FSA and based in San Francisco. But she was terminated a second time ten months later. Even after that, she wrote to Stryker, saying, "You know that I am always one of your people." She pleaded with him for prints of her photographs since she had "nothing at all to show for my 3 years of government work."[67] Over the course of the next year, Lange continued to write to inform Stryker of her plans, offering her services without pay (Stryker did buy some of her negatives).

Out of a job for the second time, Lange teamed up with her husband in 1938 to begin a book that would become *An American Exodus: A Record of Human Erosion*. Paul Taylor was primarily responsible for the text, but Lange instigated the project and was its driving force. "Dorothea wanted to do it," said Taylor. "We worked together sorting out the photographs until we got them the way we wanted them. Dorothea really took the lead at that point."[68] In January 1939, the two rented a work space, a one-room apartment near their home in Berkeley, where they would go at night after dinner; Lange would lay out the images on the floor, section by section, in pairs like facing book pages, and together they would compose captions and text to tell the larger story. It was a story they had been following since 1935: of rural families rendered landless and homeless by mechanized agriculture, their plight aggravated by drought, their exodus to California, and their transformation from independent owners and tenant farmers into agricultural laborers for hire. In May 1939, a pasted-up dummy was ready; in June, Lange and Taylor took a train to New York City to look for a publisher and asked Paul Kellogg, editor of *Survey Graphic*, for advice. Kellogg gave them the title: *An American Exodus*. In July, they signed a contract with Reynal and Hitchcock and a few weeks later delivered the manuscript for production. With the book on a remarkably fast track, over the next two months Lange and Taylor reviewed, revised, and approved galley proofs, page proofs, and the design of the jacket, binding, and endpapers. Advance copies arrived by Thanksgiving 1939.

When, a year before, in September 1938, after a hiatus of almost a year without a job, Lange was reappointed as an FSA photographer, she had asked for Stryker's blessing to work on the book, "to take a day off now and then maybe a week at a stretch . . . to work on it. I cannot do this without your knowledge and can arrange in whatever way you prefer. This is . . . not primarily a personal venture. . . . It's all the same job and when it comes out it will further your purposes, I hope." Stryker's response was quick and generous: "I see no reason why you

couldn't take out a little time now and then. You will have to use discretion, since there are folks around who are not at all sure that a photographer should not be in the field all the time. I know differently—and after all, I am the boss! The book is important, and will benefit us all."[69] Yet within a year he fired her once more, for the third and final time.

The Lange-Stryker correspondence from late 1938 through 1939, more than forty letters and telegrams (of the approximately 150 they exchanged between 1935 and 1939), is a dramatic dialogue: Stryker affable in one letter, testy in the next, puffing with good news, spinning the bad; Lange brimming with enthusiasm and ideas, hurt or baffled by his occasional attacks, on the defensive and taking the offensive, all in one letter. Lange's letters, direct and insistent, reflect an eagerness to please; they invite response and critique. Reading Stryker's complaints and confidences to Rothstein and Lee, one sees Lange's fall coming long before she does. "The long suffering Lange," Stryker's biographer called her.[70]

Lange's wrangles with Stryker over control of her negatives and the printing of her photographs became increasingly rancorous.

Lange: Roy, will you please get back to me, just as soon as you can, *proof prints* from these negatives [submitted in October and November] before the field memories become dull and submerged under other work? (November 12, 1938)

Am disappointed not to have received my proof prints for captioning. There remains nothing for me to say about this which I have not said before. (December 12, 1938)

Stryker: The laboratory has been thrown back into confusion. (December 22, 1938)

The prints were finally dispatched a month later, three months after Lange sent in the first batch of negatives. In January, she wrote to request a set of the proofs and captions she had already submitted.

Lange: I have no record of what I have done and no record of titles and negative numbers. [Such a record] guides [the photographer] in how the work is building up, whether or not it is taking *form*. Without this a photographer ... is lost because he forgets. (January 18, 1939)

Lange also needed the materials for the book; without her prints, she was forced to rely only on memory and notes.[71]

Lange: What is the chance for me to have the proof prints of my last field trip.... If too much time elapses the quality of the documentation suffers, and the edges of things become blurred and less distinct. I think it is bad technique, and am sure that you agree. Am also convinced that things must be far more hectic than I realize for you. Nevertheless

I feel that we must have, or rather, that *I* must have your support. It is *necessary*." (March 2, 1939)

Stryker: It seems to me unnecessary that the laboratory should have to print up fourteen or fifteen negatives of an almost identical picture of an old couple in a rehabilitation office. (March 4, 1939)

Lange: Some items *appear* to be duplicates, but are not duplicates. Also repetition of situations in different locales is the only means we have to suggest the size and spread of some types of conditions. (March 13, 1939)

Lange's friend Ansel Adams had agreed to make the prints for her book, and Lange sent Stryker a list of negatives she wanted to borrow.

Stryker: I just don't see how we can possibly release so many negatives, and so many important ones for this long a time. I appreciate very much your desire to have Ansel Adams do the work.... I hate like the devil to turn you down on this. (March 24, 1939)

Lange decided to go to Washington herself to supervise the printing in the FSA lab since Stryker would not let her borrow her work to prepare in California. Stryker, obviously beside himself, wrote to Russell Lee in mid-June to cancel a trip in the field:

Dorothea Lange will be in here tomorrow, and I do not dare leave town while she is in the place. Her coming is a sad story which I will have to tell you later. The outcome of it I do not know. She has pretty badly messed things up for us. Paul [Taylor] got all excited because we wouldn't let Dorothea have a whole flock of her negatives for Ansel Adams to print from. It all turned out to be a regular tempest in a tea-pot and I don't know how it's all going to come out. One thing is certain—she cannot work in the laboratory. If she does, I shall have to hire a whole new laboratory force. There is too much work to do to let the place be paralyzed by her silly ideas. (June 18, 1939)

In an effort to get Lange out of the lab in a hurry, Stryker wrote to Howard Odum at the University of North Carolina, suggesting a ruse to send her south to document a region in the Piedmont:

Dorothea Lange is to be in Washington for a couple of weeks—or possibly longer. While she is here, I am anxious to utilize some extra time she has to make some pictures in your sub-region.... It occurred to me that one of the most likely things for her to start on would be some of the sharecropper and tenant wives whom Mrs. Hagood has already interviewed ... I am not very particular what she does at this time.... I would appreciate an answer as soon as possible, so we can make plans for Miss Lange's trip. (June 17, 1939)

And he wrote to prepare Margaret Jarman Hagood, a sociologist and research associate at Odum's institute, for Lange's coming:

Dorothea Lange is here in the East now, and I would like very much to have her do some work.... I expect Lange back in town today; we can arrange for her to come down by train and meet you some time this week. (June 26, 1939)

Four days later, doubtless wholly unaware of the plot, and presumably after frantic hours in the FSA lab supervising the printing of her negatives for the book, Lange was out of Washington and on Zollie Lyons's farm in Wake County, North Carolina (figures 55, 56).

Lange herself had little indication that her job was in jeopardy until early October, when Stryker telephoned her hotel in Portland, Oregon, to ask her to consider a transfer to another section in the FSA, to work with filmmaker Pare Lorenz. "I was sorry to get you all stirred up last night," he wrote the next day, explaining the transfer as a budget problem: he might not be allowed to keep all four FSA photographers (Rothstein, Lee, Lange, and Marion Post, who had been hired in 1938) in the coming year. Yet he added, "Congratulations from all of us.... We are all very much pleased with the last captions which you sent in. It was a very excellent job."[72] A few weeks later, Stryker was writing to Arthur Rothstein, "We are going to have to terminate one photographer. That one photographer I am afraid is going to have to be Dorothea. I am notifying her at once."[73] He sent Lange a telegram and followed up with a letter three days later—on Halloween. Her job would indeed end, on January 1, 1940, as Stryker had hinted back in early October; but she would have to finish her assignments by November 28 and begin her accumulated leave. There would be no transfer after all; the job with Lorenz wasn't mentioned again. Lange stopped her fieldwork and left Oregon immediately for Berkeley; by the end of the month, she had grouped all her photographs from the Northwest and written 1,720 individual captions and fifty general captions and dispatched them to Washington.

Meanwhile, unbeknownst to Lange and Taylor, Jonathon Garst was pleading with Stryker to retain Lange on a per diem basis, both for her sake and for Taylor, "the father of our migratory camp program." Garst wrote that Taylor "has continued his study of the problems of agricultural labor to his own great detriment in a Republican-controlled University of California.... Dorothea has been whole-souled in this enterprise ... and she has made great contributions through her photography." Both Lange and Taylor had been "very much hurt" by her termination and "anything that would hurt her feelings would have very much more effect on Paul's feelings than anything that was done to him directly," Garst added. "I hear that after I interceded with you and arranged for you to bring her back ... difficulties arose.... I don't know what these amount to, and I can readily believe that Dorothea with her pell-mell enthusiasm may be at times difficult to work with," but if Stryker "found it difficult to deal with her from Washington," she could work directly with the staff of the western regions.

Garst's handwritten postscript said: "Probably it is all my fault for asking you to bring her back."[74]

"I selected for termination the person who would give me the least cooperation," was Stryker's response. Yet just three days before (on November 27), after she had turned in a massive amount of work, Stryker had written to Lange: "Let me congratulate you right now on the nice job you did on the captions; I am particularly pleased with the general captions. They are going to be most useful. You have backgrounded the stuff with some awfully good information which will prove of particular importance when we try to get these pictures out for you. I think this idea of General Captions is the best [that] has come out for some time. The photographic material is enhanced no end when so much good information is available." And earlier that month, he had told Lange, "I went over all your pictures very carefully, and was much pleased. You sure did run across some swell things.... Those pictures are going to be a very valuable addition to the file. The Northwest was a pretty bad blank.... The thing that pleased me most was the wide range of things which you included in the job."[75] Within weeks after firing Lange, however, Stryker met with a young photographer, Jack Delano, and held out the possibility of a job. Two months later, he hired Delano.[76]

Stryker's treatment of Lange was duplicitous at best. Certainly he had lied to her. Yet throughout the rest of her life, as earlier, Lange frequently spoke generously of him and maintained a cordial relationship. He was "a colossal watchdog for his people," she told an interviewer in 1964. "If you were on that staff, you were one of his people."[77] The loyalty went only one way. How Dorothea Lange, one of the great artists of the camera, could have been summarily fired, let alone three times, is difficult to understand. The reasons were undoubtedly complex and multiple: a male boss who saw Lange as a difficult woman who meant trouble, not as a great artist who brought his office renown; a clash between artist and bureaucrat; an insecure boss who needed to protect his sense of power. It was for all these reasons, and more.

Lange's letters to Stryker are of full of ideas for exhibits and reports intended to influence both popular opinion and key congressional committees, including exhibits she proposed to mount herself. But to Stryker, Lange's desire to tell the stories she discovered in the field was a distraction from her real job, which was simply to get out in the field and photograph. He had a staff in Washington to produce exhibits and reports. While Stryker had seemed to welcome Lange's book project, he may have been unprepared for the demands it entailed, and perhaps he was jealous. Lange's access to congressional leaders and other influential people, whom she met through Paul Taylor, also rankled and sometimes gave Stryker administrative headaches. His principal passion was for building and safeguarding "the file" compiled by the agency; it trumped other causes. Stryker learned how to ride the political waves to keep his photographic division intact and to protect its growing archive; both the division and Stryker survived many budget cuts and changes in policy and leadership (including the departure of his patron, Tugwell, in 1937). In 1942, however, the division was

transferred to the Office of War Information; the following year, Stryker left the government to work for Standard Oil.[78] In the end, the FSA file of more than 165,000 photographs is what Stryker is remembered for, and justly so.

Lange's final loss of her job was a double tragedy: not only had she lost her livelihood, but she was left with almost no photographic record of what she had accomplished that last climactic year. The D.C. office did not send her copies. She would not see the 1939 photographs until twenty-five years later, at the end of her life. As for Stryker, when he was eighty years old, a few years before his own death in 1975, he selected as his "credo" a small group of photographs from among the many thousands in the FSA collection. These he assembled in a book, *In This Proud Land: America 1935–1943 as Seen in the FSA Photographs*, written with a coauthor, Nancy Wood. One day he went into his bedroom and came out with a large mounted print of Lange's "Migrant Mother." He looked at it for a long time, then said to Wood, "After all these years, I still get that picture out and look at it." Of the two hundred photographs by the thirteen photographers represented in *This Proud Land*, more are by Lange than by anyone except Russell Lee; together Lange's and Lee's images make up more than 40 percent of Stryker's "credo."[79]

Lange was a complex individual: outspoken, demanding, sometimes commanding, both self-confident and self-deprecating, passionately committed to people, ideas, and causes, generous, supportive, and loyal, a mentor to many, a colleague to peers. "It was a privilege and a pleasure to work with her," Pirkle Jones said of their collaboration on "Death of a Valley," deeming it "one of the most meaningful photographic experiences of my professional life."[80] Although Lange and her son Daniel were estranged for several years during his youth, they later produced important work together with Daniel as coauthor. Lange's principal collaborator was, of course, Paul Taylor. Their professional partnership, which began in 1934, continued through the 1950s. Lange, Taylor testified, was "vital . . . never petty, always thoughtful of others . . . planning to make things work out all right, *making* them work out all right." "She held one's attention, one's thoughts, one's feelings . . . as a magnet. But never did she make you feel, 'I am a photographer, I am an artist, I am an extraordinary person.' Never. But she was all of these." "To live thirty years with a woman like that is a gift. . . . What more could you ask from life?"[81]

When Lange defended her practice of taking several photographs of "the same thing," she did not mention an additional, and crucial, reason: she was feeling her way into a subject, each successive image a step to the next—as "the physical sensation of taking one picture may compel the taking of another." Frequently, the final photograph was the best: "White Angel Breadline" had been the last of a series, and "Migrant Mother" probably was also.[82] Ansel Adams and Walker Evans, who worked in a different way, would carefully analyze a scene and frame it precisely before releasing the shutter. Stryker understood neither approach; he criticized Evans for submitting too few photographs, Lange for submitting too many. To Stryker, supplying glossy photographs to newspapers, magazines, and book publishers was the goal; artistic quality was

not a priority, as it was for Lange, Evans, and Shahn. Not himself a photographer, Stryker saw photographs as illustrations, "the little brother to the word."[83] Initially, as Stryker reviewed the proofs of the photographers' work, deciding which shots to "kill," he would punch a hole in each rejected negative, until the photographers protested the mutilation of their work. Artists are trouble. Especially an artist like Lange, who was passionate not only about her art, but about social reform.[84]

"A bold experiment . . . a new medium"

Almost three decades after 1939, Beaumont Newhall, in a foreword to Lange's *American Country Woman*, praised *An American Exodus* as "a bold experiment, pointing the way to a new medium, where words and pictures do not merely explain and illustrate: they reinforce one another to produce . . . the 'third effect.'"[85] To read the photographs is to hear a consistent voice and point of view, but to read the words is to become attuned to diverse voices and points of view, both converging and conflicting, and hence to encounter awful conundrums. To read photographs and words together is to understand how the images' narrative line connects the disparate texts and propels the reader, and to grasp how words complicate photographs by exposing multiple underlying meanings. To read those visual and verbal images together is to experience the passion in the photographs that counters, even subverts, the dispassionate moderating tone of the brief essay concluding each chapter. The impact is cumulative: if a single pair of image and caption or a set of facing pages seems to make a simple statement, all the words and photographs, taken together, pose a complex dilemma. As the reader progresses back and forth across the pages and chapters, the memory of images and words produces afterimages and echoes.

Another of Lange's innovations was her pairing and sequencing of images. When Lange, in 1965, spoke of a recent show of her work, in which every photograph was one of a pair, she could also have been describing the pairs of facing photographs in *An American Exodus*: "The twos are inseparable. In some cases, one of them is dominant to the other, so that the second is contributory. In some cases, they are perfectly balanced in importance: one amplifies the other. In some cases, they act completely together and make a loud noise. In each case, they are together because of the inner connection that I felt, not primarily that I made them at the same time."[86]

Eleanor Roosevelt's newspaper column, "My Day," praised *An American Exodus*: "In the pictures and in the spirit this book marks a high point in artistry and shows us what life means to some of our citizens." The *New Yorker*, in a brief note, called the photographs a "superb documentary analysis of 'human erosion.'" Carey McWilliams's review for the *New Republic* concluded that "the combination of talents" that produced it "could scarcely have been improved upon." Paul Taylor's "running commentary" was "wholly characteristic of the man: quiet, scholarly, dispassionate, unassailingly accurate" and "the photo-

14–15. An American Exodus. 1939.

Homeless family, tenant farmers in 1936. Cut from the land by illness, driven to the road by poverty, they walk from county to county in search of the meagre security of relief.

Atoka County, Oklahoma. June 16, 1938

HIGHWAY TO THE WEST

"They keep the road hot a goin' and a comin'."
"They've got roamin' in their head."

U S 54 in southern New Mexico

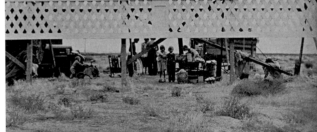

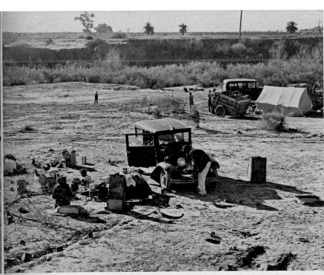

THREE FAMILIES, 14 CHILDREN

U S 99, San Joaquin Valley. November 1938

"COME TO THE END OF MY ROW IN ROCKWELL COUNTY, TEXAS."

Family with 5 children left home September 1938. Picked their way across the country in Texas and Arizona cotton. Entered California the night before, and encamped along U S 80 near Holtville.

Imperial Valley. February 23, 1939

graphs by Dorothea Lange are beyond praise; indeed they are so good that the text is not really essential." Margaret Jarman Hagood of the University of North Carolina, who had accompanied Lange on that unexpected foray into the field the previous July, reviewed the book for *Social Forces*, calling it the "best example to date of the use of photography as a tool for social research" and referring to Lange as a "pioneer" in this approach.[87]

But despite excellent reviews, sales were disappointing. John Steinbeck's *The Grapes of Wrath*, published ten months earlier, had stolen the book's thunder. Indeed, "Steinbeck in Pictures" was the title of one review of *An American Exodus*. Actually, it was the reverse: Steinbeck's powerful text was, in effect, Dorothea Lange in words. Her photographs had inspired Steinbeck's novel and also the film that followed. The movie *The Grapes of Wrath*, directed by John Ford, with Henry Fonda as Tom Joad, opened to critical and popular acclaim in January 1940, the same month that *An American Exodus* was released. For a time, Lange and Taylor had worried that their book might not be published at all; Hitler had invaded Poland a few months before, and by January much of the world was at war. "People began very quickly turning their eyes away from Depression into what we called the Defense Period," Taylor later recalled. His and Lange's book was remaindered.[88]

Yet *An American Exodus* was influential. More than sixty years after the book's publication, A. D. Coleman, an eminent photography critic, lauded it as "a classic of its genre ... a model with rich potential for the future." "In terms of both form and content, in style and substance alike, *An American Exodus* established a model that has dominated documentary photography from the time of its publication down to our own day." As Coleman wrote in 2002, "No one had ever before seen anything quite like it," "yet within two decades its strategies would pervade the form." It "changed the way investigators used photography as an instrument of social research, affected the ways in which they wrote and/ or organized texts to accompany photographs, and reconfigured the ways in which they constructed photography books and exhibits."[89]

An American Exodus influenced Lange as well. The process of composing a book, of weaving the many narrative threads to tell a story, often transforms the author as well as the manuscript. I believe that producing *An American Exodus* transformed the way Lange saw photography. With that book, what she sought to express became more comprehensive, expanding the scope of her vision from the individual person and family to the larger cultural landscape. The general captions she wrote during the year of the book's production are both an assortment of individual tales and strands in larger national stories; they extend her experiments with combining words and images, juxtaposing perspectives, setting the stories of individuals and families against stories of towns and regions, combining diverse sources of evidence (from interviews and observations in the field to advertisements to statistics), and organizing these nonlinear narratives within geographic frames. The 1939 photographs and captions from Oregon, Washington, and Idaho are the raw material for a sequel to *An American Exodus*; they extend that book's story from California to the Pacific Northwest and from

migrant laborers to resettled farmers. Lange's general captions are sketches and not, like the book, a coherent single project, yet those composed at the end of 1939 for her Pacific Northwest photographs are more sophisticated and nuanced than the paired photographs and captions in the book, employing a broader range of rhetorical strategies and figurative language.

Both in the book and in the general captions, Lange included what people said to her, but in a larger context, setting the photographs in opposition or agreement to each other, composing dialogues. What people are saying resonates within each caption and across multiple ones.

"We watch all the time for agitators. An agitator will turn the whole yard upside down in two hours." (Small farmer, general caption 46)

"'Why do you keep it? Why don't you tear it down?' Answer, 'In the event we need it, we've got it right there.'" (On the stockade built in Yakima in 1933 to imprison strikers attempting to picket; general caption 31)

Many of the rhetorical and compositional strategies Lange employed in the 1939 photographs she had developed through years of experience. Money changing hands at the paymaster's scales in the Imperial Valley is both a literal exchange and emblematic. A spiky tree trunk among stumps in a cutover landscape in northern Idaho is at once the remnant of a tree, a reference to a process of exploitation and abandonment, and a sign of desolation. Lange's photographs are rich in metaphor, especially the part or quality that stands for the whole. She commonly emphasizes significant details by placing them in the center of the frame (the point where money changes hands, the tree trunk in a field of stumps), by using contrast (dark against light, focused and out of focus), by exaggeration (enlarging the small), or by repetition (of lines, shapes, things). Her photographs, like her text, tend to be straightforward, not enigmatic; it is rare to find significant detail hidden in the corners of the frame as a way of implying relationships among the disparate and seemingly unrelated. Lange creates complexity of meaning by juxtaposing multiple photographs, rather than by juxtapositions within a single image, and by combining photograph and caption. In her quest to tell a story, she experiments with framing, perspective, and angle of view, her compositions of 1939 surprisingly diverse, some anticipating photographic ways of seeing that would not be common for another twenty to thirty years. So, for example, is her oblique and layered streetscape with unemployed migrants, standing on a street corner, signs pointing in different directions as if to ask, "Which way to turn?" To look at these 1939 photographs is to see a foreshadowing of future work by Eugene Smith, Robert Frank, and Lee Friedlander.[90]

Lange's voices in her 1939 general captions are also strikingly varied: poet (no. 1, "U.S. 99"), dramatist (no. 47, "To show process of resettlement in the West"), ethnographer (no. 23, "Annual cleaning-up day at Wheeley's Church"), social critic (no. 45, "Hop harvest in Oregon"), objective reporter (no. 35,

16. Documents submitted by Lange with general captions in 1939.

"Columbia Basin, near Quincy, Grant County, Washington"), propagandist for government programs (no. 36, "Thurston County, western Washington"). To some extent, the diverse voices reflect the sources and subject of the captions, but I believe she was also trying out styles of writing in search of her own voice. Lange's work on her first trip to the Northwest in August 1939, with the general captions and pairs of associated photograph-captions, contains more surprising turns, and more paradox and irony, than either *An American Exodus* or her earlier and later captions. Many last lines pack a punch, delivering a terse phrase that could stand for the whole ("It's the same old dirty story wherever you go") or adding a new perspective or dimension to the preceding text by introducing the unexpected, perhaps a contradictory phrase such as "We think we're doing swell." By the end of 1939, Lange was appending and incorporating into her texts the same kinds of rich primary sources she and Taylor had used in their book: articles clipped from newspapers and journals, research reports, government memoranda, and advertising brochures.

Lange's photographs of northern Idaho and eastern Oregon, from her second trip in October 1939, with their many series, embody a new, more systematic and panoramic approach to documenting a region. She would stand on a

hill or on the roof of her car to gain a broad overview of roads, settlements, and canals within the larger landscape, then move in, photographing a house in its surroundings; then closer still, to capture implements on the doorstep or people in the open doorway, against the barn, or in the field; even closer, a view of a face against the sky. From a height in the remote cutover region of the Idaho panhandle, Lange followed this strategy, framing a valley of spiky stumps, then driving down to the valley for a nearer view. The series tells a story: house surrounded by stumps; bathtub and brush hanging on the outside wall (no inside plumbing); a family's children, ranging in age from a baby to an eighteen-year-old son; a close-up of a stump.[91]

Particularly striking is Lange's use of expressive context in photographs of the cutover lands of the Idaho panhandle, where she photographed landscape features and phenomena in ways that evoke or amplify human feeling. Like her 1937 photographs of abandoned shacks in Texas, many of the 1939 Idaho photographs contain no people; instead, there are stumps, abandoned churches, groups of mailboxes along an empty road, isolated cabins. The absence of people in the presence of human artifacts evokes a sense of the isolation and loneliness of life there. Before 1939, the great majority of Lange's photographs prominently featured people; by the end of that year, in nearly half of her photographs of the Pacific Northwest, no people appear, yet all carry evocative clues to human presence and portray the individuals and communities to which the places or objects belong.

Lange would write years later:

In one of his poems, Wallace Stevens says: "I am what is around me." In the same way, the objects with which people furnish their homes can speak more clearly about them than anything else, even more clearly than the people themselves. Of the woman whose home is an unmade bed, a view of that bed can sometimes tell more than her face. The same is true of the man whose home is a bar stool. In photographs particularly, a still life can often declare more about people than a portrait.... So although these ought to be pictures *of* people, they ought also to be pictures *without* people.... We ought to know beyond a doubt that to some people the things we look at in these pictures are the most important things in the world—that to them, this desk or this garden, this bottle of pills, this racing form or this box of candy is home.[92]

As the field of strawberries in neat rows surrounded by raw stumpland is home to the Arnold family even more than the house itself. As Mrs. Whitfield's North Carolina kitchen with its butter churn, rug, and tablecloth is home to her. As the bags of alfalfa seed piled in the doorway of a father's two-room cabin, "waiting for a better price," are home to him. As a roll of kitchen linoleum is memory and dream of home to a migrant family with nine children, still carrying that roll of linoleum after three years on the road. These too are portraits. (See figures 51, 144, 97.)

"A wholly free individual . . . grounded only in the work itself"

A few months after Lange was fired for the last time, she applied for a Guggenheim fellowship.[93] A fellowship, she argued in her application, would enable her to "produce stronger work . . . as a wholly free individual," unhampered by the "routines and techniques which result from administrative necessities, time requirements, etc." "I believe that the camera is a powerful medium for communication and . . . a valuable tool for social research which has not been developed to its capacity." Lange proposed to produce "a collection of photographs, integrated and closely documented, with brief collateral text," "a direct continuation" of the work she had "been doing over the past five years." She planned to concentrate on a few from among the "astonishingly great" range of social patterns she had witnessed in rural America: "from the isolated and still primitive Mormon villages of Utah to the agricultural towns of Wisconsin and Ohio where merchants, bankers, and retired farmers live amid a cluster of farm homesteads," "from the Amana cooperative farm communities of Iowa to the raw cotton town of Firebaugh in the San Joaquin Valley of California where a mobile, landless labor population surges in and out with the seasons, serving the huge, unpeopled fields of industrialized agriculture." "I desire to document some of these patterns, photographing people in their relations to their institutions, to their fellowmen, and to the land," and "to make known some contemporary American ways of life which are not well-known, some contemporary farm types and cultures, and institutions—some stable, some dissolving, and some rising."[94] In 1941 Lange became the third photographer ever to receive a Guggenheim; Edward Weston in 1937 and Walker Evans in 1940 were the first and second.

To work as "a wholly free individual" meant to Lange that she would set her own schedule, choose her subject and follow its lead, assemble and arrange the photographs according to associations "grounded only in the work itself," and possess her negatives and control how they were developed and printed. Freedom did not mean, to Lange, working alone, without support, but working with people who respected her. To be free was to develop fully the potential of her camera as a "tool for social research" and a "medium for communication." For Lange, the photograph itself was not the goal. Her primary purpose was to discover, to understand, and to share. She wanted to study people and their institutions and landscapes. Years later she would use her camera even more searchingly as an "instrument of inner vision" to explore family and self.

Anthropologists too were pioneers in the use of the camera as a tool for social research. Filmmaker Robert Flaherty had made *Nanook of the North* in 1922 and *Manoa* in 1926; the term *documentary* was coined in a review of the latter film. Lange may or may not have been aware of Flaherty's work or that of Claude Lévi-Straus, who took a 35-millimeter Leica camera with him to Brazil in the 1930s and used photographs as a form of note taking to supplement the words, sketches, and diagrams in his journals, but she did know about Gregory Bateson and Margaret Mead's photographic analysis of Balinese culture and recognized

its significance. After Bateson and Mead's book *Balinese Character* was published in 1942, Lange wrote to one of her protégés, photographer Homer Page: "This I urge you to get from the library and study for this is an attempt to do a very big thing which has direct bearing on what you are working on. Very direct bearing."[95] Her excitement is understandable, for Bateson and Mead's approach was similar to her own. The basic units of their presentation are those of Lange's general caption: individual photographs with captions and a longer text that places them in context. Bateson and Mead explained that their "form of presentation" is "an experimental innovation," undertaken to compensate for the inadequacy of words alone to describe and analyze a culture. Bateson and Mead split the task of note taking and photographing, as Lange and Taylor did when they were in the field together: Mead took notes while Bateson was "moving around in and out of the scene." They culled the book's photographs from twenty-five thousand Bateson had taken between 1936 and 1938 with a Leica camera, then grouped and sequenced the photographs and texts in "carefully selected series" within crosscutting themes, cross-referencing them as Lange did with her own photographs and captions. The step from a single photograph to pairs and groups was significant, Bateson explained, since "juxtaposition of two different or contrasting photos is already a step toward scientific generalization." To Lange, the work of these two anthropologists must have seemed a vindication of her own approach to discovery: "We tried to shoot what happened normally and spontaneously," Mead and Bateson had said. "We treated the cameras in the field as recording instruments, not as devices for illustrating our theses."[96]

Lange too was suspicious of preconceptions embodied in shooting scripts and other instructions for the photographer, "written by people not on the scene and taking the pictures." "There is not room in the script for rearrangement, for probing, for balance, for discard, for embrace," Lange would say, reflecting a decade later on the dialogue between photographer and subject. "It is not allowed that the physical sensation of taking one picture may compel the taking of another. It is not permitted that the subject matter as much controls the photographer—interprets the photographer—as the photographer controls and interprets the subject matter. The script does not concede the possibility—and the necessity—of growth. It is in effect an order to be carried out, occasionally at the sacrifice of those things for which photographs and photography are the most valuable.... This is not to say that a photographer should be without a plan," but, ideally, "a shooting script writes and even creates itself, just as the photographer experiences and is created by his subject matter."[97]

Lange made such plans in 1939 in response to her experiences, noting in her daybooks not only what she had seen and heard but also what she wanted to watch for. In Utah in 1953, she jotted down a rough script as a guide: "Gunlock... a town along a river... the church next Sunday... the road on the main street so soft and irregular... the barns against the dry hills... a car on the road, going to town... the general store... the relaxed atmosphere.... Simple life? How in the world do these people make a living?" But not even the most "inventive" and

"creative outline" would guarantee that what she hoped for would be captured on film, especially not in a single photograph; if it was, it "would be a miracle." "But the photographer can never abandon that hope. And hope is really what it seems to me a shooting script should be: a hope more than a plan, a vision more than an image, a suggestion more than an order." "At best, the shooting script [is] the thoughts of the photographer enlarged and nourished by his subject. At worst, it is his subject wizened and starved by his thoughts."[98]

For Lange, as for Bateson and Mead, recording in the field was only the beginning. The process of discovery entailed writing, grouping and juxtaposing, comparing and contrasting, an approach that Lange believed distinguished documentary photography from photojournalism, a field also emerging at the time and one she considered "quicker, easier and catchier." When Lange and Taylor wrote in 1939 that they "adhere to the standards of documentary photography" and that the "quotations which accompany photographs report what the persons photographed said, not what we think might be their unspoken thoughts," they may have been thinking of *You Have Seen Their Faces* (1937) by Erskine Caldwell and photojournalist Margaret Bourke-White, for which the authors invented quotations as captions for the people portrayed.[99] Lange also distinguished documentary photography from the earlier work of Jacob Riis and Lewis Hine, both of whom learned to use a camera in order to document the social conditions they worked to improve. "They made photographs that they kept together," Lange explained in the early 1960s. Although "they were series and sequences," "the documentary thing is a little different, because it's filed and cross-filed … and it's buttressed by written material and by all manner of things which keep it unified and solid."[100] Lange herself offered such crossfiling and buttressing with her captions, particularly the general captions.

Lange had begun composing groups and sequences of images with accompanying text in spring 1935; by 1939, in *An American Exodus*, pairing had evolved into a basic unit, a device she would use often from then on. "I used to think in terms of single photographs, the Bulls-eye technique. No more," Lange wrote to Beaumont and Nancy Newhall in 1958. Insisting on selecting the images of her work for the Newhalls' *Masters of Photography*, she paired those images and then sequenced the pairs: "I find that it has become instinctive, habitual, necessary, to group photographs. A photographic statement is more what I now reach for. Therefore these pairs, like a sentence of 2 words." "I am doing everything in doubles," Lange explained to curator John Szarkowski, when he came, in 1964, to discuss the selection of photographs for a retrospective exhibit of her work at New York's Museum of Modern Art. "One, two photographs, which spell one photograph, or which so feed each other that it's wonderful to grasp."[101] For the MOMA show, she paired a photograph of three churches with one of a highway as a "comment on changing American forms": "The church was the transmission line and the channel of communication, now it isn't," Lange explained to Szarkowski. "There's a … big change of function. [Now] it's the highway that carries it, not the church."[102] "This business of grouping, by likeness of association, by dissidence, by extreme opposites, … is on the way to the development

of an idea or a statement of photography, and it is unique to this medium. Note, this has nothing to do with photojournalism."[103]

"If you would really be a consummate worker in photography," Lange said in 1964, "you'd work in threes, and maybe when you got better, you'd work in fours ... to *fortify*.... From idea you would go to statement, from statement you would move to ... what in writing is a paragraph, and ... eventually you might do a book.... It wouldn't be just a collection of separate photographs bound together.... I haven't gotten anywhere near it. But I can, I *do*, think in twos."[104] But Lange had gotten near it, in one of her least known but greatest works, "Death of a Valley," coauthored with Pirkle Jones. "Death of a Valley," published in 1960, two years before Rachel Carson's *Silent Spring*, tells the story of Berryessa Valley, north of San Francisco, which had been inundated by a reservoir to provide water for the state's growing urban population. It is, like Carson's famous opening chapter, a "fable for tomorrow." The arc of each work is the same, moving from idyllic valley to the "strange stillness" of a "stricken world" and the realization that "people had done it themselves."[105]

Unlike the town and farms of Carson's story, however, the Berryessa Valley is a real place. To that small California valley, a "place of settled homes and deep loam soil" that had "never known a crop failure ... changes came slowly and quietly" at first, then "families disappeared ... emptying the valley.... The animals were terrified.... Fires burned. Dust and smoke filled the air.... Just raw and mutilated earth remained.... The water came seeping in.... No dust now, no smoke, no hum of insects ... only stillness and the water rising and rising."[106] In "Death of a Valley," photographs amplify the spare poetic prose, and words provide metaphoric depth. A horse stumbles in a ravaged landscape from which all traces of human settlement have been obliterated except for deep ruts made by bulldozers and trucks. Lange and Jones express "overtones" of "changing values," introduced at several points within the essay as "Voices" enter and stand apart from the text, like a Greek chorus. It is a classic environmental cautionary tale of "the relation of man to the earth and man to man" and "the forces of stability and change."[107]

Lange increasingly used her camera as "an instrument of inward vision" not only to study other "people in their relations to their institutions, to their fellowmen, and to the land," but to study herself, as a means of self-discovery. In 1958 at the California School of Fine Arts, she taught an experimental photography course, "The Camera, an Instrument of Inward Vision: Where Do I Live?" deciding to "work along with the students on the same assignment, submitting her work to the students each week for their reaction and criticism." "To ask 'Where do I live?'" wrote Lange, "presupposes that one lives in a house, or a trailer, or a house boat or someplace with a certain amount of things—personal things. 'Where do I live?' could also suggest a type of dream-land full of ideas and ideals, or a social structure which seems to have established a guiding class ethic. Yes, this is where I live: in a land of road markers and guide posts; yet every man must still find his own way."[108] Lange had come full circle, back to portraiture, where she began, but with an even larger ambition: to explore both the

FROM PEAK TO PEAK,
FROM THE VACA MOUNTAINS TO THE CEDAR ROUGHS,
THIS WAS A VALLEY ELEVEN MILES LONG
TWO AND ONE HALF MILES WIDE,
WARM SUNNY AND QUIET. IT WAS A PLACE
OF SETTLED HOMES AND DEEP LOAM SOIL.
IT WAS A PLACE OF CATTLE AND HORSES,
OF PEARS AND GRAPES, ALFALFA AND GRAIN.
IT HAD NEVER KNOWN A CROP FAILURE.

IT CONTAINED THE TOWN OF MONTICELLO, A CENTER
WITH ONLY ONE STORE, TWO GAS PUMPS,
A SMALL HOTEL, AND A ROADSIDE SPOT, "THE HUB."

AND THE VALLEY HELD GENERATIONS IN ITS PALM.

THE ANIMALS WERE TERRIFIED

17–18. "Death of a Valley." 1958.

outer reality of the relationship between individual and society and the inner reality, to probe the self.

Lange was "a discoverer, a real social observer." With the sensibility of an artist, she adapted methods of social science and literature to develop photography as a medium of research and storytelling. "We use the camera as a tool of research," Lange and Taylor had written in the foreword to *An American Exodus*. "Upon a tripod of photographs, captions, and text we rest themes evolved out of long observations in the field." But what did it mean, for Lange, to "use the camera as a tool of research"? For her the word *camera* encompassed her whole approach to photography as a way of seeing and knowing, from looking through the viewfinder out in the field to creating essays of images and words back in her studio. When she called the camera "a great teacher," in 1965, she meant that it opened up the possibilities of "the visual world." When she said that "the camera can find its way through a chain of events, very marvelously . . . if you hold on to the thread, if you hold on to that thread," she meant composing a series of photographs "that has sentences and paragraphs and builds to a whole."[109] In creating *American Country Woman*, Lange held on to the threads her camera had found and drew out the theme of rural American women through paired portraits of person and home, individual landscape and common landscape. A theme "can grow almost of itself, depending upon the photographer's instinct and interests. As fragmentary and incomplete as the archeologist's potsherds, it can be no less telling."[110]

Lange's methods cannot be separated from the work itself; means and ends evolved together. So did her themes and ambitions. She did not use method for method's sake, but for the sake of her themes. When she began to interview pickers in the fields in 1935, her themes deepened, and this is reflected in her photographs and captions. She began to group photographs, not from a purely artistic impulse but because the subject demanded it. She responded to her material and was shaped by it, her work enlarging with the stories, which broadened further out of the work itself. As she composed pairs and series of photographs to tell these stories, other themes emerged. With a general caption she could set individual stories within larger contexts. She employed metaphor to express connections, and as she did so, she saw even more relationships. Her approach to photography as both an art of discovery and a medium of expression, and the ways she achieved this—these too are Lange's legacy, more important than any individual photograph, no matter how iconic.

Lange was no solitary artist-discoverer. She preferred to work collaboratively, enlisting fellow photographers, authors, and helpers: junior colleagues like Pirkle Jones, peers like Ansel Adams and Paul Taylor, and young assistants, photographers like Rondal Partridge and writers like Christina Gardner and Lange's son Daniel Dixon. Lange and Adams were friends and worked together on several projects for magazines. Gardner, assisting Lange and Adams on a 1944 assignment to photograph the Richmond shipyards for *Fortune*, tells of Lange coming to the door of a house, seeing children inside, and discovering that she had run out of film. "Come on the double, Ansel!" she shouted. "Come on the

double and bring your small camera!" She turned to Gardner and instructed, "Write down everything in this room." Then she left. Gardner produced an extraordinary list, and Adams's photograph of that room, with Gardner's caption, was published, accompanied by a credit line for both of them and no reference to Lange. Gardner reports that Lange was fastidious about attributing credit to others, but sometimes Lange included her assistant's work, unattributed, with her own: she sent Stryker some photographs taken by Rondal Partridge, including his aerial views of a labor camp taken from the top of a water tower that she had been unable to climb.[111] Lange edited the North Carolina texts, drafted by Harriet Herring and Margaret Jarman Hagood, and submitted them in 1939 as general captions to the Farm Security Administration without explicit attribution; she saw her assistants and partners as allies in a common cause, and in that particular assignment she had been instructed to work with those two social scientists. Their collaboration would have been no secret in the FSA, in any case, since Stryker was in close communication with Hagood. Yet Lange's work was also distinct. In her collaborations with Taylor, a reader can spot her clearly. With one ear attuned to Lange's characteristic manner of phrasing in her daybooks, letters, and interviews and the other to Taylor's writing style, one can hear the shift from her tone and words to his. In "Documentary Photography," a definition Lange wrote at Adams's request, published by him in *A Pageant of Photography* in 1940, one reads: "It records his customs at work, at war, at play, or his round of activities through twenty-four hours of the day, the cycle of seasons, or the span of a life" (probably Lange) but also "Among the tools of social science—graphs, statistics, maps, and text—documentation by photograph now is assuming place" (undoubtedly Taylor). Taylor said after Lange's death, "Dorothea asked me to help her write the definition.... If she were here, she would say that I wrote the definition. We did it together."[112]

From her street photography of the early 1930s to her 1950s and 1960s portraits of self and family, Lange's work is documentary photography (though she disliked the term) by her own definition of 1940 and by William Stott's in his groundbreaking 1973 study *Documentary Expression and Thirties America*. The documentary deals with "actual fact," writes Stott, but within the genre are two "tendencies": "one gives information to the intellect," the other "informs the emotions."[113] Both of those tendencies are present in Lange's words and photographs; she had the eye of an ethnographer and the vision of an artist. Yet she rarely called herself an artist and, by the 1960s, no longer considered her work documentary (perhaps because she had been married first to an artist, then to a social scientist, and identified fully with neither). Writing with Taylor, in 1940, she stressed the value of a documentary photograph as observed data, not as an artistic record of lived experience. But writing with her son Daniel, in 1952, she spoke eloquently, in "Photographing the Familiar," about photography as an art of discovery and expression. The essay is a manifesto of documentary photography as practiced by Lange. Of contemporary photography, Lange and Dixon wrote, "Photography is in flight...from the familiar....The spectacular is cherished above the meaningful, the frenzied above the quiet, the unique above

the potent. The familiar is made strange, the unfamiliar, grotesque." Lange and Dixon urged photographers instead to find "a refreshed relationship with the world," to make photographs that are "full of the world," to make impulse "a movement of the common," instinct "a gesture of the ordinary," vision "a focus of the usual," and thus to discover "not only the familiar but the strange, not only the ordinary but the rare; not only the mutual but the singular. . . . These, then, are the issues: whether we, as photographers, can make of our machine an instrument of human creation, whether we, as artists, can make of our world a place for creation."[114]

"Photographing the Familiar" was written at the end of a bleak period of incapacitating illness. From 1945 to 1952 Lange barely picked up a camera. After losing her job at the Farm Security Administration at the end of 1939, Lange enjoyed only five years of good health and intensive work over the next twenty-six years: in 1940, for the Bureau of Agricultural Economics; in 1941, for the Guggenheim fellowship; in 1942 for the War Relocation Authority, documenting the evacuation of Japanese Americans to internment camps; from 1943 through 1945 for the Office of War Information (OWI). In 1945, Lange was hospitalized for the first of a series of serious illnesses that would dog her for the rest of her life. In terms of the available evidence and historical record, the years 1943 to 1953 are almost a total blank: the OWI photographs from 1943–1945 are lost (although the general captions Lange wrote to accompany them survive).[115]

Of the few photographs that remain from this period, Lange wrote, "Some were made on the fringes of assignments. Some were made between bouts of illness, to test whether the eye remained true and the hand steady, and whether eye and hand would work together again." "Some were made at random, by instinct, waiting on street corners or during expeditions to the supermarket."[116] But in 1953 she began to take on larger projects again: with Ansel Adams in Utah on a story for *Life* magazine; in 1954, with her son Daniel, in Ireland, also on assignment for *Life*; by herself, in 1955, on a photographic essay about a public defender in Alameda County, California; from 1956 to 1957, with Pirkle Jones in the Berryessa Valley.[117] When Paul Taylor's work took him to Asia, South America, and the Middle East from 1958 through 1963, Lange went too. "Generally, you don't work very well . . . in completely foreign countries," Lange said of that period. With no collaborator (Taylor had his own work), no shared language, no knowledge of local culture, no larger social purpose, Lange was cut off from her familiar sources of support and inspiration. "In a strange country, surrounded by . . . nothing that you understand," Lange asked herself, "what are you doing there, for the love of God, with a camera?" Out of her context, Lange's foreign work, strong as it is, is not informed by deep knowledge of time and place or by empathetic connection with her subjects; indeed, many looked into her lens with bewilderment or even hostility. "I go [to Egypt] because Paul's work takes him there," Lange wrote to the Newhalls in 1962. "For my own work I would choose to stay in my own country." Her "best periods," she said, were those of intense visual experience "when the familiar suddenly becomes transfigured in your eyes . . . not when you are surrounded with the unfamiliar."[118]

In 1964, back in her own country, Lange had begun what she referred to as "a real series, a sequence of photographs on the subject of freedom" in which her family's cabin on the Pacific coast "would be the device." Typically, others have described it instead as a book about her family. The cabin was where Lange's extended family gathered for weekends and holidays, but Daniel Dixon describes the special sense of freedom enjoyed there: "There were no rules or restraints or rituals. We did what we wished, when we wished, as we wished. We were liberated from her strictures and standards, and so was she herself."[119] But Lange wrote on September 15 to her new publishers, Richard and Jill Grossman, to say that it was not to be. "There will be no beautiful little book [on freedom] about which I spoke so hopefully.... There would have been more of what I feel and wish to speak about ... in this little book as I see it in my imagination than any of the other undertakings, including the exhibit at the Museum of Modern Art."[120] The month before, Lange had learned that she had cancer of the esophagus. It was considered inoperable, and she was told she had from a few months to eighteen months to live.[121]

"A trick of grace"?

In February 1964, John Szarkowski, recently appointed as director of photography at the Museum of Modern Art in New York, acted preemptively to give Lange center stage: "Whether you like it or not," he wrote to her, "you are down on the schedule for a one-man show two years from now." MOMA had previously sponsored only five major exhibits on a single photographer: Walker Evans (1938), Paul Strand (1945), Edward Weston (1946), Henri Cartier-Bresson (1947), and Edward Steichen, the previous curator at MOMA (1961).[122] She was to be the sixth. Steichen considered Lange one of the greatest American photographers, and MOMA's famous "Family of Man" exhibit of 1955 had featured her work prominently, as had the museum's 1962 exhibit "The Bitter Years: 1935–1941."

When the retrospective exhibition of her work opened to the public on January 26, 1966, Lange was not there to see it. She had died three months before, on October 11, 1965, at seventy. At the entrance to the exhibit, on a panel, was a statement by Szarkowski: "Lange was by choice a social observer, and by instinct an artist. In the best of her photographs the demands of these two commitments are reconciled and resolved; the image and its comment are inseparable.... What distinguished Lange's work was a challenging intelligence and an artist's vision. Her intelligence allowed her to bypass the exceptional—the merely newsworthy—and discover the typical. Her art gave to her observation an irreducible simplicity, the eloquence of inevitability."[123]

That same spring, MOMA presented another major retrospective exhibition, featuring the work of surrealist painter René Magritte. The New Republic's art critic, Frank Getlein, called it the "happiest of coincidences" that the two shows, Lange's and Magritte's, "side by side ... both first rate in themselves ... together form part of a baseline for triangulation into the ways of art and life." Getlein

compared Lange's photograph "Migrant Mother" to Michelangelo's "Creation of Adam" on the ceiling of the Sistine Chapel and Botticelli's "Birth of Venus" as one of "the stock of mental images we all carry around in our heads," an image that "gets into our interior magic lanterns." In Lange's 1956 photograph of a man's foot stepping off a streetcar, Getlein saw "an image as chilling and as compelling and as baffling as anything in Magritte." "We are witnessing life," he wrote, "not momentous life, not the imaginative life, certainly not the life of social protest, just plain, every minute, life—halted, examined, presented."[124]

The MOMA retrospective traveled to museums in Worcester, Massachusetts; Los Angeles; Oakland; and Italy. The exhibit itself was ephemeral, as almost all exhibits are, but the catalogue produced for the exhibit, with MOMA's book of selected Lange photographs, remained in print for years after the exhibit closed. The catalogue did not include Szarkowski's brief tribute, but featured instead an essay by George Elliott, which introduced, or simply continued, a series of persistent misconceptions and errors about Lange's work.[125] Thus Elliott describes Lange's *An American Exodus* as a "context of words and pictures" and reports that Lange "did not use this method again." Not so. She did so often, including in the classic 1960 "Death of a Valley," with Pirkle Jones. Elliott asserts also that the making of a great photograph was, for Lange, but "a trick of grace, about which she can do little beyond making herself available for that gift of grace." Of the photograph "Migratory Cotton Picker, Eloy Arizona, 1940," he suggests, "This time she was lucky, as she was a few dozen other times in her life":

She could not have known, she a small woman with a reflex camera hanging from her neck, shuffling back and forth near a ranch hand she is also talking to and listening to—she could not possibly have known the contrasting effect of textures, especially the dull palm and the glistening face, as it appears on the print. Quite likely she took a good many shots of him, as she had taken many of other subjects, and afterwards was grateful to find this one on the film.[126]

Nonsense. Lange knew what she was doing. She knew where to stand and how to move, she chose her photographic tools deliberately and astutely, and she had a fine-tuned sense of what she wanted in a final print. To say that she "could not possibly have known" the effect as it would appear in the print is preposterous. She may have been "lucky," but luck favors the artist who is well-prepared in heart, mind, and craft. It is highly unusual, perhaps unprecedented, for a MOMA publication accompanying a major retrospective exhibit to attribute any artist's achievements to "luck" or "grace" rather than to genius. The Italian edition of the catalogue substituted Szarkowski's testimonial for Elliott's essay.[127]

Highly unusual, as well, is the MOMA catalogue's failure to situate Lange's work in the general context of twentieth-century art or in the specific world of documentary photography, and also its omission of even a hint of her influence on other artists. In contrast, the 1947 Cartier-Bresson MOMA catalogue compares Cartier-Bresson to the painter Giorgio de Chirico and declares that

his "discoveries in the realm of space" inspired contemporary artists, including painters.[128] And Lincoln Kirstein's essay in the catalogue for MOMA's 1938 exhibit of Walker Evans's work says that "Walker Evans' eye is a poet's eye," comparing Evans to the pioneering photographers Eugene Atget and Mathew Brady and to some of the century's great poets, T. S. Eliot, William Carlos Williams, Marianne Moore.[129] Although Lange stands among giants, certainly with Williams and Moore and Muriel Rukeyser, one looks in vain in the Lange catalogue for any such recognition. A pity that Rukeyser herself was not asked to write the catalogue essay or that Ben Shahn, Lange's colleague, was not approached; both would surely have understood Lange's purpose, her poetry and politics, her content and its shape.[130]

It was Evans, not Lange, whom Philippe de Montebello, director of New York's Metropolitan Museum of Art, in 1994 spoke of as "one of the most influential artists of the twentieth century and the progenitor of the documentary style in American photography." Yet Robert Frank, whom Earl A. Powell, director of the National Gallery of Art, has praised as "one of the most important and influential photographers of all time," cited both Dorothea Lange and Walker Evans as his "favorite" photographers.[131] As Lange's reputation has waned, Evans's reputation has risen, his ascent seemingly accomplished, in part, through an undermining of Lange, a belittling of her skill and accomplishments, a disparaging of her social engagement, an emphasis on her passion and a downplaying of her intellect, and even an erasing of her existence.[132] This is not at all to disparage Evans's own extraordinary work, simply to point out that his reputation has been carefully cultivated by influential friends and colleagues, often at Lange's expense. MOMA curator Peter Galassi, for example, contrasts Lange's work and Evans's in a by now common caricature: hers is "an instrument of social reform" as opposed to Evans's "disinterested observation" and "challenging vision of an independent artist"; hers is "a hortatory voice," "a cry of distress," his "a taciturn reticence."[133] Despite the parallels between Lange's innovative 1930s photographic essays experimenting with thematic sequences and Evans's subsequent work, her influence on Evans remains unexplored.[134]

Lange's erasure started early. In 1971, when MOMA presented a retrospective of Walker Evans's work, Hilton Kramer, art critic for the *New York Times*, suggested that the work of "a single photographer, Walker Evans," had determined how many Americans imagine "what the United States looked like and felt like in the nineteen-thirties."[135] Alan Trachtenberg, in *Reading American Photographs* (1989), devised a pantheon of documentary photography in which Evans is preeminent, while Lange receives only three passing mentions. In *Walker Evans & Company* (2000), Galassi presented the work of more than one hundred artists and photographers as part of a tradition stemming from "the idea of an art based forthrightly on photography's appetite for recording fact." Evans's work is the book's focus, Lange's is excluded. And yet, for those with the eye to see, ghosts of Lange's photographs hover over the multitude of images that reflect her influence.[136]

At the center of the famous 1958 book *The Americans*, by Robert Frank, is a photograph that is an homage to Lange, a photograph of a highway that echoes her photograph of U.S. 54 in *An American Exodus* (figure 14). Frank's concluding photograph, of a woman and child in a car, "once again evokes Lange, not Evans," A. D. Coleman has observed, and yet, Coleman says, "the connection between Robert Frank's *The Americans* and Walker Evans's *American Photographs* has received thorough annotation," while its connection to Lange and Taylor's *An American Exodus* is unexamined. "Within the field of documentary photography," Coleman writes, "there are specific lines of influence radiating out from *An American Exodus* that someone will eventually trace."[137] One hopes that "eventually" means soon.

Lange's MOMA show in 1966 had provided the occasion for reviews of tepid praise and curious criticism. With the notable exception of Frank Getlein's piece in the *New Republic*, the reviews appeared under "photography" rather than under "art," and even the reviewers for the *New York Times* and *Saturday Review* were photography critics, not well-known art critics like Getlein or Kramer. Their vaguely positive reviews said nothing of the significance of Lange's work or of her influence on other artists (one called the show a "visual autobiography"). The photographic journal *Infinity* did laud the exhibit as "major in scope and importance . . . a show of solid merit and uncommon interest" and praised the quality of the prints, then promptly took it all back: "many of Miss Lange's negatives posed considerable difficulty for a printer."[138] Pity for a printer is not, generally, something critics offer, and Lange is not alone among great photographers in having produced negatives that are difficult to print (some of Edward Weston's were nearly impossible).

It is worth examining this critique more carefully, for Lange's technical competence has been persistently disparaged in print, giving credence to the notion that her great photographs must have been a matter of "luck," not skill or even genius. Quite the contrary. Lange knew how to print, recognized the qualities she was after, and instructed and supervised her printer, as many fine art photographers do. "Dorothea always printed her own negatives, and she always worked with an assistant," says Rondal Partridge, Lange's assistant and longtime colleague, who disputes the common view that Lange lacked skill in photography's craft.[139] Her negatives hold detail in the shadows: in a photograph of a woman taken on a bright day, one can see the rings on the dark bottom of the bucket she holds (figure 35). Even for photographs taken in dimly lit rooms, her negatives have rich midtones, effects that are difficult to achieve, like the grays of the seed bags in a stump farmer's home or the butter churn in a sharecropper's kitchen (frontispiece, figure 51). Partridge recalls that Lange deliberately chose a combination of film, developer, and paper that could hold a broad range of tones, especially in the midtones, the grays. To catch a fleeting expression or situation, Lange needed to move fast, to focus the lens and set exposure on the fly. Under such conditions, no photographer always makes perfectly exposed negatives. But, for Lange the proof was in the image itself and what it held.

In the final stage of preparing the 1966 MOMA retrospective, Lange had arranged for an expert printer, Irwin Welcher, to produce the prints that would be exhibited. She provided explicit instructions, explaining her goals, why she had made certain photographs, and what mood she wanted the prints to convey. Concerning the photographs of Ireland, she described Ireland as "a country of mist and rain and wind," cautioning Welcher to "watch the sky" of one photograph, "just a bit of glow at that horizon, then deeper and stronger at the top," and to "keep the feeling of the rain" in another, retaining "the misty light feeling in the upper left—burn it down a bit, not too much." In a third, he should "hold the detail" in the dark black peat and "bring out" the body of a young man so that "the texture of the peat and the line of his body separate." Welcher extolled Lange's sense of the print. The photographer, says Lange, "doesn't have to do developing, he doesn't have to do printing, but he has to *see*."[140]

Henri Cartier-Bresson, the photographic master of movement, did not make his own final prints, but no one refers to Cartier-Bresson as technically inept. Just the opposite. In an introduction to MOMA's catalogue for the 1947 exhibit of Cartier-Bresson's work, Beaumont Newhall writes that "there is nothing accidental or unforeseen in his photography," though "he cannot tell you the film, lens and shutter settings, and other technical minutiae of each photograph" and though he uses the "film speed recommended by the expert laboratory technicians who develop his film" and who make the final prints "under his personal supervision."[141] Why are such methods described as a strength in Cartier-Bresson and a weakness in Lange? The issue of gender looms large.

Lange devoted most of the last year of her life to selecting the work for the MOMA retrospective and supervising the printing of its photographs. She sorted through prints and negatives in dozens of boxes, choosing, grouping, and drawing out themes of her life's work. Among the thousands of photographs were those she had taken in 1939; in 1964, when she ordered copies of these images from the Library of Congress, she saw them for the first time in twenty-five years. This is undoubtedly the reason why so much of this work has been "lost" until now. As Lange sorted through the boxes of her life's work, her spontaneous exclamations on seeing particular photographs were captured on audiotape; so were hours of reflections on the nature and potential of photography, conversations with family and friends, and discussions with John Szarkowski about the nature of the MOMA exhibit and her rationale for selecting and grouping. Lange had agreed to let the local educational television station, KQED, make a film about her. KQED made two films but used only a tiny fraction of this material.[142] The taping had begun in 1962, before Lange left for Egypt, picked up again in July 1964, and continued until September 1965, the month before she died, more than forty hours in all. To listen to these tapes, stored in the Lange Collection in the Oakland Museum, is to feel the force of her personality and to experience her sharp sense of humor, her determination, courage, intelligence, and genius.

Many books have reproduced and discussed Lange's photographs, but her work as a whole has not been fully appraised. In searching for such appraisals,

I found only spare instances of expansive and unequivocal praise from critics and discovered some patronizing, even scornful, put-downs and a deepening neglect. Whereas, in 1958, Lange was among the nineteen masters included in Beaumont and Nancy Newhall's *Masters of Photography*, several influential books on photography published since the 1980s denigrate Lange's work or ignore it entirely.[143] The ambiguity and doubt, and the silence, seem to begin in the mid-1960s. Paradoxically, Lange's reputation seems to have declined partly as an aftermath of the 1966 show meant to honor her. It is time to set the record straight.

"Well, there's a Lange for you!"

"I don't say I'm highly original, but after all these years of work I have a certain, well, not exactly a style, but a tonality...I recognize as my own....I'll say, 'Well, there's a Lange for you!'"[144] Lange was speaking of far more than the actual tones of her prints, but their tonality is revealing. Lange's photographs are almost always composed of shades of gray from dark to light with complex overtones, her prints low-key, speaking with a softer voice than the loud shout of a high-contrast print. When she wanted her prints to shout, they did, like the high-contrast print of a man yelling into a microphone during the 1934 general strike. She disliked using flash because it distorts; thus her photographs show the dim interior of a sharecropper's cabin or a basement dugout home as dark, not bright.[145] A photograph by Lange leads the viewer to focus on the subject; it does not call attention to the photographer, to how clever or acrobatic she was. Lange has her feet on the ground. "So that no one would say, 'How did you do it?'...But they would say, 'That such things could be.'"[146]

"What would I do with a camera if I did what properly belonged to me?" Lange asked in the KQED tapes. She answered by quoting Goethe: "Every traveler should know what he has to see and what properly belongs to him on a journey."[147] Her work was her journey. What finally "properly belonged" to Lange, what attracted her "intense curiosity," was, as she wrote in 1940, people in and of themselves, but also their relationships to each other and to the landscape, and how both changed over time. She portrayed these relationships in the intimate connections between person and home, on the one hand, and, on the other, in the connections between a community and its "home," whether a building or a landscape. She depicted what a place is and "what it is becoming," "who its people are, where they came from and how they got this way," and sought to convey the changes taking place and their effects on people and such "democratic goals" as "individualism," "political democracy," and "freedom from want."[148]

Lange engaged the subjects of these relationships directly, with intellect and emotion, and with an empathy that registers her presence, investing her photographs with her particular "tonality." But not the tone one scholar meant when he said disparagingly: "Lange had very strong feelings about social injustice and her feelings came through clearly in her photographs. There were few ambiguities here, just pictures that hammered away at the senses with bludgeonlike

impact."[149] Passion need not make work simple or sentimental; Lange's "just pictures" were not bludgeoning at all, not hammering. They are, indeed, often complex, nuanced, ambiguous. Look at the series of a family in the migrant camp at Brawley, the husband and wife at odds (figure 9). Some people Lange photographed regarded her with suspicion, as this migrant mother of eleven children did. Who else among the FSA photographers would have taken a series like this, who else would have recorded the poignant conflict? Not Ben Shahn or Walker Evans, with their trick viewfinders to lull subjects into thinking they were looking the other way. Evans did not reveal his movements as openly and kept his distance, remaining detached. As Lange observed of him: "He doesn't go any closer than just so far, and no further … which can be a man's strength." (Cartier-Bresson, too, she said, "keeps his middle distance.") As for herself, "I can never go close enough…. I push close. It's right for me."[150]

It didn't matter whether Lange was photographing a person or a tree, "I don't know … where the human leaves off and the inhuman begins…. This sharp division between what is human and what is not human, I don't quite understand…. You can photograph a tree, certainly [that] isn't photographing humanity. But you … are a human being and your understanding and the reason for doing that tree are strictly human motives…. If I'm dealing with a tree, or with a human being, it is an interpretation … of the world I live in."[151] She photographed the broken stump in northern Idaho as she would photograph a person, both close up and rooted among thousands of other stumps, investing that tree with feeling and meaning. As she advocated a decade later: "We suggest that, as photographers, we turn our attention to the familiarities of which we are a part. So turning, we in our work can speak more than of our subjects— we can speak with them; we can more than speak about our subjects—we can speak for them. They, given tongue, will be able to speak with and for us. And in this language will be proposed to the lens that with which, in the end, photography must be concerned—time, place, and the works of man."[152]

Lange's approach was based on three considerations: "First—hands off! … Second—a sense of place…. Third—a sense of time."[153] It was an approach reflected in some of the 1939 North Carolina photographs:

Pittsboro … Saturday afternoon. This is a small town in the South, I remember that summer so well…. (figures 72–74)

There is Queen…. Everything she has on her is made at home, including her apron, including her gloves, no J. C. Penney, everything. That's still part of a world…. (figure 76)

Sons of a Negro tenant farmer go visiting on a Saturday afternoon. (figure 62)[154]

For the MOMA show, Lange selected a North Carolina photograph (incorrectly labeled in the catalogue as having been taken in Alabama) of sharecroppers sitting on the porch of a crossroads country store with the owner's brother

standing. "That store is where all business is done," she explained to Szarkowski, "where everything is transacted, where all loans are given, where they're kept in hock forever. That store is everything" (figure 177).[155]

In a Lange photograph, there are always multiple stories, one immediately apparent, others implied. Composition and technique serve the story. She had a few formulas of her own to fall back on, like framing the person against the sky or centering the subject head on; but sometimes she broke convention, cutting off a head or photographing backs. "Big wide shot is never my shot, not really," said Lange, but sometimes it was, when she needed it to express the desolation and degradation of the cutover land, the forest laid waste.[156] *There's a Lange for you.* She was more likely to focus on "things that weren't working," in contrast to the unsullied wilderness of Ansel Adams's views of Yosemite (figure 129). "There are so many beautiful things in this world," Adams once said to Ron Partridge. "I don't know why Dorothea photographs all those dirty people" (or, one might add, dirty landscapes).[157] Wilderness is, for many Americans, a pristine ideal. The stumplands of the Pacific Northwest of 1939 are neither pristine nor a cultural ideal, but they are as American as "purple mountain majesties."[158] Though Lange was critical of some people and conditions, the "tonality" of her portraits is never derisive or demeaning. Harriet Herring, her guide in North Carolina, described Queen's "amazing set of false teeth, much artificial gum showed when she smiled but may not in photographs as she clamped her mouth very tight as if self conscious of them."[159] Another photographer might have waited around to catch the woman off guard, her mouth open. Lange let Queen preserve her dignity.

Lange treated her audience with respect too. Composing "a wall on relationships" for the MOMA show, a month before she died, Lange thought about that audience:

Your viewer, and he is a very mysterious person, you have to keep him in mind, always, and you don't know him. When he looks at such a wall on relationships, my hope would be that he would say to himself, "Oh yes, I know what she meant. I never thought of it, I never paid attention to it." Or . . . "I've seen that a thousand times." But he won't miss it again, won't miss it again. You've told about the familiar, the understood; but in calling attention to what it holds, you have added to your viewer's confidence or his understanding, and the most complimentary thing . . . that anyone could ever say to you is, "I saw something today that you would have liked." Then you know you have reached him. . . . If they say that, you know that you have reached them and given them something.[160]

"I myself . . . see things, many things, many things that I never would have seen . . . had not . . . some people [who] lived with cameras in the world showed it to you, brought it to you, gave it to you, contributed it."[161]

"Looking at these pictures . . . by the time we have looked at them all, we ought to feel that our homes and hearts, by the view we have been given of the homes and the hearts of others, are not just what they were when we began."[162] Look-

ing at—reading—Lange's images and words is to see the roots of our own time and place. And by the time we have looked at and read them all, we ought to come back to Lange's work, as a whole, and see it, and her, in a new light. Lange, in her work, speaks with and for her subjects, and they, "given tongue," "speak with and for us." This is her great gift.

On the essence of a photograph, Lange observes, "What is it in the end? It is a mounted piece of paper with a photographic silver image on it. But in it there is an element which you can't call other than an act of love. That is the tremendous motivation behind it. And you give it. Not to a person, you give it to the world, to your world … an act of love—that's the deepest thing behind it.… The audience, the recipient of it, gives that back."[163]

TWO

Photographs & Reports from the Field, 1939

DOROTHEA LANGE

EDITOR'S NOTE

Selection and presentation of Lange's photographs and general captions. Lange made more than three thousand photographs in 1939, the crucial year addressed by this book. From that large body of work, I have selected the photographs reproduced here, my principal criteria being aesthetic quality, documentary content, representation of Lange's diversity of composition, subject, and theme, and association with a general caption. The photographs appear with the relevant general captions and with Lange's captions for individual images. All of Lange's general captions for 1939 are reproduced in this book, including seventeen in Appendix E.

Most of these photographs were never printed in Lange's lifetime (except as proofs) and appear here for the first time, reproduced from high-resolution digital scans of Lange's original negatives. Photographs include the full frame of Lange's negatives; no cropping has been done. While Lange did not hesitate to crop to emphasize certain features or to refine composition, and no doubt would have cropped some of the images presented here, there is no way now to know what she would have done if she had printed them. However, in preparing the digital files for production, I sometimes made adjustments to contrast and tone, consistent with Lange's own preference for rich midtones. To confirm these adjustments, I consulted photographer Rondal Partridge, who was Lange's assistant in 1939; he reviewed and approved all my prints.

Order of general captions. Overall, I have organized the general captions geographically and chronologically, following the sequence of Lange's assignments in the field. Within these broad divisions, I have composed thematic groups based on her descriptions of the subjects of the photographs, and for the sake of those themes or a sequence, I have reordered some of the general captions. (The caption numbers indicate Lange's own order, for those who wish to trace it.) Lange numbered these general captions from 1 through 76 (number 40 does not exist) before sending them and the individual captions, in several batches, to Washington, D.C.: three from California (in July), twenty-one from North Carolina (in September), and fifty-one from the Pacific Northwest (in November).

Format of captions. During the fall of 1939, Lange developed a consistent format for her general captions: each started on a separate page, with a header at the

top of the first page giving the date, location, and subject. Following the text of each general caption, she listed the applicable negative numbers, an important feature because it identifies which photographs belong to each story (in some cases more than fifty). The Farm Security Administration, whose assignments Lange performed, often failed to provide consecutive numbers for photographs on a particular roll of film (or on connected sheets of film), and Lange herself always worked with more than one camera; thus her photographs were often scrambled, taken on different days and in diverse places, but numbered as if in sequence. Without Lange's list of negative numbers, it would be difficult, at times impossible, to identify and assemble related images. (A key to the negative numbers appears at the end of this book; see appendix D.) During the fall of 1939, Lange standardized the format for her captions. Before August, she used a variety of styles for the title block of her general captions and for headings within the text; these have been converted to a consistent style of capitalization, indentation, and so forth. In her captions for individual photographs, the date, the location, and the description often appeared on separate lines; I have combined these lines into paragraphs.

Individual captions. The full text of Lange's caption for each photograph is reproduced here, except for redundancies (as, for example, a reference to the general caption); captions in the Library of Congress's online catalogue (http://www .loc.gov/rr/print/) are sometimes abbreviated or altered. When quoting from Lange's caption sheets, I have used the original negative number as it appears there. In the list of illustrations, I have used current Library of Congress negative numbers, incorporating the prefix (LC-USF34-0) rather than the original numbers, to make it easier for the reader to locate the photographs there. The photographs include a few that Lange or Roy Stryker, her boss at the Farm Security Administration, rejected (these are noted in the list of illustrations). She wrote no captions for the rejected photographs; in such cases, I have provided a caption from a similar photograph, if one existed. In the few instances when Lange referred to a general caption for a quotation that was missing, I have hunted in her field notes for that quotation and supplied it.

Introductions, clarifications and addenda. An editor's headnote, signed "AWS," introduces each section of Lange's texts and photographs and provides contextual background, drawing especially from publications Lange sent along with her photographs and captions to the Farm Security Administration in Washington, D.C. Minimal explanatory notes appear within Lange's own general captions. Editor's interpolations, explanations, and corrections of factual errors appear in square brackets, as do clarifications of Lange's text, such as spelling out of abbreviated terms; notes supply explanations when needed.

Corrections of spelling and punctuation. Certain spelling and punctuation errors in Lange's copy have been corrected. Her typist may have introduced some of

these. Capital letters were employed freely and inconsistently; such inconsistent capitalization has been retained here in most cases, although capitalization in the headings was made consistent. Lange's inconsistency in style of numbers (for example, "50" and "fifty"), abbreviations ("W.P.A." and "WPA," "Co." and "County," "no." and "#"), and spelling ("share-cropper" and "sharecropper") has also been retained.

<div align="right">AWS</div>

CALIFORNIA

JANUARY TO MAY 1939

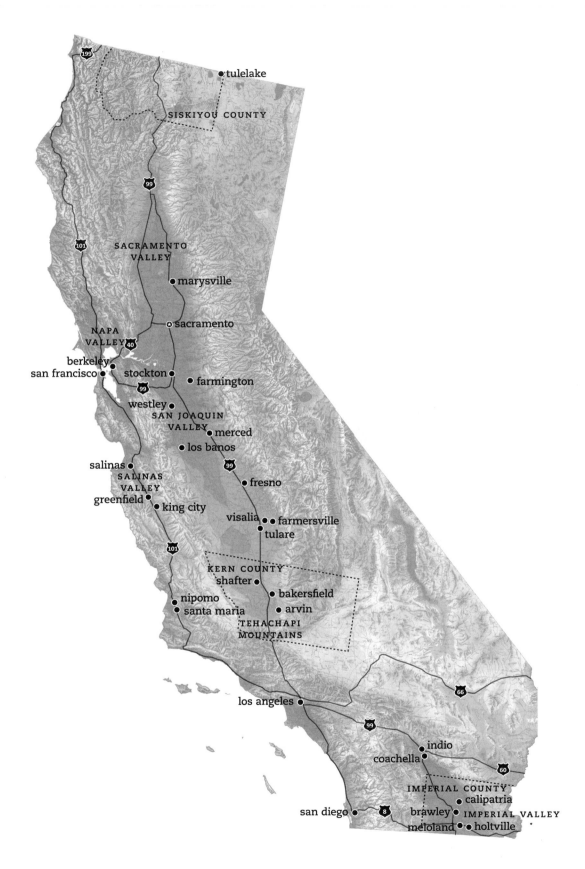

19. California. Places photographed by
Dorothea Lange in 1939.

THE HIGHWAY

U.S. 99, DOROTHEA LANGE'S BEAT IN 1939, stretched from the Mexican border to Canada. It was the product of a federal decision in 1925 to facilitate movement across the continent by designating a few roads as interstate highways. In 1919, it had taken two months for a young colonel, Dwight Eisenhower, to drive from Washington, D.C., to San Francisco with the U.S. Army's first transcontinental motor convoy. There was no interstate highway system: "Vehicles stuck in mud or sand, trucks and other equipment crashing through wooden bridges, roads as slippery as ice or dusty or the consistency of 'gumbo.'"[1] The dusty, rutted, rural roads in some of Lange's 1939 photographs were no different. Despite a succession of federal appropriations to construct highways, most road work consisted of simply grading the roadbed and laying down gravel. In 1939, U.S. 99 was still many roads pieced together: narrow lanes with no painted center line, their dirt shoulders bounded by fields, and broad main streets with curbs and sidewalks bordered by used furniture stores and saddleries.

At the 1939 World's Fair in New York City, General Motors' exhibit, "Futurama," envisioned a landscape of superhighways. In 1940 the Pennsylvania Turnpike opened; with no on-grade crossings, it was the first limited-access highway in the United States. On U.S. 99, the overpass near Fresno and the three-lane highway through the Tehachapi were truly modern in 1939; no wonder Lange photographed them close up, along with the billboards, signs, and businesses that were springing up to meet travelers' needs: the gas stations, garages, used car lots, do-it-yourself garages.

On assignment for the Farm Security Administration (FSA) in 1939, Lange drove U.S. 99 from California's Imperial, San Joaquin, and Sacramento valleys to the Willamette Valley of Oregon and the Puget Basin of Washington. The highway was the subject of her first general caption, and the poetic qualities of the text in her daybook set it apart from those she would write later:

US 99...
The mess and the clutter
The heat, the monotony, the
constant hum and roar
whine growl of traffic[2]

AWS

GENERAL CAPTION NO. I

SUBJECT: US 99

Arterial highway which serves the San Joaquin and Sacramento Valleys of California. Over it moves a stream of vehicles of commerce—oil tank trucks, loads of pipe for oil wells, groceries in bulk, household goods, freight of all kinds. Growers haul upon it loose cotton for the gin or bales for the compress, cotton seed for the oil mill, grapes for the winery or the packing house, lettuce and potatoes for the sheds. Migratory families who serve the crops drive north along it in the spring, north and south in midsummer, and south in the fall. Along its sides lie the fields and labor houses of large growers, orchards of small and large farmers, ragged camps of squatters, fruit and vegetable markets, hot dog and cold drink stands, auto camps, gas stations, billboards, and stringy towns.

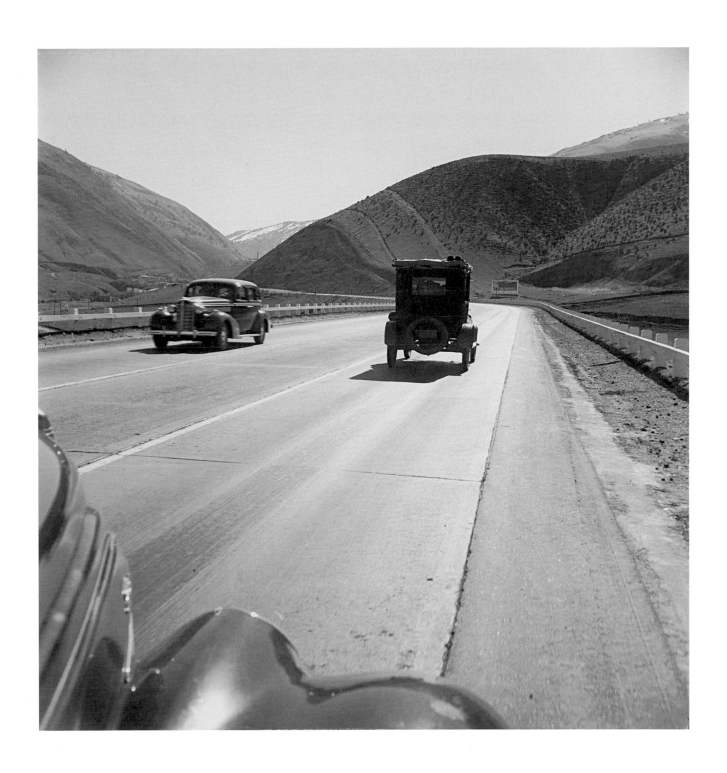

20. On U.S. 99 in Kern County, Feb. 1939. On the Tehachapi Ridge. Migrants travel seasonally back and forth between Imperial Valley and the San Joaquin Valley over this ridge.

21. Between Tulare and Fresno on U.S. 99. Farmer from Independence, Kansas, on the road at cotton-chopping time. He and his family have been in Calif. for 6 months.

22. On U.S. 99 near Brawley, Imperial County. Feb. 1939. Homeless family of 7 walking the highway from Phoenix, Ariz., where they picked cotton. Bound for San Diego, where the father hopes to get "on the relief" "because he once lived there."

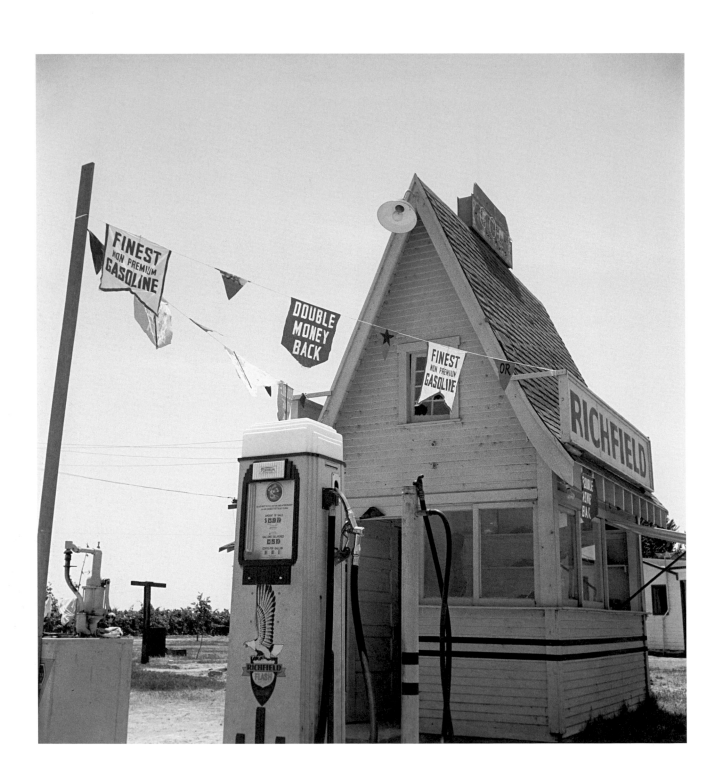

23. Between Tulare and Fresno on U.S. 99.
A large number and great variety of service
stations face the highway.

24. U.S. 99, Fresno County. "Pit and tools for
rent—work on your own."

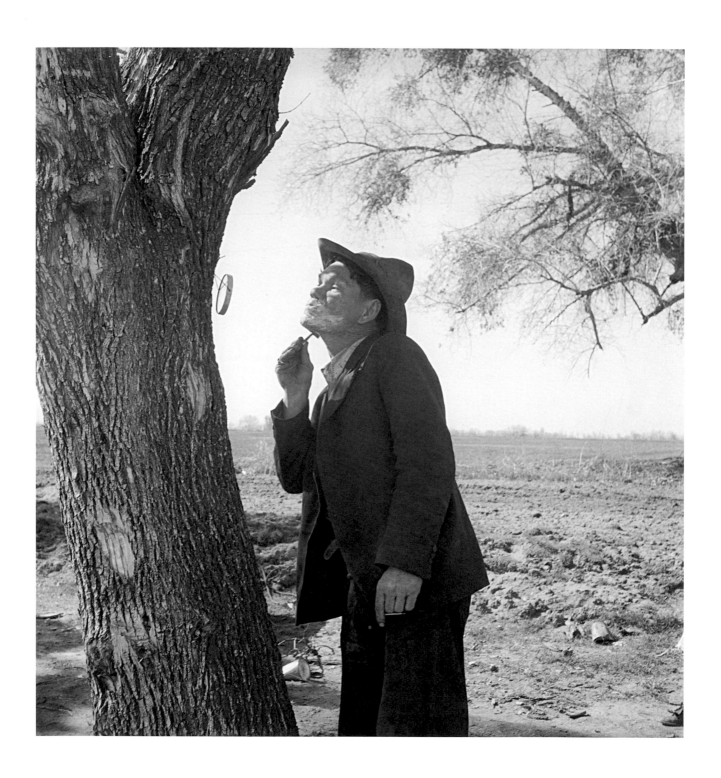

25. On U.S. 99 between Bakersfield and
the Ridge, en route to San Diego. Feb. 1939.
Migrant man shaving by roadside.

26. Between Tulare and Fresno on U.S. 99.
Many auto camps of all kinds are strewn
along this highway.

THE FARM FACTORY

DOROTHEA LANGE HAD PHOTOGRAPHED the plight of migrant workers since 1935, but in the winter and spring of 1939 she took on the larger task of documenting "industrialized agriculture."[3] Lange and her husband, Paul Taylor, were in the midst of producing their book, *An American Exodus: A Record of Human Erosion*. It would trace the westward journey and the transformation of once independent owners and tenant farmers from Oklahoma, Texas, and Arkansas into a "large, landless, and mobile proletariat" for California's "open-air food factories."[4]

By March 1939, Lange was in Salinas, where months before vigilante farmers armed with rifles had faced down striking migrant laborers. She photographed some of the enormous lettuce fields; one image, included here, appeared in *An American Exodus* with a different, briefer caption (figure 27).[5] The previous month, in California's Imperial Valley, near the U.S.–Mexican border, she had photographed "gang labor" pulling, cleaning, tying, and crating carrots "for the eastern market" and had gained entrance to the Sinclair Ranch near Calipatria, an "open-air food factory," interviewing workers and recording the picking and packing of peas, from field to crate to train (figures 28–30, 33). Because such farms employed few full-time workers, many growers hired a labor contractor to recruit a part-time army of pickers. Like the Joads in John Steinbeck's *The Grapes of Wrath*, thousands had read contractors' advertisements and left their homes for California, only to find more job seekers than jobs, paltry pay, and rent and food more costly than they had expected.

In the Imperial Valley that spring, jobs were even scarcer than they had been the year before, when, "for the first time," Lange wrote, "the labor surplus had grown so large that relief grants were necessary even during peak of harvest." "To hold a place to work," pickers got to the fields by 5:00 a.m., even though picking did not begin until 8:00.[6] Those who found no work applied for aid at the Farm Security Administration grant office in Calipatria, stood idle on street corners, and were soon forced to move on (figures 31, 32). Later and farther north, in San Jose, men without jobs told Lange, "They've got orders from the Law ... to move us out."[7]

California's farming communities and growers, fearful of strikes, organized to put down labor unrest. In 1933, after a series of strikes that brought higher wages for the pickers, growers in the Imperial Valley founded the Associated

Farmers. The growers' group spread quickly with the support of "bankers, shippers, and oil companies," compiling files and distributing lists of labor organizers and "dangerous radicals" to their members and to police.[8]

Paul Taylor, who became Lange's husband in 1935, had written in an article on the 1934 San Francisco general strike that farmers used that strike as an excuse "to arrest leaders of farm strikes"; "officials, business men, and other conservative citizens" had been so roused that they were willing to adopt "storm-troop tactics to 'save America.'" By 1935, Carey McWilliams and Herbert Klein, writing for *The Nation*, told of "anti-picketing ordinances in practically every county in the state," which "prohibited 'unauthorized line-ups of automobiles . . . and meetings of more than twenty-five persons without permits,' and . . . outlawed lectures, debates, discussions, loitering in alleys, halls, and the like without a permit." They also described stockades, such as one near Salinas, set up to imprison strikers, and charged that certain "farm factories" were using "armed deputies and machine-gun equipment." In some labor contractors' camps, they reported, "the workers live in guarded quarters . . . surrounded during harvest with barbed-wire fences and 'moats.'"[9]

Under such conditions, it took courage to go, as Lange did, into contractors' camps and out into the fields uninvited, "with heavy valuable equipment making negatives of subjects that obviously will reveal what is wrong," as she put it. In October 1938, she had an encounter with the law: "I was trying to photograph a mass of pickets, and the cop galloped up to me on a very large horse. I did not look like a representative of the U.S. government, I admit, and I had nothing to show." After that incident, she requested, and carried with her, a letter from the FSA, which she could produce if challenged. Lange had written in 1937: "What goes on in the Imperial Valley is beyond belief. . . . Down there if they don't like you they shoot at you and give you the works. Beat you up and throw you in a ditch at the county line. . . . I am not traveling alone down there. Down there it's too uncomfortable to be alone."[10]

The first two government camps for migratory agricultural laborers were constructed in 1935 at Marysville in the Sacramento Valley and at Arvin in the San Joaquin Valley, the direct result of reports and lobbying by Lange and Taylor, both of whom were working for the California Emergency Relief Administration at the time.[11] The migrants were suspicious of outsiders, apparently for good reason. When John Steinbeck asked the FSA to help him investigate firsthand "the experience of a migrant worker" for background in writing *The Grapes of Wrath*, the manager of the FSA camp at Arvin was assigned to help Steinbeck pose as a migrant, living in camps and working in the fields of the Imperial and the San Joaquin valleys. Steinbeck asked the FSA to keep his identity secret and, grateful, dedicated his book to the camp manager. But the courtesy ended the manager's career, for the migrants were convinced that he had betrayed them by bringing a disguised novelist into their midst.[12]

But Lange moved freely and without disguise among the migrants, whether in the FSA camps, the squatter camps, or the camps of labor contractors (fig-

ures 9, 34–36). To her it was a matter of establishing an open and reciprocal relationship. "All photographs are made in collaboration," she asserted. "That was the reason," Lange's former assistant Rondal Partridge told me, "she was never kicked out of a camp, never mugged, never robbed." Lange also was discrete about the persons she photographed, taking care not to endanger them. On picket lines and at meetings where strikes were planned, she almost never took photographs, putting her cameras away. She explained to her boss, Roy Stryker, in the fall of 1938 why she could not get the photographs he had requested: "The tail end of a long heart-breaking strike unsuccessful, no field activities excepting with strike breakers where it was too dangerous to go, since FSA is feeding the strikers and therefore there is hostility—a disrupted camp program, and half-empty camps. On the subject of daily life in migratory camp please expect nothing, because it could not be done."[13]

By early 1939, there were two types of government camps: new emergency mobile units, like the one Lange photographed at Calipatria in the Imperial Valley, and permanent camps, such as those at Marysville and Arvin and more recent ones at Brawley in the Imperial Valley and at Farmersville and Westley in the San Joaquin Valley. The mobile units, Lange noted, would "follow the workers from harvest to harvest." Each had two trailers, one the home and office of the camp manager, the other a mobile medical clinic.[14] The original permanent camps had provided tent platforms; the newer ones offered more solid structures, some of them actual houses of wood and steel, some even with trellises and gardens.[15] In addition to a medical clinic, each newer camp provided a laundry, showers, a community building, and a playground. The steel shelters of the FSA camp at Westley were laid out in a hexagonal pattern of streets designed by Garrett Eckbo, a landscape architect (figure 37). Such camps became models, hailed at the time as the "rural housing of the future." Eckbo and many of the young architects and landscape architects who designed these mass-produced, prefabricated structures and innovative site plans would become prominent professionals.[16]

During the spring of 1939, Lange returned to the San Joaquin Valley. Each project manager, eager to show off the camp's new features, "would have it all lined up, all the things that to him were vital," Lange recalled, "but they weren't vital in the sense of what were the real underpinnings."[17] She used her own judgment about what to photograph and also heeded the home office's requests for specific subjects. For the general caption on the Farmersville Camp in Tulare County, Lange photographed an evening meeting of the camp council and described its process of self-governance, which included electing representatives from each camp unit and holding weekly meetings with the camp manager (figure 38). It is significant that Lange chose this as the subject of her second general caption, especially since she disliked using flash. Perhaps she saw this elected council as one of the "real underpinnings."

AWS

27. Salinas Valley, California. Feb., 1939.
Large-scale commercial agriculture. This
single California county (Monterey)
shipped 20,096 carlots of lettuce in 1934,
or 45% of all U.S. carlot shipments. In the
same year, 73.8% of all U.S. carlot ship-
ments were made from Monterey County,
Imperial County, California (7,797 carlots),
and Maricopa County, Arizona (4,697).
Production of lettuce is largely in the
hands of a comparatively small number of
grower-shippers, many of whom operate
in two or all three of these counties. Labor
is principally Mexican and Filipino in the
fields, and white American in the packing
sheds. Many workers follow the harvests
from one valley to the other, since plant-
ings are staggered to maintain a fairly
even flow of lettuce to the eastern market
throughout the year.

28. Pickers coming in to the weighmaster.

29. Near Calipatria, Imperial Valley. Feb.
1939. Paymaster on edge of pea field pays a
quarter for every hamper of 30 lbs. brought
to the scale.

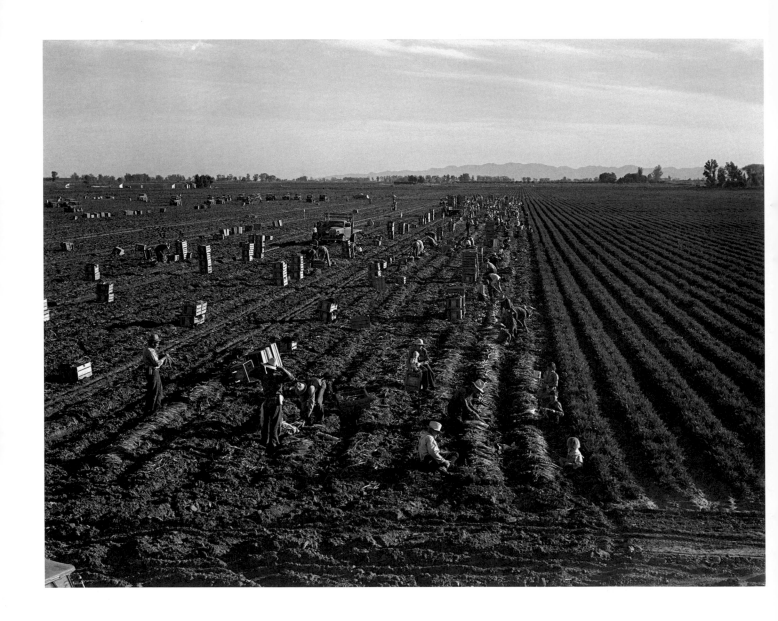

30. Near Meloland, Imperial Valley. Feb. 1939. Large-scale agriculture. Gang labor, Mexican and white from the Southwest. Pull, clean, tie, and crate carrots for the eastern market for 11¢ per crate of 48 bunches. Many can make barely $1 a day. Heavy over-supply of labor and competition for jobs is keen.

31. Calipatria, Feb. 1939. Outside FSA grant office during the pea harvest. During spring of 1938 for first time, the labor surplus had grown so large that relief grants were necessary even during peak of harvest. Colored migrants are becoming more numerous this year.

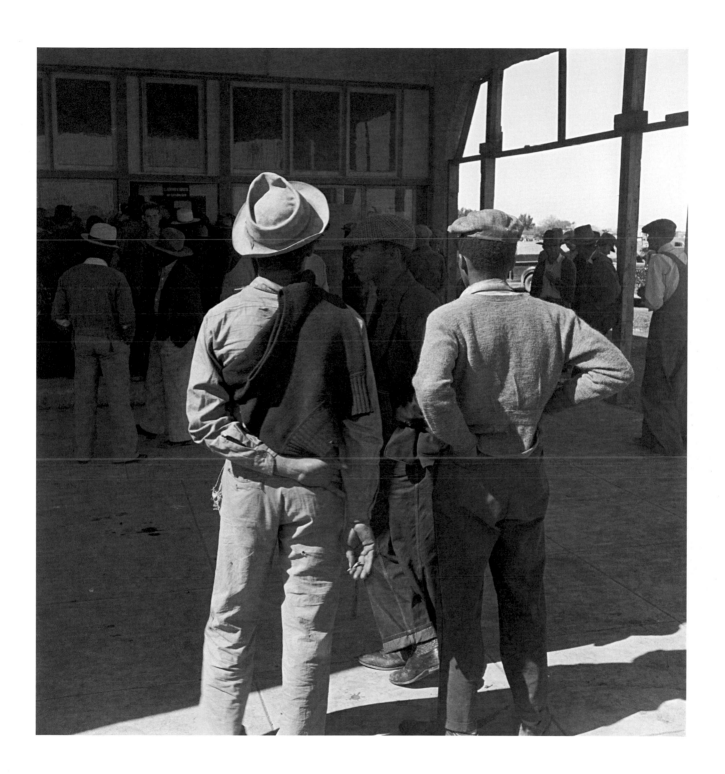

32. Calipatria, Imperial Valley. Feb. 1939. Idle pea pickers discuss prospects for work.

33. Calipatria, Imperial Valley. Feb. 1939. Car on siding across tracks from pea packing plant. 25-year-old itinerant, originally from Oregon. "On the road 8 years, been all over the country, every state in the Union, back and forth, pick up a job here and there, travelling all the time."

34. Calipatria, Imperial Valley, Feb. 1939. In FSA (emergency) migratory labor camp. The daughter. [The mother of the woman pictured] left Oklahoma Dec. 11, 1937, with husband and 2 children, and son-in-law. Ex-tenant farmers, on thirds and fourths in cotton ["a third of the feed to the land-lord and a fourth of the cotton," explained Lange and Taylor in *An American Exodus*]. Had $50 when set out. Went to Phoenix, picked cotton, pulled bolls, made 80¢ a day with 2 people pulling bolls. Stayed until school closed. Went to Idaho, picked peas until August. Left McCarl with $40 "in hand." Went to Cedar City and Parowan, Utah, a distance of 700 miles. Picked peas through September. Went to Hollister, Calif. Picked peas through October. Left Hollister for Calipatria for early peas which froze. Now receiving FSA food grant, and waiting for work to begin. "Back in Oklahoma we was sinkin'. You work your head off for a crop and then see it burn up. You live in debts that you never can get out of. This isn't a *good* life, but I say it's a *better* life than that was."

35. In a contractor's camp near Westley, Stanislaus County, California. April 20, 1939. "Been in California 14 months. From Oklahoma. The main thing is to get our families located and quieted down. Ain't no use to send them back; it's a waste of money. They won't stay." —A grandmother.

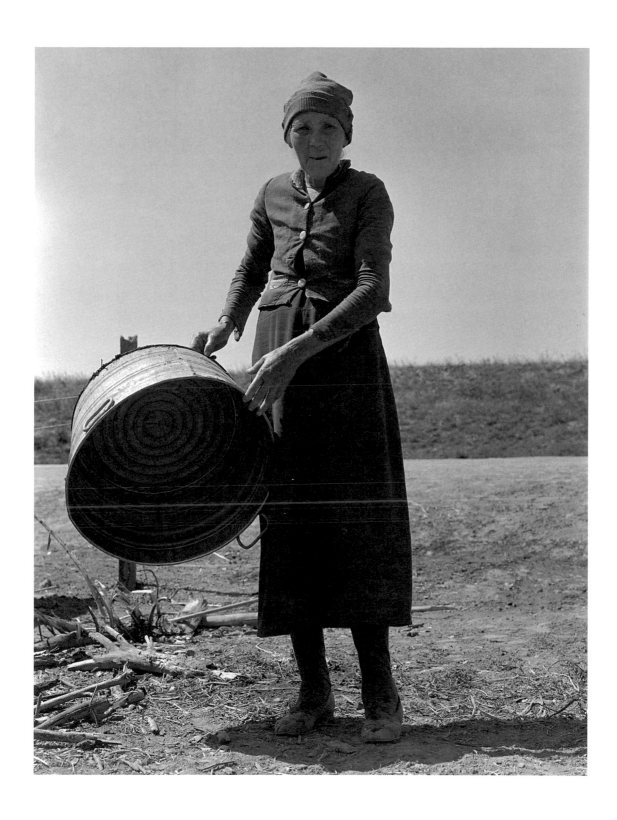

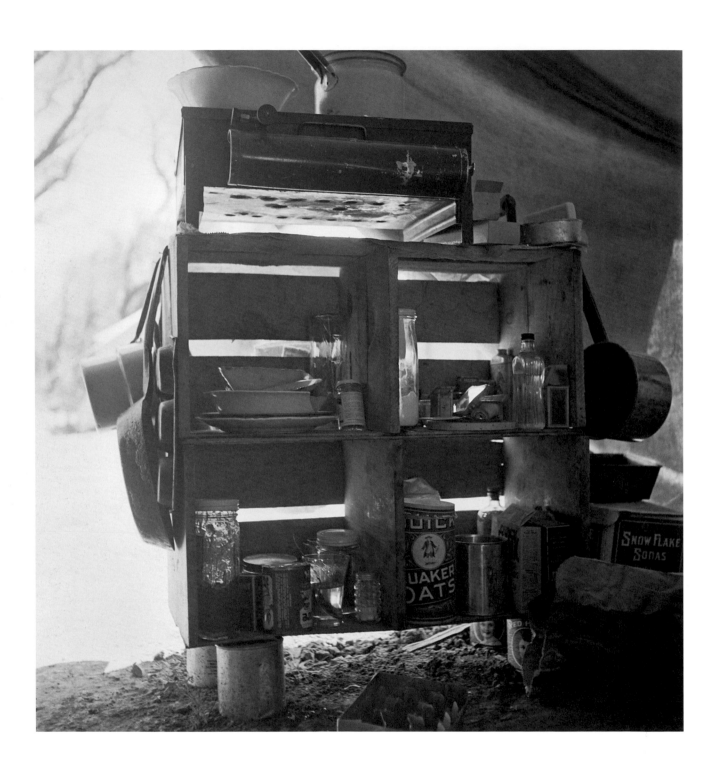

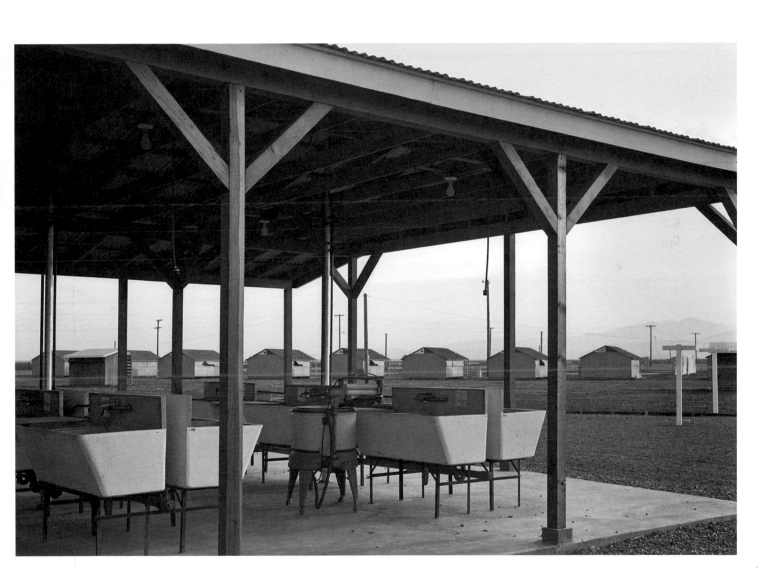

36. Near Westley, California. April 1939.
Tent interior in a labor contractor's camp,
showing household equipment.

37. Laundry facilities at Westley Camp for
migratory labor (FSA), San Joaquin Valley,
California. Feb. 1939.

GENERAL CAPTION NO. 2

DATE: May, 1939

LOCATION: Tulare County, Calif. FSA camp for migratory agricultural workers

SUBJECT: Meeting of camp council

These meetings are held weekly: 15 members, 3 elected from each camp unit. All Government camps are operated under the principle of self-government. Photographs show night meeting of council who have come together with camp manager (with leather jacket, lower left) to discuss means whereby they can send a delegate to a conference on wage scales for agricultural workers which is to be held at Fresno. Matters being discussed and voted upon are:

1. "Whether $10 would cover the expense of the delegate."
2. Clothing for the representative.
 "I'd like to withdraw my name because I'd have to petition the council for clothes."
3. Shall a councilman pay camp rent (10¢ a day when working)?
 "I make a move the rent problem before the council stands as is."
 "We're aimin' to make this place decent and it's only right we should donate our services."
 "This here motion we put over last week was plumb out of order."
4. Shall they permit an ex-boxer to organize a boys' boxing club?
 "We already have the gloves done bought."
 "We can take that up with the re-creation committee, tomorrow night, so's to have time to think on it."

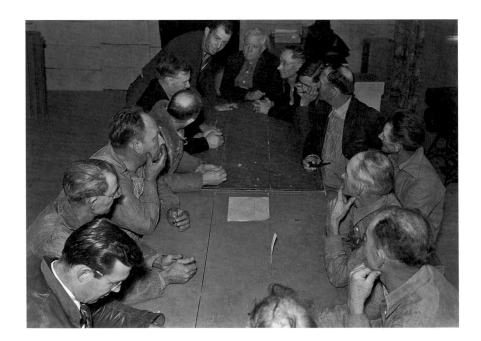

38. May 1939. FSA camp for migratory agricultural workers, Farmersville, Calif. Meeting of camp council. . . . The camp manager is at lower left, in leather jacket.

NORTH CAROLINA

JULY 1939

39. North Carolina. Places photographed by
Dorothea Lange in 1939.

THE FARMERS, BLACK AND WHITE

WHEN DOROTHEA LANGE TRAVELED to North Carolina in June 1939, her job did not involve her usual documenting of rural poverty and Farm Security Administration programs. This time, her assignment was to help sociologists study a North Carolina Piedmont region and explore how photography could augment other research methods, such as geographic mapping, statistical analysis, and ethnographic profiles. It was an unexpected assignment. Lange had gone to Washington, D.C., to oversee the printing of her photographs for *An American Exodus*, work that was to be done by the FSA photo lab. But she had been hurried out by her boss, Roy Stryker, who arranged the North Carolina trip at the last minute to get her out of town (see pages 32–33). (Another FSA photographer, Marion Post, had originally been assigned to the project, which had been scheduled for later that year.) Lange's work with sociologists from the Institute for Research in Social Science at the University of North Carolina in Chapel Hill, from June 30 to July 9, 1939, turned out to be significant for Lange herself and a valuable contribution to the university's own research.

The Institute for Research in Social Science advocated regionalism as the basis for planning and development, a concept appreciated by the FSA, whose own organization was centered around regional rather than state offices. The institute's founder and director, Howard Odum, coauthor of the 1938 book *American Regionalism*, was a leading proponent of regional development, based on an understanding of natural and cultural resources and population, as a counterweight both to more centralized national planning and to fragmented local planning.[18] Odum had recruited a group of talented social scientists, among them Margaret Jarman Hagood and Harriet L. Herring, who together were in charge of the photographic study of thirteen counties in the Appalachian Piedmont, an area considered typical of the "New South," where "industry and urbanization are forcing a new balance with agriculture and urban life."[19]

The institute's work was to be featured at a national conference, "Population Research, Regional Research, and the Measurement of Regional Development," slated for the spring of 1940 at the University of North Carolina. To stimulate discussion on regionalism and regional planning at the upcoming conference, the institute was preparing an exhibit on "photographic portraiture as exploration in the field of research through photography."[20] Lange's unexpected assignment marked the beginning of a collaboration between FSA staff and Odum's

institute; it would be continued by FSA photographers Marion Post and Jack Delano.

Despite the late notice of Lange's assignment, Herring and Hagood managed to be ready when she arrived. Herring, a professor of sociology at the university, had studied and written about mill towns of the South; Hagood was the author of *Mothers of the South*, which the University of North Carolina Press published later that year, a study of white tenant farm women that became a classic. (The 1996 edition contains photographs by Lange and Post.) To guide the "research through photography" in which Lange would participate, Herring had prepared an outline, "Notes and Suggestions for Photographic Study of the 13 County Subregional Area."[21]

Lange spent all but one day in the field with Hagood and only a single day with Herring. The researchers had identified places and families to visit and had obtained permission from landowners for Lange to photograph sharecroppers' families and farms. She was to document tobacco farms and their houses and barns, the process of "putting in" tobacco, a one-mile transect along a country road with various types of houses and a Negro Baptist church, street life in town on weekdays and Saturday, and churchgoing on Sunday.

Herring's outline provided many specific suggestions for how to illustrate contrasts among "income groups" and "types," houses "of various economic and social status and various ages," farm buildings, farm machinery and tools, and "types of people, clothing, interiors, furnishings, tools, implements and equipment."[22] More an inventory of illustrations than a research plan, it was, in Lange's opinion, not "a very good outline." "Too much emphasis on the economic set-up, not enough on the people at the center of it."[23] Herring, on her single day with Lange, was probably disappointed that Lange did not take more pictures of "machinery and tools . . . standing around rusting and put away under shelters"; at one household, she noted that Lange spent so much time making portraits of the family that she failed to photograph the rusted-out car seats used as porch furniture.[24] But Lange did take many photographs she might have otherwise passed up: for example, her many close-ups of eroded soil, her portrait of the tobacco plant, and a series of more than seventy photographs of putting in tobacco on a farm in Shoofly, North Carolina (figures 40–45).

Hagood's approach was more compatible with Lange's own. In the title of Hagood's book, *Mothers of the South: Portraiture of the White Tenant Farm Woman*, the word *portraiture* is significant; she uses direct quotations from individual women and describes their dress, behavior, and homes as the basis for comparing one woman to another and their families to other families. Hagood depicts hardworking and intelligent tenant farmers laboring to improve their lot against impossible odds, a view contrary, she said, to the opinion of "some academics," who see these people as having a high degree of "pathology" and a lack of "intelligence and vitality."[25] Lange had worked to counter similar stereotypes of migrant workers in California, many of whom were former tenant farmers. Indeed, some of Hagood's themes are those of *An American Exodus*, the book Lange and Paul Taylor had just completed.

Half of the tenant farm families studied by Hagood lived in the North Carolina Piedmont subregion, and it is likely that the Whitfields, whom she and Lange visited on July 3, were among them. In any case, Hagood's relationship with Mrs. Whitfield gave Lange the opportunity to spend an entire morning with that family, taking more than fifty photographs and creating a more in-depth portrait of these individuals and their home than she had ever before done in her work for the FSA. Mrs. Whitfield let Lange photograph inside the house as she prepared lunch and bathed the baby (figures 50–53). Several other women in North Carolina had invited Lange into their homes but had refused to let her photograph there, one saying, "Ain't cleaned up in ever so long—too big a mess," another that her kitchen had not been "cleaned up" because she "had gone to town that morning and been so tired she just sat on the porch when she returned" (figures 58, 63).

Almost all the farmers Lange photographed were tenant farmers or share-croppers, both "Negro" and "white." Tenant farm families rented use of the land for one or more years, planted what they chose, sold their crop, then paid the landlord cash or a share of the crop.[26] Sharecroppers, in contrast, planted crops chosen by the landlord, who usually advanced some cash for food and also furnished tools, seed, and fertilizer. (Some tenant farmers sublet part of their rented land to a sharecropper.) Landlords sold the sharecropper's crop and deducted half of the income for rent, plus an additional sum to recover cash advances and other expenses, with little or nothing left over for the share-cropper, who often ended the year in debt to the landlord. Tenant farmers did not fare much better: as one North Carolina farmer told Lange, he "did pretty well last year—that is, he came out just about even" (figure 60).

The Agricultural Adjustment Act (AAA) of 1933 provided funds to farmers to compensate them for cutting back production of certain crops, such as tobacco and cotton, a program intended to increase prices by reducing surpluses. But money paid to the farm owners rarely filtered down to their tenants and share-croppers. Owners were to share their federal funds, but many did not do so and instead used the AAA funds to purchase tractors and equipment that allowed them to farm the land with fewer workers. Thousands of tenants in many parts of the United States were "tractored out" in this way. Tenants were not trac-tored out in the North Carolina Piedmont, however, for tobacco required inten-sive work by hand. Still, they faced reduced circumstances when tobacco acre-age allotments were cut back, as determined for each county by a committee of local farm owners. As one sharecropper told Hagood, the allotments were made not to the tenants but to the landowners, who could take the required acreage reduction for his entire farm "wholly out of the tenants' acreage."[27] This prac-tice meant that in 1937 both this sharecropper and his brother, who were farm-ing together, cultivated less than one and a half acres each, not enough to sup-port a family.

Lange's work in North Carolina encompassed a landscape made up mainly of small farms, most tilled by tenants and sharecroppers, the relatively mod-est size of the farms a result of the original patterns of settlement in the North

Carolina Piedmont and the successive divisions of property among heirs. Although a few landowners held large estates of six hundred to twelve hundred acres, or more, with numerous tenant farmers, many others had only sixteen acres or so and a single tenant. The Whitfields farmed five acres and were their landlord's sole tenant; he owned one hundred acres, inherited from his father, whose twelve-hundred-acre property had been divided among eleven children. Mrs. Whitfield's mother had owned a small farm property, but it was sold at her death and the money divided among the heirs; Lange photographed the "Company bed room suite" the Whitfields bought with the inheritance (figure 50). Tenants and sharecroppers had no assurance that they could remain on the same farm from year to year. Of four sharecroppers who spoke to Lange about how long they had been on their current property only one had lived there for more than a year. "Renters don't take care of the land because it ain't theirs," said one tenant wife quoted by Hagood, "and they don't know when they'll be leaving; and landlords don't fix up the inside of the house because they don't have to live there and nobody sees it."[28]

None of the homes Lange visited had electricity or plumbing; some, such as Carolyn Atwater's, had a well (figure 70). The Whitfields' house—with two stories, a kitchen addition at the back, and a porch at the front—was relatively substantial (figure 49). Sharecropper Zollie Lyons's house was a "dog-run," a type with two rooms on either side of an open breezeway; Lange photographed the family there, "home from the field for dinner at noon time" (figure 55). Some houses, like those of the Lyonses and the Whitfields, had cladding of weatherboard or clapboard; others were built of chinked logs (figure 58). One Negro tenant family's "box type" dwelling was a "larger house than usual," with "seven rooms, unscreened, but well kept" (figure 63). Lange left out an important detail in her general caption about this family: they were tenant farmers but also landowners who rented their farm to a sharecropper because the soil was inferior to that of the farm where they lived as tenants.[29]

Hagood, Herring, and two other researchers wrote similar memoranda about many of the people and places Lange photographed. They prepared a separate page for each stop, with date, subject, location, map code, and the initials of the person who drafted the memorandum: MJH (Hagood), HLH (Herring), VHW, and WGB. (The last two sets of initials appeared only a few times and the identities are unknown.)[30] Lange would use these memoranda later as drafts for her general captions and captions for individual photographs, changing some radically, others barely at all; she cut, rearranged, added words, sentences, paragraphs, and submitted them to the FSA office under her own name. In this book, I have listed the other writers as coauthors. (The drafts by MJH, HLH, WGB, and VHW undoubtedly include some of Lange's own notes, since it was her normal practice to ask assistants to write down things she had seen and what she had heard people say.) I found no daybooks for Lange from the North Carolina work, but she must have taken notes; otherwise she could not have provided the details she did. "There were nine calendars on the wall," she added to Hagood's

description of the Whitfields' home; the mother's "dress came from J. C. Penney and cost 87¢," and she "was loathe" to take her shoes off.

Both Herring and Hagood observed people's responses to Lange, sometimes making notes about her exchanges with them and her methods: how she photographed "from top of car hood to get elevation," for example, and how she engaged in long conversation with various individuals, answering their "many questions about purpose of the pictures" or about "employment conditions" in California.[31] Lange deleted all these notes from her final draft of the general captions, including Hagood's account of how "the photographer ... wanted to buy" an "old-fashioned, checked apron" from a Mrs. Atwater (who had been born a slave "in the first year of the Civil War"). Mrs. Atwater's apron "was made for her by her daughter" and "she would not agree to sell it ... because she said the next time her daughter came she would say, 'Where's that apron I gave you?'" (figure 69).[32]

Lange was struck by some things neither Hagood nor Herring noted, such as the social role of country stores and gas stations: "small independent stations have become meeting places (community centers) and loafing spots for neighborhood farmers in their off times."[33] On a Sunday afternoon, her last day in North Carolina, Lange returned to the country store she had visited with Mr. Whitfield and his daughter and took a photograph, depicting four black men on the porch, the owner's white brother leaning against the doorjamb (figure 177).[34] In towns like Pittsboro, North Carolina, in July 1939, Lange also noticed the many references to the Civil War, from the brand of flour displayed in a shop window (Robert E. Lee flour) to the "ever present" monument to the Confederate States of America in the middle of Pittsboro's large open square, once the site of a slave market (figure 74).

AWS

[Dorothea Lange with WGB (identity unknown)]

DATE: July 7, 1939

LOCATION: Shoofly, Granville County

MAP CODE: Granville 9

SUBJECT: Putting in tobacco

This process is also known as "saving" tobacco; the word "priming" is also sometimes applied to the entire process, although strictly this term also describes the actual removal of leaves from the plant. The process is also known as "curing tobacco," although here again this term applies strictly only to one particular part of the process.

1. Priming: Beginning at the bottom of the plant, the leaves are stripped; usually two or three bottom leaves are removed at one priming. Only the ripe leaves are primed, and ripeness is determined by the color of the leaf. When ripe, the leaves are pale yellow in color, although they are often difficult to distinguish from the green leaves. Hence the job of priming is something of an art, which is left to the men of the family, or to those "women folks" who are skilled at it. In the field the men are priming for the second time, the "first primes," or sand leaves, having been removed.

2. "Sliding the Tobacco to the Barn": The primes are transported to the barns, where they will be tied or strung, in the "slide" (also called sled). Note construction of the slide-frame of wooden strips, on a pair of wooden runners. The body of the slide is made of Guano sacks, and the entire structure is [narrow] enough to run between the rows of tobacco without breaking the leaves. In this instance two slides are in use; while one load of tobacco is being strung, the other slide is sent to the field for another load.

3. Stringing the Tobacco: At the barn, the tobacco is strung on sticks by the women and children, and those men who are not required in the field. The sticks are of pine, four feet long. The string is fastened at one end, and the leaves of tobacco, in bunches of three or four, are strung on the stick alternately on each side. Note the notched "horses" for holding the sticks while stringing. When a stick is filled with tobacco, it is removed from the horse and piled in front of the barn, where it remains until put up in the barn. Sometimes shelters are provided to keep the sun from the tobacco after it is strung, since very hot sun will burn the tobacco. In this case two people are stringing, one of them an expert Negro boy, and two or three people are "handing the primes" to the stringers.

4. "Putting in the Tobacco": At noon, after the last slide of the morning has come from the field, the tobacco which has been strung, is hung from the barn. The barns are of four or five "rooms" (a room is the space between the tier poles; the Barn in the picture is a four room barn, and will hold about 600 sticks of tobacco).

40. July 6, 1939. Shoofly, Granville Co., N.C. Single tobacco flower. The tobacco plant is "topped" before it blooms in the field with the exception of a few plants which are saved out for seed.

41. Tobacco field, early morning, where white sharecropper and wage laborer are priming tobacco.

42. Mr. Taylor [or] wage laborer slides the tobacco to the barn from the field, about ¼ mile.

Two men go up on the tier poles, and the tobacco is handed up to them. One room is filled at a time. In the barn picture, several peoples' tobacco is being put in together; there are, in addition to the second primes mentioned, some first primes from another field. These are much inferior in quality to the second primes, and are covered with sand—hence the term "Sand leaves."

5. "Firing the Barns": When the barn is filled, the tobacco is allowed to hang for several hours, sometimes overnight, until the leaves are thoroughly wilted. Fires are then built in the furnaces, and the process of curing begins. The heat is kept at ninety degrees until the tobacco is "yellowed," then is gradually raised until all of the leaf except the stem is cured, when the final stage, "killing out," is reached. The heat is usually raised rapidly until it reaches 190 or 200 degrees. Curing takes about three days and three nights, although under certain circumstances it may take longer. After the tobacco is cured, it is allowed to hang in the curing barn until it "comes in order"—absorbs enough moisture so that it can be handled without breaking—when it is taken down and packed in the pack house. Here it remains until it is stripped out. It is usually taken up and repacked once, so that it will not become excessively moist and mould.

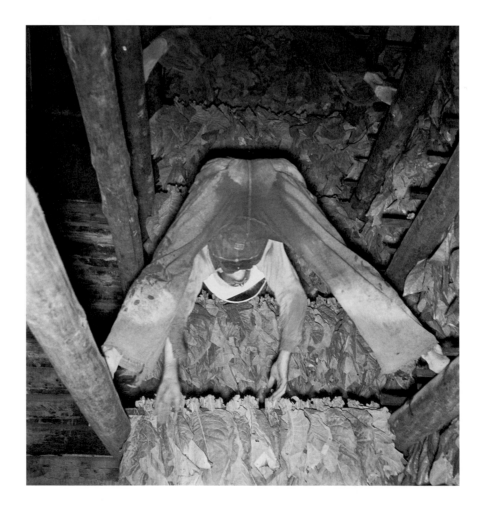

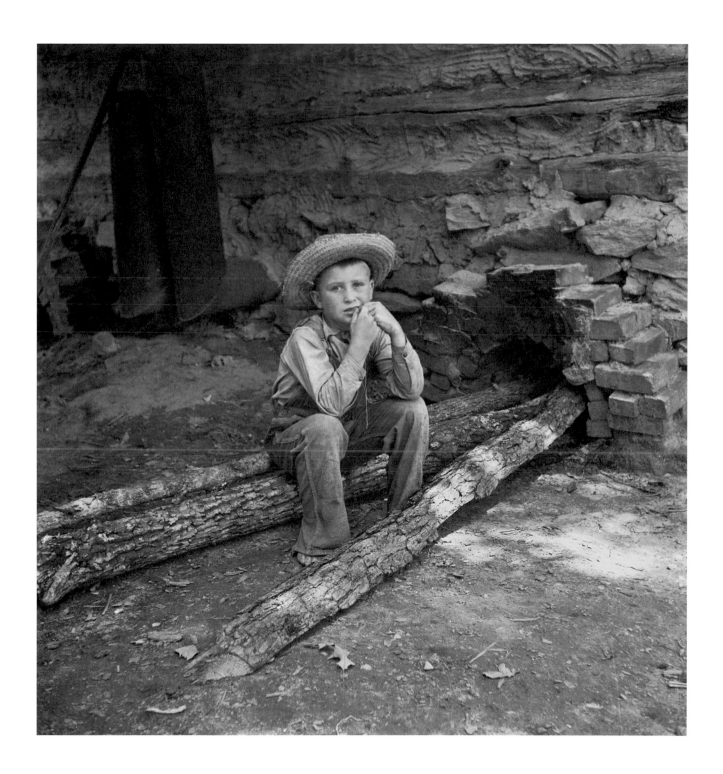

43. Sam's son handing up strung tobacco
inside the barn.

44. Ten year old son of tobacco tenant can
do a "hand's work" at tobacco harvest time.

[Dorothea Lange with Margaret Jarman Hagood]
DATE: July 7, 1939
LOCATION: Shoofly, Granville County
MAP CODE: Granville 9
SUBJECT: "Putting in" tobacco

General Notes: The tobacco is put in the barns from three fields: one, Mr. Taylor's farm, where photographs were made of topping, priming, and hauling the tobacco to the barns; two, Mr. Oakley (the tenant field); three, Sam, Negro, also a share cropper and sub-tenant of Mr. Oakley, who brought his tobacco to the barn in a wagon, having already strung it.

Each of the three families supply workers and children to play around. Of Taylor's family there are himself, his wife, young mother and baby, and his mother-in-law. Of Oakley's family there are himself, one-legged, his wife, a ten year old son, an eight year old daughter who kept care of Taylor's baby and two other younger children. Of the Negro family, there are Sam, a nearly grown son, a twelve year old son, and two or three younger children. This made sixteen of the families involved at the barns at one time or another in addition to two wage hands. There were eleven people working on one or another phase of "putting in" tobacco.

The children played all around the barns, often very near the mules. They played with pieces of tobacco twine—there are pictures of children with tobacco twine in their mouths. The three year old white girl at intervals slapped and switched the little Negro girl about her age and once called her a damn fool; but between these outbursts the children played together peaceably when those at the barn had finished one sled and were waiting for another to come to the field, the mother nursed her baby, the women rested, talked, and laughed.

The barn next to the one being filled was already fired. They were going to begin "killing out" the tobacco that afternoon. Pictures were taken of this barn, the fire burning, the door open showing a man coming out and saying, "152" (referring to the temperature).

During the morning a stranger arrived in a 1915 model T Ford riding with his legs on the outside. He made a dramatic entrance, stopped his car, and asked, "Does the road stop here?" He was looking for scrap iron to buy. They had none: They talked of him and made jokes about his car for quite a while after he left.

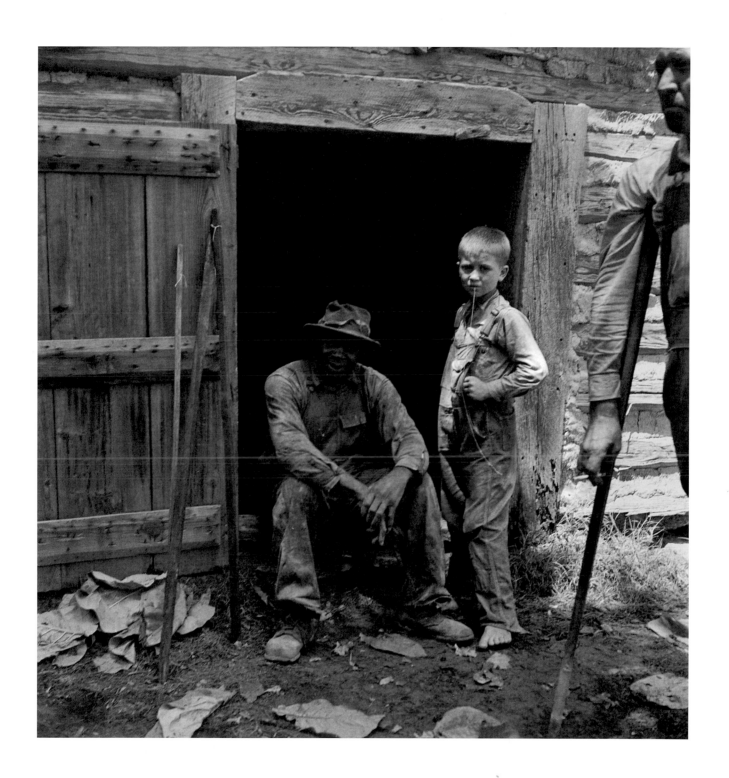

45. Tobacco people take it easy after their
morning's work "putting up" tobacco.

GENERAL CAPTION NO. 20

[Dorothea Lange with unidentified coauthor]

DATE: July 3, 1939

LOCATION: Highway 144, 7 miles S.W. of Roxboro, Person County

MAP CODE: Person 6

SUBJECT: Tobacco—tobacco barns and farm boy

Notes: Farm boy is son of owner. His father has 100 acres here and lives in a nearby house. There is a "tent" screened, back of the first barn (not visible), where the father sleeps when he is curing tobacco.

Note sign on first barn, "It pays to sell your tobacco in Roxboro." The competition between tobacco markets is very keen in this region. Note wood stacked on both sides of barn and the sticks in front of one barn, on which tobacco will be strung. Both barns are "four-room barns," which means that four sections, each the width of tobacco sticks, are inside. Tier poles divide the sections.

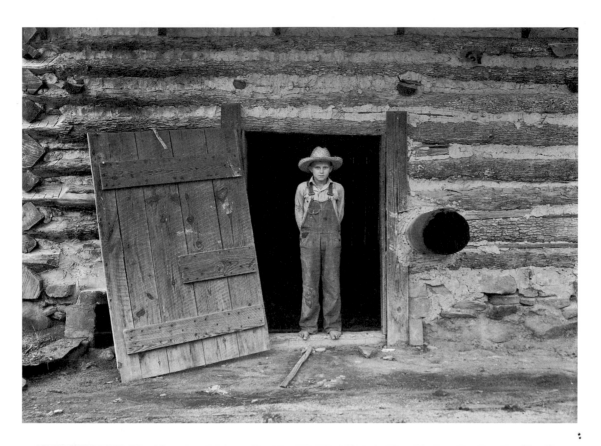

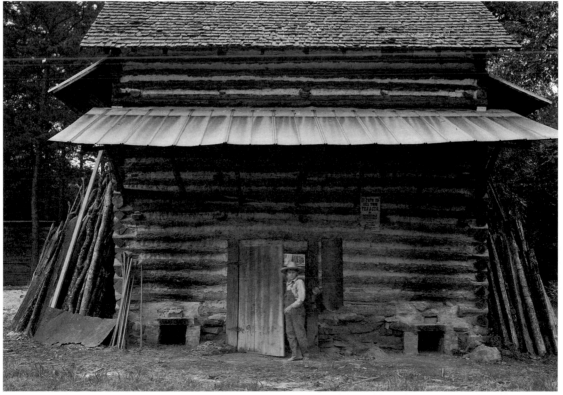

46. North Carolina farm boy in doorway
of tobacco barn.

47. Tobacco barn. ready for "putting in."

[Dorothea Lange with Margaret Jarman Hagood]

DATE: July 1, 1939

LOCATION: Highway 55, 13 miles from Chapel Hill. Chatham County

MAP CODE: Chatham 1

SUBJECT: Wilson, owner, operator, owns 200 plus acres on this place and 400 plus acres in "the other" place, has seven tenant families and raises 65 acres of tobacco. He is here building plank tobacco barn to replace old log one, piles of wood for curing.

Building a tobacco barn—building takes approximately one week. This barn is being built to replace the old log one on left, which is 50 years old and "going down." The average of the life of a barn is 15–20 years, but this old one was built well and Wilson has kept a good roof on it. He believes in good roofs (all the buildings on his farm have good, tin roofs except an old corn crib not in use now).

The new barn is of plank, it has double plank walls, storm sheeting between the two layers, and will hold better than a log barn. Wilson can build a barn like this for $100. Wilson is the stout white man on the ground, directing the building, handling planks and sheets of tin to his workmen on the roof. When ready to begin putting on the tin he asked the young Negro if he could catch a sack of nails; the Negro said, "Yessir, if I couldn't catch that I wouldn't be on the baseball team." This led to the explanation that there are local baseball teams, both Negro and white, which have ball games every Saturday afternoon. Wilson lets his hands off every Saturday afternoon. Wilson says the worms are worse this year than he's ever seen them and he has been farming 27 years—of course he's been working on a farm ever since he was just "that high," but he married 27 years ago and started farming on his own.

48. Building a tobacco barn.

GENERAL CAPTION NO. 22

[Dorothea Lange with Margaret Jarman Hagood]

DATE: July 3, 1939

LOCATION: 4-Tenths of a mile S.W. of Gordonton, Person County

MAP CODE: Person 3

SUBJECT: White share-cropper family; FSA Rural Rehabilitation clients, their home, farm, and work between 9 and 11:30 a.m. on this particular day.[35]

Notes

Family composition: Father, born September 1899 on day that [Admiral George] Dewey had triumphal parade in New York after beating the Spaniards [in the Spanish-American War] and hence named Charles Dewey Whitfield; Mother 33 years old, married at 21; Dorothy Lee, 9; Millard, 6; Katie Collen, 3; Isabel, 6 months.

Family history: Mother and father both from farming families in Person County; have both always lived on farms; both have brothers and sisters in this section of the county. When they married their families gave them some of the furniture they now have. They have always been sharecroppers. They usually pay all their debts but they did not in 1929 when a hail storm ruined all their tobacco, and again in '32 and '33, the bad years. Last year their cash income from tobacco was $236.00, but they hope for more this year. They do not owe any money except for the doctor and hospital. The last two babies were brought by Caesarian operations and the hospital bill for the last one was about $125.00. The doctor hasn't sent his statement—he said he would wait until they paid the hospital. Mrs. Whitfield's mother died last year and they sold her small farm and divided up the money. The Whitfields bought their "Company bed room suite" with their share: a glaring, Grand Rapids, highly polished imitation walnut bed, dresser, and dressing table.[36]

Farm: This is their first year on Mr. Bain's place and their second year of borrowing money for fertilizer and running expenses from the Farm Security Administration. This year they borrowed $190.00 and with it paid their half of the fertilizer, bought a cow, and will run themselves until they sell their tobacco. Mr. Whitfield likes Farm Security very much and has no complaint at all to make of it. He hopes some day to buy a place with their help. He's heard that they are going to finance six tenants to buy places each year in this county. He thinks he can get a tenant purchase loan because he has known the man who is the Farm Security agent for Person County all his life.

Old man Bain (the landowner) had about 1,200 acres and when he died 6 years ago this was divided among 11 children. Each one got about enough for himself and one tenant. Mr. Whitfield's landlord owns about 100 acres and Whitfield is the only tenant. Whitfield has about five acres of tobacco.

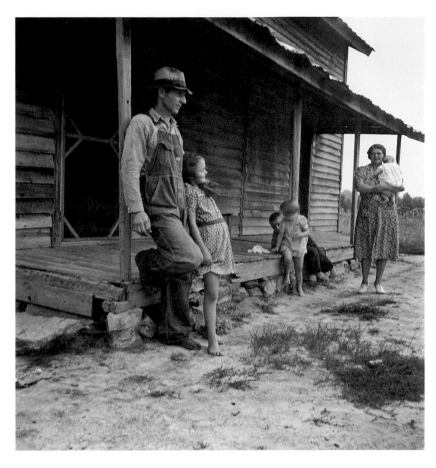

49. White share-cropper and
his family.

50. Corner of tobacco farmer's front
room. Shows enclosed stairway and
corner of the new fancy bed.

51. Corner of the Whitfield kitchen. (The interior was very dark and negative was made in natural light to try to give actual feeling of the interior.)

52. Wife of tobacco sharecropper bathes the baby in the kitchen.

53. The littlest girl comes in from outside for something to eat while Mrs. Whitfield is doing up her work. The child next to the baby is called the "knee baby." Note oil lamp and water bucket.

Notes on Subjects of Photographs

House: 1 and ½ story weatherboard house; only three downstairs rooms are used. The whole family sleep in two double beds in one room. The house is of sturdy construction [except] that one of the main sills has given away and the floor sags. The corner, enclosed, stairway to the half story above is very frequently found in this section, often with the cupboard underneath in the better houses. The "cook stove" was bought when the couple was married. There were nine calendars on the wall.

Family Group: Father and mother were both very anxious to have a picture of the baby; they have had pictures taken of the other children but have not the money to have one taken of this one. The mother was barefooted when we arrived but put on her white shoes for the picture and was loath to take them off. Her dress came from J.C. Penney and cost 87¢.

Tobacco Patch: Mr. Whitfield is topping and at the same time worming. The children are looking for worms. The three and a half year old girl (called knee-baby) found two. Her father says she is learning but she is a little too rough with the tobacco leaves sometimes and bruises them. The children like to go to the field with their father. When the mother goes the oldest girl has to stay at home with the baby. The mother has helped in the fields "right smart" this year because Mr. Whitfield has been "falling off." She thinks it is because he is so worried over paying the doctor and hospital bill.

Mother's Work: The mother is barefooted in the picture which shows her churning and is standing so that her feet will not show. When she left the churn she covered it with the cloth to protect it from the flies. When she showed us how she churned she churned with one hand and waved the other to keep the flies away. She scalded all the milk utensils after washing them carefully so they would not sour. She was brought up, she said, to follow her daddy around and likes field work better than cooking and housekeeping.

Incidental Notes

The children explained how they "claim" the pigs, chickens and feed the animals they claim. The mother was proud of her oldest daughter who has done well at school, and "has made A grade both years she's been going to school." They visited the mother's sister yesterday and she gave them dresses for the oldest girl— hand-me-downs from her own daughter.

The mother invited us to dinner very cordially with apologies that she was only going to have tomatoes, snaps, and bread she cooked at breakfast time. Both mother and father said they were glad to oblige.

54. Tobacco sharecropper and the littlest girl
work in the field together. He "tops" and she
looks for worms.

[Dorothea Lange with Margaret Jarman Hagood]
DATE: June 30, 1939
LOCATION: 6/10 of a mile east of Upchurch, Wake County
MAP CODE: Wake 1
SUBJECT: Tobacco—tobacco barns, worming tobacco, Negro sharecropper and family, Negro sharecropper's house

General Notes: Stone, landlord, has 15 mules and 12 tenant families on contiguous and non-contiguous holdings extending nearly 25 miles, as far south as Duncan, N.C. On most of his farms tobacco is the only cash crop; on one or two farms near Duncan he raises a little cotton. He sells no farm products except tobacco and cotton; he keeps for farm use all his corn and other grain.

Notes on Lyons (Negro sharecropper). Lyons was brought up near Creedmore and has farmed in Granville (adjacent county) all his life until last year when he moved here (January 1938). He made more money here in 1938 than he ever had in any single year in Granville. He likes the land, his house—which he says is "a No. 1 house"—and his landlord. His landlord has plenty of money and furnishes him whatever cash he needs so that he doesn't even have to run a store account. He says these folks (Stones) want their tenants to make money and they treat them nice.

Lyons has 13 acres of tobacco (the field pictures) and has a labor force of five with supplementary help from another child who usually stays in the house. Last year his family worked "through and through" with another tenant family on the place while they were housing their tobacco. Combined, they had a labor force of 12 and could get in a barn of tobacco by 4 o'clock in the "evening," or even by 1 o'clock on Saturday when the boys wanted to get through so they could go to town. This year his family will house alone but he hopes they can still get in a barn a day. He estimates that it takes two hours of labor to produce every pound of tobacco marketed.

Notes on Subjects of Photographs

Barns: The group of barns showed that the holdings are fairly large. The barn being used for curing has been fired for three days and they are now "killing out the tobacco." This is the first barn of tobacco to be cured on the farm this season. Items visible are the sled, which hauls tobacco from the field, the platform on which the farmer sleeps while he is keeping the fire going at night, wood stacked up to be used for curing, saw horses used in connection with repairing the sleds. Tobacco field—13 acres is a large field of tobacco for this area. The girl and the boy are worming tobacco. The worms are very bad this year. The tobacco is nearly ready for priming.

House and family: A modified "dog-run" type of house [two rooms connected by a breezeway]. Note swept bare yard, brush brooms. Composite family of couple, children, and grandchildren. One grandchild (little boy) lived with grandparents; little girl is just visiting.

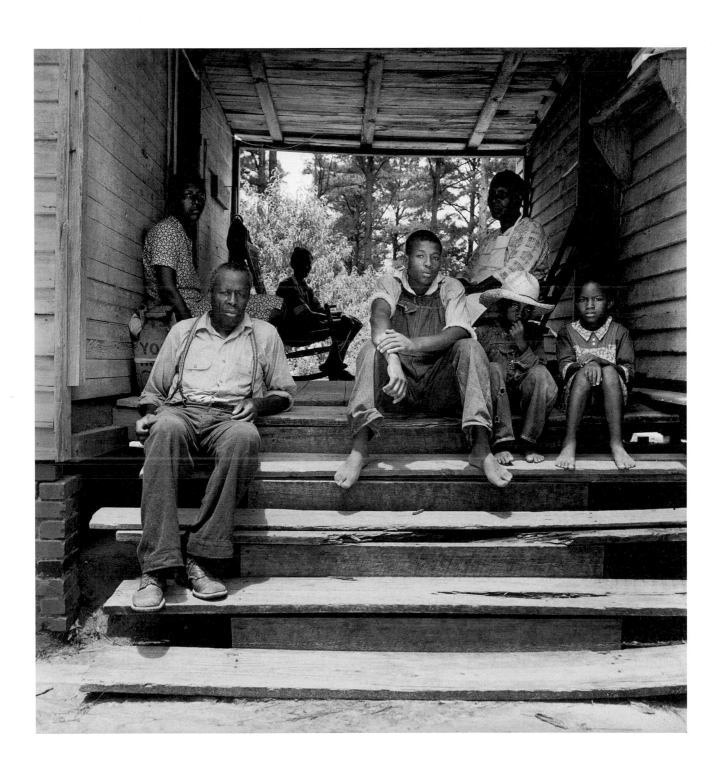

55. Zollie Lyon, Negro sharecropper, home
from the field for dinner at noon time, with
his wife and part of his family. Note dog-run.

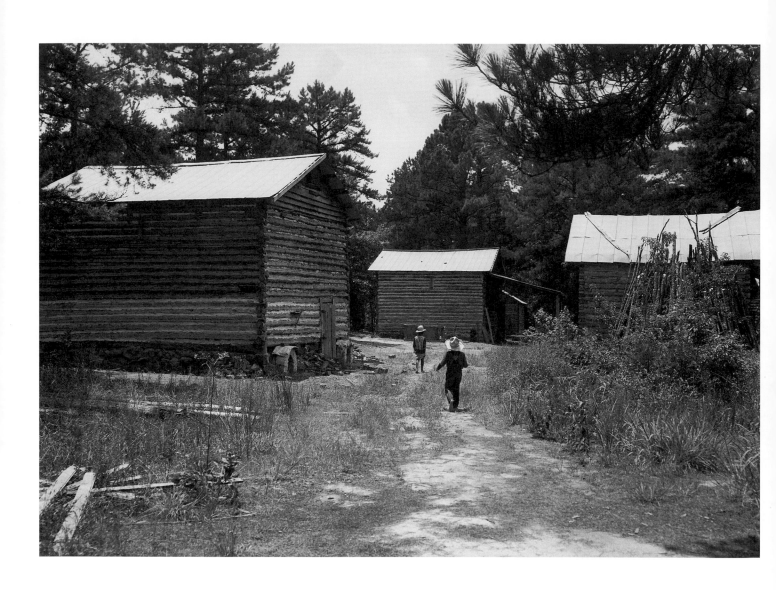

56. Tobacco barns on the Stone place.

GENERAL CAPTION NO. 19
[Dorothea Lange with Harriet L. Herring]
DATE: July 5, 1939
LOCATION: Route 501, Person County
MAP CODE: Person 18
SUBJECT: Hill side farm, facing road, showing owner's house and outbuildings and tobacco field. Share cropper's farm on other side of small hill.

Notes

Owner's house: general view of hillside farm opposite Tucks Service Station, shows home, outbuildings, and tobacco field beyond. The fields show erosion. The owner usually makes, according to the man at the filling station, about 600 pounds to the acre which is a small yield for Person County. Better yields run from 900 to 1,200 pounds.

Other side of hill: this side has been terraced—the sharecropper said before the government erosion work began, not tended now. In background is a sweet potato patch with a Negro man chopping. Could hear the sound of the hoe on the small rocks in the soil. Up the hill is the log and frame house the family live in. Steep rocky drive up hill from highway to owner's house and passed it along a single track to Negro house in background.

Negro sharecropper's house: shows different aspects of house, chimney, lean-to with kitchen stovepipe, stuffed through side of wall and capped off with joint of tobacco flue to keep smoke from blowing back into house, flower garden in front protected by a slender fence of laths, young Negro couple and baby. Note guano sacks washed and drying on a line in back. The man was shy of having his photograph made but finally held the baby in front of the house for one picture. They have just moved here this year—"They treat us better here than where we did live"; did not know how many acres he had, tobacco, corn, a potato patch, "and such." He said they did not measure up the land this year—everybody did last year when they were cut down in acreage, but this year everybody planted all they wanted to. The woman had been through seventh grade, the husband not much education. She would not let us take photographs of interior—"Ain't cleaned up in ever so long—too big a mess." No privy in sight, had to get water from "the spring" so far away that the man was gone about 20 minutes to get a bucket of water. Note disc harrow standing rusted in the field. House in background of this photograph is the pack house with log "ordering house" adjoining it.

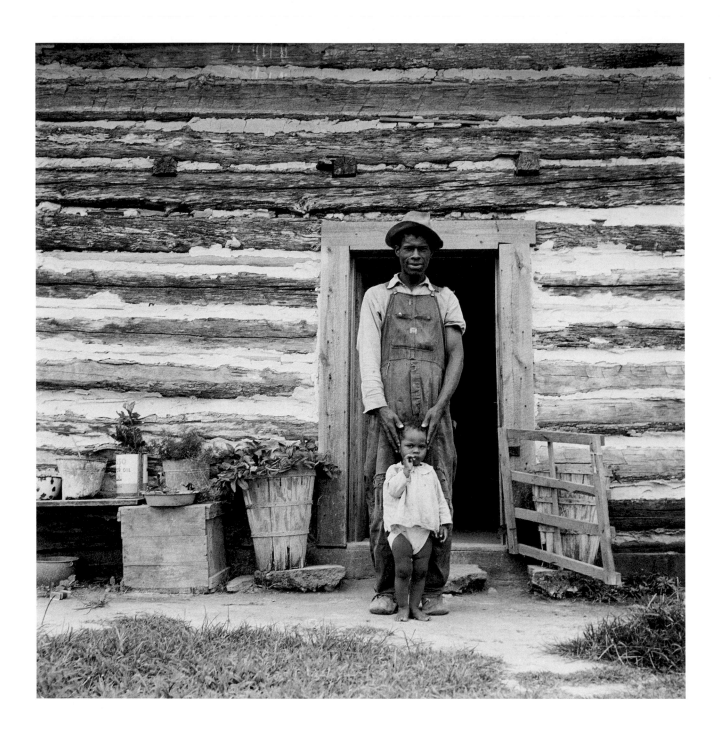

57. Young sharecropper and his first child.

58. Negro sharecropper's house.

59. Route 501 opposite Tuck's Filling Station.
General view of a hillside farm which
faces the road, showing owner's house, out-
buildings, and tobacco field. The fields show
erosion. The Negro sharecropper's farm is on
the other side of this same hill.

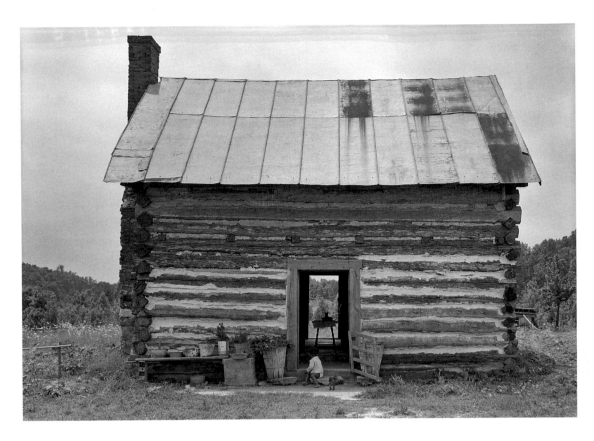

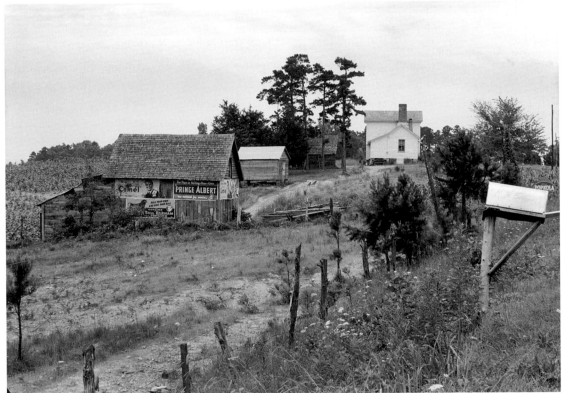

[Dorothea Lange with VHW (identity unknown)]
DATE: July 1, 1939
LOCATION: Chatham County US 15, about two miles south of Orange County Line
SUBJECT: Colored tenant

Three Negroes were sitting in the shade of a storage shed, once an old store but abandoned for the last twenty five years. Two were tenant farmers, neighbors, the status of the third (seated) unknown. One of these tenants had grown up in this section of Chatham County, had moved away to another adjoining county several years before, and had been returned some three years ago. He had a small patch of cotton and a moderate acreage in tobacco, mostly across the highway. He did pretty well last year—that is, he came out just about even. He didn't know how he would do this year; the worms were bad in the tobacco, but there was a pretty good crop. That meant prices were going to be low. They were all going to take their tobacco south or east to sell. If they waited until the markets were open close around, the companies would have bought up already and the price they would get would be mighty low. Last year they took it to Wendell (Wake County) and did pretty well with it. Which was better to raise, cotton or tobacco? Tobacco; there wasn't much in cotton; people didn't use it the way they used to, but cotton dresses were coming back. Beside, the cotton farmer is just like the tobacco worm, they eat up all they can and move on to the next place. How did the tobacco grow around here? Fair enough. He could get about 700, 800 lbs. to the acre. Down in the valley two or three miles away those people got 1,100–1,200. Why didn't he move down there? Already too many people down there. Besides when you are born in the hills, you're just born in the hills, and you want to stay there. Was there much moving? No, not now, used to be, time of the war, lots of the folks went up North, but they didn't any more. Had any of those who left come back? No, they hadn't. Would any of these three like to go North to live? No, indeed; they thought it was a pretty good place they were in, don't have to buy much groceries, only salt, sugar, baking soda, coffee. They didn't have much money, but they were getting along and they didn't have to worry about anything being stolen. There wasn't anything to steal.

Quotation on Allotment—no allotment this year on tobacco: "You plant all you want to and you get what you can." Thinks it's better to have the allotment "if they fix it up right."

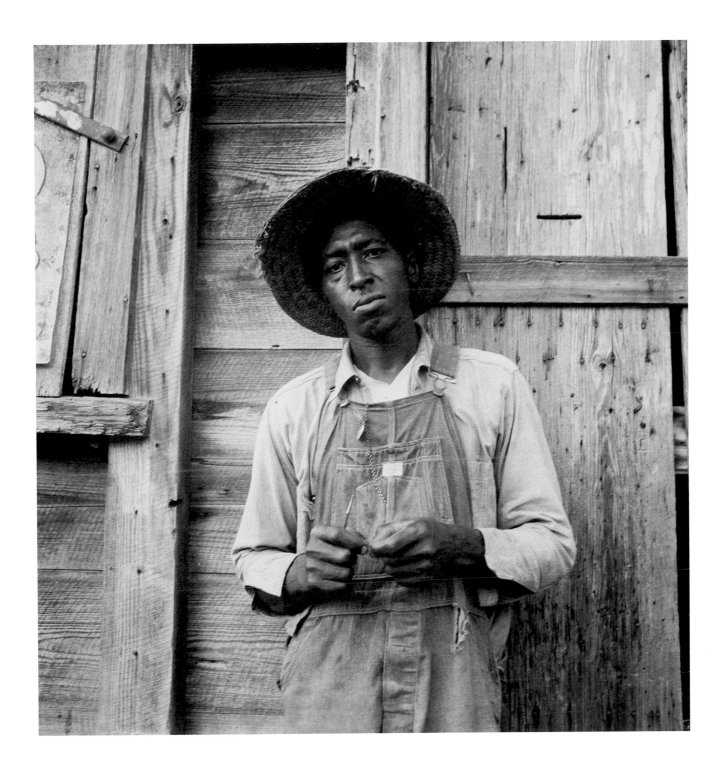

60. Colored tenant.

GENERAL CAPTION NO. 4

[Dorothea Lange with Margaret Jarman Hagood]

DATE: July 8, 1939

LOCATION: Highway 64, about 1.5 miles west of Pittsboro, Chatham County

MAP CODE: Chatham 6

General Notes: Cotton and corn are the main crops of this farm. The family have two cows, one pig, a garden, a radio, and an automobile. The owner furnishes the seed and fertilizer.

Photographs show farm house and farm landscape of Negro, tenant cotton farmer; Negro family. The house: a seven room box house, unscreened, but neatly kept. It was very cool inside on a hot summer midday. The family were sitting on the porch resting on a Saturday afternoon.

Family: the mother has had eleven children, three of whom are dead. Her youngest child is seven; six children are at home but none of them go to school. Several of them are shown on the porch and on the mules. The mother doesn't like to go to church since she can't see well, but enjoys listening to a service on the radio. The oldest boy drives the automobile—the father has never driven it.

Incidental notes: The mother let us see the interior of her house but did not want pictures made of her kitchen because it wasn't cleaned up. She had gone to town that morning and been so tired she just sat on the porch when she returned. "I aint much of a hand at going to town; I'd rather go on Monday or Tuesday when they aint so many people around."

61. Negro tenant farmer reads his paper on a hot Saturday afternoon. Note vegetable garden across footpath.

62. The older boys go off visiting on Saturday afternoon.

63. *(Facing)* House of Negro tenant family seen close up. This is a larger house than usual, box type, has seven rooms, unscreened but well kept. Part of the family sit on the porch resting on Saturday afternoon.

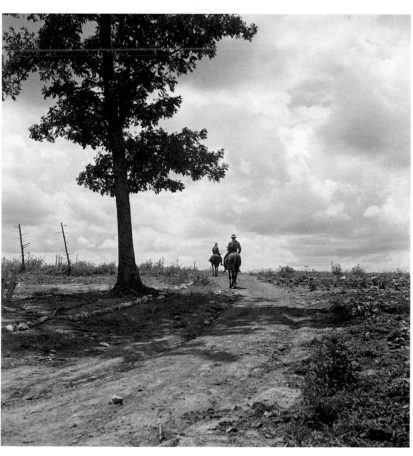

[Dorothea Lange with Margaret Jarman Hagood]
DATE: July 6, 1939
LOCATION: Near Wilton, Granville County
MAP CODE: Granville 4
SUBJECT: Negro tenant house, and noon-time chores

Photographs were made in rain. Family consists of mother, father, seven children, and several adopted children. Mother—one of the grandchildren lives with her whose father is in the penitentiary for ten years because a Negro child was killed in an automobile accident he had with a white man. They went to court but the white man (whose fault it was according to the mother) went free, while her son got ten years. "There's no justice; you have to wait on the lord for justice; the Lord has the power." Her son was a good boy—"He is a bible student right." The mother goes to the white folks' church and sits in the front row. She wouldn't go if she had to sit in the balcony. She has lived right around here all her life. "Everybody knows me and I'm respected." "All the white folks think a heap of me. Mr. Blank wouldn't think about killing hogs unless I was there to help. You ought to see me killing hogs at Mr. Blank's!"

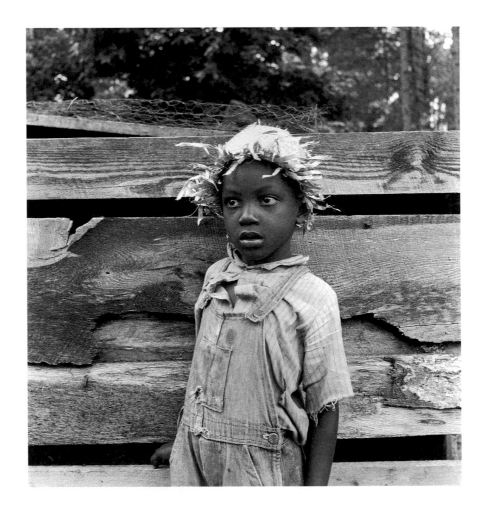

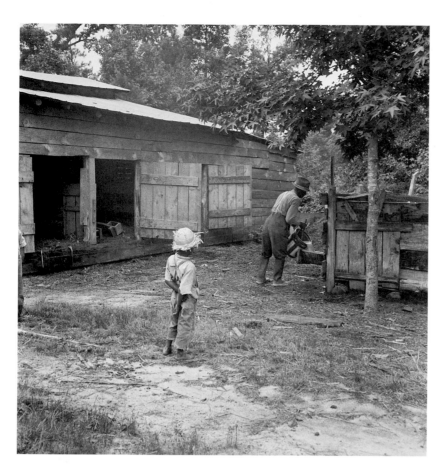

64. Grandson of Negro tenant whose father is in the penitentiary.

65. Feeding the little pigs at noon time.

66. Noon time chores. Note side view of house and the kitchen door.

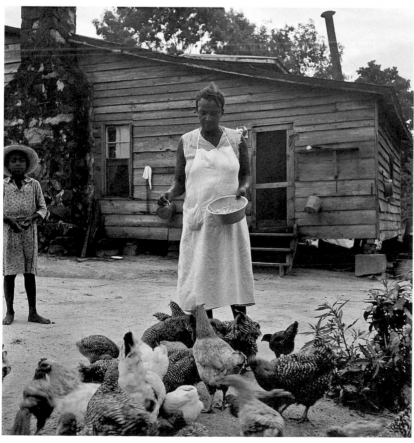

67. Some of tobacco sharecropper's children
on the porch at home.

68. Tobacco sharecropper's child playing.
Note burlap covered play house.

GENERAL CAPTION NO. 9
[Dorothea Lange]
DATE: July 4, 1939
LOCATION: On Road from Highway 144 to Hesters Store Person County
MAP CODE: Person 11

This group of photographs represents some of the elements in the Person County landscape surrounding a small tobacco farm and some aspects of the life of these Negro operators as revealed in a brief visit on Fourth of July afternoon. These photographs were made in the rain. They show the house, farm landscape with pasture, tobacco, and woods from the public road; house and yard; tobacco and tobacco barn; chicken house and pig lot; and part of this family.

69. Colored owner's home.

GENERAL CAPTION NO. 15

[Dorothea Lange with Margaret Jarman Hagood]

DATE: July 1, 1939

LOCATION: 6/10 of a mile east of Blackwood Station, Orange County

MAP CODE: Orange 1

SUBJECT: Negro small owner—house, yard, and wife

General Notes: Ernest and Caroline Atwater bought the house and one acre of land 30 years ago. Atwater had been working on the railroad and saved up the money. The house has never been mortgaged except once when they [had] to borrow on it to buy a mule. A few years later they bought two more acres. They now raise no cash crop on their three acres, only potatoes, corn, peas, etc. They have "what you call a plug mule."[37] They sell a little produce and sometimes canned berries. No children live with them now and their children do not send them any money although they often send clothes and presents.

House: a double cabin, one and a half story, log house. The cabin on the right was built about 75 years ago and 200 yards away in the field when the Atwaters bought their place. They moved it to the present location, partly rechinked it with mud, and built the other cabin 30 years ago. The shingles are "boards" and the top ones on the roof of the right cabin are the original ones. The lower boards have been pushed in as is visible. "It kivered with boards, if you can say its kivered at all." Yard—shows the care contrasting owners' from tenants' yards. Caroline Atwater—says she was born the first year of the Civil War and remembers waiting on the "mistis." Immediately told that her mother belonged to the Whitfields and her father to the Bains of Person county. Has been married twice. Did not know exactly how many children she has had, but has four living and three or four dead. Her name is on the mail box rather than her husband's because he can not read or write. She went to a "subscription" school and learned. While in the kitchen door being photographed she was telling of their church and of how she sells a little here and there to get some money, of how the stores nowadays won't let you run accounts, "except maybe until the next sad'dy."

70. Caroline Atwater tells about her church.

GENERAL CAPTION NO. 21
[Dorothea Lange with Margaret Jarman Hagood]
DATE: July 9, 1939
LOCATION: About 9 miles north of Chapel Hill, on Highway 14
SUBJECT: Log house and white rural non-farm family

Notes

House: this is an example of a basic type of house: 1 main room, log, with a half story above it and a shed kitchen behind. The original oak board shingles are on the roof and the house is over 50 years old. It is owned by the aunt of the woman who lives in it.

Family: This mother had four children in three years; the oldest girl is seven, there are twin boys of six and the baby is five. The father works in a chair factory in Hillsboro; he has not worked for a month because he has been crippled with rheumatism. The family have always lived in the country.

The farm was once used to raise tobacco but none of it is cultivated now.

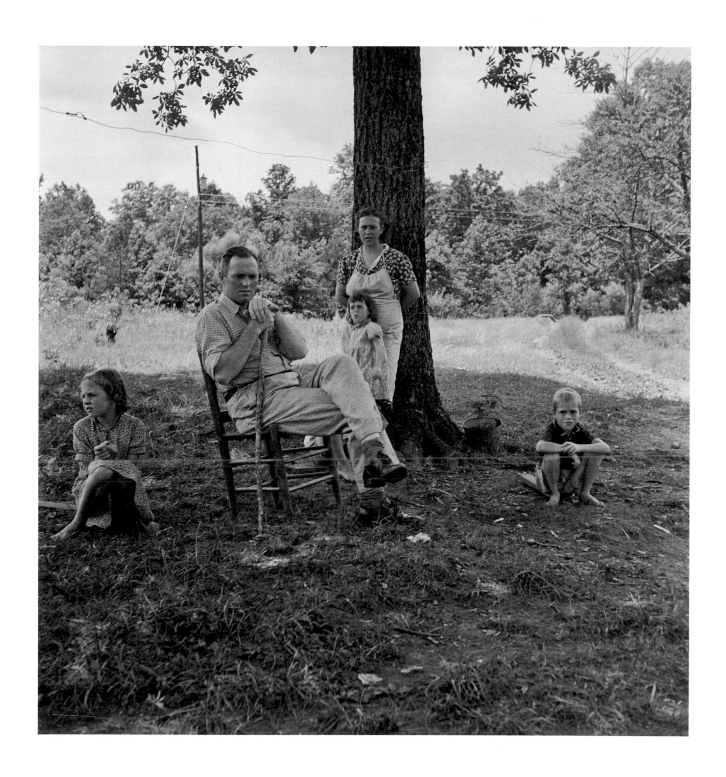

71. Sick father and family.

GENERAL CAPTION NO. 5

[Dorothea Lange with unidentified coauthor]

DATE: July 7, 1939 [July 8, 1939]

LOCATION: Pittsboro, Chatham

SUBJECT: Main Street of Pittsboro on a Saturday afternoon

Pittsboro, County Seat of Chatham County, is one of the older towns of this section of the State. It was chartered in 1785. At the present time it is an agricultural village with a population of 675 according to the 1930 census. It is a trading center for a limited area. Pittsboro is served by a branch of the seaboard airline railway from Moncure. It has a third class post office and a bank. The principal industry is a woven-label mill, which employs over a hundred persons.

Photographs show Saturday afternoon crowds on the street. While the population of the county is roughly only about one-third Negro, a disproportionate number of Negroes will be found to congregate in the town on a Saturday afternoon. Most of these are farmers, chiefly tenants or day laborers, and their families who come into town to make a few purchases and talk.

The court house is located just beyond the principal shopping district and lies straight ahead entering town on US 15 from the North. The court house stands on the site of an old slave market. The present structure was completed as it now stands in 1881 after the roof had been blown from its predecessor in a violent storm.

A man in the new town of the county (Silar City) said of Pittsboro: "They say if Cornwallis was to come back, he'd still recognize Pittsboro."

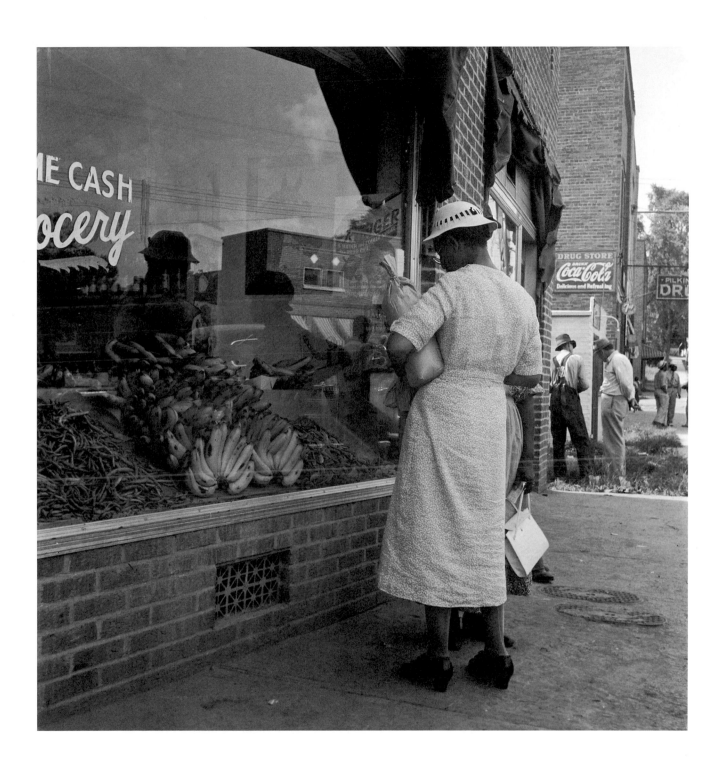

72. Shopping and "visiting" in town on
Saturday afternoon in summer.

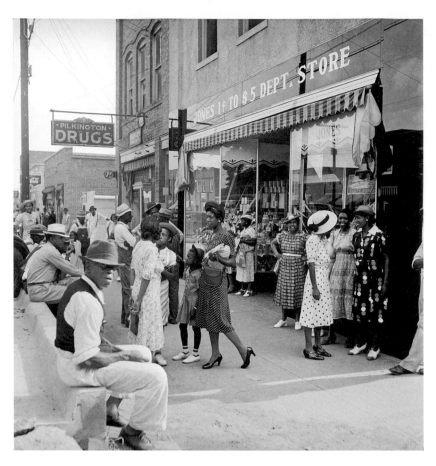

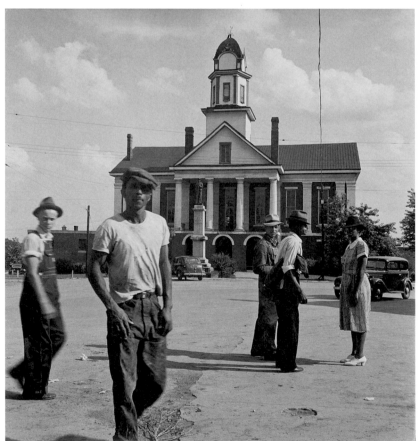

73. Shopping and "visiting" in town on Saturday afternoon in summer.

74. Note ever present CSA [Confederate States of America] monument.

[Dorothea Lange with Harriet L. Herring]

DATE: July 5, 1939

LOCATION: 1 and 1-tenth miles S.E. of Gordonton, Person County

MAP CODE: Person 21

SUBJECT: Annual cleaning-up day at Wheeley's Church

Notes

Accidentally learned at Gordonton that "everybody in the community was gathering at the church, going to take their dinner." Was not able to get back in time to see the dinner in progress and most of the cleaning done. Farm women of all ages, men and children; one six-months old baby and one woman on two crutches were still there finishing up the cleaning at about 2:30. There were fifteen cars; "a good many people" left before dinner. Had to talk to a succession of people: had to ask some of the others: had to ask the older members: had to talk to the head deacon to get permission to photograph. They very much want to have a print showing the church and the grounds. Very proud of their church, spacious well shaded church yard, well kept (though very simple) cemetery, and very proud of the fact that they keep everything so tidy. They had done a thorough job of sweeping the yard close to the door and raking the rest, about five acres. The church is primitive Baptist—"don't know whether you ever heard of that kind or not," and is "over a hundred years old" but no one seemed to know exactly.[38] It has 70 members and "lots of friends around who help out." Preaching once a month and the church is crowded. Will probably hold 500. Cleaning the church consisted of sweeping, dusting, washing the windows; "we think we ought to keep [it] as nice as we do our homes." The church is sealed, painted white inside, is heated by a small coal circular with a pipe suspended from the ceiling nearly two-thirds of its length; "that keeps the back of the church warm." A table in the space before the pulpit had a large cover of coarse crocheting and a tight little nosegay of flowers. No pictures taken inside the church because of hesitation of church members.

The people are substantial, well-fed looking, the women in clean prints, mostly ready made, the men in clean shirts and trousers, some overalls. Good looking children. Many addressed each other as cousin or aunt, etc. Very gay and folksy—evidently have a good time together. Cars new or relatively so and not all Fords. A group of solid country people who live generously and well. Much interested in the photographing, much joking about posing.

Group on church steps: Note rakes, yard brooms made of dogwood, homemade, buckets with dippers. Note woman wearing bonnet, front and side view. Note homemade gloves. This woman was called "Queen."

July 9 is "preachin' Sunday" and got permission from deacon to return to make pictures of the congregation.

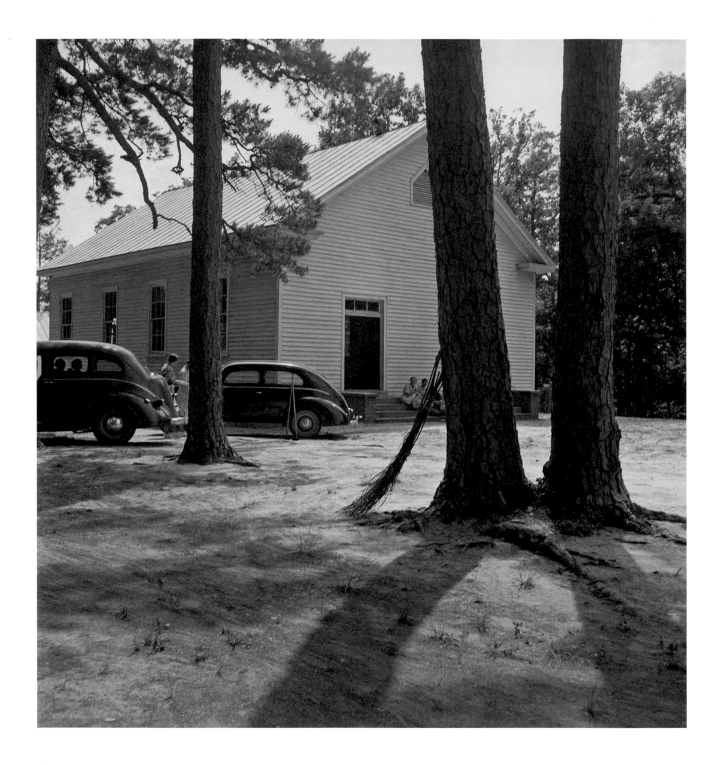

75. Church yard on annual cleaning-up day.

76. Member of congregation of Wheeley's Church called "Queen." She wears the native old fashioned type of sunbonnet. Her dress and apron were made at home. See 19919C for side view of bonnet and homemade gloves. Contrast with Texas type sunbonnet.

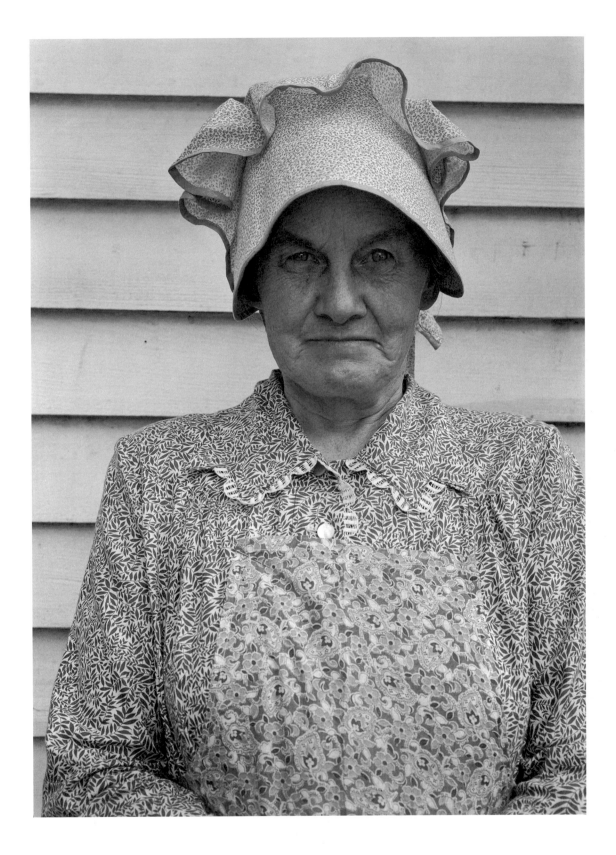

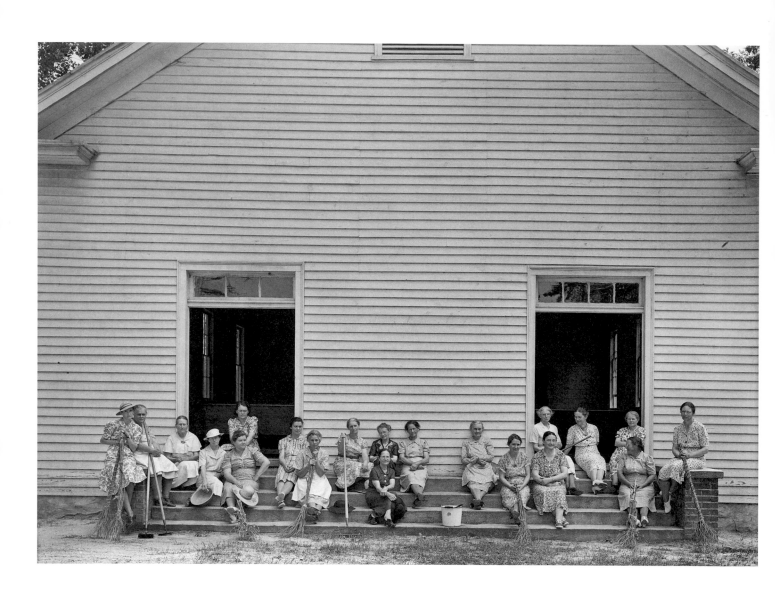

77. Women of the congregation on the
church steps with brooms and buckets. They
have assembled to be photographed.

GENERAL CAPTION NO. 24
[Dorothea Lange with Margaret Jarman Hagood]
DATE: July 9, 1939
LOCATION: 1 and 1-tenth miles S.E. of Gordonton, Person County
MAP CODE: Person 21
SUBJECT: A country church on "meeting Sunday"

Notes
See July 5, 1939, general caption No. 23 for general information about the church and its membership.

Wheeley's church is a primitive Baptist Church and, therefore, has no Sunday school or musical instruments. They have meetings once a month—"every second Sunday."

People questioned said that most of the congregation were farmers who lived within a five or six mile radius, although some of the ex-farm people who now live and work in mill towns come back to church.

Meeting began with the singing of "Amazing Grace, How Sweet the Sound."

The "Pastor" (so introduced to us) began his sermon rather calmly, worked up to a climax through increasing use of rhythmical phrasing and periodical increases in volume. The effect was very similar to the sound of a tobacco auctioneer. At the height of the climax, the phrases were not very connected, although the general theme was a plea to Church members to let the Holy Ghost into their lives. The following is an approximate quotation:

"I'm talking now about the Holy Ghost—hah—
"The third person of the Trinity—hah—
"The third person of the Godhead—hah—
"The Holy Ghost can enlight your experience—hah—
"Let the Holy Ghost come into your lives—hah—
"He will show you a new light on your experience—hah—
"The Holy Ghost will help you to see you have all those things in the Book—hah—
"You have Faith, Hope, and Charity—hah—
"You have brother love—hah—
"You will remember back when you was a child—hah—
"You will see your experience by the light of the Holy Ghost—"

Mr. Hugh Moore, deacon, had been asked about photographing the church and members and he brought the pastor over and introduced him. The pastor, Mr. Adams, was afraid of undue criticism and cautioned us to "remember what Paul said—that some things were expedient and some things were lawful"—and that was how it was now. With circumlocution he gave us to understand that he saw no reason why the pictures should not be taken but that some of the members might object. We agreed not to ask the congregation to pose, not to go inside the church. They gave their approval.

The photographs show the church with the congregation arriving, the end of the meeting with the congregation coming out the church, and the congregation standing in front of the church after the meeting. Note the division along sex lines corresponding to the seating inside where men sit on the left and women on the right. One little girl told us that "last second Sunday" was the first time in her life she had ever seen a man sitting on the right.

There was no shouting and no audible "Amens" from the audience during the meeting.

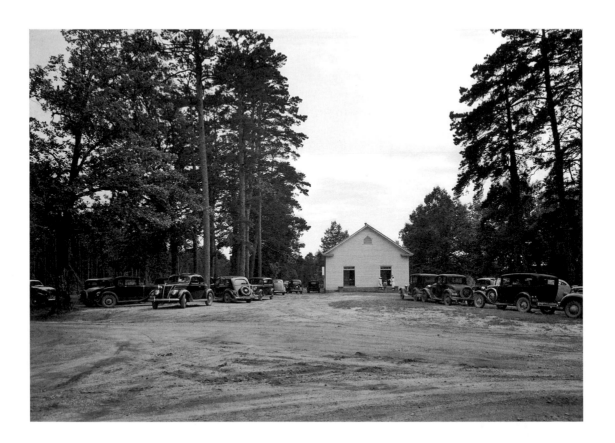

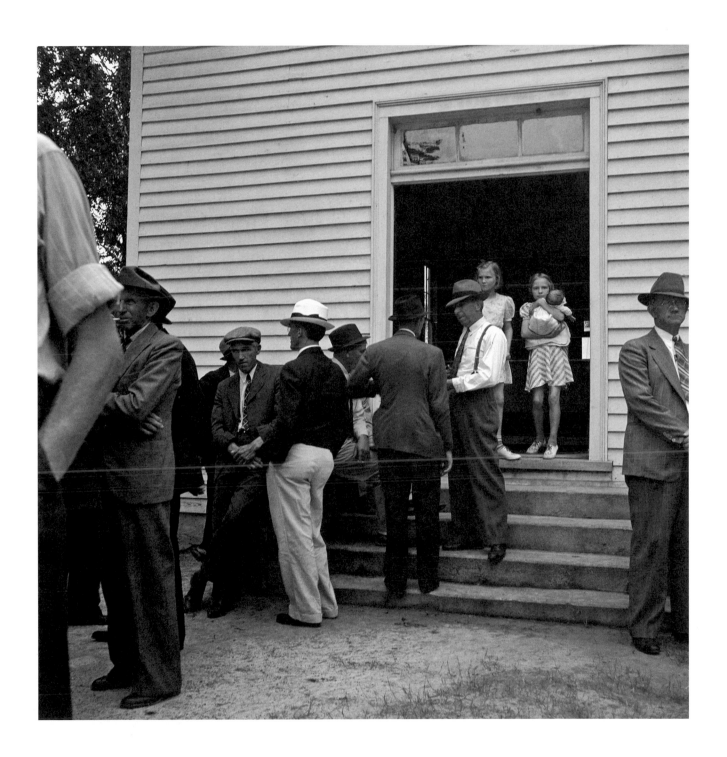

78. Wheeley's church and grounds.

79. Congregation gathers and talks in groups
after church services are over.

PACIFIC NORTHWEST

AUGUST TO OCTOBER 1939

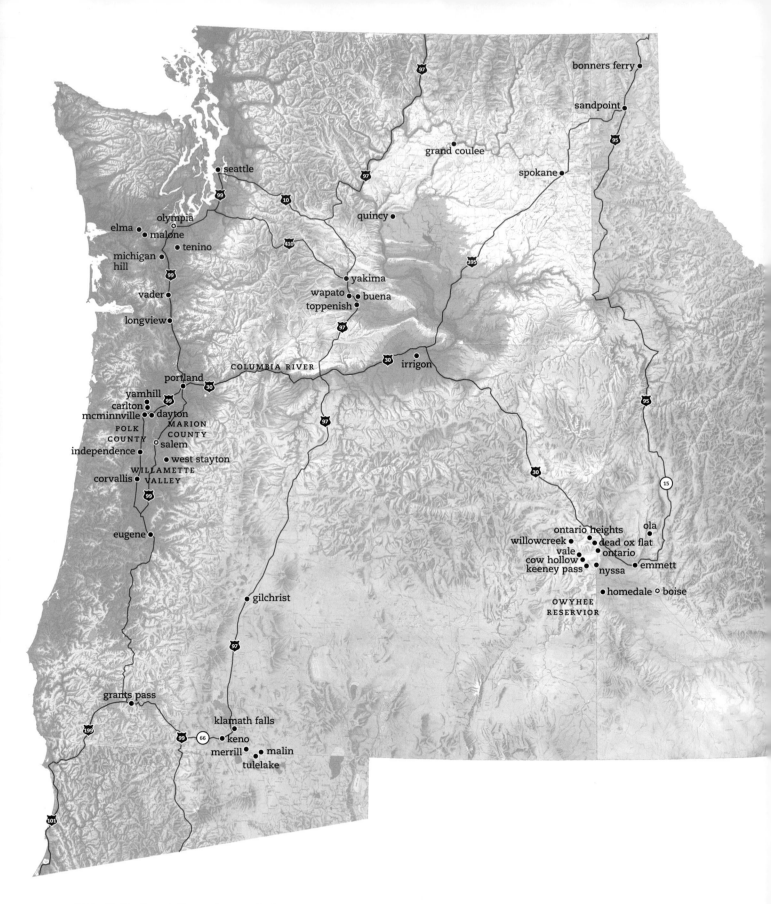

80. Pacific Northwest. Places photographed
by Dorothea Lange in 1939.

THE MIGRANT LIFE

ALONG U.S. 99, THE PRINCIPAL ROUTE across the mountains between California and the Pacific Northwest, traveled trucks loaded with goods, automobiles of families on holiday, and the jalopies of "rubber tramps," migrant laborers who harvested carrots and peas in the Imperial Valley, cotton and citrus in the San Joaquin, hops, beans, and pears in the Willamette and Yakima valleys, potatoes in the Klamath Basin. These migrants worked their way from the south in the winter and spring to the north in summer and fall, then back again, "sometimes covering 5,000 to 10,000 miles a year."[39] In 1939, the narrow winding road through Siskiyou Pass between California and Oregon was still unpaved, a new road under construction.[40] Perhaps this was why, on her first trip to the Pacific Northwest in August 1939, Dorothea Lange took coastal route U.S. 101 from her home in Berkeley to the Redwood Highway and on to its junction with U.S. 99 in Grants Pass, where she spent her first night in Oregon.

A photograph Lange made in Grants Pass alludes to her earlier work in California. It depicts a sign for U.S. 99, with one arrow pointing south to San Francisco (450 miles), another north to Portland (245 miles); behind the sign, in a gas station's window, is an advertisement for hop pickers. It was three weeks before the opening of the season (figure 81). Lange may have been in a new territory, but she was on familiar ground.

Growers advertised weeks in advance of the harvest because they needed thousands of workers. Besides, they could offer lower wages if there were more job seekers than jobs. The hops harvest in the Willamette Valley of Oregon and the Yakima Valley in Washington required fifty to sixty thousand workers: first for the early hops, which lasted from a few days to a week; then a layover with no pay; then late hops, for ten days to three weeks. The National Child Labor Committee reported that, in Washington and Oregon, "the average rate for hop picking in 1937 was 2 cents per pound, compared with just over 1 ½ cents in 1938" and, Lange noted, "1¢ in 1939." Children had to work to help support their families. Those older than ten "frequently pick a full day of 10 to 12 hours." Even those between the ages of six and ten picked part of a day. In Washington and Oregon, perhaps one in four hop pickers was younger than sixteen (figures 83, 93).[41]

The Farm Security Administration and child labor reports concentrated on white, native-born American families, but more than half of migrant workers were single men, and many were not native-born or white.[42] Before the Depres-

sion, the primary farm labor force had been migrant men or "fruit tramps," along with Native Americans and foreign labor recruited from Mexico and the Philippines. But the FSA reports ignored the foreign workers and stressed the distinction between migrant farm families and single "transient" workers. This emphasis may have been the result of a prejudice against the "bindlestiffs," not only for their hobo lifestyle but also for their historical link to the Industrial Workers of the World—the IWW, known as the "Wobblies"—a revolutionary labor organization founded in 1905.

The Wobblies had organized some of the most notorious and hard-fought strikes of the early twentieth century in the Pacific Northwest and California. In the Wheatland Hop Fields' Riot of 1913, "two pickers, a deputy sheriff, and the district attorney of the county" were shot and killed. Carleton Parker, whom the state of California assigned to investigate the causes of the "riot," reported that only one hundred of the twenty-eight hundred workers involved were IWW members and that the strike had been triggered by appalling sanitary conditions (nine toilets for twenty-eight hundred people, no water in the fields despite temperatures of 110 degrees in the shade) and unfair labor practices (false advertising and varying the pay rate from day to day depending on labor supply).[43] Wherever such conditions existed there was potential for violent protest. A California study of hoboes conducted during 1913 and 1914 found that 37 percent "advocated the complete destruction of the present political system," though only 8 percent were members of the IWW.[44] By 1939, the IWW had been seriously weakened, so it was unlikely that the bindlestiffs Lange photographed were still members of the IWW (figure 96).

Nonetheless, the memory of the IWW's militant tactics could still evoke fear. In a September 1939 article, journalist Richard Neuberger (who later became a U.S. senator from Oregon) invoked the specter of the IWW, even as he denounced the rise of a viciously antilabor growers organization known as the Associated Farmers: "Not since the Wobblies of the I.W.W. roamed the woodlands, has any organization in the Far West stirred such savage antagonisms as the Associated Farmers.... On the Oregon statute books is the most severe anti-labor law ever enacted in America.... Actual violence has occurred in some communities, with vigilantes pitted against labor unions. The malice aroused between classes may not subside for a generation." "Who are the Associated Farmers?" Neuberger asked, and how did they manage to overturn "rights gained in half a century of political and economic struggle"? Neuberger recounted how the Associated Farmers, formed in 1933 in response to strikes in California, then expanded throughout that state, establishing a Northwest outpost in 1937. In 1938, the Associated Farmers successfully lobbied for passage of a law in Oregon that, in Neuberger's words, "by practically forbidding strikes and picketing, reduces unions to mere fraternal organizations." That same year, antilabor initiatives similar to those passed in Oregon lost by only a "slender margin" at the polls in Washington and in California.[45]

"We watch all the time for agitators," one small bean farmer told Lange. "An agitator will turn the whole yard upside down in two hours." Growers some-

times hired a deputy sheriff to "scare" workers (figure 85). In 1933, a year of successive strikes by agricultural workers on the West Coast, authorities built a stockade in downtown Yakima, next to the courthouse, to imprison strikers; similar prison structures were built in California in 1934.[46] "Why do you keep it? Why don't you tear it down?" Lange asked in 1939. The answer came: "In the event we need it, we've got it right there" (figure 94).[47]

Lange herself observed some of the same disgraceful sanitary conditions to which Parker had attributed the Wheatland strike of 1913. Many migrant families lived in tents along river banks and on vacant lots; some rented tourist cabins; others stayed in primitive shelters provided by growers. Of these living quarters the FSA said: "An examination of the rural slums and jungles into which these people have drifted will appall any person with social conscience.... Their position is one of progressive despair."[48] In a survey of thirty hop camps, investigators found that:

Those on the march several years present a more haggard and worried appearance, a more feverish attitude toward job hunting.... This deterioration ... is partly the result of the loss of home ties, the pressure of low wages, the scarcity of jobs, lack of ... social security, and partly a result of living conditions so bad that they present a continual source of illness and shame to respectable families who have never lived in tents, shacks, or in jungle camps.... The ankle-deep dust, the inadequacy and filth of toilets and garbage disposal provisions, the almost complete lack of facilities for bathing, ... the usual straw beds on hard floors or on the ground, with bedding and clothing in a state of continuous griminess and filth—all tend to break the morale.[49]

To improve conditions for some, the FSA's Region XI (covering Washington, Oregon, and Idaho) built both permanent and mobile family labor camps, patterned after those in California. The Northwest region's first permanent labor camp, located in Dayton, Oregon, was completed but still uninhabited when Lange photographed its empty streets and buildings in October 1939 (figure 116). The region's emergency mobile unit was designed for two hundred families (one thousand people). Lange visited it twice at its inaugural location in Merrill, Oregon, once just before it opened in late September, and once in late October during the potato harvest. According to one FSA report, "When the mobile camp arrives, an empty field can be transformed almost overnight into an orderly, neat, little town." Its design incorporated both the organization of an army camp and the mobility of a circus ("the use of tents, and the efficient organization which made it possible to dismantle the whole tent colony overnight, and move it quickly to a new location"). In September and October, Lange photographed the "camp on wheels," which included a power unit, a water tank, and a fleet of trailers: one for showers, one to transport the tent platforms, one an office for the manager, another a medical clinic with a full-time nurse.[50]

A migrant farm worker at the Merrill Farm Family Labor Camp, formerly a Nebraska farmer, told Lange, "The WPA has ruined the working man in the

USA," his bitter comment perhaps stemming from the Works Progress Administration's practice of discontinuing its jobs during harvests, which allowed (or forced) WPA workers to compete with migrant workers (figure 115). Lange recorded his opinion without comment, just as she did for those who spoke in favor of the WPA. The New Deal agency was highly controversial, and far less popular with the general public than, for example, the Civilian Conservation Corps, which provided jobs for youth. Neither the WPA nor the CCC were intended as permanent employment; both were stopgap measures to relieve unemployment and reduce the number of individuals compelled to resort to relief. The WPA was not "relief"; its workers were engaged in all sorts of productive enterprises, from historical research, art projects, and theater productions to the building of dams and roads. But to encourage transition to regular employment, the government paid less than the prevailing wage, which drew the ire of labor organizations, even as many businesses complained that the WPA took work away from the private sector.

From 1935, Lange had studied shacktowns of all kinds in California, where many families had been able to settle only because at least one member had a WPA job. In one California shacktown known as Highway City, the father of an Oklahoma family "worried that the WPA work might be cut off at the opening of the 1939 harvests." "The cheapest thing for the Government to do," he told Lange," "would be to put people like me on enough land to make a living on. You can't tell me anything about running around with the fruit. I know that deal. You are lucky if you make enough to get home."[51]

AWS

GENERAL CAPTION NO. 45
DATE: August, 1939
PLACE: Independence district, Polk County, Oregon
Rogue River District, Josephine County, Oregon
SUBJECT: Hop harvest in Oregon

The hop picking season opened August 18, lasted until September 15, 1939. The crop is harvested by "locals" and migratory families. Hops started in Oregon in 1885.

I. Picking Hops

Hop pickers start work in the field (called "yard") with the first daylight and work until about 5:30 in the late afternoon. Wages, 1¢ per pound of picked hops and the good pickers average about $1.50 per day. See pay envelope attached.

The hop is stripped from the vine, resembles a small green cone. The vine is lowered from the high wires over which it has been trained by the "wire man" whose business it is to bring the hops down to picking level. Hops are weighed in the yard and hauled to the kiln in sacks by truck. Negatives in this group were made at noontime, August 19, all in the same field. Temperature 105 degrees.

II. Housing for Hop Pickers

Hop camps are of all kinds, depending upon the arrangement the grower makes for his pickers. It is customary for some sort of provision to be made. Photographs listed below show housing for hop pickers within an area of a few miles, on hop ranches along the Rogue River.

III. Miscellaneous Items related to the Hop Harvest

[Lange attached a pay envelope printed with "Rules For Hop Picking"(figure 16).]

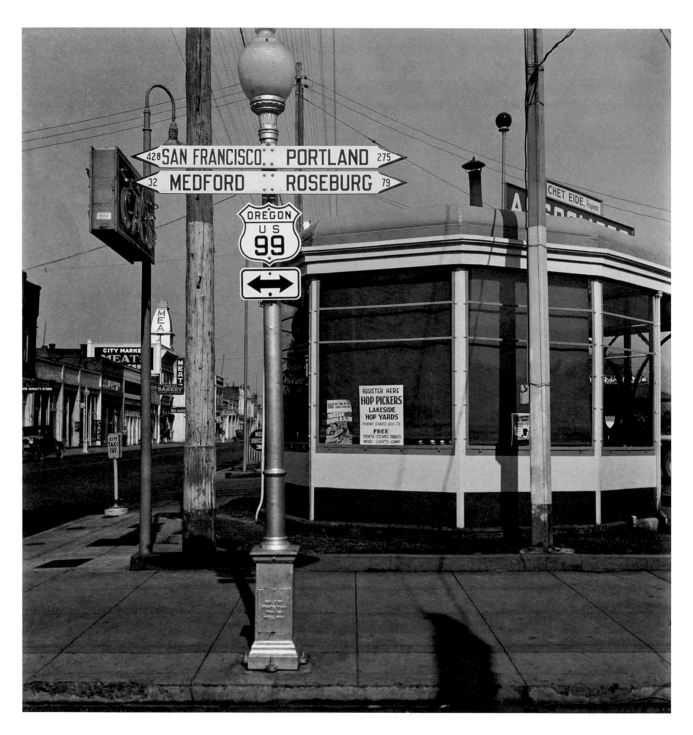

81. August 6, 1939. Grants Pass, Josephine County, Oregon. Sign on service station, U.S. 99. Hop pickers are wanted for four big growers of the area three weeks before season opens. They also advertise in newspapers, including San Francisco newspapers, 450 miles away.

82. August 21, 1939. Near Grants Pass, Josephine County. On road off main highway, leading to Rogue River, Hop Farms. Picker: "But they don't say what they pay!"

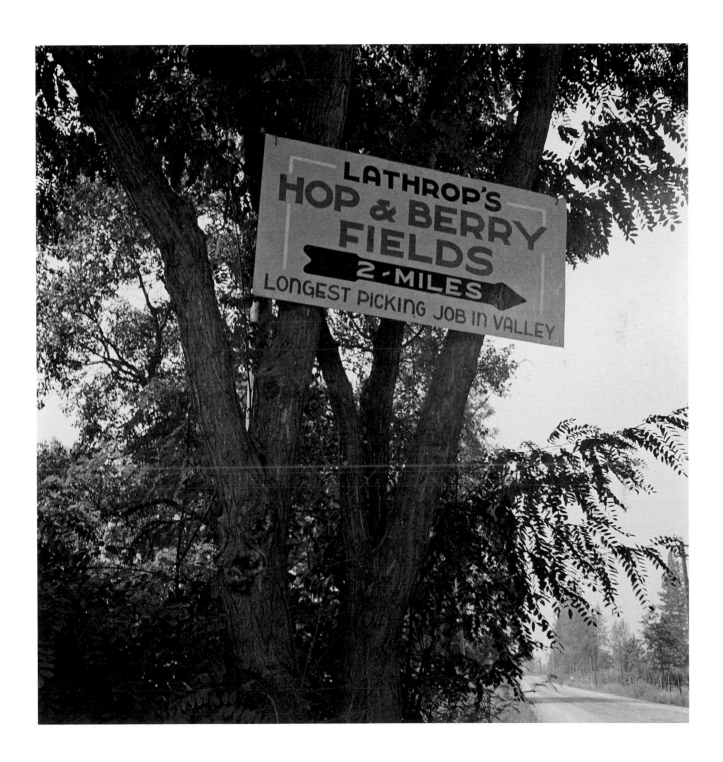

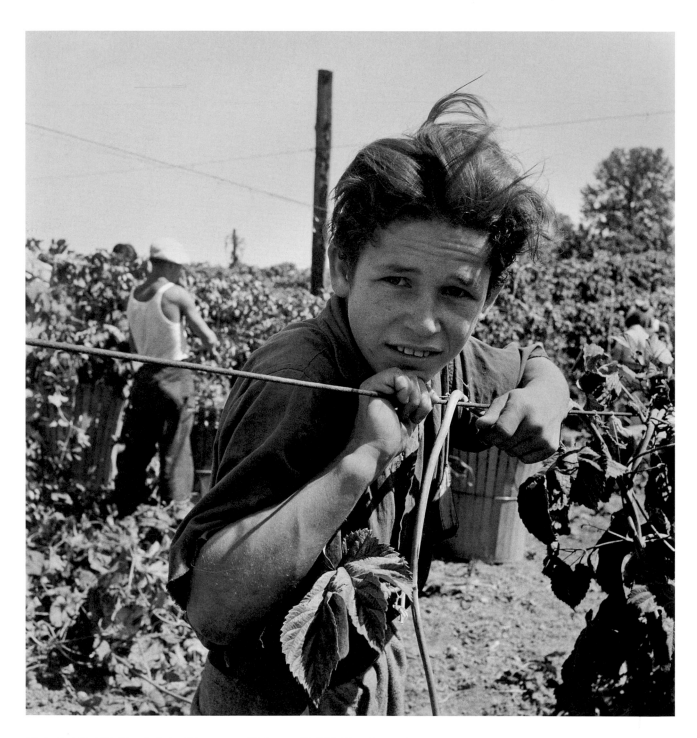

83. August 19, 1939. Near Independence, Polk County, Oregon. Migratory boy aged 11, and his grandmother work side by side picking hops. Started work at 5 a.m. Photograph made at noon. Temperature 105 degrees.

84. August 21, 1939. Near Grants Pass, Josephine County, Oregon. Hop picker, with her children, goes from paymaster's window to company-owned store adjoining. She had earned 42 cents that morning. She spent it for: 1 lb. bologna sausage, 1 package "Sensation" cigarettes, 1 "Mother's Cake."

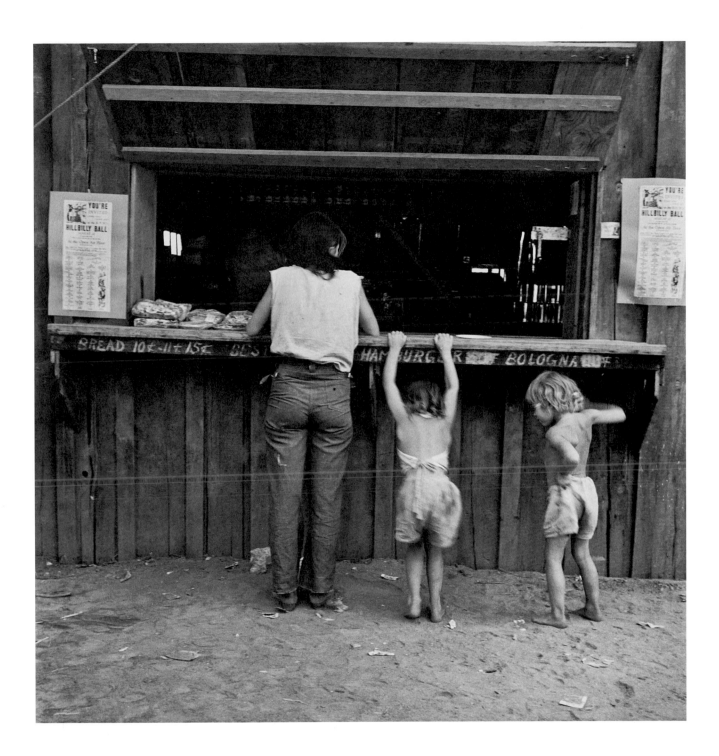

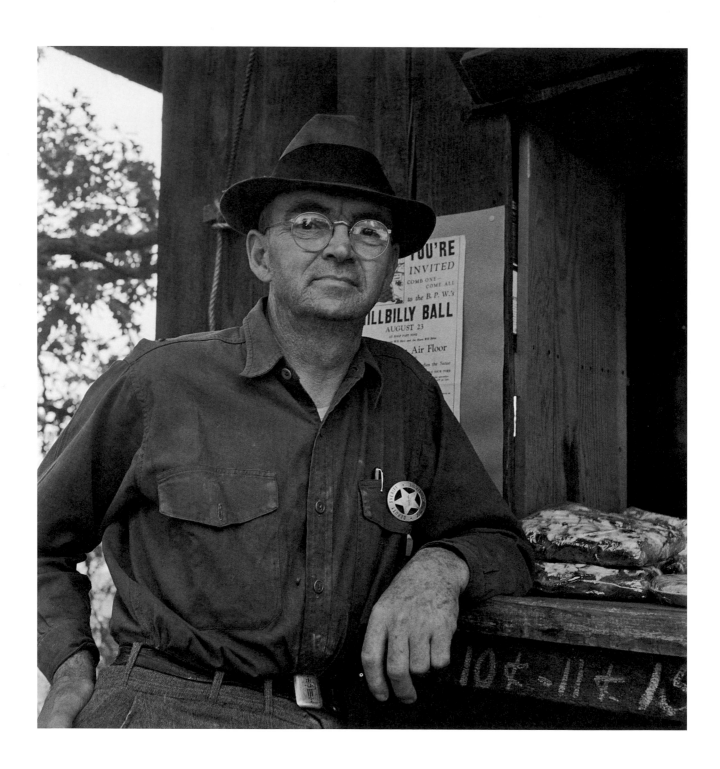

85. August 21, 1939. Near Grants Pass, Josephine County, Oregon. Deputy sheriff, stationed at paymaster's window on large Willamette hop ranch. Owner employs between 500 and 600 hop pickers for three weeks each year. He says, "We have him (meaning deputy) kind of to keep them scared as much as anything."

86. August 21, 1939. Near Grants Pass, Josephine County. Hop kiln ready for firing during hop season.

GENERAL CAPTION NO. 46
DATE: August, 1939
PLACE: Marion County, Willamette Valley, Oregon
SUBJECT: String bean harvest

The bean crop requires a large number of harvesters for a few weeks in August of each year. Beans are trained up strings attached to cross wires similar to those in hop yards, only lower. Crops are grown mostly by small farmers. Pickers are partly local people, partly from nearby portions of Oregon, who work seasonally only in the bean crop, and partly migrants who follow the crops from harvest to harvest. Many of these have come originally from outside Oregon, principally from Kansas and other states of the northern Great Plains. Some have come from Oklahoma and other states of the Southwest. Most of the pickers camp on the land of the growers. Small farmers do not maintain organized, well-equipped camps. There is less formality and freer, more intimate relationship between small farmers and pickers than between the large growers and workers in California. There are one or two large camps which charge rental. 1939 pickers' wages are $1 per 100 lbs.

A small Farmer: "We watch all the time for agitators. An agitator will turn the whole yard upside down in two hours."

This is a region where Region XI [Washington, Oregon, Idaho] plans to send its mobile camp unit for the season of 1940.

87. August 17, 1939. Near West Staten, Marion County, Oregon. Children in large private bean pickers camp. Pickers come from many states, from Oklahoma to North Dakota.

88. August 17, 1939. Near West Stayton, Marion Co., Oregon. Unemployed lumber worker goes with wife to the bean harvest. Note Social Security Number tattooed on his arm.

DATE: August 12, 1939
PLACE: Yakima Valley, Washington
SUBJECT: Pear harvesting

Harvest time on "Pleasant Hill Orchards," owned by Mrs. Nellie Mullins. This ranch is situated in the rolling hills about 5 miles northwest of Yakima, which is on the valley floor below. Refer to General Caption No. 33 ["Yakima Valley"].

It represents one of many such small fruit ranches of the valley and employs a gang of pickers annually, both migratory fruit workers and local people from the towns who depend on this work.

Wages (1939) are 30¢ an hour. Yakima county (census of 1930) ranked first in the 3,072 counties of the United States in the production of pears—their average annual value (Yakima Chamber of Commerce) over the ten years from 1927 to 1937, $2,148,048.00

Both men and women pick pears, although women are required to work along with a man since they are unable to "top out the trees" and are forbidden by law to use the long ladders. There are special skills developed in the picking and the handling of the pears, the work requires agility, to get around in the trees, balance against fall from the trees—a hazard and a common occurrence, since the bag when filled is very heavy. In some orchards the use of a metal ring attached to the metal [middle] finger is required by the grower in order to grade pears for size while picking. See negative 20873-E. Pickers prefer to work in orchards where trees are stripped and pears graded in packing house, which is easier work.

GENERAL CAPTION NO. 33
SUBJECT: Yakima Valley

The United States Reclamation Service has brought water to the valleys of the Yakima, which now has about half a million acres under irrigation. The value of crops produced in Yakima county alone was nearly 30 million dollars in 1929, close to the highest among the counties of the country. Fruits, vegetables, and hops are among the principal crops, both in total value and in amount of seasonal labor required. The number of hired workers required in the fields fluctuates between 500 in December and January to 33,000 in late September. As a reflection of this the population of the town of Yakima, numbering 22,000 in 1930, is said to double each year in the month of September. Yakima has been the scene of bitter labor strife. Refer to General Caption No. 31 ["The stockade in the center of town"]. It is a mecca for refugees from drought in the Great Plains and for migratory laborers seeking brief seasonal employment. The refugees face heavy unemployment in the valley. In this sense, as well as the sense intended,

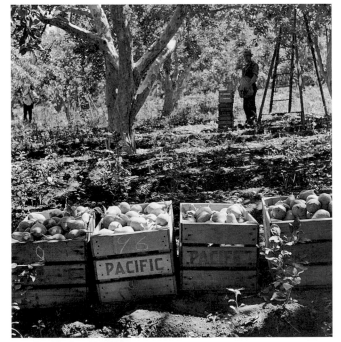

89. August 12, 1939. Yakima Valley, Washington. Picking pears, Pleasant Hill Orchards.

90. August 12, 1939. Yakima Valley, Washington. Harvesting pears, Pleasant Hill Orchards.

91. August 10, 1939. Yakima County, Washington. Roza Irrigation Canal, sides concrete-lined by machine. The project, when complete in 1945, will open 72,000 acres to cultivation in East Yakima and West Benton Counties.

92. August 8, 1939. Buena, Yakima County, Washington. Yakima Valley small town, a county which ranks fifth in the United States in value of agricultural production.

93. August 8, 1939. Yakima Valley near Toppenish, Washington. Migratory boy in squatter camp, has come to Yakima Valley for the third year to pick hops: Mother: "You'd be surprised what that boy can pick." Note: See studies by National Child Labor Committee. "Pick for Your Supper," by James E. Sidel.

there is much point to the statement of the Yakima Valley Chamber of Commerce: "Irrigation has transformed the land our forefathers viewed as a barren sagebrush waste into a substantial producing area.... While the valleys of the Yakima afford no haven for the idle, they have much to offer to those who have some capital and a willingness to work and build."

GENERAL CAPTION NO. 31
DATE: August 10, 1939
PLACE: Yakima, Yakima County, Washington
SUBJECT: The stockade in the center of town

The famed stockade at Yakima, built in 24 hours of bridge ties in 1933, at time of pickers' strike in the orchards. Three hundred "trouble makers and screw-balls" were brought into town from the orchards where they were attempting to picket. They were herded down the main street of town by vigilante farmers. They were finger-printed and some were detained here for three weeks.

The building behind the stockade is the county courthouse. Photographs show sentry walk, sentry towers, and barbed wire fence.

Question asked in courthouse, 1939, "Why do you keep it? Why don't you tear it down?" Answer, "In the event we need it, we've got it right there."

[Lange attached a newspaper clipping about the stockade; see appendix C.]

94. August 10, 1939. Yakima, Washington. The famed stockade. Building behind stockade is the court house.

GENERAL CAPTION NO. 43

SUBJECT: Migratory single workers ("solos")

Since the days when grain harvesting was the principal demand for seasonal agricultural labor in the west, migratory men—single or travelling without women—have been an important element in the labor supply. These men can be seen walking the highways or riding the freights; rarely do they thumb a ride. They carry their blankets and personal effects in an oblong, canvas covered, rope-bound bundle—hence the common name, "bindle-stiffs." In the middle western wheat belt farmers supplied bedding to migratory harvest hands. In the west from the days of the gold rush when each labored for himself, workers have carried their own equipment. The wandering single men work in agriculture, lumbering, construction, and any form of casual employment. They are the type described by Carleton Parker. They join the I.W.W.

Today they work principally from the northern San Joaquin Valley to the Yakima Valley. Their field of employment steadily has been encroached upon by a succession of Oriental workers, by Mexican workers, and more recently, by Southwestern white family workers.

[Lange included the quotations that follow in the general caption rather than in the individual captions.]

20660-E: says "There ain't a wire table made that I can't splice." Refers to lumber work. "We educated them fellows how to log and now they've got the jobs."

20665-E: says "It's hay, then grain, then spuds, and then its winter."

20917-C: (Man in the middle) "Times hasn't been good since Calvin Coolidge." (Man second from right) "The combine—that knocked us out. What we need now is something so the monied men will put out their money and not keep it locked up." (Young man on the left) "We can't fish because we've got no license."[52]

95. August 15, 1939. Near Toppenish, Yakima Valley, Washington. Bindles, against cattle corrals by the railroad track.

96. Napa Valley, Calif. Dec., 1938. More than 25 years a bindlestiff. Walks from the mines to the lumber camps to the farms. The type that formed the backbone of the IWW in California, before the war. Subject of Carleton Parker's studies on IWW.

GENERAL CAPTION NO. 27
DATE: August 8, 1939
PLACE: Yakima Valley, Yakima County, Washington
SUBJECT: Migratory families in the Yakima Valley

Three migratory families camped in "Ramblers Park" on the banks of the Yakima River. Two of these families are travelling together. There are 15 people in the group. One of these families has nine children. They came originally from Northeastern Oklahoma, and have been migrating with the crops since 1936. Note: Still carrying a roll of kitchen linoleum. They have come into the Yakima Valley to work in the pear harvest. Pear growers do not provide housing or camps. The wages (season 1939) are 4¢ per box, and they quote $1.90 per day as average day's wage, but work is highly irregular. After the pears they will work in apples, then in hops. The Yakima Valley season ends in mid-October.

All local workers (season 1939) are cut off from relief in this valley when harvests start regardless of ability to work in the fields and orchards or condition of health or susceptibility to lead poisoning from sprayed trees.

The third family (far tent) originally came from Texas, tried to make a start in New Mexico in 1936. Failed there, now migratory workers on Pacific coast. The woman wears a "cotton patch bonnet."

The Farm Security Administration is now (August 1939) constructing a standard camp for migratory workers in this valley.

97. August 8, 1939. Yakima Valley, Washington. Migratory children, living in "Rambler's Park." They have lived on the road for three years, nine children in the family.

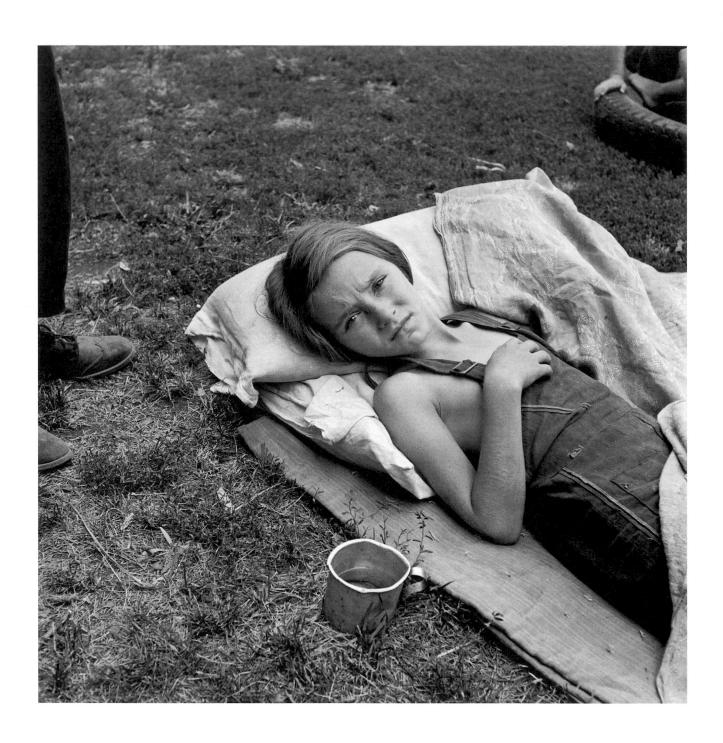

98. August 10, 1939. Toppenish, Yakima Valley, Washington. Sick migrant child.

99. August 10, 1939. Toppenish, Yakima Valley, Washington. The oldest girl, aged 11, seated in the doorway of the house trailer, cares for the family.

GENERAL CAPTION NO. 29

DATE: August 10, 1939

PLACE: Yakima Valley, near Toppenish, Washington

SUBJECT: Another migrant family

A sick and feverish child lies outside on the ground near the trailer in which they have recently (July 1939) come to Washington. There are four little girls. The oldest is 11, the one who is sick is 9. Their mother deserted the family in Missouri two years ago. Their father "used to be a miner back there, but started to get trouble with his lungs so we came here."

Family living in a vacant lot on the edge of town. Father was working on this day at day labor, wages $1 per day.

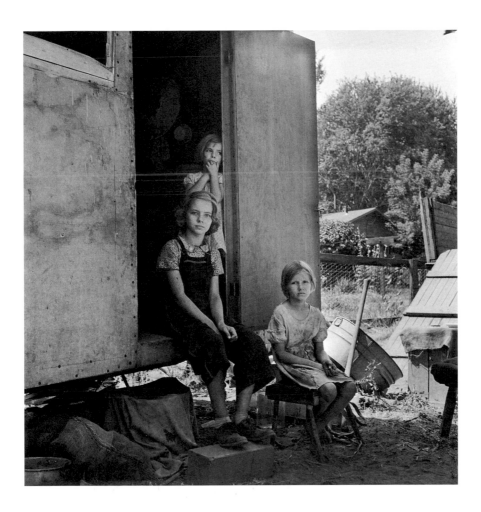

DATE: August 22, 1939
PLACE: Tulelake, Siskiyou county, California
SUBJECT: Frontier town

A newly built town on land which was a lake bottom. Drained about 20 years ago by the U.S. Reclamation Service and settled thereafter mainly by world war veterans who farmed in this district. Water for domestic service is still hauled in by railroad tank cars to supply this district. Main crop, Klamath potatoes, which requires many migratory workers.

GENERAL CAPTION NO. 63
DATE: September 28 and October 27, 1939
PLACE: Tulelake, Siskiyou County, California
SUBJECT: Tulelake, during the potato harvest
Refer to General Caption No. 44

The Klamath Basin potato harvest lasted this year from the last days of September until October 23, when the snow came. On the morning of October [24?], 55 carloads of people from Tulelake were already on the road (counted by California State Quarantine Station).

Twelve to fifteen thousand acres of potatoes are harvested in the Klamath Basin during this season, value (1938) $1,750,000. Between three thousand and six thousand people are needed to harvest this crop (Oregon State Employment Service). Many single men work in this harvest, as the living conditions are known to be bad, no water, no decent camps, and bad weather.

I

The camp across the road from the potato sheds. The photographs were made before the season was in full swing. Ninety separate camps were counted on the flat opposite the sheds. No water fit to drink except that hauled in on tank cars, at the town pump. A stagnant irrigation ditch runs along one side of the camp. Four dilapidated make-shift privies were erected. The Employment Service operates a seasonal office five hundred yards away, from which the growers are supplied with labor. Wages average $3.00 a day (?), when working.

Wherever migrant farm labor moves in the West, the physical picture, with its bad social consequences, is about the same. At Tulelake no provision whatsoever is made for these wandering men and women.

II

The potato sheds across the road from the camp.

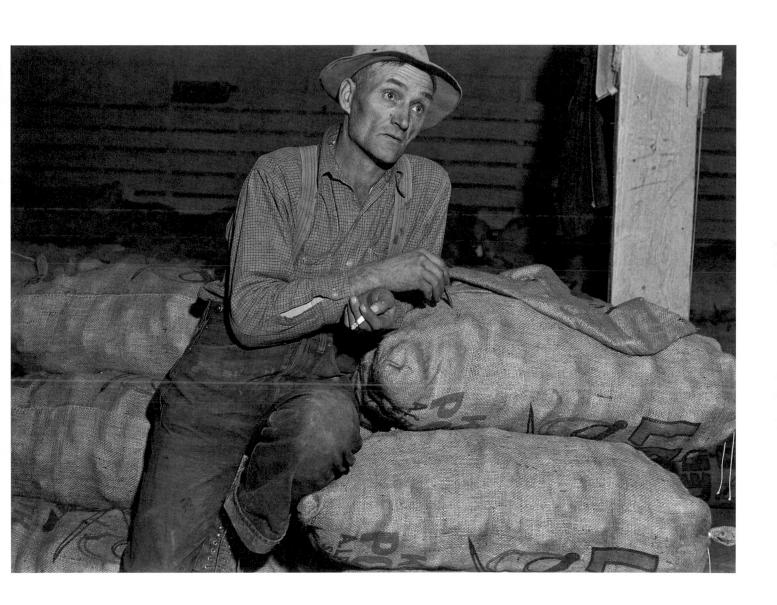

100. October 27, 1939. Tulelake, Siskiyou
County, Calif. Klamath Basin potato farmer.
He remembers when the first carload of
potatoes left this valley in 1910. In 1934
he lost $3,500 on 48 acres of potatoes. His
present acreage is 11 acres in potatoes, the
rest in hay and soil-building crops. Has 11
milking cows. "I'm gonna eat."

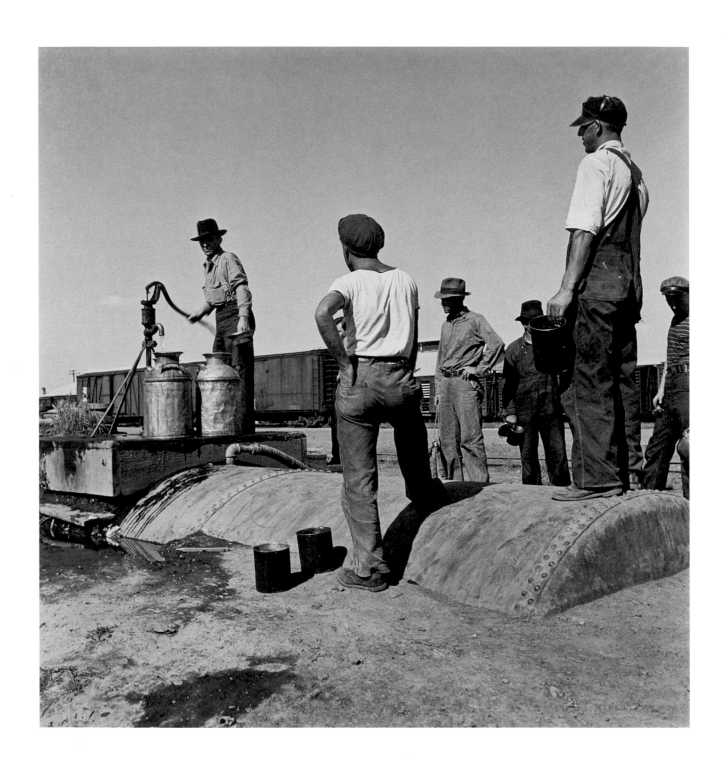

101. September 28, 1939. Tulelake, Siskiyou County, Calif. Drinking water for the whole town, also for the migrant camp across the road.

102 September 29, 1939. Malin, Klamath County, Oregon. One of the 40 potato camps in open field, entering town.

GENERAL CAPTION NO. 64
DATE: September 29, 1939
PLACE: Malin, Klamath County, Oregon
SUBJECT: Living conditions for potato pickers at Malin

This is a small town, population 215, in the Klamath Basin, established thirty years ago by Bohemian farmers from the Middle West. Malin is now in the rich potato district and requires many migratory pickers for the harvest season.

Photographs show a group of forty squatter camps, before the season opened, at road entering town from the north, along the highway. No water supply.

A local said: "It's the same old dirty story—wherever you go."

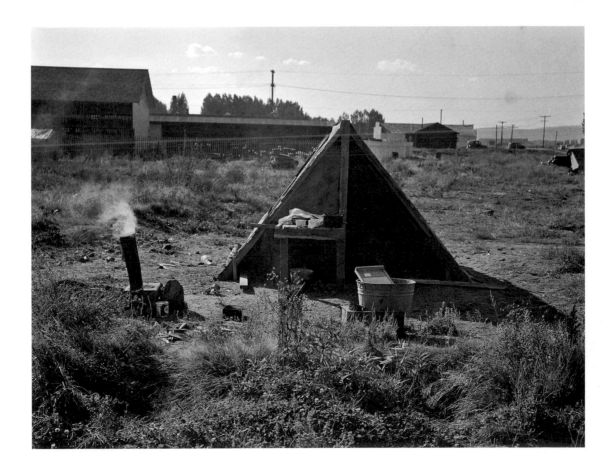

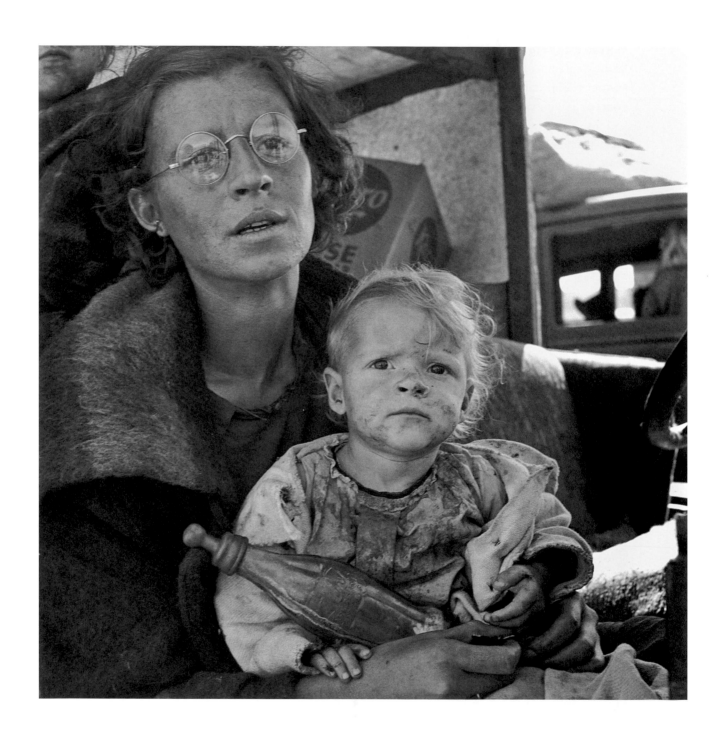

103–104. September 29, 1939. Tulelake,
Siskiyou County, Calif. Mother and baby of
family on the road.

DATE: September 29, 1939

PLACE: Tulelake, Siskiyou County, California

Refer to General Caption No. 63

SUBJECT: Family from Deadwood, South Dakota

The car is parked outside the Employment Office. The family have just arrived, before opening of the potato season. They have been on the road for one month—have sick baby.

The father worked on W.P.A. in South Dakota, "till *that* played out." Three children, oldest about five. About to camp on a site without water or sanitation. They have no tent. "Been trying to get one some way."

Mother says, of father, "What he really *likes* to do is to milk cows. He can do a little of everything, but that's what he likes."

Father washed the baby's face with edge of blanket dampened from canteen, for the photographs.

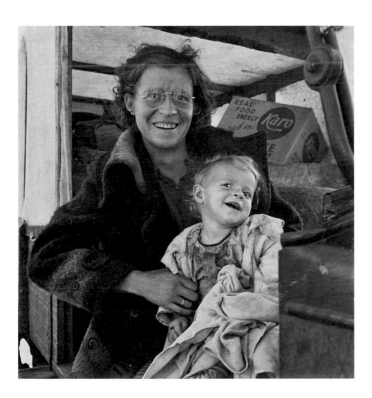

GENERAL CAPTION NO. 26

Shacktowns

The ten years since 1929 have witnessed an unparalleled growth of shacktowns in the rural communities of the Pacific coast.

These rural slums are built usually on the fringes of towns. Houses of all materials, from cardboard and old sheets of corrugated iron to second-hand lumber of odd sizes, have been erected by the labor of the occupants. Some are on river bottoms and dumps. Others, increasingly, are on small tracts opened by private real estate operators, where from $5 down and $1 a week a house site may be had. The people who crowd these towns are refugees from the larger towns or from the areas of drought, who seek cheap rent, a chance for stability, and the casual employment afforded in towns and in agriculture. It is important to note that many of these depend on W.P.A. Turn-over is high. On the lots beside the shacks stand often the trailers in which the refugees have come and the tents which gave them temporary shelter.

The richer the district in agriculture production, the more it has drawn the distressed who build its shacktowns. From the Salt River valley of Arizona to the Yakima valley of Washington, the richest valleys are dotted with the biggest slums.

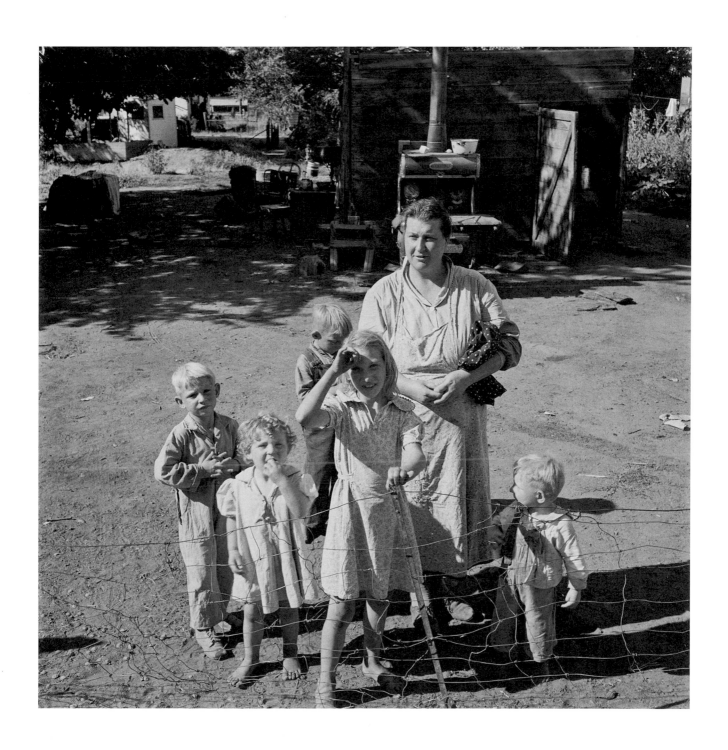

105. August 8, 1939. Yakima Valley, Wapato, Washington. Family living in shacktown community. Mostly from Kansas and Missouri. This family has five children, oldest in third grade. Rent, $7 per month, no plumbing. Husband working on WPA, wages $44.00.

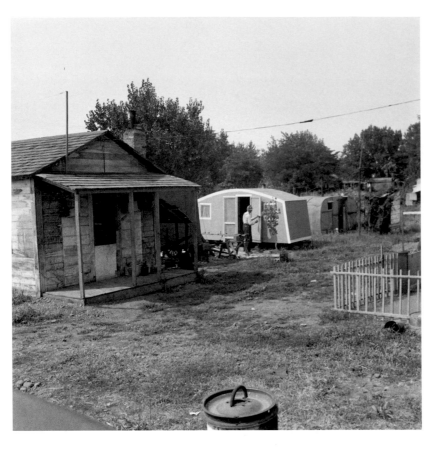

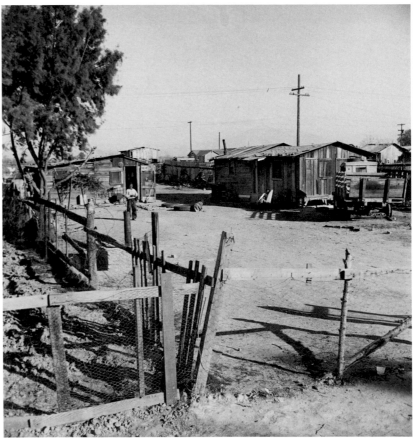

106. August 8, 1939. Yakima, Washington. Shacktown (Sumac Park) is one of several large shacktown communities around Yakima.

107. Bakersfield, Kern County, [California], March, 1939. Housing for Negroes in a new district on the edge of town. A rapidly growing community of colored people, mostly from Texas, some from Oklahoma. Rent $8 per month.

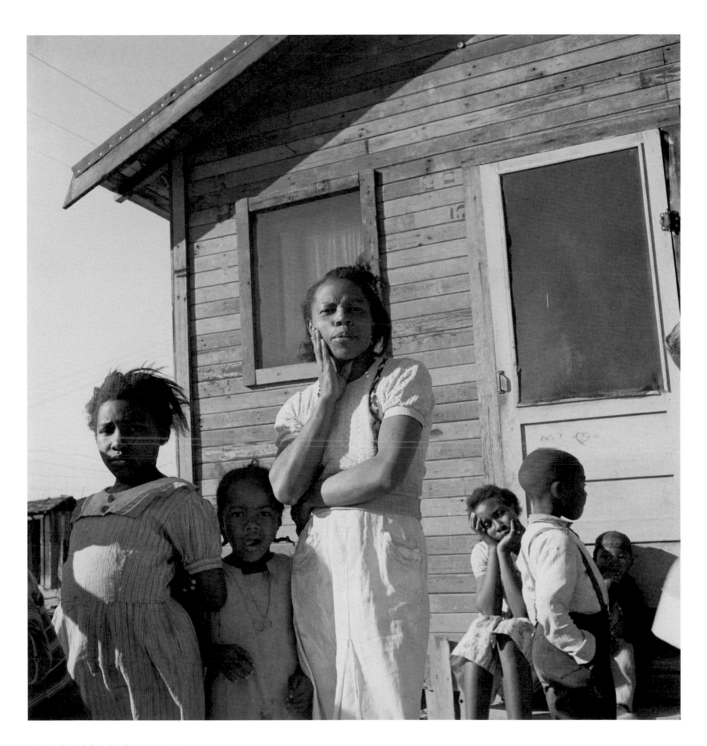

108. Colored family from near Houston, Texas. Been in California for 2 years. Husband came first, later sent for wife and two children, who traveled by bus (unlicensed car, fare $6, travelling night and day). Husband now on WPA.

GENERAL CAPTION NO. 47

DATE: August 23 and September 29, 1939

PLACE: Near Klamath Falls, Altamont District, Klamath County, Oregon

SUBJECT: To show process of resettlement in the West

Photographs were made in fast growing rural shacktown. The home was photographed on August 23 and revisited six weeks later. In that time the family had dismantled the tent and were living in a nearly completed self-built, one room house.

Family consists of husband, wife, two small children, and husband's brother. They came originally from Oklahoma to Oregon. Father works on WPA. Paid $10.00 down for the land. Pay $5.00 a month out of WPA earnings.

Father: "We build as we can, to get away from rent and get something for what we pay out."

Mother: "First we had the tent on the ground. Then we moved it up on the floor, when we got it down. We didn't take the tent down 'til we had the roof over it."

Mother: "Next year we'll be painted and have a lawn and flowers. We'll put our driveway over there where those beans are. We've got rabbits now and we'll get some chickens as soon as we can. We think we're doing swell."

109. September 29, 1939. Near Klamath
Falls, Oregon. Young mother, 25, says,
"Next year we'll be painted . . . etc."

110. *(Following page)* August 23, 1939. Near
Klamath Falls, Klamath Co., Oregon. Refer
to Gen. Caption No. 47 for story of this
family and photographs made at later
date of completed house. This photograph
was made in the rain. Refer also to Gen.
Caption No. 26, on rural shacktowns.

111. *(Following page)* September 29, 1939.
Near Klamath Falls, Oregon. Mother and
two children, husband, his brother, and
brother's wife, shown.

GENERAL CAPTION NO. 62
DATE: September 30 and October 27, 1939
PLACE: Merrill, Klamath County, Southern Oregon
SUBJECT: Merrill Farm Family Labor Camp—Mobile Unit (FSA)

The first migratory labor camp in Region XI was opened in October 1939. This camp is a mobile unit, capable of housing 200 families and its facilities will be used by some of the three thousand workers required for the annual Klamath Basin potato harvest.

All the facilities of the mobile units are portable. The potato season lasts for six weeks. The units have been organized on trucks and trailers; these permit the establishment of an orderly camp in a short time. They can then be moved to another short season area to serve the harvesters of another crop.

The units are equipped with portable water system, a power unit, shower bath and laundry units, built into trucks. The office and clinic are each built into trailer units. The toilets are of knock-down type. The tent platforms are portable. These camps are established on leased ground and are accompanied by a trained camp manager from one location to another.

Through the Agricultural Workers Health Medical Association (FSA) the camp is attended by a resident registered nurse, charged with maintaining the health of the workers in camp, not only in emergencies but as part of an educational health program. The services of a local physician are available to migratory families, another part of the health program (FSA).

Each family pays seven cents per day. The money goes into a camp fund to provide recreational activities. The camp is run by a committee elected from the camp population.

Group I
Views of the mobile camp & its facilities.

Group II
The Agricultural Workers Medical Association, as functioning in the mobile unit on one afternoon.

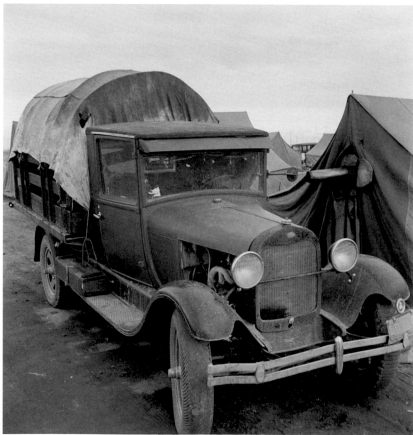

112. October 27, 1939. Merrill, Klamath County, Oregon. The camp nurse introduces the doctor to mother of sick boy.

113. October 27, 1939. Merrill, Klamath County, Oregon. Refer to neg 21823D. Truck, baby parked on front seat.

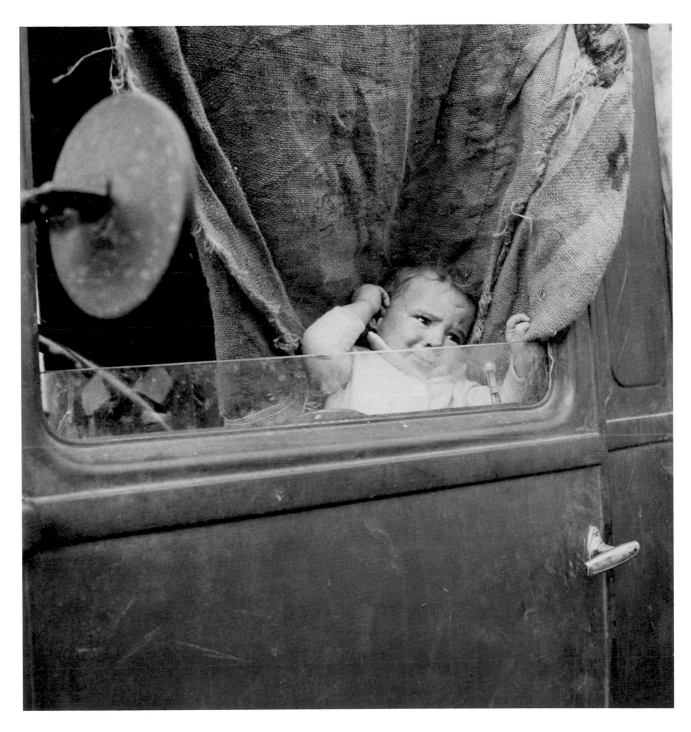

114. October 27, 1939. Merrill, Klamath
County, Oregon. Neglected baby, parked in
truck in which they came from Mississippi.
Father drunk, mother sleeping, 3 p.m., in
dirty tent. There is another 5-weeks old baby.
(Attention called to this by camp nurse.)

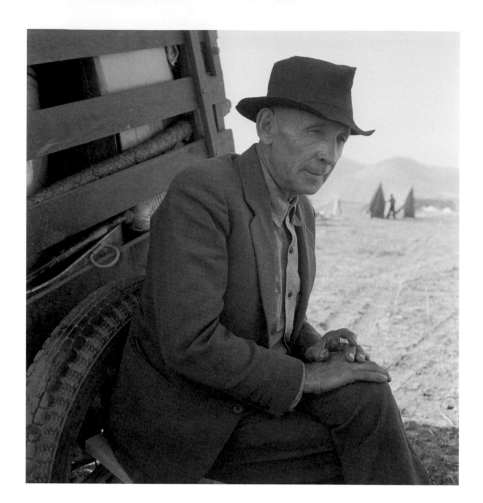

115. October 28, 1939. Merrill, Klamath County, Oregon. Was Nebraska farmer, now migrant farm worker in the West, saying, "The W.P.A. has ruined . . . etc."

Group III
Some of the people in camp.

The group above refer to a West Nebraska farmer [figure 115], one of a party of nine adults, all related, who came into camp on the day it opened, at the beginning of the potato harvest.

"The WPA [Works Progress Administration] has ruined the working man in the USA."
"You don't realize, you don't realize, that there's thousands of families out of their homes. Now look at me—this is the first time I've been out of the state of Nebraska for 30 years—"
"This country here is unfair to the people who does the farm work. Nine working, the best day we had in the hops was $9.12."
"Listen, people aren't through coming away from the state of Nebraska. They're not started yet. There's more dogs in lots of counties of Nebraska than there is hogs. I'll bet there isn't a hundred hogs in Hamilton County."
"I've never asked for as much as a piece of bread, and I ain't a-goin' to."

He believes in the Townsend Plan.[53]

GENERAL CAPTION NO. 60
DATE: October 3, 1939
PLACE: Eight Miles East of McMinnville, Willamette Valley, Oregon
SUBJECT: Yamhill Farm Family Labor Camp (FSA)

See Attached Bulletin

[This bulletin describes the need for the labor camps, referring to the success of camps in California, and the plan to help families to move from camps like this to new farms on irrigated land in the Vale area of Malheur County in eastern Oregon.]

A new camp of 176 units, construct[ion] just completed, not yet opened, to serve families who make their living through seasonal agricultural work.

Crops within a fifteen mile radius of the Yamhill camp:

19,233	acres of orchards	
955	" " berries	
2,000	" " hops	
22,188	Total acreage	

116. October 3, 1939. Near McMinnville, Yam-
hill County, Oregon. Looking down one street
in newly completed camp (FSA). Note garbage
disposal, street lights, street curbing, water
tank, and manager's house at end of street.

THE GOVERNMENT
AND THE FARMERS

LANGE BEGAN WORKING for the federal government in 1935 as an employee of the Resettlement Administration; by 1939 she was working for the Farm Security Administration, a shift in name that says it all. To Congress, which was less activist and more conservative than FDR's executive branch, "resettlement" smacked of government intrusion in the private lives of citizens, whereas "farm security" suggested the preservation of the independent farm and a Jeffersonian ideal, the yeoman farmer. Helping farmers remain independent was politically popular; moving and "resettling" families was not, especially when they were relocated to cooperative farms or subsistence homesteads, as was the case with the resettlement program. The FSA programs were a grab bag of initiatives inherited from several early New Deal agencies that had been dissolved or reformulated. The agency had four major divisions: Rural Rehabilitation, Farm Ownership, Resettlement, and Labor. Family labor camps and the health program for migrant laborers accounted for only 2 percent of the FSA budget, and resettlement for only 9 percent; far more significant, and less controversial, were rural rehabilitation programs, the actual core programs, intended to help farmers stay on their own land (59 percent of the budget), and the farm ownership program designed to assist tenant farmers in purchasing land (13 percent).[54]

Some of the FSA's resettlement projects, such as cooperative farms, were lightning rods that drew considerable criticism from Congress and the press. The resettlement program bought some large farm properties, subdivided them into smaller farms of forty to eighty acres (Yamhill Farms in Oregon were an example), and offered these small farms to those who owned parcels of land too small to be viable, those who had settled on poor, unproductive land, and those who, like the Granger family, had lost their own farms (figure 117). But to many members of Congress, farms that were set up and managed by the government, with farmers leasing property in common, sounded like the collective farms of the communist Soviet Union. As a consequence of such political controversy and public confusion, there was a continual demand for photographs to illustrate the full scope of the FSA's programs and their soundness and success. Lange recalled Roy Stryker's writing to the FSA photographers: "'For God's sake, when you're in Ohio, stop at least at such and such a project. The fellow is all right. Handle him as well as you can, and spend a day at it. We've got to keep

him quiet.' So we would do that." But, she added, "you'd be photographing the half-built buildings all the time, with the project manager and all his staff standing there looking at the camera."[55]

Many of the farmers Lange photographed in the Northwest were getting themselves established with support from rural rehabilitation programs that provided loans and technical assistance in farm management and home economics. The purpose, as the FSA put it, was "to help the dependent family regain its independence" by increasing its "cash income" and by improving "its standard of living."[56] When FSA borrowers like the Arnolds of Thurston County, Washington, could not meet payments on their farm, FSA staff helped them renegotiate the terms of their mortgage (general caption 36). Through cooperative ventures like the Ola sawmill in Idaho, farmers could purchase equipment together and pool their labor on their own farms; these cooperatives, unlike those of the resettlement programs, were initiated by groups of farmers, not by FSA staff (figure 120). Applications for standard FSA loans (for seed, livestock, equipment, and similar expenses) were first screened by an advisory committee of local farmers, who then recommended which applications should be considered.[57] An FSA family in distress might receive an emergency loan. In addition to cash loans, grants were also available, often in the form of essential commodities such as food, clothing, and pressure cookers or jars for canning vegetables and fruit. FSA grants and loans were generally small; the average loan increased from $240 in 1937 to $600 in 1940. But some were more substantial. The Adolf family, described by Lange, received $2,138, a large loan considering that the Adolfs held only a three-year lease on "Indian land" on the Yakima reservation, obtained under a program sponsored by the Office of Indian Affairs (dating from 1891) through which the federal government rented land owned by the Yakima to white farmers (figures 121–122).[58]

After a family received a loan, the county farm supervisor met with the farmer to develop a management plan for the farm and to review progress. A home management supervisor evaluated the condition of the family's house and furnishings, as well as the clothing, diet, and health of family members, helping the families to set up budgets and encouraging them to join community institutions such as churches or the local Grange, an organization of farmers.[59] To her general caption on the Arnold family (figures 123–125), Lange attached a home management supervisor's report from the local FSA files. The report was in the form of a long memo, followed by a short paragraph on the farm itself, probably written by the farm supervisor, revealing the values embodied in rural rehabilitation: education, thrift, sanitation, nutrition, cooperation, and community involvement (see appendix C).

Although critical of programs to resettle displaced farmers and industrial workers on subsistence homesteads, Lange and Paul Taylor, in the conclusion to their book, *An American Exodus: A Record of Human Erosion*, point with approval to the programs of rural rehabilitation:

A very old American ideal, crystalized in the Homestead Act of 1862, holds that our land shall be farmed by working owners. But history has made serious inroads on this ideal.... In order to preserve what we can of a national ideal, new patterns ... must be developed. Associations of tenants and small farmers for joint purchase of machinery, large-scale corporate farms under competent management with the working farmers for stockholders, and cooperative farms, are developments in the right direction.[60]

AWS

GENERAL CAPTION NO. 57
DATE: October 3, 1939
PLACE: Willamette Valley, Oregon
SUBJECT: Yamhill Farms (FSA)

A former Resettlement Administration project which was turned over to FSA represents a demonstration in which 105 farm families from the submarginal land areas or rehabilitation families having insufficient acreage were established on complete and developed farm units, in parts of Yamhill, Washington, and Polk Counties. Each unit is a diversified family sized farm, with modern buildings and improvements. Size averages about 75 acres with 40 to 50 in cultivation. They have forty years to pay for their units. Refer to Caption No. 58 for photographs of one of the community cooperative activities of this project.

This farm is one of eleven newly established farms on a contiguous piece of land. The owner from whom the RA [Resettlement Administration] purchased 500 acres had inherited the land, built himself a large home, and ran the farm with a manager. That farm was subdivided by RA into seven farms: three poultry units, four diversified. Adjacent to the east was a 400 acre farm, which was subdivided by RA into four diversified farms. All but one of the families were moved onto the project from submarginal farms in other parts of Oregon.

Cory G. Granger, aged 39. Born and reared in eastern Nebraska. Has lived on farms all his life. His people were prosperous, stable, Midwestern farmers; native Americans. Has had two years in high school and is interested in scientific aspects of agriculture.

Was married in 1929 and leased a 160 acre farm for himself. Didn't have sufficient credit to carry him through the bad years that followed and "lost out." Then operated on year to year basis, small scale, but the drought finally "finished me," and he decided to come West.

Granger left Nebraska with $7.00 in his pocket and hitch-hiked his way to Oregon. He landed at Eugene ten days later, with $2.80. He got a job on a dairy farm. His wife, three babies, and their household belongings arrived six weeks later. She drove out in an old truck. She was ten days making the trip. They then lived in an attic of a chicken house on the dairy farm with nine hundred birds on the lower floor. His wages were $30.00 per month, he worked 14 hours a day.

He is now reestablished on an 80 acre farm (Yamhill farms), 22 acres under cultivation. He plans a dairy unit. Has twelve cows. Has 95 laying pullets. The eggs pay for the groceries and the children's clothing.

117. October 3, 1939. Near McMinnville, Oregon. Farmer from Nebraska and his new barn on the Yamhill farms (FSA).

118. October 5, 1939. Near West Carlton, Yamhill County, Oregon. Farm women of the "Helping Hand" club display a pieced quilt which they are making for the benefit of one of their members.

GENERAL CAPTION NO. 58
DATE: October 3, 1939
PLACE: Three miles west of Carlton, Willamette Valley, Yamhill County, Oregon
SUBJECT: West Carlton chopper cooperative on Yamhill Farms (FSA)
Refer to General Caption No. 57 on Yamhill Farms, and negative 21896-C on same sheet

I

Photographs show cooperative community activity of eight farmers who live on adjoining land on Yamhill farms. They are shown storing the corn on the Miller farm (Unit No. 35), using the Papco ensilage cutter, which they have purchased on the cooperative purchase plan (FSA).

II

The wives of the members of this West Carlton chopper cooperative have formed a "Helping Hand" club. They meet once a month in each other's homes. Photographs were made on following Thursday afternoon in a home one-half mile from the Miller place. The ladies are making a quilt for the member in whose home they [are] sewing. She is going to have a new baby. They made a quilt last year, held a raffle and made $17.00. The money is now in the club Fund "for something that may come up." The club is two years old. "This is the smallest crowd we've had for ages, we're all so busy cutting up silage."

GENERAL CAPTION NO. 48
DATE: October 18, 1939
PLACE: Squaw Creek Valley, Gem County, Southern Idaho
SUBJECT: Ola Self-Help Sawmill Cooperative (FSA)

In about 1862 a group of pioneers moved into a little valley way back in the foothills of Gem County. Due to the lush feed growing upon the ranges and in the valleys they settled upon what is now known as Upper Squaw Creek Valley. They built log cabins and barns. They raised their families there, and their sons and grandsons still live there. As the years progressed more people came in. The log cabins were supplanted by wood farm houses—but Squaw Creek Valley is still an isolated and remote settlement of small farms 40 miles north of the nearest town, Emmett, over an unimproved road, which is impassible in winter. They are 30 miles from the nearest electricity.

In 1935, after years of overgrazing, lessened rainfall, and low farm prices, most of these families were on relief. They were living in houses which had depreciated until they were unfit shelter for people or livestock. The nearest supply of lumber available is at Emmett, which makes its cost, delivered to the farmer, prohibitive. Their own valley is bordered on the east by a forest that could develop an unlimited supply of yellow pine and Douglas fir. This forest is under the supervision of the Payette National Forest Service and permits could be obtained.

In the fall of 1935, 36 men made application to the Farm Security Administration for a loan of $1,500; this to be used for purchase of equipment to help establish a small sawmill. With the lumber produced they planned to rehouse themselves [and] to sell lumber to other small-scale farmers near them at prices which they could afford to pay, for shelter for the livestock, for fences for their fields. Also to use their lumber as a medium of exchange for commodities. This loan was granted late in 1936—the first group loan existing in Region XI (Washington, Oregon, Idaho).

That was three years ago. The cooperative has been successful. None of these families are now on relief. They have met the repayments on their loan. Their chief struggles have been in building the road up to the timber (see letter attached [not reproduced here]), since they had to use pick and shovel method, lacking heavy equipment. They have been handicapped in growth and in operation because they have had no working capital.

This community is now making application to the Farm Security Administration for an additional loan to supply this working capital. This is a farm valley, and they work in the sawmill in slack times as a supplement to work on their own farms. On the day photographs were made nine of the farmers were working in the mill.

I
These photographs show a view of the mill, Squaw Creek Valley, the farms, the kind of country which surrounds the mill.

II
These photographs show the kind of men who are members of the Ola Self-Help Cooperative.

Heard at the Mill, October 18, 1939:

"Now take this year—with the drought. If we hadn't a had the sawmill to drop back on to I don't know what we'd a done."
"I says, we don't want to replace a shack with another shack."
"We don't want to be asking too much in what we ask for, but we would like to see it so we don't have to be always rebuilding the road and fixing around so we can get a load (that is logs) out."
"We went to the Governor but he didn't understand—thought it was just more of a relief scheme."
"If we don't get the loan we'll go ahead just the same, but it will be a long slow process."

III
These photographs show the mill, members that work at the mill, members that work in the woods, member plowing.

119. Member of the cooperative lives in what was once the "Jacknife" Saloon. "Hasn't been able to get lumber for his house yet." This type building is characteristic of early Idaho. The stagecoach used to stop here, to change horses and for the refreshment of travelers. This continued in 1914.

120. Five Idaho farmers, members of the cooperative, in the woods, standing against load of logs ready to go down to their mill, about three miles away.-

DATE: August 10, 1939

PLACE: Yakima Valley, near Wapato, Washington

SUBJECT: Rural rehabilitation, F.S.A.

Name of client, Chris Adolf. Amount of loan, $2,138. 80 acres of Indian land, on three year lease.

Came to the Yakima Valley in 1937 from Bethune, Kit Carson County, Colorado. He owned his own farm there and he had lived there all his life. Drought forced him out with his wife and 8 children. His wife had been a school teacher. "I'd like to go back. I was born and raised there and it was hard to leave, but my wife and my children don't want to go back."

"I've broke thousands of acres of sod. The dust got so bad that we had to sleep with wet cloths over our faces."

All 8 children live at home, all work on the farm, and the family are making a good start.[61]

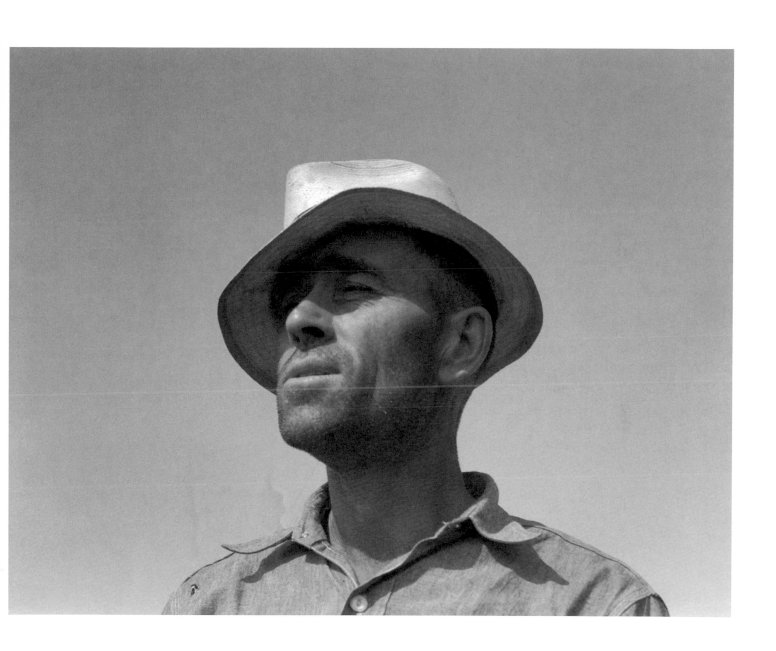

121. August 10, 1939. Yakima Valley, near
Wapato, Washington. Rural Rehabilitation
(FSA). Portrait of Chris Adolf. "My father *made*
me work. That was his mistake, he made me
work too hard. I learned about farming but
nothing out of the books."

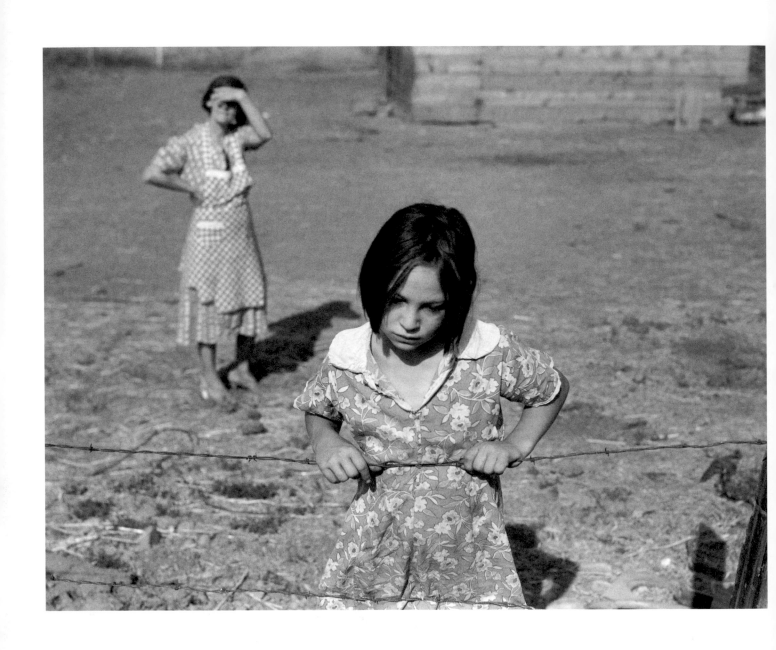

122. August 10, 1939. Yakima Valley, near
Wapato, Washington. One of Chris Adolf's
younger children.

DATE: August 14, 1939

PLACE: Thurston County, western Washington

Thurston County is a cut over area. There are 2,900 farms in the county. 900 are adequate, 500 are farming less [than] 5 acres. Many refugees from drought in other parts of the U.S. are settling, or attempting to settle, in this part of Washington. Some became Rural Rehabilitation borrowers of the F.S.A. 14 of these borrowers are now operating under the new "Non-Commercial Experiment," devised where it seemed impossible for the borrowers to continue under land debts and standard rural rehabilitation loans; to scale down the basis of their loan, to enable them to continue.

These Non-Commercial Experiment borrowers are located in a section called Michigan Hill. The Bulldozer, under contract, has been employed to help them clear needed acreage. Strawberries for the canning industry are being developed for a cash crop, after sufficient land is cleared.

Arnold family, example of Non-Commercial Experiment borrowers. This family came to Thurston county from Las Cruces, New Mexico, where they sold out their place for $2,000. Had written to the railroad company for information regarding western Washington and arrived by train in May 1935 [railroads had resettlement offices with immigration agents]. Three days later they had made a payment of $1,200 on 80 acres of uncleared land. This is the farm which they are now developing. At first they lived in a tent. They grubbed out 80 stumps from what is now the hay field in front of their present house which they built themselves, since. All the children work.

They are planning and depending on considerable acreage in strawberries for cash income. This year, just before harvest, there was a frost.

The Arnold family have had some clearing done by Bulldozer, but only for uprooting and moving the stumps. All clearing of the debris, the leveling and filling, they and their children are doing themselves. This family have done a tremendous amount of hard physical labor in order to gain what they call independence.

Mrs. Arnold: She was unwilling to have any photographs made in or even around the house, which was messy and unkempt. She explained that she was unable to attend to household affairs properly because she put in all her time "on the place." She plans however a "nice house, with a porch across the front."

Mr. Arnold was not at home on this day. He was working on another farm nearby on an exchange of labor.

The two oldest Arnold children earned money picking strawberries during the past season for neighbors. The boy earned $8, the girl $7. This money they gave to their parents with the exception of the following expenditures:

Boy		**Girl**	
Bicycle	$2.00	Shoes	$1.39
Shoes	2.19	Slacks	.59
Fishing pole	1.00	Set of combs	.10
Reel & line	.62	Needle book	.15
Hooks	.05	3 pr. socks	.39
Salmon eggs	.10	apron	.49
3 pr. socks	.39	candy	—
hat	.25		
mattock and ax handle	.50		
candy	—		

The Kytta family, Non-Commercial Experiment borrowers (F.S.A.). The family are building a well on the place. When they received their loan they were on W.P.A. They have cleared 8 acres. The father can not be shown in the photograph for he was down 45 feet digging in the well, the boys worked with him, the mother and daughter watched. They came from Michigan three years ago, have been on this place for 2 years. The father had been a copper miner.

Mother says, "I hope it's worth it, but we don't know for sure, but we do know you have to work hard anywhere, and we're willing."[62]

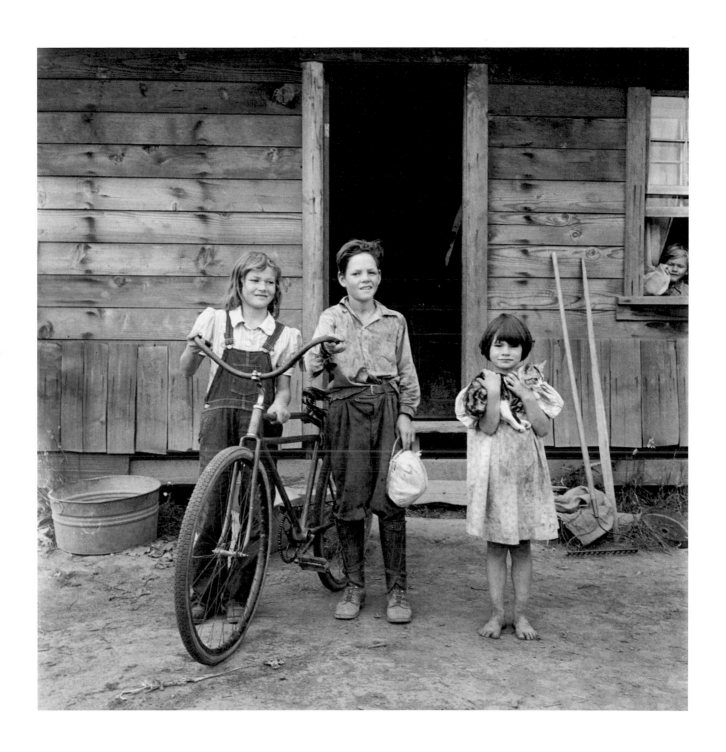

123. August 14, 1939. Michigan Hill, Thurston
Co., Western Washington. Three of the four
Arnold children. The oldest boy earned the
money to buy his bicycle.

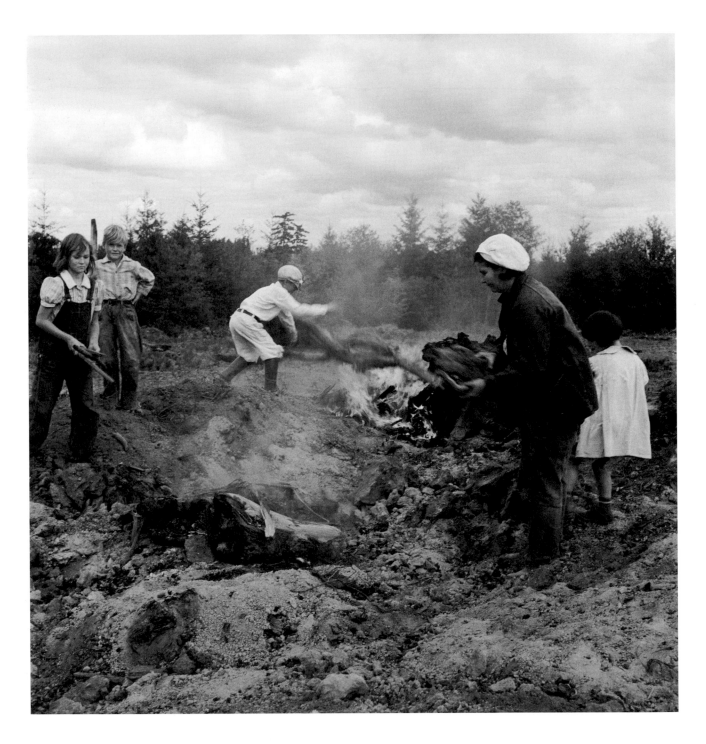

124. August 14, 1939. Michigan Hill, Thurston Co., Western Washington. After the bulldozer has taken out and piled the heavy stumps, the family gather the debris, roots, and chunks, from the field to the stump pile for burning. Negative made in rain.

125. August 14, 1939. Michigan Hill, Thurston Co., Western Washington. The Arnold children and mother, on their newly fenced and newly cleared land. Note strawberry plants.

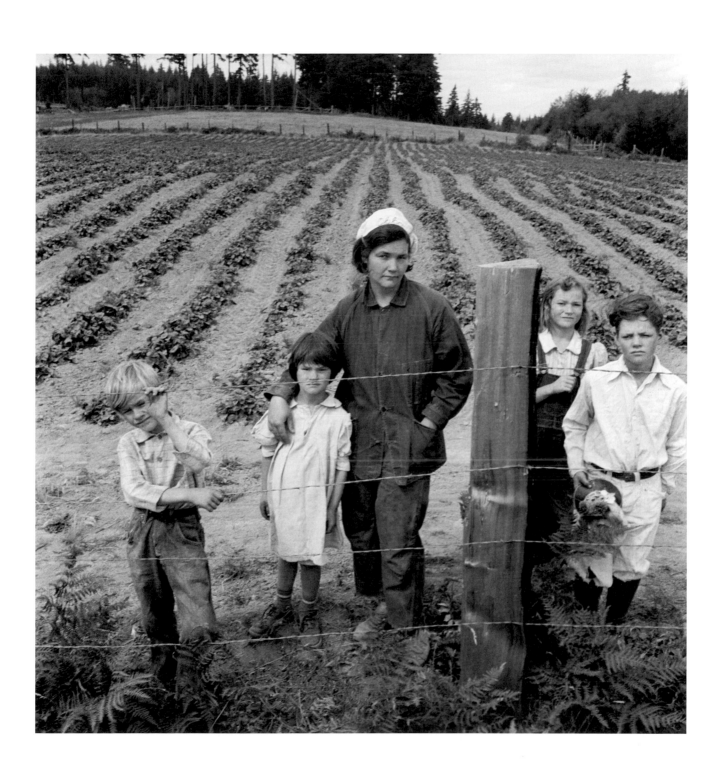

THE CUTOVER LAND

LANGE ENCLOSED A PROMOTIONAL PAMPHLET from the Humbird Lumber Company (founded by J. A. Humbird and Frederick Weyerhaeuser in 1900) with her general captions on the settlement of cutover land in northern Idaho. "Owners keep chickens all over the world, but in Bonner County, Idaho, the chickens keep their owners," crowed the pamphlet.

Crop failures are unknown.... Strawberries, huckleberries, raspberries, dewberries... are found growing wild.... A few days spent in catching whitefish during the winter furnishes the family salt fish during the year.... Avoid the blizzard-swept prairies and hot winds. Come to Idaho and enjoy life in a timbered country, where water is plentiful and pure, soil strong and quick, climate mild and equable—where you can buy of us close to good markets, in any size tract in rich, alluvial, protected valleys along a railroad.[63]

The smooth-tongued brochure also included a map of land for sale. T. L. Greer, manager of Humbird's Land Department, invited farmers to "write me fully of yourself, telling me your experience, what family, how much capital you can bring, as well as your equipment. Give me facts, then I can honestly advise you what to do.... We are Lumbermen. Not land promoters.... REMEMBER We are here to make good every promise made you."[64] One family, the Halleys, told Lange that they had seen Humbird's advertisement in *Western Farm Life*, had written for more information, and were persuaded by it to sell their farm in New Mexico and move to the panhandle of northern Idaho to purchase cutover land there (figures 138–139). (The advertised price was ten to twenty dollars an acre, but the Halleys paid twenty-five dollars an acre.)

Humbird was right in asserting that the lumber industry in the Pacific Northwest was not in the land promotion business, at least not typically. Most timber companies simply abandoned logged-over land, refusing to pay taxes on it. When the land passed into county ownership for tax default, the resulting tax burden shifted to farmers and to business owners, who now had fewer customers. From 1930 to 1936, the lumber industry "failed to show a net profit."[65] Entire towns disappeared; others, some of them company towns, struggled to survive. Lange photographed the Mumby Lumber Mill in Malone, Washington, as it was being dismantled, with the mill workers' cottages rented out to WPA workers (figures 126, 127).

In the face of declining population and insufficient tax revenues, other towns found it difficult to maintain basic services and institutions such as schools. In Tenino, on U.S. 99 in Thurston County, Lange photographed the padlocked door of a lumber company as well as the town's main street. "The question which faces this town and many others in western Washington," Lange observed of Elma, a few miles north of Malone, "is 'How can the loss of the lumber mills be absorbed?'" By 1939, seventy-six towns in the Northwest once "devoted to wood products . . . had completely disappeared," reported the Pacific Northwest Regional Planning Commission.[66]

The forest industries were the Pacific Northwest's most pressing social, economic, and environmental problem, the biggest threat to the region's future prosperity, according to political scientist Charles McKinley, who offered the keynote address, "Five Years of Planning in the Pacific Northwest," at a 1939 conference.[67] Harvesting timber and abandoning the cutover land had wasted resources, produced social misery, and threatened to deplete the nation's largest remaining timber supply in a matter of decades.[68] Everyone, including many lumber companies, seemed to agree on the solution: to replant forests and manage them in ways that could produce a "sustained yield." But there were obstacles, including a tax system that made it expensive to retain forested land; hence, the practice of cutting and abandoning was financially most attractive to the lumber industry. Already thousands of acres of abandoned stumpland were a serious fire hazard and a blight on local communities.

Farmers of the Pacific Northwest, well aware of the many failed attempts to establish farms on stumpland during the 1920s, were unlikely to buy cutover land. But the Humbird Lumber Company did manage to sell such land by publishing pamphlets and by advertising in magazines in other parts of the country. It was unemployed mill workers and farmers from outside the region, like the Halleys from New Mexico, who settled the stumpland in northern Idaho. The Arnolds, also from New Mexico, purchased cutover land in western Washington. With her caption on the Arnolds (general caption 36), Lange enclosed a promotional pamphlet from Weyerhaeuser, titled "Live—Farm—Play," similar to the one produced by Humbird.

Nelle Portrey Davis's 1942 memoir, *Stump Ranch Pioneer*, describes what many settlers faced. She and her husband sold their sheep ranch in Colorado and drove fifteen hundred miles to Bonners Ferry, Idaho, with two children and all their belongings, attracted to northern Idaho by reports of "cheap land, good soil, and abundant moisture." The day after they arrived, they purchased forty acres from a widow whose husband had been killed by a falling tree. Like the families portrayed by Lange, the Davises spent their first year clearing trees and stumps. They were "just plain lucky" in their choice of land; other locations within a mile of their new home were free of frost for only one month a year or had sandy, thin, and infertile soil.[69] Attempts to farm such land were futile.

In 1938, FSA published "Suggestions for Prospective Settlers to Idaho, Oregon and Washington," which listed the county agricultural agents and FSA county supervisors, who could provide expert advice, and urged: "Get your help

before you buy land." Declaring that "land of good quality is no longer available at low price," this publication warned that it would take at least sixty to eighty acres to support a family in northern Idaho and that to bring cutover land into cultivation would require years of work, another source of income, and considerable capital investment: "*at least five or six thousand dollars* is usually necessary for a farm business that will provide an income sufficient for even a minimum family living."[70] But these warnings came too late for those who had already bought land.

With stump farms providing only a bare subsistence, farmers bartered and traded labor to supplement what food they could grow, gather, or hunt. The Davises milked a neighbor's cows in exchange for milk; the Halleys got a share of the potatoes they raised on someone else's land. According to Nelle Davis, the average stump ranch wife would say that she canned between four hundred and eight hundred quarts of fruits and vegetables annually. "But," she added, "this answer is misleading.... As the spring and summer vegetables are used, the jars are refilled with winter produce."[71] Cash was hard to come by, although it was necessary: for taxes and mortgage payments; for goods such as flour, clothing, nails, equipment, dynamite, and kerosene; for a doctor or bulldozer operator; or for the electricity that was introduced to the area in 1939 as part of the New Deal's rural electrification program. To get cash, Davis's husband split, stacked, and sold cords of firewood; in the fall, he cut hay and hauled wheat on the large farms in the bottomlands. The Halleys' cash income came from the father's job with the Works Progress Administration and the son's employment in the Civilian Conservation Corps, which provided work, food, and shelter for young unmarried men and required them to send home part of their pay.

During their second year in Idaho, Davis supplemented her family's income by writing a column for the county newspaper about daily life on a stump farm. In response, she received letters from all over the country, from "Dustbowlers" and "unemployed city dwellers."[72] In 1941, after the *New York Times Sunday Magazine* published her article "Out of the Dustbowl into 'Paradise Valley,'" Davis was asked to expand the account into a book, which became *Stump Ranch Pioneer*, published in 1942 and reviewed by the *Times*. Urban readers were undoubtedly entertained by the idealized tales of heroic frontier living. Davis provided detailed descriptions of life and landscape and was frank about the hardships, but she was also a booster, her tone echoing the manager of Humbird's Land Department. "She's probably sold more real estate through her book than any real estate agent," one emigrant told a reporter.[73] Seven years after the publication of *Stump Ranch Pioneer*, Davis and her husband left their farm in Paradise Valley to establish a guest ranch near Bonner's Ferry.

The realities of stump farming, as Lange's photographs and captions attest, were far starker than Davis's depiction. Walter Duffy, director of FSA's Northwest region, sent Lange a memo about the conditions that confronted migrant families from "the drouth-stricken Great Plains" in the cutover lands:

Thrifty and hard working farm families ... found an altogether different Far West than the early pioneers. Free land was gone.... Good, undeveloped farms were scarce. Unscrupulous real estate agents were ready to rob them of their meagre savings by selling them worthless farms in the vast cut-over areas, where free wood and water were the only assets.... Those with small savings of several hundred dollars, were forced to locate on once-abandoned farms in the cheap land areas, doomed to failure before they began. Some invested their savings in "stump ranches" ... where costs of clearing enough land for a productive farm ranged from $40 to $200 per acre. Making a down payment with their savings, they soon found themselves penniless.[74]

Although the FSA scrambled to mobilize support for the families who settled on these stump farms, the agency was frustrated in its attempts to prevent the purchase of land that was unsuited to agriculture. The staff of many federal, state, and local agencies described the problems and advocated solutions. The Pacific Northwest Regional Planning Commission amassed stacks of reports about the region's economy and environment and ideas about how to plan its future. In 1938 the Northwest Regional Council was formed to disseminate this information to the public, to serve as a clearinghouse, and to foster cooperation. It produced the "Know Your Northwest" series of publications on regional problems and resources, designed for use by teachers and students. Lange finished her assignment in the Pacific Northwest in October 1939, just as the council was preparing to publish a book, *Caravans to the Northwest*, that summarized the research and planning documents compiled for the region. Published by Houghton Mifflin in 1940 (in two editions, one for bookstores and the other for public schools), it was lavishly illustrated with Lange's photographs and was promptly adopted for use in junior and senior high schools in Seattle, Spokane, and Portland.

AWS

DATE: August 14, 1939

PLACE: Malone, Grays Harbor County, western Washington

SUBJECT: Abandoned mill town

Refer to General Caption No. 38 ["Another western Washington town"[75]]

This is the mill upon which the life of the town of Elma [a town nearby] has largely depended in the past. It is now being dismantled, its machinery being sold for scrap. The mill was closed down in 1938 because of labor trouble and rapidly exhausting timber resources. Now, after 35 years of operation, the timber is too far away from the mill.

The mill workers have all moved away—gone elsewhere. The mill houses are for sale, and being sold mostly to W.P.A. workers, who find it cheaper to buy a place from the Lumber Company than to pay rent in Elma. Price of these company houses is $100 to $150 depending on whether there is a bath. They are sold on terms. They are all occupied.

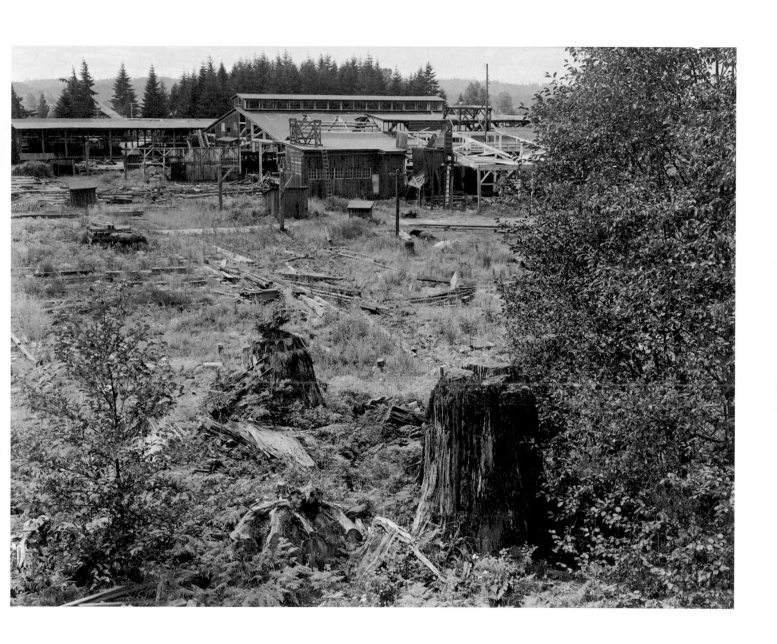

126. August 15, 1939. Malone, Grays Harbor
County, Western Washington. Mumby
Lumber Mill, closed in 1938 after thirty-five
years of operation. Now being dismantled.

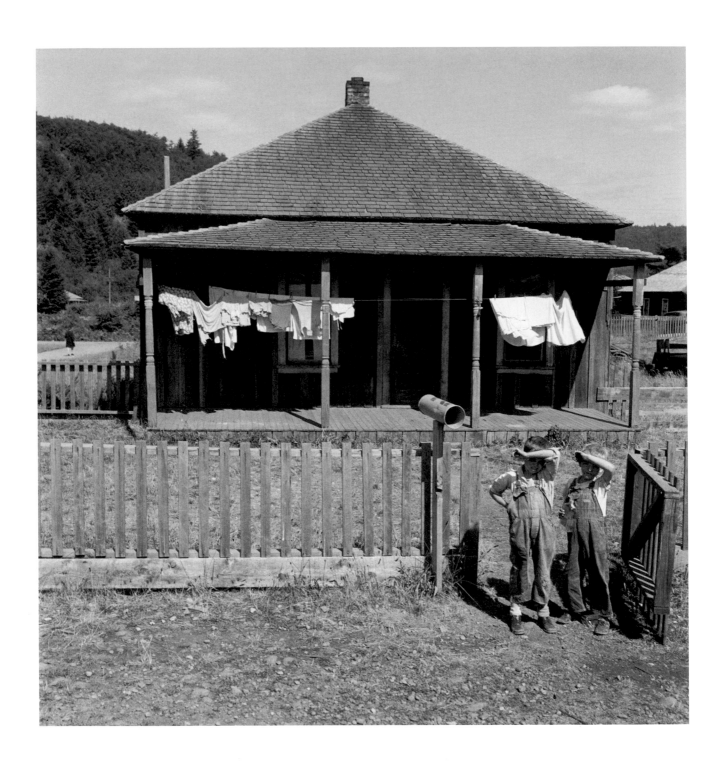

127. August 15, 1939. Malone, Grays Harbor County, Western Washington. Company house in abandoned mill village now occupied by WPA workers.

128. August 16, 1939. Near Vader, Lewis County, Western Washington. Bulldozer contractor's car.

Various types of Caterpillar tractor "Bulldozer" machines are now used in the Northwest to clear cut-over timber land for farming. Bulldozer is the name given to a crawler type of tractor which has an adjustable heavy duty grader blade or tooth blade mounted in front. This equipment pulls, pushes, lifts stumps, and digs and levels land.

Bulldozers and operators (called "Cat skinners") work on contract, generally a price per hour. The contractor on the Nieman farm charges $6 per hour which included his three helpers who clear and stack debris.

In the Spring of 1939 there were 71 such bulldozer contract outfits operating in the state of Washington. The machine costs $7,000 to $8,000. The method is still in an experimental stage but offers a real chance of cheap land clearing. The stumps are first loosened by dynamite.[76]

GENERAL CAPTION NO. 49
DATE: October 20–23, 1939
PLACE: Bonner and Boundary Counties, Northern Idaho
SUBJECT: Recent settlement of cutover lands in northern Idaho

Boundary County is the northernmost county of the Idaho Pan-Handle, bounded on the north by Canada. Bonner County joins it on the south. This is a logged-off region, the big lumber mills are abandoned. It was once heavily forested with stands of Ponderosa pine, Douglas fir, Larch, Cedar, and Hemlock. Agriculture settlement on the bench lands of this region began as early as 1902, but was relatively unimportant until 1932. A major portion of the settlement has taken place since then. The river bottom lands are held in large ownerships. They are the richer lands and are high-priced.

The majority of the new settlers of northern Idaho are land hungry farmers from the drought stricken areas of the Northern Great Plains states. South Dakota leads in the number of people who have fled here—then North Dakota, then Colorado. Many Washington, Oregon, and Idaho families are also attempting to establish farms here, of whom the heads have formerly worked in the lumber and forest industries.

Advertisements of cut-over lands by railroad and lumber companies desirous of disposing of their logged-off land have brought many of these new families. (Note advertisement of Humbird Company in file.) Practically all the land available for settlement is privately owned, with lumber companies holding the bulk of it. The price of the land appears low. Many contracted for land they had never seen. They have bought raw lands, partly developed farms, which were abandoned by previous settlers. Many come with little cash, many come with no cash, and no equipment. Forty three percent of the land purchased by new settlers for farming is classified by the United States Department of Agriculture as non-agricultural. The most recent settlers are taking up the poorest land.

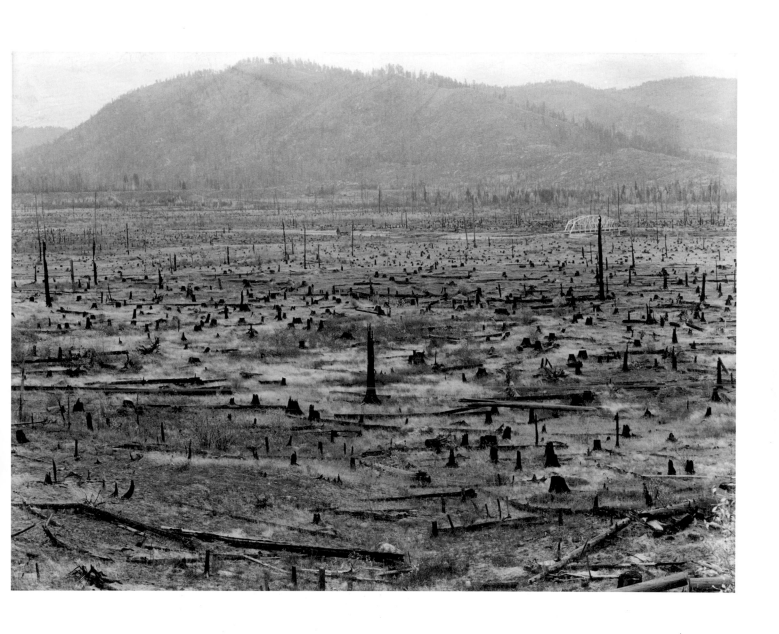

129. October 22, 1939. Bonner County, Idaho.
Priest River Valley, where new settlers grow
hay between the stumps.

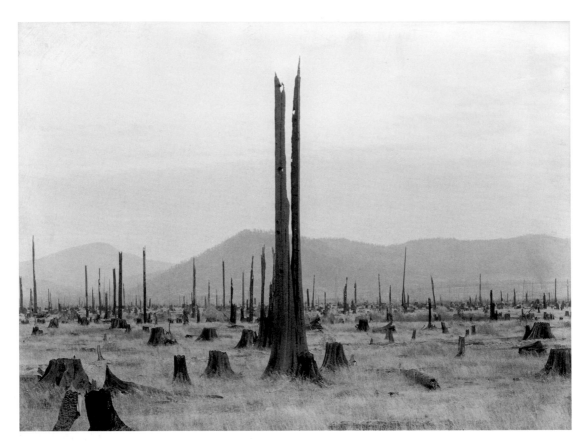

130. October 22, 1939. Bonner County, Idaho. Shows character of land which new settlers are buying in the Priest River Valley.

132. *(Facing, bottom)* October 22, 1939. Priest River Peninsula, Bonner County, Idaho. Shows log home. Farm established 6 years ago.

131. *(Above)* October 21, 1939. Bonner County, Idaho. This farm has been occupied by four different families since 1936:

Claude Sargeant '36–37 failed
Lenny Davis '38 failed
Roy Silton '38–39 failed
Davy Walker '39

The soil is sandy and the effort of clearing has been wasted.

The severest problem which newcomers in this area have to face is that of getting enough land cleared to support a farming enterprise and their inability to make a living because of the difficulties involved in getting rid of stumps. Farms in the cutover area are most commonly 160 acres in size, but very few farmers have been able to clear more than 30 for cultivation. Of [illegible number] cases of new settlers studied in Boundary and Benewah counties (Bureau of Agricultural Economics—1939), 36 percent have cleared at the rate of less than one acre per year, 35 percent have cleared no land, 39 percent have been clearing two and a half acres or more.[77] The median is 1½ acres per year. At this rate it would take a settler nearly 12 years to get 20 acres under cultivation. Lack of cash dooms the new farm family to years of hard manual labor before even a modest amount of cleared land can be obtained. There is very little supplementary income from outside work, since mills have closed down [and] the region is sparsely settled, remote from commercial enterprises.

The Farm Security Administration is assisting these people to develop their farms by granting powder loans and loans for land clearance by the bulldozer method. (See general caption #41 for photographs of bulldozers operating in Washington, August 1939.) Fifty land clearing loans were made by the Farm Security Administration in this area during the spring and summer of 1939.

190 Bonner county, Idaho, families have received standard loans totaling $54,758, of which $15,846 principal and $1,257 interest has been repaid. A total of 340 families have received grants totaling $42,835. Of this number, 84 were also standard loan clients. 23 active cases at present, 19 families from drouth area.

142 Boundary county families have received loans totaling $33,049, repaying $6,623 principal and $381 interest. 99 families have received grants totaling $15,617. 47 of these families also have standard loans. There are only 3 active grant cases now, 2 of whom are from the drouth area.

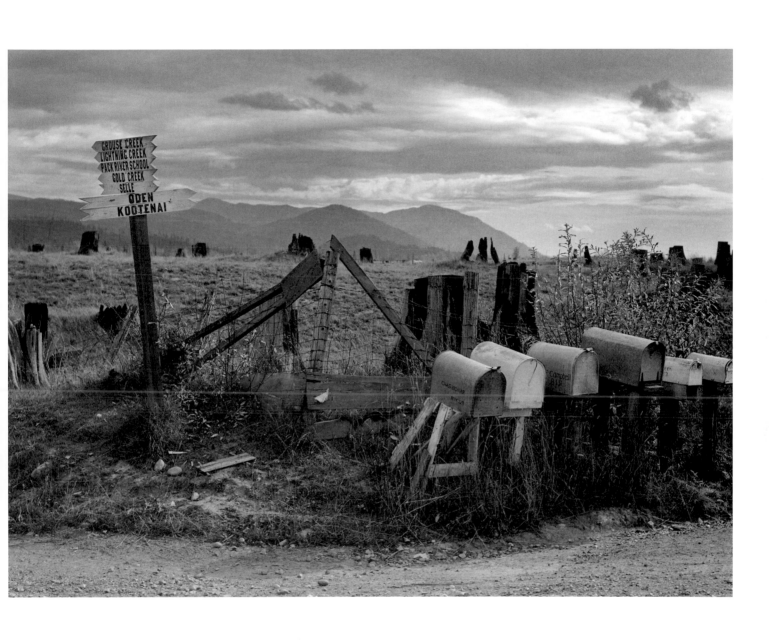

133. October 23, 1939. Boundary County,
Idaho. Roadside at crossroads, off the high-
way in cutover area.

GENERAL CAPTION NO. 55

DATE: October 23, 1939

PLACE: Six miles North of Sandpoint Boundary County, Northern Idaho
Refer to General Caption No. 49 for information regarding this county

NAME OF CLIENT: Denchow (FSA borrower), standard rehabilitation loan $99.00, land clearing loan 250.00

This farm belongs to a family who have been in this region for years. They were mill workers and forced to farming when the mill closed down some years ago. Were handicapped by lack of team for clearing operations. The soil on this farm, Mission Silt Loam, is the best type in the county. FSA loaned the money for a team (appearing in photograph) and additional money for hiring the Bulldozer, on contract. The Bulldozer worked for twenty hours and cleared the tract (eight acres) in which photographs were made.

Photographs show the land being cleared after the Bulldozer has pulled out the stumps. A son, ex-millworker, picks up the roots and chunks and loads them on the sled, bound for one of the stump piles in the field. The sled will then be unloaded, piece by piece, and the pile burned. Land clearing is arduous and slow work.

"The little stuff is almost as much trouble as the big stuff, because it makes your back tired leaning over to pick it up all the time."

134. October 23, 1939. Boundary County,
Idaho. Cedar stump in field which family are
clearing by means of FSA loan.

135. *(Facing)* October 23, 1939. Boundary
County, Idaho. Ex-millworker clears 8-acre
field after Bulldozer has pulled the stumps.

GENERAL CAPTION NO. 50
DATE: October 23, 1939
PLACE: Bonner County, Northern Idaho
NAME OF CLIENT: Cox (FSA borrower)

This family came to Bonner County in 1936 from Western Nebraska, where they were farm owners. Drought refugees. Grown son came first with his young wife, bought a piece of land, and on his son's recommendation, the father (aged 54) bought this 80 acre uncleared piece from the Humbird Lumber Company. He paid $800.00, terms, $80.00 per year on the principal. The interest is six percent on unpaid balance. His taxes now are $16.76 per year (unimproved land).

In April 1936, shortly after arrival, the Cox family applied for a loan from FSA for powder to clear land. This was the first Government help for which Mr. Cox had ever applied. The loan was for $60.00. In May, 1939, he applied for an additional loan of $246.00 for land clearance (Bulldozer). In three years Mr. Cox and his wife have built a small house, farm sheds, and cleared 17½ acres of land. They plan to clear 30 acres in all, which they believe enough to raise feed for six cows.

Mr. Cox says that the Humbird Lumber Company have been fair to him, "But there are two things wrong":

1. Their prospectus makes clearing sound easy.
2. After people become discouraged and move off, they raise the price of the land for the next fellow.

"I'd like to go back home to Nebraska for a visit but I never want to go back to live."
"If I had to do it over again I'd never go on a place like this."
"This is all right for a young man—but I'm past fifty years old."

136. October 23, 1939. Bonner County, Idaho. Portrait of ex-Nebraska farmer, now developing farm out of the stumps.

137. October 23, 1939. Bonner County, Idaho. Ex-Nebraska farmer, and the piece of his cutover farm which he hopes to clear next year.

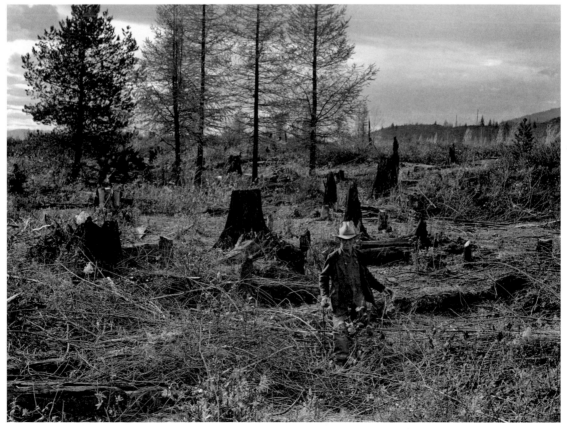

GENERAL CAPTION NO. 51

DATE: October 22, 1939

PLACE: Priest River Peninsula, Bonner County, Northern Idaho

Refer to General Caption No. 49 for information about this county

NAME OF CLIENT: Halley (FSA borrower)

This family came from Guadalupe, New Mexico, in June 1938. They had read an advertisement of the Humbird Lumber Company in *Western Farm Life*, published at Denver, Colorado. They sent for literature (see literature in file [Humbird Lumber Company, "A Naturally Timbered Country Is the Best for the Farmer"]) and decided to come. They have seven children, ranging in age from one year to twenty. The two oldest are high school graduates.

The family bought a partly developed farm, in the stumps. They applied to FSA for a grant. For the past six months the father has had WPA work. Boy in CCC sends $22.00 a month. FSA has just approved a land clearing grant to this family ($135.00).

The price of this farm was $1,500.00, 60 acres. They paid $300.00 down, balance to be paid at $150.00 per year plus six per cent interest.

They have enlarged the barn, built another room on the cabin, started an orchard, canned 500 quarts of vegetables and fruits (procured by trading), and farmed another nearby place, which was already cleared. They work on this place on shares; got 65 sacks of potatoes from a ½ acre patch, which encourages this family in their belief in the future of this country, once the land is cleared.

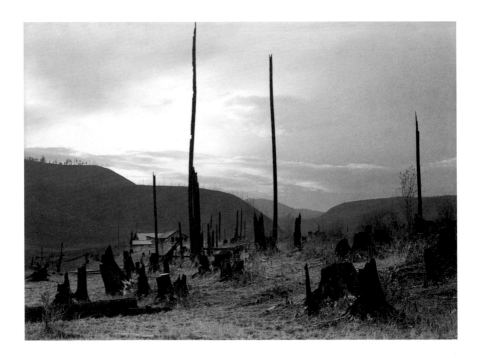

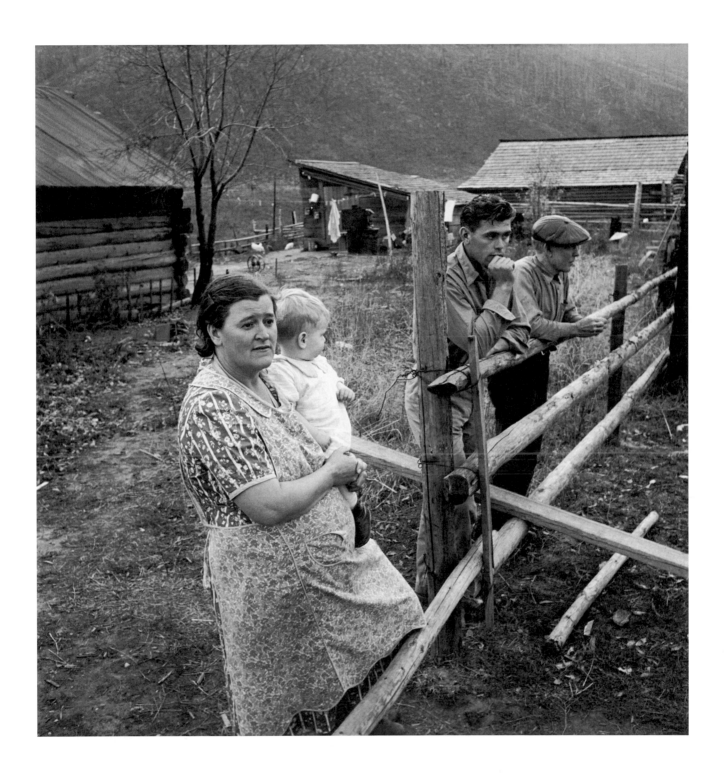

138. October 22, 1939. Priest River Peninsula, Bonner County, Idaho. View of the Halley farm, from the road which winds through the stumps leading to it.

139. October 23, 1939. Bonner County, Idaho. Members of the Halley family look over their new place, on a Sunday afternoon.

DATE: October 21, 1939
PLACE: Boundary County, Northern Idaho
Refer to General Caption No. 49 for information about this county
NAME OF CLIENT: Unruh (FSA borrower)

140. October 21, 1939. Boundary County, Idaho. The Unruh family.

141. October 21, 1939. Boundary County, Idaho. Father and son have cleared 30 acres of raw stump land in three years.

This is a Mennonite family with three children. They were wheat farmers, owned 600 acres in 1930 in western Kansas. "Dust overtook me and I lost my place." Came to Northern Idaho, three years ago, "broke almost." Bought this forty acre farm from private owner, for twenty dollars an acre. Paid $25.00 down, terms $50.00 per year. "In 1936 when I came, we couldn't turn around on this place, stumps were so big."

Have cleared 29 acres in three years, have good soil. Have put up farm buildings. Have poultry and cows, garden, and put in 24 fruit trees. After they had been on the new farm two years, applied for land clearing loan from FSA (Bulldozer). Clearing cost $18.00 an acre. They have no well yet, still hauling water in barrels for domestic use. Rural electrification came in in 1939.

"I knew it was a lot of work when I come here, but I wouldn't know where else to go. This is the only place I could see where I could get a start again."
"Next year, if I can, I build me a decent barn."
"When I get this cleared up I'd like to get another patch close and clear it. My boy will want some later on."

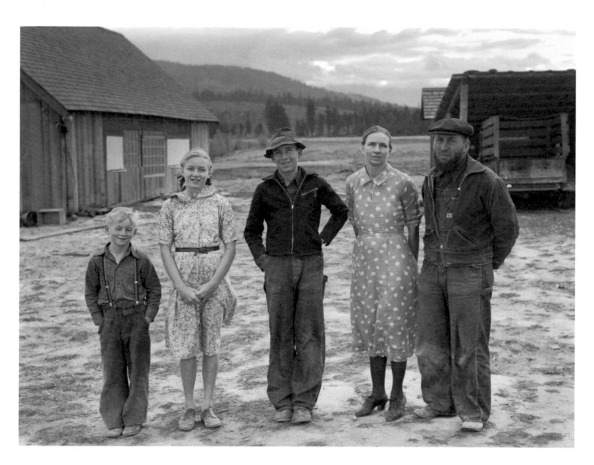

GENERAL CAPTION NO. 54
DATE: October 22, 1939
PLACE: Priest River Country, Bonner County, Northern Idaho
Refer to General Caption No. 49 for information on this county
NAME OF CLIENT: Evanson (FSA borrower)

This couple were born in Norway and married there, 25 years ago. Came to the United States, settled in North Dakota. They stayed there three years then moved to Northeastern Montana where they lived until "the drought burned me out." They heard of the cutover land through a neighbor in Montana. Started buying 90 acres in the Priest River Valley and have been living on this place for one year. Borrowed $100.00 from FSA for land clearing. Their children are now grown. Mrs. Evanson has never had time to learn to read English. They are now making their third start.

142. October 22, 1939. Priest River Valley, Bonner County, Idaho. Shows Evanson new home, looking across land which has recently been cleared by the Bulldozer.

143. October 22, 1939. Priest River Valley, Bonner County, Idaho. Interior of Evanson one-room cabin. Mrs. Evanson brought the plants with her from Montana.

GENERAL CAPTION NO. 56

DATE: October 21, 1939

PLACE: Boundary County, Northern Idaho

Refer to General Caption No. 49 for information regarding this county

NAME OF CLIENT: Nieman (FSA borrower, land clearing loan)

This family came here in 1933. The father had been a stockman, worked on large ranches, including that of United States Senator Carey, out of Cheyenne, Wyoming. Two sons are grown and married and have newly established farms on adjoining pieces to their father's. They work out every summer at day labor, on the large farms in the Kootenai Valley, below the bench lands on which their farms are situated. This family plan to develop dairy farms when they have cleared enough land to support a herd. They have orchards started.

Their buildings are substantial, but they have no well, which would cost $1,000.00. They have no garden for lack of water, and they haul their drinking water in barrels. Rural electrification came in this year.

"We couldn't make it if we didn't get to work out every summer."

"Our place ain't much yet without water."

"The Bulldozer has been a big help."

144. October 21, 1939. Boundary County,
Idaho. Another interior of father's two-room
log home. Have their alfalfa seed stored in
corner, "waiting for a better price."

THE IRRIGATED DESERT

"THIS TRACT OF LAND HAS A HISTORY." So begins a clipping that Lange attached to her general caption 35, "Columbia Basin, near Quincy, Grant County, Washington." The July 1939 article by Richard Neuberger tells of the basin's "ruined past," of a "sky from which no rain fell," of failed farms and deserted homesteads (see appendix C). Titled "The Columbia Flows to the Land," the lengthy article extols the Grand Coulee Dam, then under construction in central Washington, for the water and power it would deliver to the Pacific Northwest. The paragraph Lange clipped was the article's rhetorical pivot, an appeal to transform decline into progress, to fulfill, in Neuberger's words, the "dream of a Promised Land in the Northwest—a dream deferred almost half a century."[78]

"Six years ago national irrigation was a dream; to-day, the dream has come true," William E. Smythe had written in 1905 in the foreword to a revised edition of his 1899 book *The Conquest of Arid America*.[79] Smythe's "dream come true" was the National Reclamation Act of 1902 (also known as the Newlands Act). Neuberger's "dream deferred" was the application of the act, on a vast scale, to the Columbia Basin. The Newlands Act had authorized the U.S. Department of the Interior to plan and construct "irrigation works for the storage, diversion, and development of waters" and to establish prices at which irrigated lands would be sold. It limited the size of land holdings to be irrigated: "No right to the use of water for land in private ownership shall be sold for a tract exceeding 160 acres to any one landowner, and no such sale shall be made to any landowner unless he be an actual bona fide resident on such land."[80] By stipulating that larger farms were ineligible for water from federally funded irrigation projects, the new law declared its intentions: to help individuals establish family farms and not to enrich large landowners at public expense, a principle that had been the foundation of federal land policy since the Homestead Act of 1862, which specified that each homesteading family was entitled to no more than 160 acres (a quarter of a square mile or a quarter "section"). In practice that requirement of the Newlands Act was not enforced.

The designation of a quarter section was based on the size of farm necessary to support a family, or so the government had decided with the Homestead Act. It was also a convenient measure for surveying land and designating the location of property accurately.[81] But using 160 acres as a standard for a farm capable of supporting a family did not take into account the wide variation in climate and soil quality across the nation. Farmers had tried to settle "Arid America" be-

fore the Newlands Act, but settlement of desert regions had lagged far behind that of more humid and temperate areas. Forced to admit that not all land was equal when it came to farming, and that 160-acre farms in the desert might be too small to support a family, Congress passed the Desert Land Act of 1877, offering a homestead of one square mile (640 acres) to those who managed to irrigate the land for three years. That was easier said than done, however; few could afford to irrigate at the scale required, and many individual efforts failed, as did those of private irrigation companies. Farms on arid land were left without water, and crops shriveled.

Large wheat farms in the arid Columbia Basin had alternately flourished and failed in the nineteenth and early twentieth centuries when railroads first offered land, access, and transport. Wheat farmers in the town of Quincy, Washington, founded in 1902 along the newly constructed transcontinental line of the Great Northern Railroad, practiced dry farming—a set of techniques designed to produce crops in arid regions without irrigation—as did farmers elsewhere in the basin.[82] In 1939, Lange photographed abandoned homesteads near Quincy (figures 151–152). Drought was a factor in the demise of many farms, but it was not, as Neuberger implied, the sole cause. There were economic reasons as well, including a surplus of wheat and the collapse of the foreign market for wheat in the 1920s after European farmers returned to their fields at the end of World War I.

Federal support for the construction of dams and canals on a large scale promised a dependable and plentiful supply of water for the Northwest's arid regions, and the Newlands Act of 1902 was cause for celebration there. The town of Stokes, Oregon, on the Columbia River, changed its name in 1902 to Irrigon (combining the words *irrigate* and *Oregon*); Lange would later photograph Irrigon's railroad station and the tracks leading to the town through sagebrush desert (figures 145–147).[83] The Reclamation Service, established in 1902 to plan and carry out public irrigation works, quickly began to undertake projects. By 1905, the "reclamation" of the Klamath Basin was underway, and the area opened to homesteaders shortly thereafter. One farmer in Tulelake told Lange in 1939 that he had been there "when the first carload of potatoes left this valley in 1910" (figure 100).

Yakima was the third largest irrigation project in the nation in 1938. "Yakima has been a testing laboratory for what may occur on a larger scale at Grand Coulee," Neuberger wrote that year, in his book *Our Promised Land*. "Yakima was desolate once. . . . The irrigation ditches that tap the Yakima River are the line of demarcation; they separate Canaan from the wastes."[84] Although irrigation may not have been new to the Columbia Basin in 1939, when Neuberger wrote his article, "The Columbia Flows to the Land," the scale envisioned in the Grand Coulee project was unprecedented:

On the course of the Columbia through the state of Washington rises a dam that . . . dwarfs any . . . structure ever built. . . . This dam will irrigate more than 1,200,000 acres of wasteland. It also will generate the largest chunk of electricity produced

at any place on earth. . . . Here is the American dream: the conquest of wilderness, a nudge at the final frontier. Grand Coulee. . . . typifies the nation. Here are the ingenuity, the resourcefulness and the peremptory action of big business. . . . Here also . . . is the social consciousness of the New Deal. . . . Grand Coulee will span the region with steel-latticed towers carrying cheap power to ranch and bungalow. Wandering men and women . . . form a migratory population all over the West. Their rehabilitation is a crucial problem. Grand Coulee will irrigate land for as many farms as there are in the entire state of New Jersey. All this will be controlled by the government, with speculation and profit subordinated to the general welfare.[85]

Settling people on "as many farms as there [were] in the entire state of New Jersey" (in 1939) would be an enormous undertaking. As a guide for how to settle a large population of farm families on reclaimed land in a short time, researchers for the U.S. Bureau of Agricultural Economics (BAE) carefully studied a smaller project in Malheur County in eastern Oregon. More than one thousand farms were established in that county during the 1930s as part of reclamation in the Vale and Owyhee Irrigation District, over seven hundred of them between 1936 and 1938 (figures 154–157). The BAE's findings were described in a report, "New Farms on New Land," which attempted to formulate guidelines for future projects. Lange must have read this report while working in the field for she underlined passages in it (about the preponderance of middle-aged settlers, for example) and scribbled notes in the margins that would guide her photography ("portraits," "houses," "look for old pictures").[86]

The Bureau of Reclamation (the renamed Reclamation Service) had considered undertaking parts of the Vale and Owyhee projects for nearly twenty-five years before actual construction began.[87] The region was a desert, with fewer than eight inches of precipitation per year, mostly falling as winter snow, with rain rare in summer. Farming was impossible without irrigation. By 1926, the private irrigation districts that had brought water to the bottomlands were already on the verge of ruin when the Bureau of Reclamation stepped in to repair the systems, build a dam, and bring water up to the "flats," benchlands about a hundred feet above the river valleys. By the mid-1930s, the new irrigation system in Malheur County was in place, and the land had been consolidated and divided into separate farm units before property was offered for sale on the Vale and Owyhee projects. The initial price of land was set, with limits placed on resale to control speculation. In selecting homesteaders for that land, the bureau required previous farming experience and gave preference to those with sufficient capital to purchase land and equipment and sustain themselves for the initial years. During the first two years, all farmers would find that expenses exceeded income; it would take at least three to four years for some farms to break even.[88]

"Everything was sage brush as far as you could see, there was only one house," Mrs. Hull told Lange, describing how Dead Ox Flat looked when she and her family arrived in 1936 (figure 158).[89] Water from the Owyhee Reservoir, forty

miles away, flowed through tunnels, in canals, and, under pressure, was siphoned up and down the sides of valleys in pipes. But the water was for irrigation, not drinking, and besides, it was shut off each fall in mid-October and not turned on again until spring. Until families like the Hulls could afford to drill a well, they had to haul drinking water in barrels from the town of Ontario, ten miles away over roads of rutted dirt (figure 163).

As a condition for construction of the Vale and Owyhee projects, the Bureau of Reclamation had required owners of more than a quarter section of land to sell any excess above 160 acres at a stipulated price. But most new settlers could not afford even the 160 acres in a quarter section, at least at the beginning. The authors of "New Farms on New Land" concluded that a minimum of eighty acres could support a family with children; forty acres would employ one man without children to help with farm work and, without an additional source of income, could support only two people. Many FSA clients, like the Roberts family, who had two or more children on only forty acres, were now struggling to get by. Others were doing well; the Hulls, also with two children, owned eighty acres in 1939 and hoped to purchase an additional forty.

"Farms too small" was a principal cause of rural poverty and soil impoverishment, the Northwest Regional Council reported in 1940: "[The] great bulk of . . . farmers on units under 50 acres in size in the Pacific Northwest are hard put to keep a roof over their head, clothes on the children, and groceries in the pantry. Theirs is a pocketbook with precious few dollars for such land needs as fertilizers, erosion control, crop rotations, contour plowing, the expansion of their holdings into units of economic size."[90]

Richard Neuberger, who later became a U.S. senator from Oregon, and other boosters of the Columbia Basin project were envisioning the area as a future "Garden of Eden," but some farmers were skeptical, and others also had more modest goals.[91] "It could be a Paradise, and was meant to be, but I don't think it's going to be a go," George Roberts, a farmer on the land irrigated by the Owyhee project, said to Lange. "It's not the land nor the water nor the man that's going to make the success or failure. . . . It's the market that makes the success or the failure. . . . We get 9½ cents [in 1939] for clover seed that we had to pay 42 cents for in '36, when I came" (figure 167). Chris Ament, who had been working as a wheat farmer in the Columbia Basin since 1906, told Lange, "It's alright if you can break even, or make enough to hold your place" (figure 153).[92] Ament's expectations for the Grand Coulee were tempered by the experience of a son in Yakima—"a good farmer, plenty of water, good soil, and *he* can't make a go of it."

Dorothea Lange and Paul Taylor did not share Neuberger's optimism. Their book *An American Exodus*, already in press by the time Lange visited the Northwest, concludes with this somber assessment:

It is plain that with advances in agricultural techniques the country requires fewer farmers rather than more. . . . We do not believe . . . that more small subsistence

farms afford suitable solution for those who are displaced from either agriculture or industry. . . . The great reservoirs which the Reclamation Service is building in the West have given hope to some that upon their completion a new, if brief, era of homesteading will return. But the capacity of these projects to absorb settlers is limited. . . . The real opportunity for large-scale absorption of the displaced must lie in the direction of industrial expansion, not in crowding them back onto the land where already they are surplus.[93]

AWS

GENERAL CAPTION NO. 59

DATE: October 9, 1939

PLACE: Irrigon, Oregon (Morrow County)

Farmer and his wife, in field, digging sweet potatoes. They have a small irrigated farm on reclaimed land, Northern Oregon. Came from Idaho in 1919, and cleared the land from sage brush. Raised ten children here, five now at home. Melons and turkeys are their cash crop.

"We done everything you see here."
"We haven't had one cent of this relief money—but we've had to work twenty-four hours a day to stay off. You can, if you'll work."

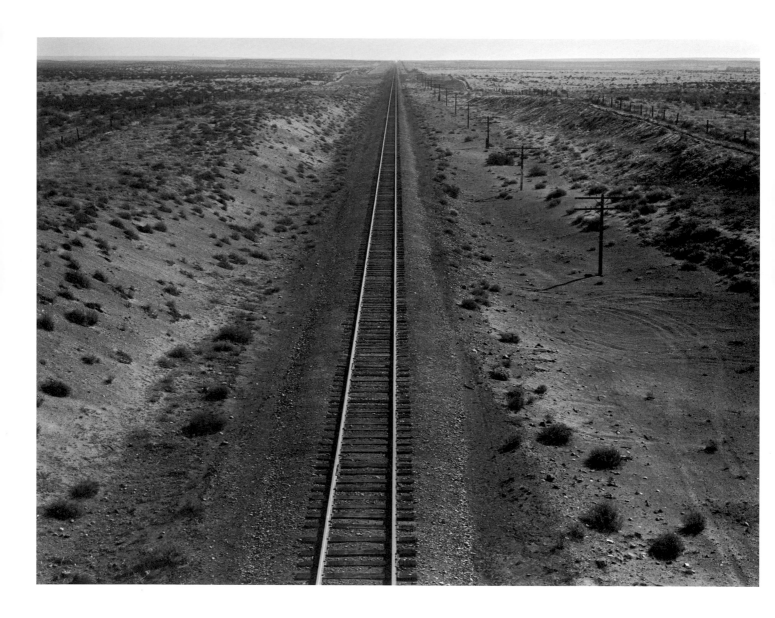

145. October 9, 1939. Morrow County, Oregon.
Western Pacific Line runs through unclaimed
deserts of northern Oregon. Ten miles from
railroad station at Irrigon.

146–147. October 9, 1939. Morrow County,
Oregon. Detail of old railroad station, small
farming town, pop. 108.

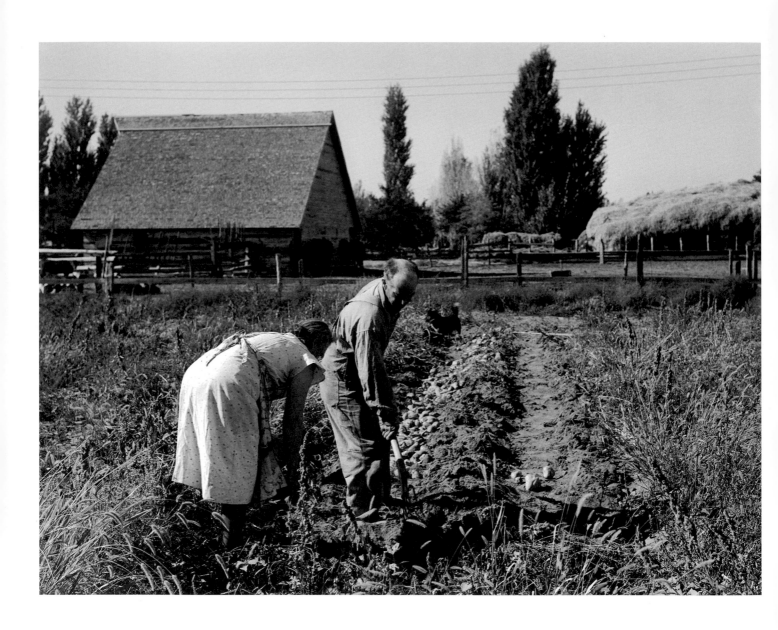

148. October 9, 1939. Morrow County,
Oregon. Couple digging their sweet potatoes
in the fall.

149. October 9, 1939. Morrow County,
Oregon. Type of hay derrick characteristic
of Oregon landscape.

150. October 9, 1939. Morrow County, Oregon.

Note on rural life in northern Oregon.

DATE: August 14, 1939

PLACE: Columbia Basin, near Quincy, Grant County, Washington

Deserted homesteads tell the story of the past in the dry lands of the Columbia Basin. The future of these lands depends not only upon plenty of water for irrigation from the Grand Coulee Dam. Refer to the Yakima Valley General Caption No. 33.

This group of photographs were made about 75 miles from Grand Coulee in the Columbia Basin where soon orchards and alfalfa will grow. They show three abandoned farms, and an ageing couple who have remained on this land through 33 years, although all their neighbors have left the country. This is the area, part of the 1,200,000 acres which the Grand Coulee will irrigate.

Chris Ament, German Russian from the Volga, came to this country in 1899, and settled in Nebraska.

Heard of fine crops and cheap railroad land in the Columbia Basin region, arrived in 1906. By 1912 most of his neighbors who came at the same time he did had left. Many of them went to Canada. He stayed. He now owns two pieces of land, 320 and 480 acres. From one of these he still gets 21 bushels to the acre (higher land). "That held us here—that piece." He and his wife have raised 9 children in the Columbia Basin, now all grown, all living in the State of Washington, but only two are farmers. Chris Ament says—

"I'm 67 years old and won't be able to get the benefits of the water, but I hope to be able to see it. If the government handles it right it will be a good thing, but my boy has a good piece of land down in the Yakima valley, he's a good farmer, plenty of water, good soil, and *he* can't make a go of it."

"Speculators and owners have come in here lately and bought up lots of this land for taxes. Some of it they got for a few cents an acre by way of back irrigation tax. One place over here was owned by a neighbor of mine. He went to Canada, paid his taxes here, but lost his place (160 acres) because of a $9 back payment on irrigation district tax. He never even knew about the tax—2¢ an acre."

Mrs. Chris Ament: has lived in this county since 1899 on an isolated lonely farm in the Columbia Basin. She raised 9 children. She can speak no English. In the early days she stacked wheat in the fields, [with] Chris and the older children on the header [a machine for harvesting], all day long.

[Lange attached a clipping with a handwritten note that it was written by Richard Neuberger and published in *Survey Graphic*; the article appeared in July 1939. See appendix C.]

151. August 13, 1939. One mile east of Quincy, Grant County, Washington. Abandoned farm house in Columbia Basin.

152. August 13, 1939. One mile east of Quincy, Grant County, Washington. Weeds crowd the barn door. Abandoned in Columbia Basin.

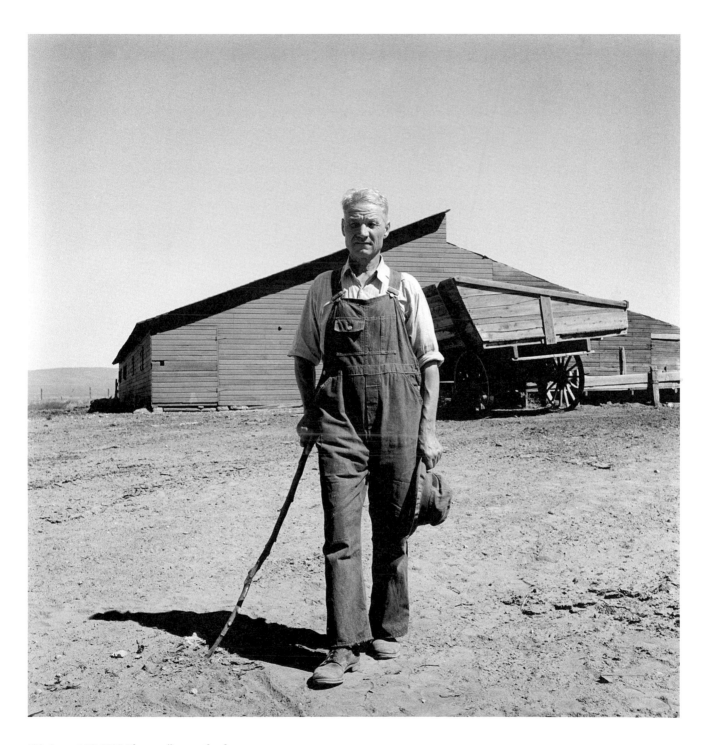

153. August 13, 1939. Three miles south of
Quincy, Grant County, Washington. Chris
Ament, on dry land wheat farm of Columbia
Basin where he has farmed for 33 years. "I
won't live to get the benefits of the water, but
I hope to be able to see it."

DATE: October 11–October 16, 1939
PLACE: Malheur County, Southeast Oregon
SUBJECT: Malheur County

The United States Bureau of Reclamation has spent $22,000,000 in the construction of the Vale and Owyhee Projects. While these two projects join one another in Malheur County they are actually distinct and receive irrigation water from different sources: the Vale from the Malheur River, and the Owyhee from the Owyhee River (see map affixed).[94] The last water was brought to the land in 1938.

About 100,000 acres of raw lands have been appraised and classified under the direction of the Department of the Interior and offered for settlement at an unimproved land price. The price of the land is from $5 to $15 per acre. Electric power is available, three Oregon state highways traverse the project, the Union Pacific Railroad serves the area. The soil is of lava origin, the elevation about 2,500 feet.

The Farm Security Administration is assisting many land-hungry families to set up a pattern for orderly and sound development of their new farms. Many of the new settlers are refugees from dust and drought on the Great Plains. Six hundred and twelve standard Rural Rehabilitation loans have been set up in Malheur County. Ninety per cent of the farms are eighty-acre units.

On this project (1939) almost no tents or tenthouses are now seen, but housing has been developed on the new lands over the first five years in this manner.

First year Tent and trailer
Second year Shack and garden
Third year Basement house, dugout basement, and flat roof
Fourth year House, on basement foundation

There are 612 standard loans totaling $595,966 in Malheur county, Oregon, of which amount $133,860 principal has been repaid with $12,445 in interest. A total of 119 families have received grants, 111 of whom are also standard loan borrowers. Grants total $17,745. At present there are only five families in the county receiving grant assistance.

[See appendix C for text that Lange attached.]

154. October 16, 1939. Malheur County,
Oregon. Shows siphon, 5 miles long, 8 feet
in diameter, which carries water to Dead Ox
Flat. This is the world's longest siphon.

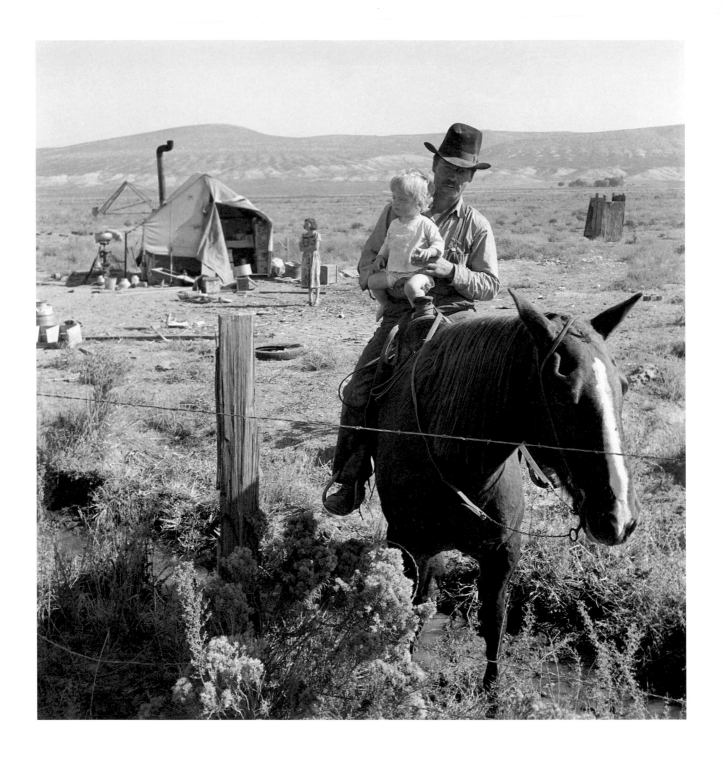

155. October 12, 1939. Willow Creek area, Malheur County, Oregon. The Fairbanks family have moved to three different places on the Project in one year.

156. October 13, 1939. Malheur County, Oregon. New farm in Cow Hollow. Name of client Niccum (FSA borrower—see office report in file). Note basement dugout house and excavation for new house in foreground. Mail comes every other day. "We'd be further along, but the rabbits ate us up this year."

157. October 12, 1939. Warm Springs District, Malheur County, Oregon. See General Caption No. 74. Daugherty home. Note siphon which brings irrigation water from the opposite bench.

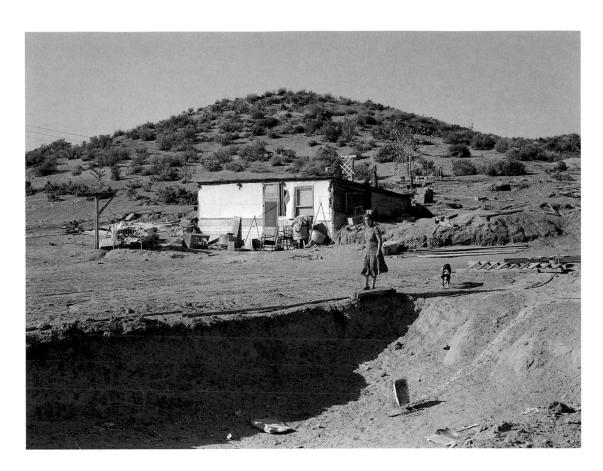

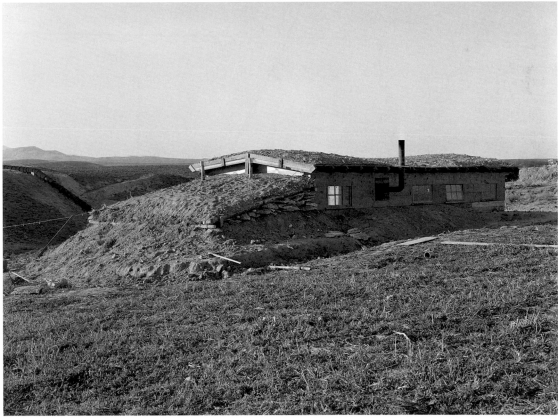

DATE: October 11–17, 1939

SUBJECT: Dead Ox Flat, Malheur County, Southeastern Oregon
Refer to General Caption No. 66 on Malheur County

158. October 11, 1939. Dead Ox Flat, Malheur County, Oregon. View of newly reclaimed bench land. Emmett Smith (farm in background) "took his place out of the brush three years ago."

159. October 15, 1939. Dead Ox Flat, Malheur County, Oregon. Mrs. Wardlaw, after church service.

Water was delivered to the 14,000 acres known as the Dead Ox Flat Division in 1937. These lands lie on a bench [a broad, relatively level, elevated terrace] north of the Malheur River. The farmers on the flat are all now engaged in building up the soils by planting alfalfa and red clover hays so as to eventually produce diversified crops. "Three years ago (1936) this was all sage brush, not a plowed furrow on it, no green spear, no house, no road."

I
This group shows the character of the landscape.

II
This group shows the church, a basement construction. It was established and built in May, 1939, by about twenty Quaker families who had settled on the flat. The group also shows the congregation of the church after services on Sunday morning.

Excerpts from the sermon, heard through the window:

"The easiest time for Christians to lose faith is when hard times come."
"Just because we have to go through these things is no reason to become separated from the love of God."
"It's a good thing to know that God won't fail us."
"All these distresses instead of turning God away from us will make Him love us all the more."
"There is an eternal Security for those who are eternally faithful."
"Those who are lovers of God shall never perish—so we can face Life because there are Provisions for us."

The closing hymn was "Joy Will Come Tomorrow."

III
This group shows the homes of seven families who are establishing farms on Dead Ox Flat. [Only two of the seven are included here. For the remaining five, see appendix E.]

Name: E. D. Wardlaw (not FSA borrowers)

The Wardlaw family sold their farm in northwest Arkansas and left on July 20, 1936, for southeastern Oregon. They had heard about the land from relatives who live in Idaho. They were one of the first families on the flat. They have two half-

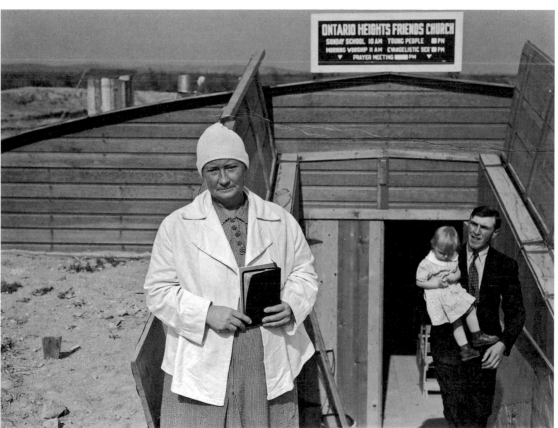

grown sons, own forty acres of land free and clear, four cows, garden, chickens, and live in a dugout basement house. They have no well yet. Photographs were made after church service, early Sunday afternoon. The Wardlaws are not members of the Friends church, "but we like to worship with them."

Mr. Wardlaw says:

"I've learned to irrigate by main strength and awkwardness, and the neighbors told us."

"We'll have a home here some day. That pasture over there is our living now. That and our chickens. Our cream check is about $7.00 a week, and we don't buy much of our living out of the store. We wasn't raised that way."

Mrs. Wardlaw says:

"We lived like Injuns when we first come here, but we've never lacked for anything to eat since we come. We have no lack."

"The neighbors back home are different. They don't want to exchange help out here. First time we butchered we gave our neighbors a mess. They thought we was crazy. We was raised to be friendly and divide up. Every one here seems to be equal, but it seems so strange."

"There was a hundred came the last night I lived in Arkansas. We opened up thirteen freezers of ice cream that night—and they was all from right around at my door."

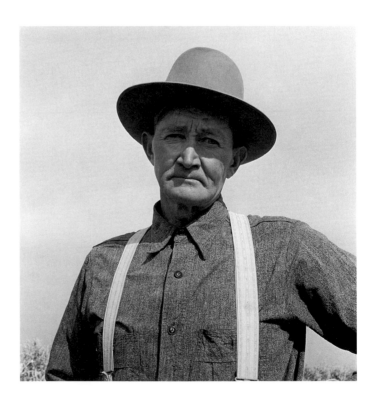

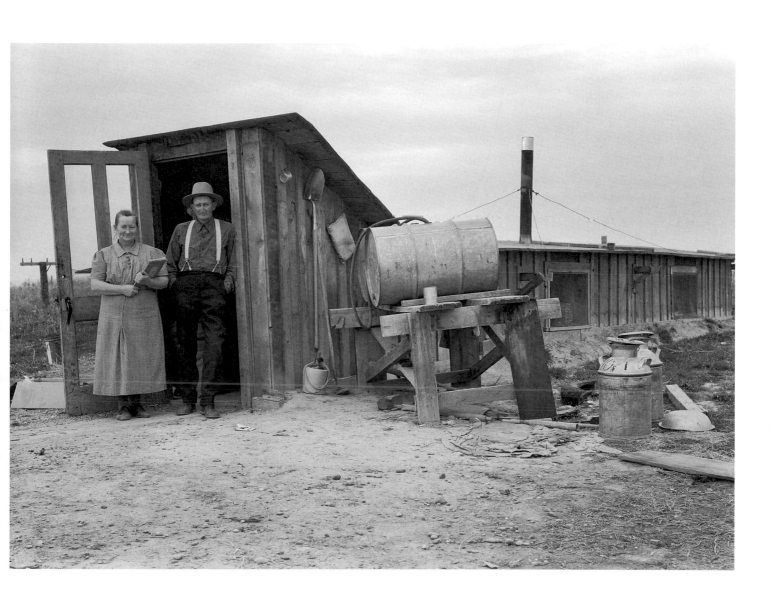

160. October 15, 1939. Dead Ox Flat, Malheur County, Oregon. Mr. Wardlaw, a drought farmer, adjusting to a western farm.

161. October 15, 1939. Dead Ox Flat, Malheur County, Oregon. The Wardlaw couple at entrance of basement dugout home.

Name: M. M. Hull (FSA borrower)

See information regarding this family, attached [see appendix C].

Mr. and Mrs. Hull were youngsters together in the Oklahoma Strip, were married there, then moved to Caldwell, Idaho, in March, 1918. Mr. Hull's father is said to have once been one of the wealthiest farmers in that section. They are both Quakers, "for generations back."

Three years ago this family moved to Dead Ox Flat from Idaho. "Everything was sage brush as far as you could see, there was only one house." Since then the father and three sons have earned two forty-acre tracts, clearing land for other owners. They will get their deed to a third forty-acre unit soon, so that they will have a 120-acre farm. It will be three or four years, Mrs. Hull says, before they build their permanent house. "The well comes before the house, we think." The well will cost $1,000, including casing and pump. They now haul water. They live in a one-room basement dugout house.

The mother has worked putting up fruit to sell so that one of the boys can go to college (Cascade College, Portland, a Friends Bible School). She sold five dozen two-quart jars of fruit for $23.00 last year. This year she hopes to sell dried corn for the same purpose. "We couldn't get the crop off in time this year for him to go, and we didn't have the finances. Last year he had to stop in the middle of the year, so this will finish his school year."

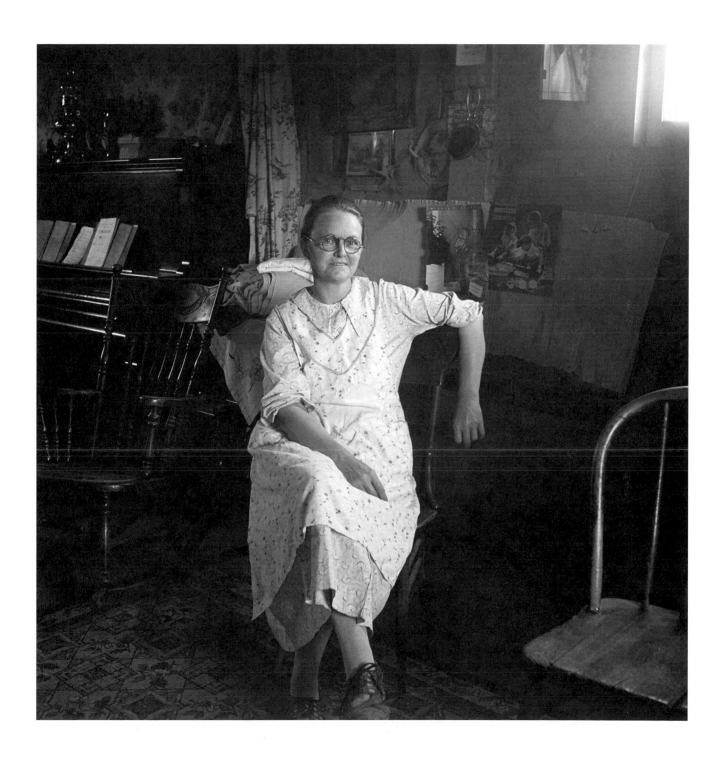

162. (*Above*) October 11, 1939. Dead Ox Flat, Malheur County, Oregon. Mrs. Hull, in one-room basement dugout home, late afternoon.

163. (*Facing*) October 11, 1939. Dead Ox Flat, Malheur County, Oregon. The Hull family haul their drinking water, and when the irrigation water is shut off (about October 15) they will have to haul water for the stock.

GENERAL CAPTION NO. 69
DATE: October 12, 1939
PLACE: Near Ontario, Malheur County, Oregon
SUBJECT: Lincoln Bench School
Refer to General Caption No. 66

60 per cent of children in this school come from families which FSA is assisting to establish themselves on farms. Photographs made at 9:30 a.m. Boys on bench in No. 21212-E were born in 6 states: Indiana, Kansas, Washington, Idaho, Colorado, and Oregon. Note: Classes held outdoors this day because furnace smoked so badly.

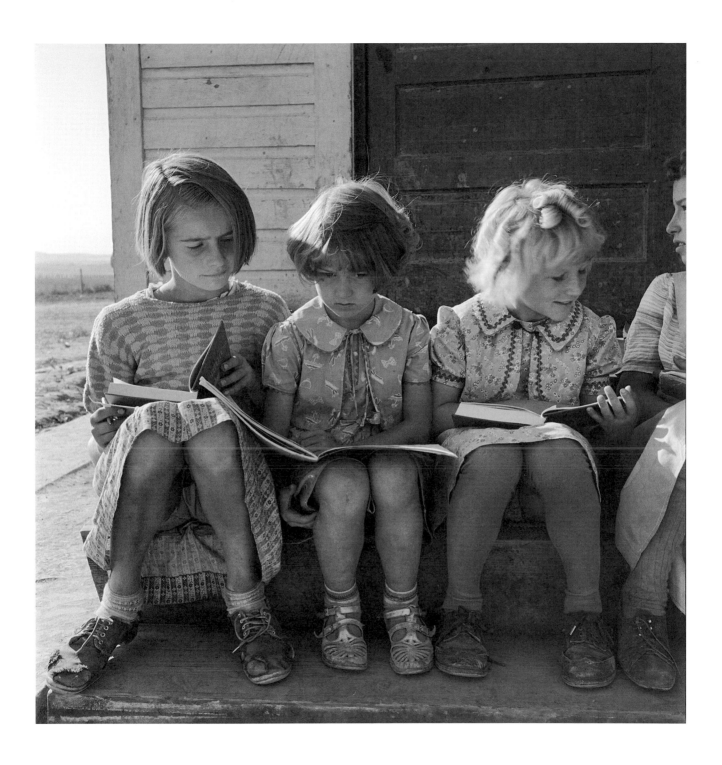

164. October 12, 1939. Near Ontario, Malheur County, Oregon. Entrance to Lincoln Bench School.

165. October 12, 1939. Near Ontario, Malheur County, Oregon. Girls of Lincoln Bench School study their reading lesson.

DATE: October 14–15, 1939
PLACE: Nyssa, Malheur County, Oregon
SUBJECT: A trading center for the newly opened country
Refer to General Caption No. 66

A town in Malheur County, 400 miles from Portland, Oregon, and 60 miles from Boise, Idaho. On the Snake River and Union Pacific Railroad. In 1915 there were about 400 people within a radius of 15 miles. Population has risen from 800 to 2,000 in past three years. Main Street is four blocks long. In 1938 a $2,500,000 sugar factory of the Amalgamated Sugar Company was established here. During the 85-day beet sugar "campaign" the factory works three shifts daily, seven days a week.[95]

35 per cent of the new people have come from the Dust Bowl. 27 families came from in and around Calloway, Nebraska, alone.

Chamber of Commerce pamphlet of 1939: "Nyssa has a Methodist Community church, an Episcopal church, and a Church of the Latter Day Saints. There are many active clubs and fraternal organizations: Eagles, Masons, Oddfellows, American Legion, Civic club, Lions, Chamber of Commerce, and other active clubs. For the newcomer, the right hand of friendship is extended, and he and his family soon become active participants in the affairs of Nyssa."

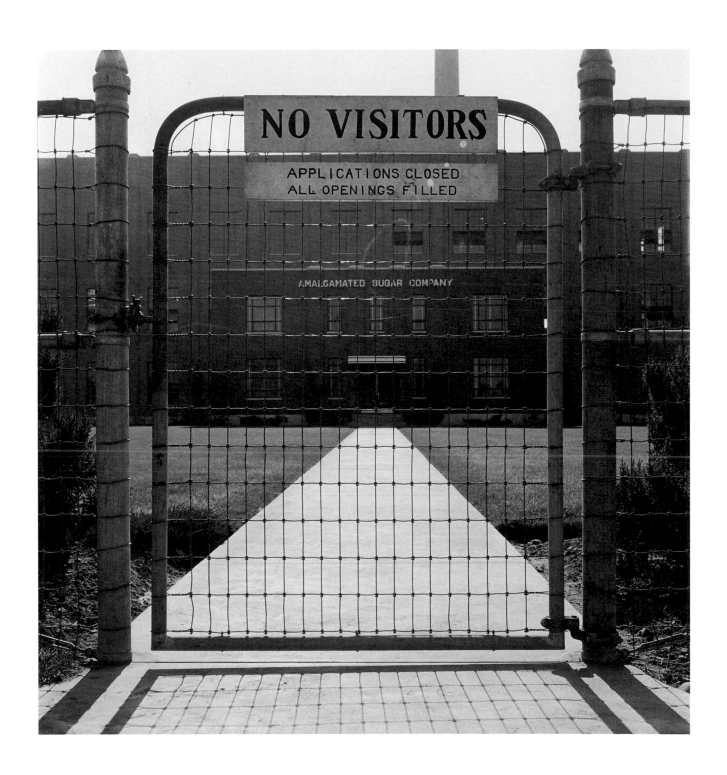

166. October 14, 1939. Nyssa, Malheur County,
Oregon. Entrance to Amalgamated Sugar
Company factory at opening of second beet
"campaign."

GENERAL CAPTION NO. 73

DATE: October 12, 1939

PLACE: Willow Creek area, Malheur County, Oregon

SUBJECT: The Roberts family, FSA borrowers

Refer to Office Report Attached [see appendix C]

See General Caption No. 66

Roberts came to the Owyhee Project in 1936. They live in a basement adobe house, partial dugout, which they have built. Have two children. Mr. Roberts is a native of Kansas, brought up on a farm, but "turned myself into a boiler maker and steam fitter." Worked for 18 months on the catwalk of the Golden Gate Bridge. "I have too many grey hairs. They sort you out after you're 30, and get you closer and closer to the ground."

"It's not the land nor the water nor the man that's going to make the success or failure for these farmers on this project. It could be a Paradise, and was meant to be, but I don't think it's going to be a go. It's the market that makes the success or the failure. Our hay sells for $4.00 a ton, our hogs for 6½ cents, and we get 9½ cents for clover seed that we had to pay 42 cents for in '36, when I came."

"Most of the fellows that worked on that bridge is on the WPA now and I'm out here."

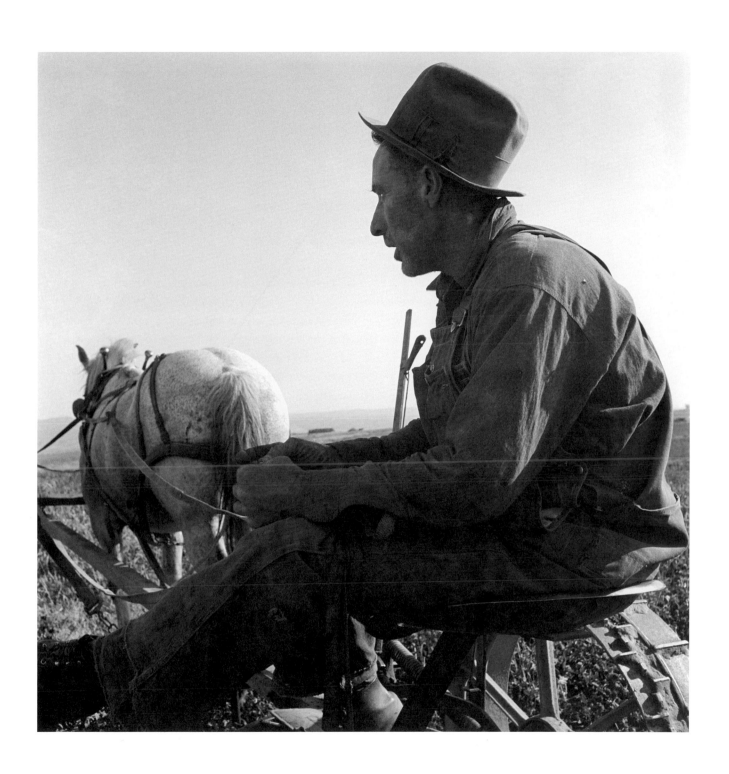

167. October 12, 1939. Malheur County,
Oregon. Mr. Roberts saying, "It's not the land
nor the water . . . etc."

GENERAL CAPTION NO. 72

DATE: October 12, 1939

PLACE: Willow Creek area, Malheur County, Oregon

SUBJECT: The Soper Family, FSA borrower

See Office Report Attached [see appendix C]

The Soper family came from northeast Wyoming three years ago where they were dry farming. They have ten children, one a baby and another 17 years old. They have cleared 120 acres of sage brush land, "all but one piece we still have to do back of the hill." Came to Malheur County December 12, 1936, when the ground was covered with snow. Didn't see the ground until the next April. Built a tarpaper shack. Lost one child of pneumonia that first winter. Built a new house after two years. Land cost $5.00 an acre, "but we cleared it out of the rough."

They have hogs, small grain, and a few cows, an orchard started, bees, and chickens. They lost three cows last year with Bang's disease [a highly contagious disease that may cause cows to abort and can infect humans]. Haul firewood 50 miles. "Boys went hunting and brought back a load of wood and one buck. Put some of the meat down but didn't have enough cans." Tomatoes were blighted. Had plenty to eat but none to can. Canned lots of plums. One boy is hauling onions to market for a local grower, one boy is janitor at school. Have a well. Next year hope to plant potatoes or beets for a cash crop.

Mr. Soper is member of a feed-grinding cooperative (FSA).

Three oldest boys, 17, 16, and 14, have been unable to continue to school because they had to help their parents to establish this farm. One is interested in electrical engineering.

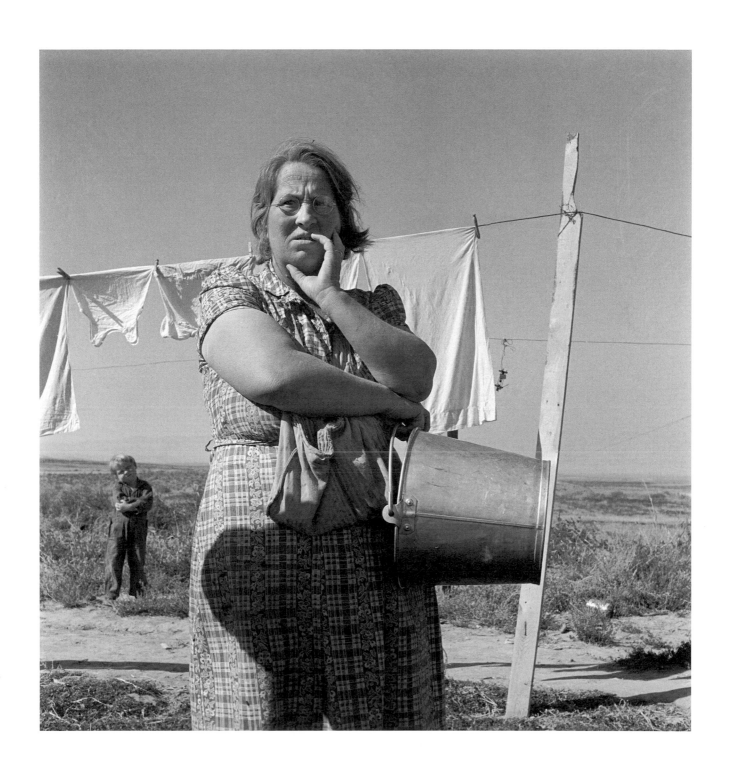

168. October 12, 1939. Willow Creek area,
Malheur County, Oregon. Mrs. Soper tells
how it was when they first came.

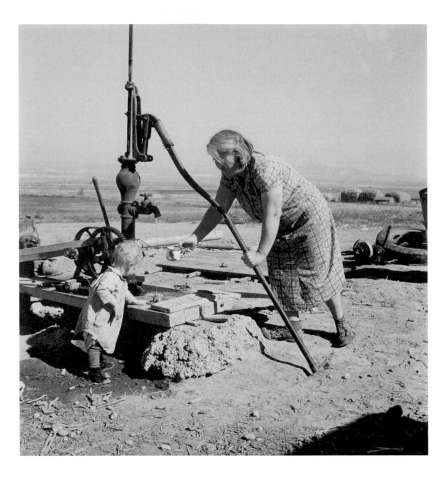

169. October 12, 1939. Willow Creek area, Malheur County, Oregon. Mrs. Soper with youngest child at the well.

170. October 12, 1939. Willow Creek area, Malheur County, Oregon. Exterior of Soper house. Just finished painting. For a long time only one side was painted.

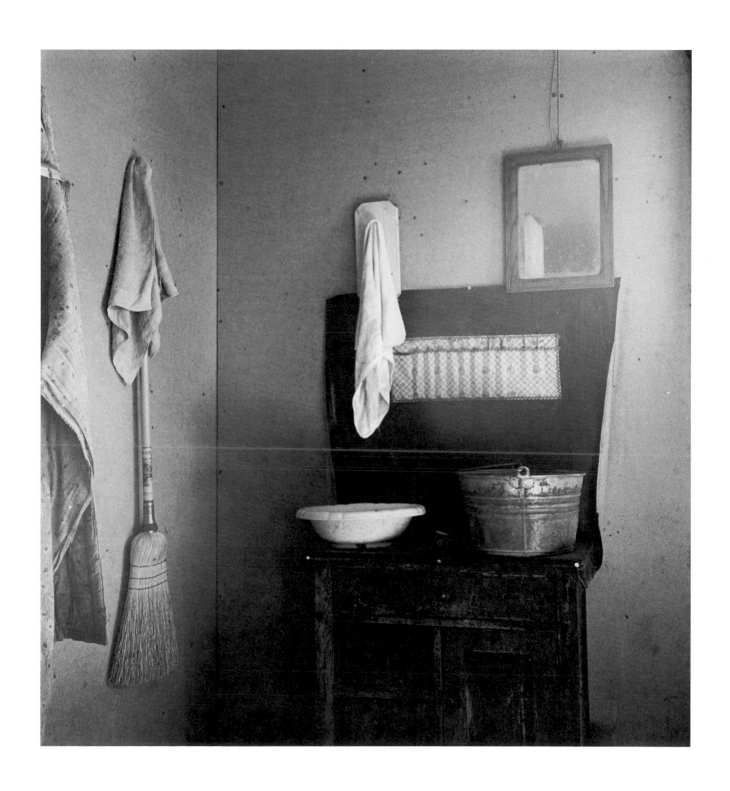

171. October 12, 1939. Willow Creek area,
Malheur County, Oregon. Another corner of
the Soper kitchen.

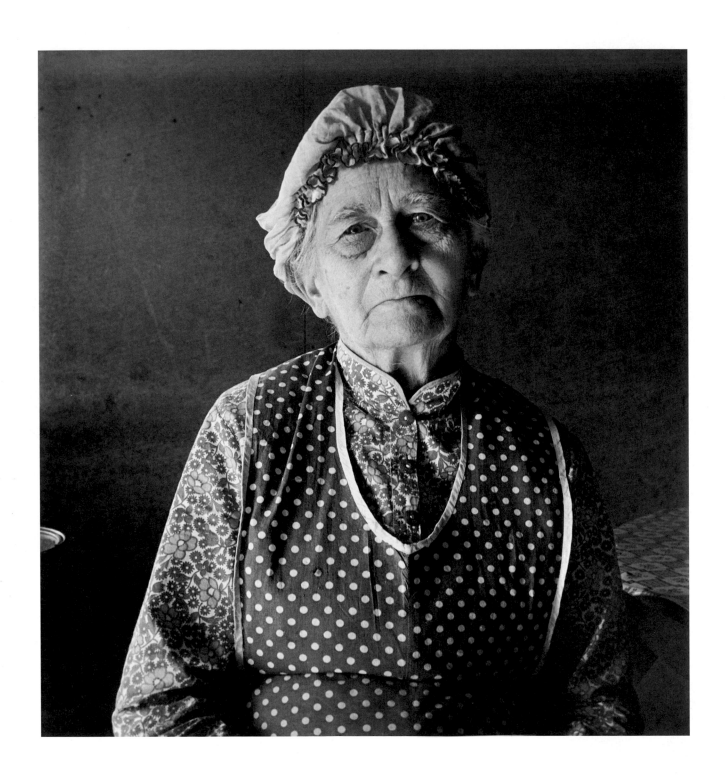

172. October 12, 1939. Willow Creek area,
Malheur County, Oregon. Soper grandmother,
who lives with family.

THREE

Then & Now

ANNE WHISTON SPIRN

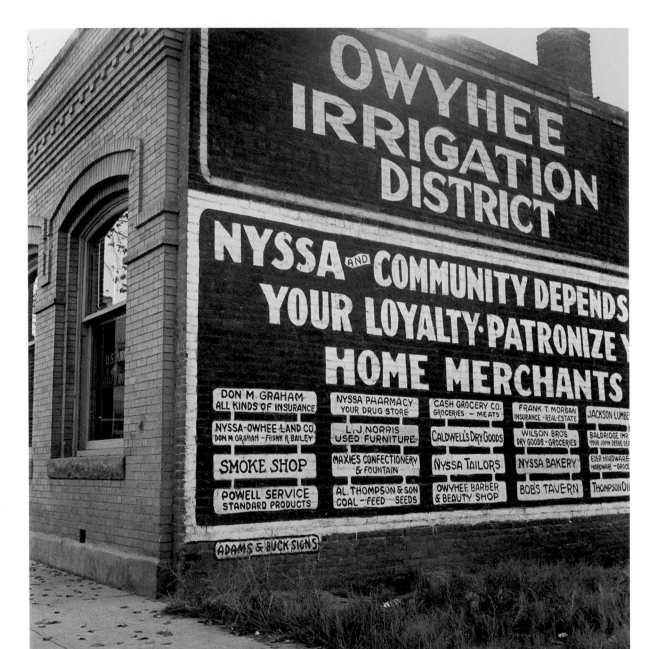

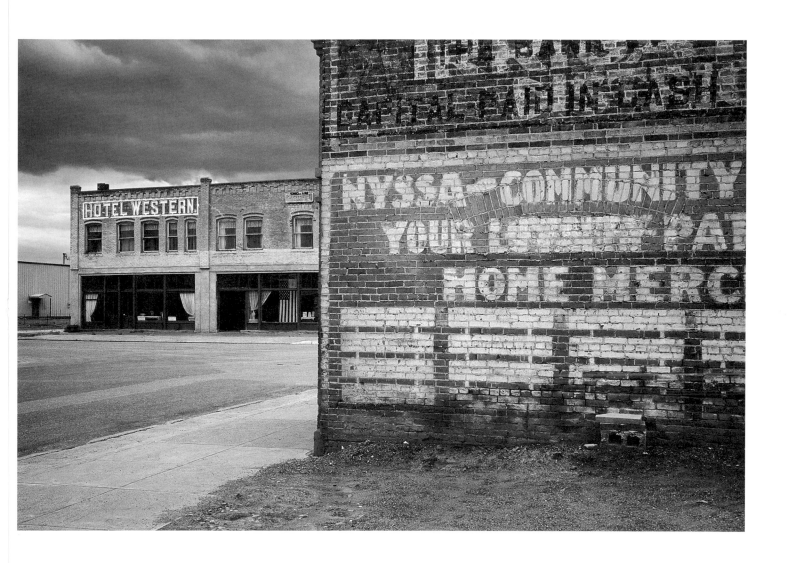

173. October 14, 1939. Nyssa, Malheur
County, Oregon. Sign on old bank building
which now houses the office of the Bureau
of Reclamation.

174. May 17, 2005. Nyssa, Oregon. Building is
now office of the Owyhee Irrigation District.
Anne Whiston Spirn.

find the people she had photographed or their children. Dale Maharidge and Michael Williamson had interviewed and photographed the families Walker Evans and James Agee visited in Alabama in 1936. Their powerful book, *And Their Children after Them: The Legacy of Let Us Now Praise Famous Men*, won the Pulitzer Prize. Bill Ganzel's wonderful book of 1984, *Dust Bowl Descent*, had paired photographs of people made, in the 1930s and 1940s, for the Farm Security Administration with portraits of those same people taken in the 1970s.[3] "You're too late," Ganzel told me when I mentioned my plan to visit the locales where Lange had worked. But it was not too late for what I wanted to discover. The terrain Lange traveled through. What she saw. And what she did not see, such as the wagon ruts on the Oregon Trail. The difference between my eye and hers and whatever lesson that difference might teach me. The changes between then and now in the places she photographed and what those changes might reveal about the nation.

My journey took me to places I might otherwise never have gone, to people I would never have met: in California's San Joaquin, Salinas, and Imperial valleys in March; the lush farms and woods of the Willamette Valley and Puget Basin in May; back and forth across the Cascade Mountains to the drylands of the Klamath Basin, the Yakima Valley, the Columbia Plateau, and eastern Oregon, and the forests of the Idaho panhandle; to North Carolina in the humid heat of July. I learned firsthand the long distances Lange routinely drove and the sheer number of miles she covered. Some things are almost as they were. I discovered, high up in the Siskiyou Pass in Oregon, a narrow, winding segment of U.S. 99, more or less as it was built in the late 1930s, the switchbacks steep and curving, without a shoulder and with a slope that dropped off at the road's edge, where twenty-five miles per hour was as fast as I dared drive. How could trucks and lines of cars, single file in each direction, have negotiated those sharp turns without disaster, especially in winter? How could this have been the principal route between California and Oregon? A month earlier, I might have moved even less freely; on I-5, the highway that replaced U.S. 99, a sign saying "Snow Zone" ordered use of chains on tires when its lights were flashing.

I did meet people, if not, at first, the people of Lange's photographs. But searching for the site of Yamhill Farms and the Grangers' barn, "three miles west of Carlton," I found Dolly and Mel Wasson, who came to Carlton, Oregon, from Oklahoma in the 1930s and met in the strawberry fields. Mel gave me a tour of a room he had dedicated to Carlton's history and signed my copy of the local history he coauthored, a book still read in the town's elementary school classes.[4] I did not find the Arnolds or the Halleys, who sold their homesteads in New Mexico in the 1930s and bought stump farms in western Washington and northern Oregon, but I met Carl and Lorene Walker, who grew up in the 1920s and 1930s on farms their families homesteaded in New Mexico before they married and settled in the Yakima Valley in the 1940s, Carl Walker taking a job with the Soil Conservation Service, Lorene working as a home economist organizing 4-H programs for rural youth. The Max Hull I telephoned in Ontario, Oregon, was not related to the Mack Hull of Ontario Heights, whose family Lange had

met, but I did meet Allen Brown, a ditch rider for the Owyhee Irrigation District, who helped me find families Lange had photographed—the Wardlaws and Sopers, and the Hulls. As I asked questions, jotted down what people told me, decided when and where to make their portraits, rapidly assessed light and background, selected significant detail, I was keenly aware of Lange's mastery and my own clumsiness, juggling camera and notebook. People's words, so vivid and memorable, flew out of my head unless I recorded them the instant they were spoken. Lange had a gift of remembering phrases. I bought a tape recorder.

I found many of the places and projects Lange portrayed. Some of the old FSA projects, including the family labor camps at Farmersville and Westley are in the San Joaquin Valley, where large-scale industrial agriculture is apparently still the norm. The Mineral King Cooperative Farm near Farmersville and the Dayton Family Labor Camp near Carlton, Oregon, have been demolished, but the influence of the FSA's pioneering experiments with prefabricated metal and wood structures, once hailed as "the rural architecture of the future," is apparent in the pervasive prefabricated metal trailers, in the wooden houses split in half, each half transported by truck from factory to home site, and in the metal barns of pastel blue, pink, yellow, and green (figures 37, 116).[5] The stump farms in Michigan Hill, Washington, and the Idaho panhandle, which the Arnolds, Halleys, and others worked so hard to clear, are now forest again. The struggling small towns Lange photographed, like Tenino in Washington and Malin in Oregon, still seem to be struggling, and others look less prosperous than during the Depression. In agricultural regions of the west, many businesses are now catering to the growing Hispanic population. In North Carolina, the country stores Lange described as community centers are now boarded up, but the churches she visited have active congregations. One town stood out as strikingly similar to Lange's 1939 photographs: Ola, Idaho, in a remote valley about fifty-five miles north of Boise, where eighteen students attend kindergarten through sixth grade in a two-room school. I could find no physical sign of the cooperative sawmill established there in the 1930s, but the family of one of the farmers who organized it is in the lumber business. The Vale and Owyhee irrigation systems of eastern Oregon that Lange photographed soon after they were completed still provide water to hundreds of farms (and to new subdivisions).

Following Lange, I became attuned to the agricultural calendar. Traveling in May to places she had photographed in August or October, I found that seasonal difference sometimes changed the character of a place even more than the passage of a half century. When, on April 1, I reached the Imperial Valley, the enormous furrowed fields near Brawley looked much like those in Lange's photographs, but they were empty of workers: I was too late. Lange had photographed in February; by April she was four hundred miles north in the San Joaquin. Obsessed with the plight of migrant workers, Lange tracked their seasonal march from south to north, drawn repeatedly to the agricultural valleys of California. I, fascinated by water, was drawn back to eastern Oregon at the height of the irrigation season to meet the ditch riders who deliver the water and the farmers who use it. I followed the water from dam to farm and learned

how to ride ditch, to move the water and "park" it. Comparing my photographs of that place to Lange's, I was startled to find among hers only two images of a ditch, none of the dam and reservoir, and no ditch rider, while among mine were hundreds of irrigation artifacts—siphons, weirs, chutes, slides, bubblers—and ditch riders in action, adjusting flow, conferring with farmers. I recalled one of Lange's favorite quotations, from Goethe: "Every traveler should know what he has to see and what properly belongs to him on a journey."[6] My journey was aligned with Lange's, but I am a different traveler. My second trip to eastern Oregon in late July, en route from Seattle to Nyssa, was too early for the pear and apple harvest in the Yakima Valley, but it was an ideal time to see the irrigation system flowing at full capacity, canals and ditches brimful. Water demand had slowed by my third trip in mid-September, when the onion harvest was in full swing: lines of golden orbs drying in the fields; fallen onions scattered along roadsides; topper-loader harvesters blowing dust and skins; heavy trucks, piled high, hauling. Lange was there in mid-October at the tail end of the onion season, just before the irrigation water was cut off for the winter (figure 175). This region was an onion capitol then, as it is now.

To find the places in towns Lange photographed, I looked for buildings or landmarks that matched her images, but buildings had been demolished and monuments moved. In North Carolina, I could find the locations for which Lange had noted names of roads and mileage from crossings, but it was difficult to find her exact spot in the countryside of California and the Northwest. I had copied all three thousand of Lange's 1939 photographs, twelve images on each sheet of letter-sized paper, along with the captions she wrote, and I inserted them in notebooks that I kept with me as I traveled. I navigated with 1930s road maps Lange might have used and with modern maps at different scales. State atlases (¼ inch = one mile) provided an overview, but to locate the farms of families Lange photographed, I needed the more detailed maps of the U.S. Geological Survey, in which an inch represented only a thousand feet. A third set of maps, of intermediate scale, eased the transition between larger and smaller and helped me discern broad landscape patterns. Besides these maps and notebooks, I carried in the rental car my cameras, my journal, and the books, pamphlets, trail guides, postcards, newspaper clippings, and tourist brochures I gathered along the way. I had read just enough beforehand to avoid missing something significant (and I might well have missed the Oregon Trail itself since Lange never mentions it). I read some along the way to make sense of what I was seeing and some back home afterward, as Lange did, to understand what was in the images I had made.

Lange's photographs were my passport into foreign territory. People I met were my guides; intrigued by pictures of their hometowns, they spotted familiar places, names, even individuals, and helped me locate them. I sought out librarians, postmasters, staff of county historical museums, and schoolteachers. Usually they had never seen the photographs or even known of their existence. Amy McBryde, teacher at the two-room school in Ola, Idaho, was astonished

175. October 17, 1939. South of Ontario,
Malheur County, Oregon. Onions in sacks are
drying. Those on the ground are culls. 1,000
acres of onions are grown, 700 to 800 cars are
shipped from this county annually.

to learn that her hero, Dorothea Lange, had photographed Ola, population 171. How do you know her work? "Every school teacher knows her photographs," she replied. "We use them in our teaching."

Lange's texts and photographs make it possible to see, hear, and read what Lange saw, heard, and read, in the context of her own time and also in the context of the present day, to sense both the anomalies and the continuities. Still, what one sees and feels when reading Lange's photographs and captions of 1939 depends on the person. Geographer Paul Groth pointed to the details of vernacular architecture in the tobacco barns and cabins. Historian William Cronon read networks of exchange, both traditional and new, in the specifics of clothing, furniture, roofs, and fertilizers. Amy McBryde and Allen Brown recognized places and the names of people they knew. Glen Wardlaw saw himself and his parents and how they had farmed. From each of these personal readings, I learned, and, in learning, gained an appreciation for the depth and richness of Lange's work. Each person's experience, knowledge, and passions lead the eye into a photograph and provide special meaning.

<div align="center">*</div>

BERKELEY, CALIFORNIA. "Looking at these photographs is creepy. This is exactly how I learned to plow [with a single mule], and we had a plow just like this." Randy Hester is pointing to a black tenant farmer leaning on the wooden handles of a plow in one of Dorothea Lange's 1939 photographs. Lange's caption says that the farmer's field was on a dirt road in Person County, North Carolina near a crossroads called Hesters Store, which is where Randy grew up, and his father and grandfather before him. He still owns the family farm and knows how to grow tobacco, although he has been a professor of landscape architecture for thirty years, now at the University of California at Berkeley.

Hester was born a few years after Lange photographed his home territory, but "our area didn't change for twenty years," he tells me, "not until the 1960s. This tobacco sled is exactly the same as the one we used, and we used it into the 1970s. We had a tractor by 1955, but we still took the tobacco from the field with the sled and mule. A little kid would take the mule from field to barn" (figure 42). He explains how tobacco is "primed," or "pulled," by picking the "sand leaves" at the bottom of the stalk first and then gradually working up. It is not pleasant work. "The leaves are in your face; you have to get right down near the ground. Tobacco leaves are waxy, and your forearms get covered with black tar. The goal was to get one barn pulled a day, but on Saturday, you'd get a whole barn pulled by one o'clock" (figures 41, 43).

Lange photographed Mr. Whitfield's three-and-a-half-year-old daughter as she plucked worms off the tobacco (figure 54). She "is learning," her father told Lange, "but she is a little too rough with the tobacco leaves sometimes and bruises them." "That's just how it was," says Hester. "Your father would complain you weren't tender with the leaves."

"I never got to prime tobacco, my uncle wouldn't let me. I wasn't skilled enough." Walter Hood, a professor of landscape architecture at Berkeley and a North Carolina native, grew up in "the city," but he spent three summers on his uncle's tobacco farm. He only recently discovered that his uncle was a share-cropper; he thought his uncle owned the farm. Although younger than Hester, Hood recalls scenes like those Lange depicted, though now "all the old tobacco barns are rotting and falling apart" (figure 47).

Hood has the eye of an urban designer, and he is drawn to the photographs of Siler City, Oxford, and Pittsboro; I imagine him using Farm Security Administration photographs like these for his work in bringing African-American history into urban design in cities like Oakland, California, and Macon, Georgia. "I remember driving through this square," he says of Lange's photograph of the Pittsboro central square and courthouse, once the site of a slave market (figure 74). "My father would always say, 'Keep your head down—the devil might be here.'" Hood is African-American.

"That's how we cured tobacco, by burning wood." Hester is looking at the photograph of a boy sitting on a log projecting from an opening at the base of a tobacco barn (figure 44). "The temperature was regulated by pushing the wood in or pulling it out. By the 1950s we started burning kerosene instead. You had to do this all summer. All July and all August, sometimes until mid-September. Curing all that time. My father and uncle would sleep out at the tobacco barn, each on an army cot."

A white church catches Hester's eye, and he reads the caption: "Person County, North Carolina.... Young's Chapel, a Negro Baptist Church.... A cross in the yard has an inscription, this stone marks the place where J. W. Bradsher professed faith in Christ October 1891" (figure 176). "Wiley Bradsher is the preacher I've been writing about!" cries Hester. Bradsher's own church, once known as the Garden of Eden Church in the Wilderness and now called Union Grove Church, is near Hesters Store. Excited by this find among Lange's photographs, Hester draws a map of the church yard, telling stories as he draws: how Wiley Bradsher used to ring the church bell every time someone did something wrong, how he once hoisted an automobile up into a tree where it hung outside the church as a warning, how Bradsher preached that black men should buy land, and how many of his parishioners did so and prospered. Hester, who is white, is writing a book about the landscape of Person County and the influence of Wiley Bradsher, the black preacher.

"This looks just like Wheelers Church," Hester says of another photograph, the church Lange called "Wheeley's" (figures 75–79). "It's near the church where Wiley Bradsher preached." Sure enough, Lange's caption notes that "Wheeley's" is 1.1 miles southeast of Gordonton, the location of Wheelers Church. "And this is the Gordonton store. It's still there, closed, but someone recently put a new roof on it. Hester's store used to be exactly like this except it had exquisite oak trees in front of it, and it had no 'white's only' sign. It was integrated racially, but not by gender. At lunchtime, there might be two dozen men, black and white. If

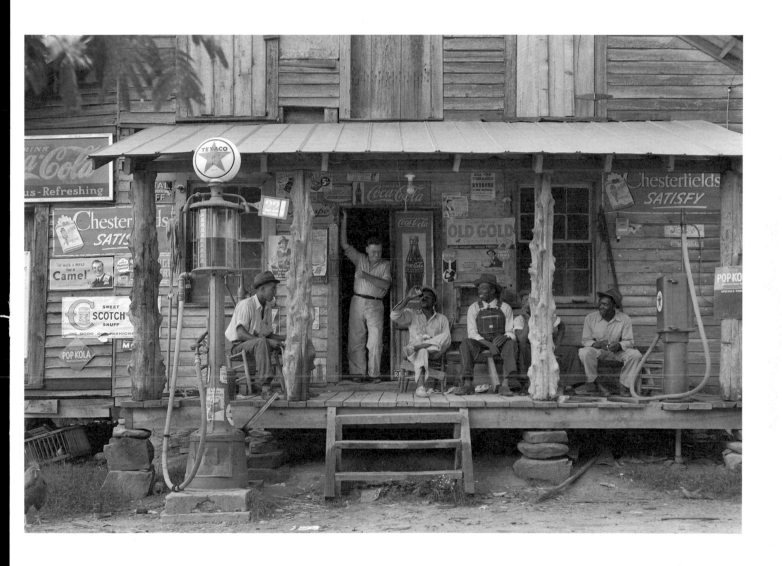

176. July 3, 1939. Person County, North Caro-
lina. Negro Church called Young's Chapel, a
Negro Baptist Church. The corner stone says
"organized May, 1887," Rev. C. J. Springfield.
A cross in the yard has an inscription: this
stone marks the place where J. W. Bradsher
professed faith in Christ October 1891.

177. July 9, 1939. Gordonton, Person County,
N.C. Country store on dirt road. Sunday
afternoon. For other photograph of store on
week day see negative number 19740E. Note
the kerosene pump on the right and gasoline
pump on the left. Brother of store owner
stands in doorway.

you were there for an hour, two or three women might come in and buy something, but they would never sit down."

A mutual friend had once told me that the Hesters were one of the old families of North Carolina, among the first white farmers to settle the Piedmont in the 1700s. So when I visited the Hester homestead, I was surprised to find a modest house and small farm, no imposing mansion or grand estate. "North Carolina is a state of small farms, a paradise for the poor man," Randy Hester explains. "From its inception, it was unquestionably more modest and egalitarian than other Southern states." Taking out his pen, he draws a map of North Carolina in my journal and explains, "The Outer Banks, known as the graveyard of the Atlantic, were treacherous for ships and there were thousands of shipwrecks. This effectively blocked access from the sea to the interior, so the large plantations of Virginia and South Carolina did not develop in North Carolina. Most settlers came to North Carolina overland, traveling from Virginia or South Carolina, settling on small farms."

Last summer, Randy Hester was back at the farm working on his book about the landscape of Person County. As he sat at his desk, he saw his cousin Donald drive by with a truckload of tobacco on the way to his tobacco barns. "I'm writing three pages for every barn of tobacco you primed," he later told him, and his cousin replied, "You'd be better off priming tobacco than writing if you're not getting more done than that." (March 24, 2005)

*

Today, a small tobacco farm cannot support a large family or even a family with a single child, like Hester and his son Nate. Since 1939 (and before), there has been a diaspora among North Carolina farmers, both black and white. Thousands of families moved north to cities like Philadelphia. I look at the places Lange portrayed in North Carolina in 1939 and see where families of my friends in West Philadelphia once came from and where they return for reunions. It is striking that Randy Hester, Walter Hood, and two of their colleagues at the University of California at Berkeley, all with roots in rural North Carolina, have become prominent landscape architects. Hester inherited his family's farm after his mother's death a few years ago; he had promised his father he would never sell it. Randy's son Nate, an artist, now lives with his wife on the farm. Though many other farms around Hesters Store have been sold as estates or for new subdivisions and second homes, the large Hester clan is holding on to theirs even though most are no longer farmers.

*

PERSON COUNTY, NORTH CAROLINA. "My great uncle owned that store," Bess Whitt, born a Hester, told me; she was referring to the Gordonton country store, which is much smaller than I had imagined, its porch shallower (figure

177). An electric meter is mounted next to a boarded-up window, but it isn't running. The store is about a mile down the road from Wheelers Primitive Baptist Church, so it's not surprising that Lange photographed both church and store on the same day. When I drove down the road, however, I was confused. Could this be the right church? Wheelers, not Wheeley's, and brick. not wood, but it's Primitive Baptist, on the right spot, and a sign says, "Organized 1791." About fifty cars parked on the grass, but not a soul in sight. I returned later that afternoon, parked beside other cars, and approached the church. A man stepped out of the church. Yes, it was once called Wheeley's, and the brick was added in the 1950s. Would I like to come inside? The chapel is simple and beautiful, much as Lange described it in her general caption. I mention the photograph of Queen. "That's my great-aunt, Queen Bowes. My name is Reuben Bowes." He told me how to find Queen Bowes's gravestone. She was fifty-seven years old when Lange made her portrait and had been a widow for a year. Normally there are church services once a month—"every second Sunday," as in 1939— but the first weekend in July is the annual "association" meeting of Primitive Baptists, and representatives are here from all over the state. Everyone is over in the lunch room now, having supper. He's just locking up. "Please come have supper with us." The lunch room is a one-story white building with a single open room filled with tables; the pine trees in Lange's photos were cut down and used in its construction. Supper is laid out buffet-style on a long table—fried trout and chicken, homemade pickled cabbage and beets, potato and egg salads, desserts, and soft drinks. Folks are friendly and curious. I pass around my notebook of Lange's photographs.

"I don't know anyone over by Wheelers Church," Randy had told me earlier. "It's another world over there." But Reuben Bowes knows Randy: "He's fixing up my house." The house Randy and his wife Marcia had bought down the road from his family's farm had belonged to Mr. Bowes's grandfather. (July 1, 2006)

<div align="center">*</div>

Although he attends church every second Sunday at Wheelers Church, Reuben Bowes lives ten miles away, in Roxboro, the county seat. When Lange photographed farmers there "on a Monday afternoon, idling around the county court house," Roxboro was bustling, the square shaded by tall trees. She noted the "confederate monument . . . characteristic of southern towns." The courthouse and monument are still there, but urban renewal remodeled the square (figure 178). On Sunday at noon, not a soul is on Main Street and many buildings are vacant, though stores and restaurants are bustling along the highway that bypasses downtown. The same was true on Saturday at noon: the downtown deserted, the bypass busy, with twenty cars lined up at the McDonald's takeout window and a long line inside too. (July 2, 2006)

<div align="center">*</div>

178. July 2, 2006. Roxboro, Person County, North Carolina. County courthouse with monument to Confederate soldiers. Anne Whiston Spirn.

Lange photographed landscape as a portrait of the people, institutions, and society that over time shaped it, and shape it still. Her photographs and captions are now historical documents that give perspective to the present, especially when read in place next to the actual landscape, for landscape embodies time, space, and story. Like a play, landscape is enacted, and it can be read. An evolving play, landscape is constantly changing. To enter a landscape is to come on stage during a drama already long underway. Landscape records the ongoing dialogues, and in it one can read those dialogues. Failure to recognize and respond to landscape dialogues, in place, and to their deep context, in time, can spell repeated failure and disaster. The actor's challenge is to engage and extend the discourse. Dorothea Lange's portraits of people and places remind current actors that they are part of a long story. In landscape, unlike the theater, there is no final act, nor are future scenes predestined since there is no preexisting script. Yet in landscape, as in literature, foreshadowings portend events to come. The actors who invent the script do so within limits. If there is any resolution to the story, it will come through recognizing and understanding the larger stories within which the dialogues are mere scenes, and then responding judiciously.

Small episodes are connected to larger ones. Keeney Pass and its wagon ruts are part of a grand landscape epic. In the 1930s, drought refugees like the Sopers from northeastern Wyoming, the Wardlaws from northwestern Arkansas, and the family from Deadwood, South Dakota, reenacted the migration of earlier pioneers along the Oregon Trail to the Northwest (figures 168–172, 159–161, 103). Today, migrant agricultural workers like the family of Raul and

Maria Elena Martinez, who live in La Grulla, Texas, during the winter, drive along the Snake River on I-84, in the spring, on their way north and west to the onion fields of Oregon's Malheur County and to the orchards and asparagus fields of Washington's Yakima Valley.[7] Their journey too follows the Oregon Trail: just as the old wagon tracks converge at Keeney Pass, nineteenth-century railroad tracks and twentieth-century highways converge in the great funnel of the Snake River plain, a broad path through mountainous regions from western Wyoming to the place between Idaho and Oregon where the Snake enters the steep-sided gorge of Hell's Canyon, north of the river's confluence with the Malheur (see Northwest map, figure 80). Here, the Oregon Trail and the modern highway leave the Snake to follow a less treacherous path northwest over the Blue Mountains. With Keeney Pass, Vale, Nyssa, and Ontario clustered at the narrow end of this funnel, migration is an enduring narrative.

Traces left by the first wagon trains to rumble along the Oregon Trail in 1843 did not mark the initial episode in that enduring drama, nor was the settlement of tribal people by the hot springs along the Malheur River the opening act. In landscape, mountains, rivers, passes, and plains are protagonists, no mere set or backdrop. Aridity, for example, is part of the cast of characters. A desert, by definition, receives precipitation of ten inches or less per year; this area gets only five to eight inches, much of it falling as snow outside the growing season. Terrain and climate, together, form an enduring context that underlies all stories in a place, a context that determines which plants and animals will grow, a context that influences the pattern of human settlement. But unlike wind, water, and other organisms, humans do not always follow paths of least resistance; they convert sagebrush desert, as they did here, to fields of alfalfa, onions, and sugar beets. And to do so, they needed the resources of a nation. Federal subsidies helped and still help to sustain those green fields, for green fields are not part of that landscape's deep context and may be an ephemeral episode. Stop the flow of the water and the desert will return.

*

MALHEUR COUNTY, OREGON. I stand on the spot where Lange photographed what was then "the world's longest siphon," "5 miles long, 8 feet in diameter." My eye follows the line of the siphon that pipes water across the Malheur River valley to Ontario Heights and Dead Ox Flat (figure 154).[8] The pipe emerges from the hillside beneath my feet, runs downhill, dips under the highway, railroad tracks, and river, and rises back up the opposite valley wall, where it disappears into the steep bank beneath Ontario Heights, a benchland about a hundred feet above the Malheur River, due west of Ontario and north of Vale and Nyssa. The entire irrigation system works by gravity flow: the reservoir, the source, is fifty miles away at a higher elevation, and the water flows, pushed by pressure, down and up in siphons, into broad canals that hug the slope, then downhill again in lateral ditches.

179. October 16, 1939. Homedale District, Malheur County, Oregon. The Dazey place.

180. July 28, 2006. Malheur County, Oregon. The irrigated and the dry. Stop the flow of the water and the desert will return. Anne Whiston Spirn.

Seen from the opposite side of the river valley, the brown slopes of Ontario Heights and Dead Ox Flat are capped by green, like a felt cloth atop a bench with terra-cotta sides, a surface veneer on the deep, enduring desert beneath. This moist veneer is the principal difference between my view in 2005 and Lange's in 1939, when the benchland was still sagebrush desert. Looking at the benchland, I feel a sense of vertigo, for its moist top, dry slopes, and arid canyons seem upside-down, a reversal of the norm of moist valley bottoms and drier hilltops. I drive across the valley and into Canyon Number 2, its narrow bottom thick with brushy trees and shrubs, the desert gone, the steep, dry upper slopes held in place by spare tufts of grass. The irrigation water on the top of the flat has seeped through the soil, raising the groundwater below, changing what was once a bone-dry gully into a draw.

Turning up a steep road to the top of Ontario Heights, I emerge onto a green, irrigated world far different from what greeted Mrs. Hull in 1936 when her family first arrived: "Everything was sage brush as far as you could see, there was only one house." I am not aware of being "up," on higher ground, and the land is not level, but rolling and dissected by swales. The artifacts of irrigation are everywhere: pipes stick out of the ground, some with hoses attached; white pipes eight inches in diameter with holes in the sides lie on the ground; wheeled irrigation structures of various kinds and vintages stand in the fields. The farms are supported by an enormous infrastructure, much of it underground and many miles distant.

The farmers with whom Lange spoke in 1939 were struggling, and some farms on Dead Ox Flat today look as though their owners still face hard times. Most farms seem to be quite small; perhaps many farmers are part-time, supported by income from another job. The property owned by Emmet Smith in 1939 is still farmed, though probably not for long, since it borders a highway interchange; the "54-acre" property across the street is for sale by someone whose telephone number has a San Diego area code. Just over a mile down the road is the Snake River Correctional Institution, built in 1991.

Down in the Malheur River valley, the farms appear larger and more prosperous, though one is a modern version of Lange's "tractored out" photograph from Texas in 1937, with the fields plowed right up to a small abandoned farmhouse, a tree stump all that's left of the former farmyard garden. My eye is drawn to the sharp line between the irrigated and the dry, between green alfalfa field and brown road verge or the straw-colored grass on the steep sides of benchlands like Dead Ox Flat. Farther south, in the Homedale district along the Snake River south of Nyssa, few shrubs grow in the gulches, and only sparse grass on the slopes; trees are turning yellow. Two fields, side by side: in one the plants are full and green; in the other seedlings are shriveled and brown. Perhaps the farmer could not pay his water bill or decided to cut his losses in the face of declining prices, or maybe, because of the drought, there was not enough water to go around.

"Welcome to Nyssa: Thunderegg Capitol of the World." What are thundereggs? I asked the lady in the Chamber of Commerce office. She showed me several, sliced open, and then handed over a rockhound map to Nyssa. They look

like geodes, I said. And that's what they are. I've begun to note the signs at the edges of towns, as in Quincy, Washington, the day before yesterday: "Quincy: Another Public Power Community," "Quincy: Opportunities Unlimited." There's a Thunderegg Lounge on the main street of Nyssa, across from an abandoned gas station and a sidewalk planter full of flowers, down the street from a Mexican restaurant. The streets and sidewalks of Nyssa are immaculate. Some of the stores have signs in Spanish. Some are vacant yet well maintained, like the Hotel Western, where curtains hang behind clean windows and an American flag and patriotic display stand in the otherwise empty first floor.

Across from the vacant hotel, I spot a sign Lange photographed on the side of the Owyhee Irrigation District office, a building that was once a bank. I pull out her photograph and see "Owyhee Irrigation District" in big block letters at the top (figure 173). Beneath is a plea, "Nyssa and Community Depends [on] Your Loyalty. Patronize [Your] Home Merchants," and under that are twenty-four rectangles, each framing the name of a local business: a pharmacy, a bakery, grocery, furniture, and candy stores, feed and seed supply, a tailor, a tavern. Today, the sign is faded but legible, but the boxes that once advertised local merchants are blank (figure 174). In 1939 Lange wrote that the population of Nyssa had "risen from 800 to 2,000 in past three years"; in 2000, the population was just over three thousand and declining. Nearly 20 percent of the town residents are foreign-born; nearly 60 percent are Hispanic or Latino, most of them Mexican Americans.[9]

The Owyhee Irrigation District office is still here, and I showed my notebook of Lange's photographs to Kris Ward, a staff member, and to the manager, Jay Chamberlin, who confirmed many of my observations. The sugar company that opened in 1938, the year before Lange photographed it (figure 166), had just closed the year before. Yes, the farms down in the Malheur River valley are doing better than most. Settled first, those farms have more senior water rights than those whose owners came later, so now, in the middle of a drought, they "get more water." Yes, the owners of midsize to large farms are buying smaller farms and consolidating them, but even they are in trouble because of overall economic conditions and because of increasing competition from newly irrigated farmland that has opened up in the state of Washington.

I wondered whether the new farmlands in Washington were part of the Columbia Basin Federal Reclamation Project, where I had seen enormous farms with no houses, only a few isolated trailers. Were these owners' homes or those of farm managers or workers? Why use federal funds to build irrigation projects to create new farms that compete with already struggling farmers on existing reclamation projects? (May 17, 2005)

*

In Cambridge, Massachusetts, eight months later, in January 2006, my phone rang. "This is Allen Brown from the Owyhee Irrigation District. We're having the seventy-fifth anniversary of the Owyhee Dam, and I understand you have

some old photographs from the Library of Congress." I promised to send copies of the photographs and instructions on how to find others on the Internet. What do you do for the irrigation district, I asked. "I'm a ditch rider." What does a ditch writer do? "I ride ditches!" Do you clear out the brush, that kind of thing? "Yes, so the water can run. The district likes me to ride the ditches every day. I've got two hundred customers. I keep the accounts. A farmer'll call me up and say he needs three foot [acre feet] of water. I put in the order, and the dam releases three foot of water. Then I make sure it gets to them." Brown's ride includes Ontario Heights and Dead Ox Flat, and he offered to track down the families Lange had photographed. Seven months later, I was back in eastern Oregon, where I met the Wardlaws, Hulls, Sopers, and others who took their farms out of the sage brush in the 1930s.

In 1939 the Ontario Heights Friends Church commanded a view over a dusty open land (figure 181). Today it is hidden, the doors padlocked, under a grove of trees, surrounded by green alfalfa fields. In 2005 I had driven right by the church, but now Allen Brown found it for me, down the road from the house of Ralph Cammack, a farmer on Brown's ride. "My dad gave seven acres for the church and pastor's house, which left about 72 acres for our farm," Ralph told me. He was three in 1937, when his parents moved here from Salem, Oregon, where he was born; as he grew, he helped care for the church, starting the fire on Sunday mornings and mowing the lawn in summer. He and his wife Charlotte now own the farm. They raised three children here and put them all through college and one through graduate school. "You're wondering how we managed that," Charlotte said and laughed. "Cooperate with your neighbors, don't buy anything you don't need, make for yourself as much as you can." "The old farm tradition is still alive," said Ralph, pointing to his neighbor harvesting hay across the road. "We work together, help each other. That baler's actually mine, the tractor's his, but we use it as a pair. Thirty-five years ago we decided we didn't each of us have to have everything. We own some things together and use each other's stuff." Every piece of equipment used on the farm since 1937 is stashed in Ralph's "boneyard." He's continually adapting equipment, welding parts from castoffs, inventing new tools. "One of the reasons I'm a farmer is that it allows me to be creative." But none of his children are farmers.[10]

Ralph Cammack had given me Glen Wardlaw's phone number in Nampa, Idaho (figure 182). When we met, Glen paged through hundreds of Lange's 1939 photographs, commenting on the specifics of farming equipment and practices, delighted to find himself among them. His mother had invited Lange to Sunday dinner after a church service, and there are ten photographs of the interior of their basement dugout home: the dinner table, pots and pans, and stove. Glen lingered over the photograph of his mother and father standing outside in the doorway (figure 161). "Mom's holding her cookbook. That was one of the few things she brought from Arkansas. It was her mother's cookbook. Later, when our house burned, that was the thing she regretted most, that she lost her mother's cookbook." His first job on the new farm was sowing bluegrass seed along the ditch banks "so the ditch would have something to hold it.

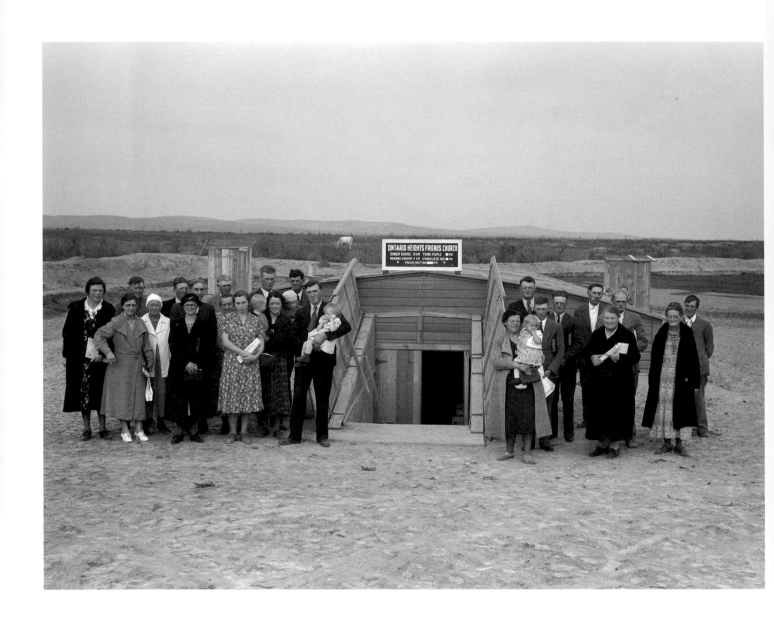

181. October 15, 1939. Dead Ox Flat, Malheur County, Oregon. The entire congregation after Sunday morning service. Preacher is a young farmer, man at left of door holding baby. The Free family, Wardlaw family, and Hull family attend this church.

182. August 1, 2006. Nampa, Idaho.
Glen Wardlaw and his wife Mary.
Anne Whiston Spirn.

Many times, middle of the night, you'd take a lantern and check the ditch, because it would wash out. When we first plowed this land up, it was just like flour. And anywhere you stepped when it was wet, you'd sink in just as deep as it was plowed. If it was plowed eight inches, you'd sink in eight inches." I assumed Glen had been a farmer, but, no, he has a Ph.D. in audiology and speech therapy. None of his children are farmers.[11]

"It takes three generations to make a go of it," according to Allen Brown. "The first generation is just scratching dirt, and the second too. The third generation can make it, if they are still around. I'm standing on two generations' shoulders." Brown has no fourth generation to farm the eighty acres along the Snake River that his grandfather took out of sagebrush in 1904. Farming today is too tough. "If I had a son who wanted to farm it, I'd run him off." He's been riding ditch for twelve years to pay the bills and subsidize the farm. Allen's friend Terry Oft, who took on his family farm after his father's death, breeds registered Angus bulls and sells them to ranchers as breeding stock, raises alfalfa for feed and onions as a cash crop (figure 183). His strategy is to specialize and diversify. He's doing fine, but there is no one else in the family to take over the farm when he retires. "The family farm is gone," he says, "My generation is the last." "We're getting 1950s prices for commodities and we're paying today's prices for seed and equipment," explains one farmer on Dead Ox Flat. "It's hard to make a living on a farm smaller than three hundred acres. Those with a thousand acres or more, they're doing better." He just sold the farm his family homesteaded in the 1930s. Because the buyers are not farmers, he will continue to farm the land as a renter. None of his children are farmers.

The northern part of the Owyhee Irrigation District is only fifty miles from Boise, Idaho, a rapidly expanding city, and people who work in Boise are buying homes (from five-acre lots to larger "farmettes") in new subdivisions on old farmland. In the southern part of the irrigation district, the buyers are often California farmers, who were either pushed out by new suburban growth in that state, or corporate farms that want to expand. For someone familiar with the farms of the eastern United States or Europe or even those of eastern Oregon the scale of many California farms is inconceivable. Take the unpeopled farms of Kern County, for example.

<p style="text-align:center">*</p>

SAN JOAQUIN VALLEY, CALIFORNIA. In Tulare County I drive from Farmersville to Exeter to Porterville, through orange groves laid out like city blocks, with dirt tracks or asphalt roads separating them and each block numbered. The trees are heavy with fruit ripe for picking —globes of saturated orange against dark green leaves and brown earth—and the pickers are out on this Easter Sunday morning. There are few houses on Route 65 south of Porterville, then, just before I cross from Tulare County into Kern County, all buildings disappear. It is like a ghost landscape after some terrible catastrophe. No people, though signs of human purpose are everywhere: Orange groves, vast fields of grain, pastures with cattle in the distance. A large clearing of eroded dirt among the blocks of groves, with plastic bins piled up—hundreds of them, empty, waiting. Oranges on the trees, hanging. Then to the east, off the road, a beige tower with a screw-shaped stack rises up from a green field, a factory in the middle of nowhere.

The scale of this surreal landscape reminds me of Carleton Watkins's photographs of Kern County in 1881. Watkins, known for photographs of Yosemite

183. July 28, 2006. Malheur County, Oregon. Farmer Terry Oft and his mother, Betty. Anne Whiston Spirn.

and of wild Western landscapes, also made photographs in the San Joaquin Valley. The title of one of these, "Haying at Buena Vista Farm," evokes a romantic pastoral image, but the actual image is of a gigantic haystack, sixty feet high, dwarfing the six human figures standing on top, another group of people at its base, and the operator of the derrick hoisting the hay from a wagon. Two horse-drawn wagons loaded with hay are waiting. Flat fields stretch to distant hills. In the foreground are three men on horseback, one in a white shirt and vest. Off in the distance are more workers. This was no pastoral idyll, but farming on an industrial scale. (March 27, 2005)

David Igler calls the proprietors of Buena Vista Farm "industrial cowboys"; the farm was part of an empire of land and water rights amassed by Henry Miller and Charles Lux, owners of a San Francisco meat-processing firm, who, from the 1850s on, expanded from butchering into cattle production and real estate. When the once Mexican lands of California became part of the United States in 1848, the Treaty of Guadalupe Hidalgo required recognition of land claims held by Mexican owners. As these lands were sold off, American businessmen were able to buy enormous tracts in single purchases. By the 1870s, half of the land holdings of Miller and Lux came from indebted Mexican owners of huge California ranchos, estates that were artifacts of the original Spanish and Mexican land grants. Miller and Lux's cattle ranches at that time encompassed more than 300,000 acres between San Francisco and the San Joaquin Valley, farmed by a labor force of more than twelve hundred migrant workers. In 1872, the State Board of Agriculture reported that Miller and Lux owned 450,000 acres in California alone. The same study of land ownership found that one hundred individuals owned 5,465,206 acres in the state.[12]

Carey McWilliams's 1939 book *Factories in the Field* told this "hidden history" of California agriculture. Its problems "may be traced to the fact that the lands of the State were monopolized before they were settled, that a few individuals and concerns got possession of the agricultural resources of the State at the very moment when the State was thrown open for settlement and that the types of ownership thus established have persisted. The ownership itself has changed, but the fact of ownership remains." McWilliams attributed the origins of the monopoly not solely to the transfer of Mexican land to American owners but also to the consolidation of additional property and water rights and to the development of large-scale agriculture that demanded thousands of laborers at harvest, first Native Americans, then Chinese, Japanese, Hindus, Mexicans, Filipinos, and "Okies." Dorothea Lange wrote in March 1939 that she had focused on photographing "industrialized agriculture" in the Imperial Valley because it seemed "to be a spreading pattern ... appearing in other parts of the country with rapidity—an important theme."[13] To solve the violent labor conflicts of the 1930s between growers and farm workers, McWilliams proposed "the substitution of collective agriculture for the present monopolistically owned and controlled system."[14] Needless to say, this did not happen. McWilliams's own historical perspective was not Lange's. But she knew the book: "Be sure to read Carey McWilliams' *Factories in the Field*," she wrote in a letter to her boss, Roy Stryker.

Like Lange, the New Deal planners were not looking to the past. They were promoting present and future progress. Lange's assignments for the Resettlement Administration and the FSA gave her a firsthand view of the programs Roosevelt and his colleagues devised to ease the urgent crisis and to keep alive the Jeffersonian vision of a nation of yeoman farmers as the foundation of

American democracy, to minister to the rural poor and migrant laborers and help the unemployed and displaced resettle on new farms.

If Lange saw through the lens of her own time, not of the past, she did not see uncritically. On the ground, out in the field, she discovered "things that weren't working," including the programs whose presumed success she was assigned to document.[15] So Lange reported that with FSA loans for "recent settlement of cutover lands in northern Idaho," farmers were clearing stumps from land that was worthless for farming: "Forty three percent of the land purchased by new settlers for farming is classified by the United States Department of Agriculture as non-agricultural. The most recent settlers are taking up the poorest land."[16] One farmer told Lange, "If I had to do it over again I'd never go on a place like this" (figures 136, 137).

<p style="text-align:center">∗</p>

REDWOOD CITY, CALIFORNIA. "The fools. They're wasting their time, wasting their time. It wasn't worth clearing that land. The best thing they could have done was to get those people out of there, which is what World War II will do." Richard White, a historian at Stanford University, is paging through my collection of Lange's 1939 photographs and reading her general captions, muttering under his breath. His is the Olympian perspective of the audience at a play who sees the precipice the protagonist is about to tumble over. White is the author of books that have rewritten the environmental and social history of the American West, arguing the folly of separating natural and human history, describing the hardships suffered in an environment that has been successively and repeatedly exploited and abandoned.[17]

"Lange is coming into the middle of events that have been going on for years," White observes. "Since the 1880s, Indians from all over the West were marshaled to harvest hops, up until the 1920s. The dislocation of farmers from the Great Plains happened repeatedly, in the 1870s, the late 1880s, the 1890s, and the 1920s. There exists a myth of a stable America, overturned at one terrible moment during the 1930s, and then we got over it. Lange seems to believe this myth, as if what she is photographing in 1939 is a singular phenomenon of the Depression itself, not a recurring one."

"None of the rules Lange described for irrigated land were followed," White tells me. "There have been endless, unsuccessful attempts to limit the size of farms in areas irrigated by public reclamation projects to 160 acres." This explains the huge farms I would see later in the Columbia Basin. It is White's opinion that "these are not Western success stories. If someone did do well in a place, it was at the expense of ten other families whose land they took up. This is the story of the entire West from the 1920s to today: settling then emptying out, leaving giant units of land where many farmers survive through government subsidy. Many of the places Lange was looking at were environmental disasters in 1939 and still are." (March 29, 2005)

Most of the stump farms Lange photographed in 1939 are second-growth forest now. Many lasted thirty years or less. Driving north in remote northern Idaho, from Sandpoint to Bonner's Ferry, I pass many guest ranches, including one near where Mr. Denchow, a former mill worker, was clearing stumps in 1939 (figure 135). This transition from farming to vacation spot began in the early 1940s. Nelle Portrey Davis reported in *Stump Ranch Pioneer* that, by 1942, few drought refugees remained here; many had abandoned their stump farms for jobs in munitions factories and shipyards. Others came and bought land, but they were mostly middle-aged city folk, "mechanics, truck drivers, office workers, and miners," who bought, then returned to their city jobs with the prospect of retiring some day to this new land. When Davis and her husband sold their stump farm in the 1940s, they moved farther north, near the Canadian border, and bought a guest ranch.[18] Even before I reached Sandpoint, former home of the Humbird Lumber Company and now looking relatively prosperous, I noted that the shores of Lake Pend Oreille are lined with large vacation homes. Sandpoint is a tourist destination, and Priest Lake, north of where the Halleys cleared their farm, is "a premier vacation destination" with "spectacular scenery, unlimited recreational opportunities, a true year-round resort region for both business and pleasure," according to the Priest Lake Web site.[19] Signs in Sandpoint list the town's population as 6,835 and caution: "Sandpoint is a walking town. Please stop for people in crosswalks."

In Michigan Hill, Thurston County, Washington, where the Arnolds cleared their stump farm back in 1939, the woods are at least thirty years old, possibly forty (figures 123–125, 184, 185). There are few farms now, and I saw no guest farms like those in the Idaho panhandle. Trees have sprung up around barns; old trailers, ramshackle houses, and sheds remain. Dozens of No Trespassing signs are posted, sometimes three or four in a single driveway, perhaps to warn off hunters (there is also a No Hunting sign). There are lots of For Sale signs too: land for sale, old farm houses, and a few new houses. Despite Michigan Hill's location, about twenty-five miles south of the state capitol in Olympia, it does not appear to be thriving. Loaning money to people to resettle on infertile land or on farms too small to support a family did not abolish rural poverty.

Down the road from the former sites of government-sponsored family labor camps, such as the one Lange photographed in Oregon's Yamhill County, are modern-day rural slums with dilapidated cars parked alongside decrepit shacks (figure 116). Building labor camps with improved housing, medical clinics, and day care had met the immediate emergency but failed to address the causes of problems migrant agricultural workers faced; hence, unpredictable and short-term employment, hazardous work, and child labor persist today.[20] As Lange observed in the early 1960s, the conditions of "migratory labor" she photographed in the 1930s persisted twenty-five years later: "I might have made [those photographs] yesterday. This is a mighty interesting thing. Not many things don't change in twenty years, not many things."[21]

184. August 14, 1939. Michigan Hill, Thurston Co., Western Washington. Shows land which the Arnold family have cleared and planted in strawberries, fence which they have built, uncleared land adjoining.

185. May 15, 2005. Michigan Hill, Thurston County, Washington. Land reclaimed by forest. Anne Whiston Spirn.

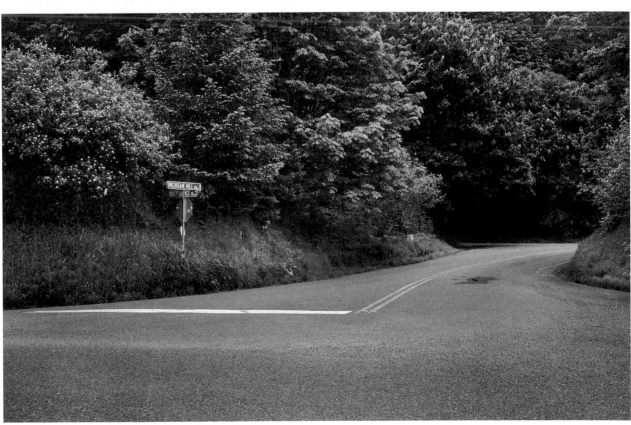

The Buena of 1939, in the Yakima Valley, looks more prosperous than the Buena of today, filled with abandoned houses, dilapidated shacks, some occupied and some not, with torn screen doors hanging off hinges (figure 92). There is no meat market or soda fountain now, and the gas station is boarded up and covered with graffiti; there is a library in a trailer open three afternoons a week, with bars on the windows. The librarian is a retired teacher, the library her hobby. She was pleased to see Lange's 1939 photograph of Buena along with others of the Yakima Valley. Children, mostly Hispanic, come and go: borrowing books, working on computers. I remarked on Lange's many photographs of children working in the fields. "Children still do," she replied. Wapato, not far from Buena, is a town of broad streets. Vacant and refurbished buildings stand side by side. The shelves of a drugstore are nearly empty. In a storefront window, a display on community development alludes to conflict among residents over the future of Wapato. Many businesses cater to Hispanic customers, not surprising since 76 percent of the population is Hispanic, according to the 2000 U.S. Census. As in Buena, Toppenish, and other towns of the Yakima Valley, many children are living below poverty level (41 percent).

In present-day Merrill, in the Klamath Basin, are some of the most decrepit dwellings I have ever seen: drapes in the windows torn or hanging askew, piles of trash heaped in the courtyard. In contrast, dwellings in Tulelake, eight miles to the southeast and across the state line in California, while of similar style (one-story attached units), are neat and in better condition. Though it does not look prosperous, Tulelake looks cared for. Vacant buildings are freshly painted with small murals. Trash barrels, painted blue with "Tulelake" stenciled on the side, stand on street corners. The streets and sidewalks are clean, the crosswalks recently painted, as is the school. "Honker Pride," proclaims a sign, referring to the local high school athletic team. The Tulelake Community Partnership building has a state employment office and a sign for the Department of Agriculture. While the landscape of Tulelake reflects pride, that of Malin, eight miles to the north and again in Oregon, reflects disintegration, despite the flowers in the median of the road leading into town and the well-tended park next to the municipal building. On the main street is a post office, a hardware store next door, but more than half of the other stores are vacant.

The demographic profile of the three towns is similar, but the residents of Tulelake are less affluent, with a third of the families below poverty level, compared to one-fifth in Malin and Merrill. The farmers of all three communities were reportedly hit hard in 2001 by a federal decision to cut back on irrigation water after a severe drought reduced the flow of the Klamath River, threatening fish downstream. Several of the affected species were protected under the Endangered Species Act, including the chinook, coho, and steelhead salmon, on which commercial fisheries, tourism industries, and Native Americans depended for their livelihoods. But the Klamath Basin is a desert, so the farmers cannot survive without irrigation water, and a bitter fight ensued between farmers, on the one hand, and government agencies, Native American tribes, and businesses that depended on the fish, on the other. The farms had origi-

nally been homesteaded, and farmers protested that the U.S. government had promised a continual water supply but then "stole" the water. The controversy is not yet resolved, and it is difficult to see how it can be settled. One article reported a comment by a member of the Klamath tribe: "I heard a farmer who lost his water saying he felt like he was part of a big government experiment. All I can say is, welcome to the party."[22] All this was set in motion in the early twentieth century when the U.S. Reclamation Service "reclaimed" the Klamath Basin.

*

IMPERIAL VALLEY, CALIFORNIA. Lange's photographs of vast fields full of migrant workers pulling carrots and hauling crates of peas did not prepare me for the new crop of subdivisions and shopping malls (figures 28, 30). East of Calipatria, the soil is rosy tan and parched. Without water, no crops will grow here. But more and more water is being siphoned off to coastal cities, and farmland lies fallow. For Sale signs on farmland are a frequent sight: "For Sale—Prime Development" (near Brawley); "Coming Soon—Desert Rose Family Homes" (in Calipatria). South of El Centro, driving through farm fields, I spot balloons high in the distant sky; teenagers with placards stand on street corners, urging me to visit this or that new housing development. At KB Homes' "Sienna Trails," a few miles away from the new Imperial Valley Mall, a boy dressed up as a yellow house, in black tights and bright green clown shoes, waved me in to an open house. With dozens of houses under construction, Sienna Trails is surrounded by fields. Many families, mostly Hispanic, are moving furniture into new homes today. Balloons are flying, flags flapping, music blaring from loudspeakers; a temporary playground fills an intersection. The three- to six-bedroom homes are seventeen hundred to twenty-eight hundred square feet on lots of about sixty-two hundred square feet. Prices range from $323,000 to $385,000 and up. San Diego is a hundred miles away, a ninety-minute drive on Interstate 8. (April 1, 2006)

*

Property in the Imperial Valley is in the hands of relatively few large landowners, many of them absentee, a legacy of the original Spanish and Mexican land grants. In the mid-1990s, for example, one corporation based in Texas amassed forty-two thousand acres of Imperial Valley farmland, 10 percent of the county's total irrigated land.[23] A corporation such as this, with diverse investments and the goal of realizing the greatest profit, will be tempted to treat water as a commodity, especially when a thirsty city like San Diego will pay more for the water than could be reaped in farming the land. This is what happened in the 1990s.

I look at the enormous farms and new subdivisions of the Imperial Valley, and I see the expansion of Las Vegas and Phoenix into the desert, every bit as impossible without publicly funded water projects. New cities here need massive, sustained energy to overcome the heat and aridity and fuel the daily

travel of a settlement pattern dependent on private automobiles. I look at this "conquest of arid America" and see prime agricultural land disappearing under expanding suburbs outside Kansas City, whose new system of roads, water, sewer, and power that makes that development possible could not have been built without public subsidies. And I see, too, the vacant land and abandoned buildings in Kansas City—and in Saint Louis and Philadelphia and other cities, where hundreds of thousands of houses and businesses are being abandoned. The creation or division of property and construction of infrastructure should not be undertaken lightly, for the effects are felt ever after, in that place and elsewhere. Dividing land into property opens opportunities but also limits the future, as the early Spanish land grants did in California, as the pattern of initial settlement and the nineteenth-century infrastructure of sewers and streets built on former floodplains did in cities like Philadelphia and Boston. It is a cautionary tale.

I have worked for more than twenty years in inner-city neighborhoods that have been devastated by flows of water and capital. It was once standard practice to bury streams in sewers and fill in valley bottoms to create building sites for roads, houses, and business. In Philadelphia, Boston, and New York, among others, the effects have been felt continuously since the early twentieth century; where once there were blocks of homes, vacant land now marks the course of former streams. Water flowing underground, flooding basements and undermining foundations, contributed to the abandonment, but so did political processes and racial discrimination that discouraged investment in old urban neighborhoods and encouraged development of new suburban communities. Exurban development has dealt a double blow to the Mill Creek neighborhood of West Philadelphia, where I have worked since 1987: the inward flow of sewage and stormwater, producing water-logged soil and ground subsidence, and the outward flow of population and capital, segregating races, concentrating poverty, and impoverishing city government.

Lange, in 1939, recorded a great American exodus from farm to city. Not long after that, the cities too were hemorrhaging population, and American society now is feeling the effects of a later exodus, effects that are far-reaching, equally dramatic, and just as damaging to society and individuals: the white flight from the city, the post–World War II planting of suburbia on former farmlands. Today there are fewer farms and farmers. As farmers retire, often they are not succeeded by the younger generation. Subdivisions are cropping up way out in the countryside, one or two hours' commute from new residents' jobs. Many small towns are in trouble; main street businesses are losing ground to chain stores outside downtown, like Walmart, Kmart, and Home Depot. In the arid West, such national trends are complicated by conflicts over water rights and use, between farmers and nonfarmers, farm and city, city and city. These are familiar stories, but it is one thing to know about them, another to visit hundreds of places, one after another, to experience the consequences firsthand, and to appreciate the scope of change. The nation is being remade on a vast scale.

I look at the abandoned buildings in West Philadelphia's Mill Creek and see the vacant buildings on the main street of Nyssa, Oregon, and the rampant growth of new subdivisions in the Imperial Valley of California, in Phoenix, Arizona, and Las Vegas, Nevada. The effects may be felt locally, but they are set in motion outside a neighborhood or city and must be addressed in the context of watershed, region, and nation.

"They built a pipeline across Alaska. They could build a pipeline from here to Las Vegas. And there goes our water." To Allen Brown, Ralph Cammack, Terry Oft, and fellow farmers in eastern Oregon, water is what nurtures their livelihood and way of life, once considered the bedrock of American society and culture. To Las Vegas and Phoenix and San Diego, water is what they must have to sustain a burgeoning population. To a corporation, especially one far removed from the source, water is a commodity to be bought and sold. To the nation, water and fertile land should be treasured resources, not goods to be sold to the highest bidder. Public investment in new infrastructure and settlement patterns must not be undertaken lightly, for they are the framework within which society evolves.

Lange's words and photographs speak eloquently to the present, for the forces she saw and recorded in 1939 are still in play, forces of that particular moment, but not only of that moment. Her images have past sources and future manifestations. They reveal the heartrending consequences of shifts in jobs and decline in industry and their impact on the environment, the human stress of migration and resettlement. They demonstrate, too, the human capacity for endurance, resilience, cooperation, and hope. They show that all large-scale events, policies, and plans have a human face. "If you see mainly massed human misery in my photographs and decry the selection of so much suffering," Lange wrote, "I have failed to show the multiform pattern of which it is a reflection. For the havoc before your eyes is the result of both natural and social forces. These are my times, and they, too, are my theme," she said.[24] They are mine as well.

APPENDIX A

Chronology of Dorothea Lange's Life

1848 Maternal grandmother, Sophie Vottler, born in Germany; immigrates to the United States and marries Frederick Lange

1868 Father, Heinrich (later Henry) Martin Nutzhorn, born to German immigrants

1894 Mother, Joanna Lange, marries Henry Martin Nutzhorn, a lawyer

1895 May 25. Dorothea Nutzhorn (Lange) born in Hoboken, New Jersey

1902 Contracts polio

1907 Henry Nutzhorn abandons the family during economic depression

Joanna, Dorothea, and her brother Martin move to grandmother Lange's house in Hoboken

1913 Graduates from high school, enrolls in New York Training School for Teachers

1914 Grandmother Sophie Lange dies

Begins a series of apprenticeships in photography

1917 Takes Clarence White's photography course at Columbia University

1918 Drops the name Nutzhorn and assumes mother's maiden name

Embarks on a trip around the world; in San Francisco meets photographer Imogen Cunningham and Cunningham's husband, artist Roi Partridge; opens a portrait studio

1920 Marries artist Maynard Dixon

1923 Travels with Dixon to the Southwest; photographs Hopi Indians

1925 Birth of son Daniel Dixon

1928 Birth of son John Dixon

1931 Goes to Taos, New Mexico, with family; photographs Hopi Indians

1933 Begins photographing on street in San Francisco ("White Angel Breadline")

1934 Exhibits street photographs at Willard Van Dyke's gallery in San Francisco; Paul Schuster Taylor (born 1895, Sioux City, Iowa) asks to publish her photograph of San Francisco general strike in *Survey Graphic*

First field trip with Taylor

1935 Hired by Taylor to work for California State Emergency Relief Administration (SERA)

Series of illustrated reports produced with Taylor for SERA's Division of Rural Rehabilitation

Hired as "field investigator, photographer" for the Resettlement Administration's Division of Information; transferred to the Resettlement Administration's Historical Section at request of Roy Stryker; photographers Ben Shahn and Walker Evans of the Resettlement Administration impressed by Lange's work for SERA

Divorces Maynard Dixon and marries Paul Taylor

1936 Makes "Migrant Mother," her most famous photograph, in Nipomo, California

Travels through the South photographing conditions of farm tenants and sharecroppers

October. Dropped from Resettlement Administraētion by Stryker; used thereafter on a per diem basis

1937 Rehired by Stryker (full-time, January to October); in November, laid off for the second time

Resettlement Administration renamed Farm Security Administration (FSA)

1938 Rehired in the fall by Stryker

1939 January. Photographs FSA camps, works on *American Exodus*

February–March. Photographs U.S. 99 and San Joaquin, Imperial, and Salinas valleys; edits, prints, and writes captions; meets with regional staff to plan work

April. Photographs Salinas Valley, Monterey County, Santa Clara County, San Jose, Stanislaus County, FSA programs in migrant camps

May. Photographs San Joaquin Valley; writes captions; finishes layout for *American Exodus*

June. Travels to New York to find book publisher and to Washington, D.C., to arrange for reproduction of her photographs

July. Works with Margaret Jarman Hagood and Harriet Herring on documentation of North Carolina Piedmont before returning to California; Reynal and Hitchcock agrees to publish *American Exodus*

August. Photographs in Oregon and Washington: Willamette and Yakima valleys, Klamath Basin, central Washington

September. Writes captions for North Carolina work; returns to Oregon (Klamath Basin)

October. Rebuffs Stryker's offer of transfer to a job with filmmaker Pare Lorenz (October 5); continues work in Oregon (Willamette Valley, Columbia Basin, Malheur County); photographs northern Idaho; returns to California at the end of the month via Klamath Basin; receives telegram from Stryker terminating her job and instructing her to complete all work by November 30

November. Writes captions for Pacific Northwest photographs

December. Job at Farm Security Administration ends

1940 January. *American Exodus* published

Becomes head of photography, Bureau of Agricultural Economics, on a per diem basis

Writes statement titled "Documentary Photography" for book edited by Ansel Adams

1941 Receives a Guggenheim fellowship to "photograph people in selected rural American communities. The theme of the project is the relation of man to the earth and man to man, and the forces of stability and change in communities of contrasting types." Photographs the Amana in Iowa, the Amish in Illinois, and the Hutterites in South Dakota

1942 Hired by War Relocation Authority; photographs evacuation and internment of Japanese Americans

1943 Hired by Office of War Information to photograph American life; asks Ansel Adams to work with her on a story about Italian Americans

1944 Works with Ansel Adams on a story for *Fortune* magazine about workers in the shipyards of Richmond, California

1945– Surgeries and illnesses; occasional and
1948 sporadic photographing near home

1949 Featured in "Sixty Photographs by Six Women," an exhibit curated by Edward Steichen for the Museum of Modern Art in New York

1951 Participates in Aspen Conference on Photography; becomes a founding member of *Aperture*

1952 Writes "Photographing the Familiar: A Statement of Position," with Daniel Dixon

1953 Completes story for *Life* magazine on three Mormon communities, with Ansel Adams and Daniel Dixon

1954 Completes story for *Life* on Ireland and Irish people, with Daniel Dixon

1955– Works on a story about a public defender.
1956

1956– Works on a story about the flooding of Berryessa
1957 Valley, with photographer Pirkle Jones

1958 Is one of nineteen photographers featured by Beaumont and Nancy Newhall in their book *Masters of Photography*

Teaches a photography class titled "The Camera, an Instrument of Inward Vision: Where Do I Live?" at California School of Fine Arts

Accompanies Taylor to Japan, Korea, Hong Kong, the Philippines, Thailand, Indonesia, Burma, India, Nepal, Pakistan, and Afghanistan

1959 Publishes "Death of a Valley" in *Aperture*

1960 Travels with Taylor in Ecuador and Venezuela

Publishes "The American Farm Woman" in *Harvester World*

1960– Interviewed by Suzanne Riess of Regional Oral
1961 History Office, Bancroft Library, University of California at Berkeley

1962 KQED proposes a film on Lange, begins recording audiotapes

1962– Travels with Taylor in Egypt
1963
Writes proposal for Guggenheim fellowship to produce a "photographic and text record of the California Central Valley," "what the valley is and what it is becoming"

1964 John Szarkowski, curator of photography at New York's Museum of Modern Art, proposes a major retrospective exhibit of Lange's work at MOMA

1964– KQED taping of conversations continues up to
1965 the month before her death in 1965

1965 Works with Szarkowski on MOMA exhibit

KQED produces two films, *Dorothea Lange, Part One: Under the Trees* and *Part Two: Closer for Me*

October 11. Dies of cancer

1966 Retrospective exhibit opens at Museum of Modern Art, New York

1967 Publication of *The American Country Woman* by Amon Carter Museum

APPENDIX B

Description of New Deal Organizations and Programs

Starting with his first Hundred Days in office in spring 1933, Franklin Delano Roosevelt created the New Deal, setting up dozens of programs, both freestanding and within existing agencies. Over time, these programs were revised, reinvented, transformed, moved, and reorganized. Competition among them for authority and funding was keen, especially among agencies with overlapping programs, like the Works Progress Administration (WPA) and the Public Works Administration (PWA). Some, like the Civilian Conservation Corps (CCC), were popular, others, particularly the Resettlement Administration and the Works Progress Administration, were controversial. In the 1940s some agencies were abolished; others persisted, and some still exist. Lange's captions refer to those described below.

Agricultural Adjustment Agency (AAA). To increase prices farmers received for crops by cutting production, the Agricultural Adjustment Act of 1933 paid farmers not to grow certain crops, like tobacco, cotton, and wheat, and to reduce dairy and meat production. Farm owners were required to share federal funds with tenants and sharecroppers, but many did not. With the cash from the AAA, farmers purchased tractors and labor-saving equipment, enabling them to plant and tend more acres and to harvest crops with fewer workers. As a result, many tenant farmers were "tractored out." Rexford Tugwell, later director of the Resettlement Administration, drafted the Agricultural Adjustment Act.

Bureau of Agricultural Economics (BAE). The BAE, established in 1922 to help solve the economic problems of farmers, was the central planning arm of the Department of Agriculture in the 1930s. In 1937, the Resettlement Administration's program on land and land use was transferred to the BAE, "in order to consolidate all research, planning, service, and administrative functions related to conservation, retirement, development, and utilization of submarginal land."[1]

Bureau of Reclamation. Before the Reclamation Act of 1902 authorized establishment of the U.S. Reclamation Service, renamed the Bureau of Reclamation in 1923, irrigation projects were undertaken by private companies and by states. Congressional appropriations for the Hoover Dam in 1928 inaugurated a wave of large-scale public funding for irrigation and power projects; with projects like the Grand Coulee Dam, the Bureau of Reclamation expanded during the New Deal.

Civilian Conservation Corps (CCC). The CCC, established in 1933 and abolished in 1942, employed American citizens seventeen to twenty-three years old, who were physically fit, male, unemployed, unmarried, and not in school. Enrollment was for a minimum of six months and a maximum of two years, and participants had to send part of their pay to their families. CCC workers fought forest fires; planted trees; built roads and trails, lodges and picnic grounds, dams and bridges; planted grasses to halt soil erosion; drilled wells; made stock ponds, irrigation ditches, and reservoirs; and built terraces and established contours for crops.[2]

Farm Security Administration (FSA). The Farm Security Administration, established in 1937 as part of the Department of Agriculture, consolidated earlier programs of the Federal Emergency Relief Administration (under Harry Hopkins), the Agricultural Adjustment Administration, and the Resettlement Administration (under Rexford Tugwell). In the Washington office, there were four major programs (Rural Rehabilitation, Farm Ownership, Resettlement, and Labor), each with its own director. The FSA was organized into twelve regions, further subdivided by state and county. The Information Division included five sections: editorial, special publications, historical (photographic), radio, documentary film.[3] In 1942 the Historical Section was transferred to a new Office of War Information (OWI) and renamed

the Division of Photography; the FSA/OWI files were moved to the Library of Congress in 1943.

Federal Emergency Relief Administration (FERA). FERA was created in 1933 to provide jobs and commodities, such as food and clothes, to the unemployed. States applied to FERA for funds for local relief programs. Taylor's and Lange's first reports were prepared for the Rural Rehabilitation Division of the California State Emergency Relief Administration (SERA); they worked for SERA from the beginning of 1935 until June, when Rural Rehabilitation was transferred to the newly established Resettlement Administration.

Public Works Administration (PWA). The National Industrial Recovery Act of 1933 created the PWA to promote employment and build infrastructure through construction of public works, such as airports, dams, schools, and hospitals. Among the projects it undertook was the Bonneville Dam on the Columbia River. After the PWA was abolished in 1943, its functions were transferred to the Federal Works Agency, created in 1939.

Resettlement Administration (RA). The Resettlement Administration was intended to consolidate several programs: low-interest loans to help poor farmers buy land; soil conservation; resettlement of poor farmers on communal farms. To head the agency, President Roosevelt appointed Rexford Tugwell, who hired Roy Stryker to create the Historical Section in the Division of Information. The RA was transferred to the Department of Agriculture in 1937 and renamed the Farm Security Administration.

Rural Electrification Administration (REA). Created in 1935 as an independent agency to introduce electric service into rural areas, the REA encouraged establishment of rural electric cooperatives and expansion of private utility companies' service in rural areas. It was transferred to the Department of Agriculture in 1939.

Social Security Administration. Roosevelt signed the Social Security Act in 1935, which was to provide pensions from a payroll tax, unemployment insurance, and benefits, with states, for the disabled and for dependent mothers and children. Farm workers were not eligible for social security benefits (Paul Taylor was engaged as a consultant to determine what effects this might have). Payroll taxes were first collected in 1937, with the first payments to citizens over sixty-five in 1940. The act was amended in 1939 to expand old-age insurance.[4]

Works Progress Administration (WPA). The WPA, established in 1935 by President Roosevelt to create jobs for unemployed workers, from laborers to professionals, included special programs for writers (Federal Writers Project), artists (Federal Art Project), musicians (Federal Music Project), and theater folk (Federal Theater Project). WPA programs often overlapped with other New Deal programs: as in the CCC, WPA workers planted trees, laid out trails, and stemmed soil erosion; like the PWA, the WPA built highways, sewage treatment plants, and airfields. Like the CCC, its jobs were not permanent, but were a stop-gap measure to relieve unemployment and reduce the number of able-bodied workers on relief. In 1939, WPA employment was at its height, with more than 3,000,000 workers. By 1940, the number had dropped by a third, and in 1943, the last year of the program, with the war and war industry at their peak, only 271,000 WPA workers remained. In 1939, the Works Progress Administration was renamed the Work Projects Administration.[5]

Documents Submitted by Lange with General Captions

General Caption 31

Lange attached to general caption 31 the following newspaper clipping, dated October 21, 1939. She did not provide the name of the newspaper.

SEEK TO REMOVE JAIL STOCKADE.

Property Owners File Petition Claiming
It Is Detrimental to District.

YAKIMA, Oct. 20.—A petition bearing 131 signatures asking the removal of the county stockade at the jail was filed with the county commissioners today. The movement was instigated by property owners in the vicinity, Commissioner Frank Boisselle said, who claim the stockade is unsightly and detrimental to property values in the district. They further cited in the petition that the stockade has served its purpose and causes adverse comment and criticism. The stockade was constructed during the labor troubles here in 1933.

NO FUNDS AVAILABLE.

"The county has no money at this time to remove the wood stockade and construct a steel fence in its place, as requested by the sheriff," Boisselle said. "What we may do, however, will be to remove the barbed wire and catwalk at the top of the stockade and paint the remainder."

General Caption 35

Lange attached to general caption 35 the following clipping with a handwritten note indicating that it had been written by Richard Neuberger and published in Survey Graphic; the article appeared in July 1939.

THIS TRACT OF LAND HAS A HISTORY; LIKE MANY CHAPTERS in the colonization of the Northwest, the history is not a pleasant one. Nearly seventy-five years ago every alternate section of the area was owned by the Northern Pacific Railroad as part of its congressional land grant. The line encouraged westward migration; settlers bought the land for wheat raising. Other parts of the tract were homesteaded. Men borrowed heavily to finance farm buildings and other improvements. Equipment was expensive. For a few years the moisture stored in the soil supported dry farming. Then the ground began to cake and harden; crops burned up in the field; the wind started to blow away the arid clods; the settlers moved on. Mortgages were foreclosed and much of the area reverted to banks and loan companies. One bank now owns 27,880 acres; 5 percent of the land is owned by the federal government; 5 percent by the state of Washington and 5 percent still by the Northern Pacific. Some of the land became so tax delinquent the counties took over: Grant County owns 35,000 acres; Franklin County, 21,900 acres; and Adams County, 13,340. A considerable portion of the area still belongs to the colonists who were able to finance themselves; these people had no mortgage companies hanging over them, only the steely-blue sky from which no rain fell. They pulled out and left their farms to the elements. Today, the area is dotted with crumbling ranches and boarded up schoolhouses that tell the story of this ruined past. And here and there a farmer still hangs on, running a herd of scraggly cattle or raising wheat with sporadic results.

General Caption 36

Lange submitted the following report by the local FSA home management and farm supervisors with a handwritten note: "Please add to General Caption #36 (Arnold family)."

Irving G. Arnold	Thurston County
Route [illeg.]	56-34-210, 745
Central Washington	Non Commercial Experiment

The Arnold family consists of Mr. Arnold 39, Mrs. Arnold 30, two daughters age 10 and 6 and two sons age 11

and 8. They came from New Mexico to Washington four years ago.

The Arnolds are one of the few families in this particular district who have managed to get along without relief. They have needed assistance and were finally allowed commodities only, but have been forced to a very low standard of living. One question [is] how they have kept well.

They came here 4 years ago, paid down what they could on the place where they live, built their 2 room shack and proceeded to clear and develop their land. Possibly they were denied relief because of what his industry seemed to bring forth. He cleared the land, sowed potatoes to live on the first year then set out strawberry plants the 2nd. The same procedure has been followed out through these 4 years. Mrs. Arnold has worked at clearing with him and has picked beans and worked in the cannery in Olympia when possible to aid the family finances.

They have also built a good root cellar and here they store apples and potatoes (their chief articles of diet in the past). They have also secured a cow and so have had milk and butter. Mr. Arnold seems to have unfounded notions of what is "good" for him in matter of food, but as nearly as possible a balanced food plan was worked on, with Mrs. Arnold's help. The family has used cooked whole cereals and milk regularly. This with plenty of exercise and fresh air has no doubt been responsible for health of family.

Housekeeping is very sketchily done—could hardly be otherwise with Mrs. Arnold's working out-of-doors regularly and with only 2 rooms to house tools, etc., and in which to carry on the process of living. However, it is felt that more attention should be given to living. It seems advisable that all emphasis be placed this summer upon procuring an adequate supply of food. Then an additional room should be added to house as soon as possible.

The Arnolds have taken no part in community affairs since coming here, but they should like to belong to Grange when they can afford it. They have already been interested in Extension [the educational arm of the Department of Agriculture] meetings and attended 1st of a series planned for the next few months.

Both Mr. and Mrs. Arnold have one frivolity, that of smoking. They state that $15.00 annually is sufficient.

As has been stated previously, children and parents' health seems not to have suffered but both parents' teeth are in bad condition. Mrs. Arnold feels that her teeth must be removed soon as she has had some neuralgia and her teeth are beyond repair. Likely that a part of his will need to be removed.

Operating expenses are kept to a minimum. A few kitchen utensils will be needed. Feed sacks are to be used for pillow cases. A pressure cooker and 1 dozen each of 1 qt. and 2 qt. fruit jars and 2 barrels for krout and meat are planned. A family budget of $485 plus $29 for pressure cooker and food containers will be entirely adequate. They are a real type of family for whom non-commercial set-up was undoubtedly created.

—Home Management Supervisor

Farm consists of 80 acres, 40 of which can eventually be cleared. Soil is shot clay silty loam and considered to be the best berry land in Thurston county. Buying place on contract $550 balance. Holder of the contract in consideration of FSA loan is willing to give a deed to the property and take a mortgage on real estate. (Original price for the 80 acres was $1,200.) They will [pay] interest only for next four years and then payments will be $100 yearly.

Mr. Arnold is a World War veteran and homesteaded in New Mexico and sold the place to a cattle outfit.

General Caption 58
Lange attached the following memorandum to general caption 58.

WEST CARLTON CHOPPER COOPERATIVE
The eight occupants of Yamhill Farms Project in this area having, or soon to have, silos completed have saved themselves $275.84 annually through the cooperative purchase of ensilage and hay cutting equipment.

Each of the eight cooperators invested $62.00 or a total of four hundred ninety-six dollars ($496.00) to purchase the cutter. The repayment and interest charge amounts to approximately thirteen and 52/100 dollars ($13.52) per year.

By exchanging work there is no cash outlay and all are directly interested in completing the job so as to move on to the next cooperator's place. It requires an average of 12 hours (1½ 8 hour days) to fill each silo. These men paid $2.00 per hour for the rent of such equipment prior

to the purchase of this cooperative machinery. They were, therefore, paying $24.00 each for each filling or $48.00 per year. This represents a saving of $34.48 per person or $275.84 for the group of eight. Additional savings are made also in having the machine available for cutting hay and other feed stuff.

Where individual equipment is either owned or rented, additional expense is required to secure a working crew, while in the cooperative, the various members constitute a working crew which eliminates the necessity for actual cash labor.

Reference: W. B. Tucker
Community Manager
Yamhill Farms Project
McMinnville, Oregon

General Caption 66

Lange attached the following text to general caption 66 and cited no source.

THE VALE-OWYHEE GOVERNMENT PROJECTS
Four outstanding safeguards have been put into effect on the Vale and Owyhee projects as follows:

1. The land has been classified as to quality and suitability of irrigation.
2. The land was appraised as to its value without water, or on a dry land valuation.
3. Drainage costs are included in the original estimate for construction.
4. Only lands susceptible of irrigation shall carry construction and operation charges.

Then, to prevent speculation and to insure prompt settlement of the lands, the present owners were urged to and did execute contracts agreeing to the following conditions:

All land owners who own more than 160 acres must offer their excess lands for sale at the appraised valuation.

All land owners, owning less than 160 acres, may sell at any price obtainable; but fifty percent of the money received over the appraised value must be paid into the Irrigation District treasury, and there used to apply to the credit of the purchaser on the future water assessments of the lands sold.

The contract provision provides that the money must be paid into the District treasury at the time of the sale.

One of the Reclamation Bureau's requirements was to the effect that owners of seventy-five percent of the land on the projects must sign contracts agreeing to the above conditions before construction would start.

General Caption 67

This FSA Office Report by farm and home management supervisors was submitted with general caption 67.

Mack Hull
Route #2
Ontario, Oregon

1. Amount of FSA loan. $660—June 7, 1938
2. Purpose of loan. Mortgage on tractor, and plow—hay, gas oil and hired labor $660
3. Payments. $206.68
4. No Farm Visit Reports
5. Narrative Report—Home Management Supervisor

Were originally from Oklahoma but have lived near Caldwell, Idaho for about 19 years. Came here about a year ago. Fine, conscientious family, all interested in having a permanent home. Very cooperative, good, ambitious, intelligent and the ability to make the most of their efforts. Haven't enough income from sale of eggs and butter fat to take care of their living expenses. Mrs. Hull and daughter do much sewing for the family. House is unfinished. Live in basement and use part of upstairs for sleeping quarters and rest of it for a Sunday School room. House originally built for a chicken house so do not intend to improve it any. Plan to build a better house after farm is in production. Household goods are adequate, except for bedding and linens, washing machine has to be repaired this year. 1,200 fruit jars on hand. Sagebrush fuel. Kerosene light. Haul water from Ontario. Are leaders in church services in community. Personal expenses low—no tobacco, do own hair cutting.

7. Lived in Idaho 19 years—near Caldwell
8. Originally from Oklahoma
9. Farmer
10. Husband 46; Wife 45; Daughter 23; Sons 22, 19, 18, 3.
11. ——
12. Size of farm. 120 acres 7 ½ mile NW Ontario

SE ¼ NE ¼ Section 23, Township 17 South Range 46

SW ¼ NE ¼ Section 23, Township 17 South Range 46

SE ¼ SW ¼ Section 24, Township 17 South Range 46

General Caption 72

This FSA Office Report by farm and home management supervisors was submitted with general caption 72.

Stephen Soper
Willow Creek, Oregon

1. Amount of loan. $2,040—January 30, 1937; (2) $245—July 16, 1938 Cooperative
2. What purpose. Land improvement, well, fencing—$987; cows, pigs, machinery—$815; feed, seed, miscellaneous expenses, taxes—$283—$2,040.
3. Payments. $238 (1) $52.06 on Cooperative. Forbearance till Feb, 1939.
4. Farm Visit: 10-27-37

 Has about 30 acres more cleared, plowed and about finished leveling for this fall, will then lay by till spring and level before seeding.

 July 31, 1939

 Need pasture for cows. Should release grain to pay threshing, sell fat sows and keep young ones—will have hay to sell this fall.

5. Narrative—Home Management Supervisor

 This is a large family of 9 children and the parents. They came from Wyoming several days ago and at present are living at a tourist camp in Vale. Although they rented two cabins, yet they are very crowded and are anxious to become located on their farm as quickly as possible. They have started to build their house and hope to be settled in time to start the children to school after the first of the year. Most of their equipment is still in Wyoming but Mr. Soper plans to go back there and ship their things out in an immigrant car [railroad companies had immigration agents to coordinate services to migrants]. Their household goods are in only fair condition but they have enough to get by on for at least the first year. They do not have enough beds so will have about $50 expense for bedsteads, springs, and mattresses.

 Their food expense is approximately $50 at present but they will have their own butter, milk, and eggs very soon after becoming located. They do not have canned fruit and vegetables because they haven't been able to raise a garden in Wyoming. At present their diet is quite inadequate because they cannot afford to buy enough things they need. Mrs. Soper is a good seamstress and makes most of the clothing for the family. Their cash expense for clothing is rather low, but they have a fairly adequate supply of clothing on hand. Much of the clothing is handed down and made over for the smaller children. She also utilizes flour sacks for underwear, pajamas, towels, etc. The family is in good health, with the exception of one boy who has heart trouble. The Sopers appear to be a very fine, worthwhile family. They have always lived on a farm and want to become located on one permanently. The older children are of great help on the farm. The spirit of family unity and cooperation is good. This is a hard working, conscientious family, who will, no doubt, be successful with their proposed plan for the future.

7. Where from. South Dakota, Wyoming
8. Previous occupation. Farmer all life.
9. Haven't raised a crop in six years.
10. Husband, 43: Wife 33; sons 14, 13, 12, & 5 month. Daughters 10, 8, 7, 5, 3.
11. Why came. Drouth
12. Size of farm. 120 acres. N ½ SE ¼ Section 7, Township 17 South Range 44.

General Caption 73

This FSA Office Report by farm and home management supervisors was submitted with general caption 73.

GEORGE E. ROBERTS

Vale, Oregon

1. Am't of loan—$638—April 3, 1937 (2) $44—December 11, 1937 (3) $53—4-13-38
2. What for. Cows, Horse, Equipment, seed & feed—$638; (2) fencing—$44; (3) seed and water—$53.
3. Repayments: $433.17
4. Farm Visit—6-25-37

 Family has been rather hard pressed to meet living expenses as they have had no cash income, but from now on will have own farm produce to sell. Mrs. Roberts works out-doors much of the time. Has

a large garden and is planning to can and store produce for winter. Living in a tent at present but will have to build better living quarters this year.

Farm Visit—Later (no date given)

Have put up hay in good shape and need more cows to feed it. Keeping accounts for farm and home, fencing for stock and chickens and more stored vegetables should be done soon.

5. Narrative:

RR—Mr. Roberts and his family moved to the Vale project from Montana two years ago. They have farmed for a number of years and were forced to leave Montana due to drouth conditions. They are purchasing a 40 acres near Vale. This unit is not ideal in any sense of the word but should be developed into a farm that will eventually make this family a nice home. There is around 30 acres of land suitable for cropping. The balance will be used for pasture. The attitude of Mr. Roberts toward securing a loan of this nature has been somewhat questionable. However, it is believed with close supervision this family will be successful.

HM—The Roberts, whose original loan was made in 1937, are applying for a supplemental loan now to buy more dairy cows, having plenty of hay more valuable to feed than to sell, and needing a steady cash income to take care of living expenses. They have made the loan payments to date. Originally in a tent, the Roberts have built a one-room adobe dug-out, partly finished with cement. They hope to partition off the bedroom soon, if not build a new house. The lawn has been started twice, chickens have destroyed it and hogs root about dooryard. Mrs. Roberts makes most of clothing—had a dress-making shop in Chicago. Though Mrs. Roberts had been accustomed to city life, she now prefers the farm. She is sociable person and feels the isolation because of lack of transportation. Manage very cheaply; doubtful if diet has been adequate in past. It should be better with more cows and increased egg production of pullets. Garden failed except for tomatoes as Mrs. Roberts was ill and unable to care for it. No vegetables canned, so will procure more to store.

Traded hay for fruit, apples and sort potatoes for supply. Seem to need more and better cooked vegetables in diet. They seem very responsible to interest shown in them, and suggestions offered. They are very proud of the improvement they have made on the farm, and deserve further help with their efforts to make the place a comfortable and permanent home.

Key to Negatives and General Captions

The numbers below are the negative numbers for the general captions by Dorothea Lange reproduced in this book. She generally appended these numbers to her text with a note ("Refer to negatives"). Words and numbers in quotation marks were submitted by Lange; all other numbers were not on her original list. An ellipsis indicates that text has been deleted; in a few cases, for example, Lange included captions for individual photographs in the list of negative numbers. The letters that follow the numbers were intended to indicate negative size (but they are employed inconsistently). Lange made more than three thousand photographs in 1939 and did not index all that belonged with each general caption, so for many of the general captions the lists below are incomplete. By studying the photographs that Lange referenced, however, it is possible to identify others that belong to a specific general caption. Negative numbers for general captions not reproduced in the body of the book are included with the text of the captions in appendix E. All negatives are in the collection of the Library of Congress, catalogued by the numbers listed below (with the prefix LC-USF34-0).

General Caption 1

Although Lange did not list negative numbers for this general caption, her individual captions for the following photographs refer to general caption 1: 18869, 18877, 19089, 19130, 19188, 19311, 19360, 19361, 19362, 19391, 19531, 19533, 19545-E, 19548-E, 19549-E, 19550-E, 19551-E, 19553-E, 19568, 19569, 19570, 19571, 19573, 19574, 19576, 19588, 19589, 19590, 19591, 19602, 19604, 19605, 19607, 19621, 19624, 19630, 19633, 19634, 19638, 19639, 19640, 19642, 19644, 19646, 19647, 19648, 19652, 19676, 19677, 19678, 19685, 19686.

General Caption 2

Although Lange did not list negative numbers for this general caption, her individual captions for the following photographs refer to general caption 2: 19524-C,

19577–19585, 19596, 19599, 19600, 19612–19615, 19618, 19620–19622, 19635, 19636, 19656, 19657, 19660, 19662, 19665–19670, 19679, 19688.

General Caption 4

"19915-C, 19916-C, 19969-C, 20162-E, 20172-E, 20174-E."

General Caption 5

"20243-E, 19854-E, 19852-E, 19859-E, 19846-E, 19855-E, 19851-E, 19860-E, 20016-C," 19861.

General Caption 6

1. Priming: "19925-E, 19930-E, 19999-E, 20000-E, 20003-E, 20015-E, 20053-E, 20091-E, 20180-E, 20182-E, 20191-E." "(Refer also to these negatives general to this subject: 19961-C, 19963-C, 19967-C, 20160-E, 20161-E, 20057-E, 19927-E, 19959-C, 19968-C, 20087-E, 20086-E.)"
2. Sliding tobacco to the barn: "20055-E, 20058-E, 20075-E, 20117-E, 20064-E."
3. Stringing tobacco: "20039-E, 20040-E, 20067-E, 20068-E, 20072-E, 20074-E, 20075-E, 20077-E, 20073-E, 20106-C, 20107-C, 20112-C."
4. Putting in the tobacco: "19924-E, 19928-E, 19964-C, 19970-C, 19997-E, 19998-E, 19992-C."
5. Firing the barns: "20050-E, 20082-E, 20088-E, 20089-E, 20092-E."

General Caption 7

19924-E, 19927-E, 19928-E, 19964-C, 19959-C, 19961-C, 19963-C, 19967-C, 20039-E, 20040-E, 20050-E, 20055-E, 20057-E, 20064, 20069-E.

General Caption 8

"19849-E, 19843-E, 19848-E."

General Caption 9

"19922-E, 19935-E, 19936-E, 19940-E, 19941-E, 19943-E, 19944-E, 19945-E, 19946-E, 19947-E, 19948-E, 19950-E, 19954-E, 19955-E, 20002-E, 20013-E, 20030-E, 20032-C."

General Caption 14

"19869-E, 19876-E, 19877-E, 19878-E, 19880-E, 19881-E, 19895-E."

General Caption 15

"19806-E, 19902-E, 19809-E, 19807-E, 19808-E, 19810-E, 19811-E."

General Caption 17

"20121-E, 20125-E, 20138-E, 20163-E, 20175-E, 20188-E, 20184-E, 20187-E, 20193-E, 20197-E, 20206-E," 20205-E.

General Caption 18

"19742-E, 19797-E, 19798-E, 19799-E, 19800, 19823-E, 19862-E, 19863-E, 19864-E, 19865-E, 19866-E, 19868-E, 19870-E, 19872-E, 19873-E, 19874-E, 19900-E, 19903-E, 19904-E, 20014-E, 20159-E."

General Caption 19

"19971-C, 19974-C, 19993-C, 19995-C, 20200-E, 20249-E, 20258-C, 20263-E, 20264-E."

General Caption 20

"19707-D, 19715-D, 19719-D, 19722-D, 19723-E."

General Caption 21

"20202-E, 20212-E, 20214-E, 20221-E, 20222-E."

General Caption 22

"19706-E, 19712-E, 19714-E, 19716-E, 19718-E, 19720-E, 19721-E, 19726-E, 19727-E, 19729-E, 19731-E, 19733-E, 19734-E, 19735-E, 19736-E, 19737-E, 19738-E, 19740-E, 19743-E, 19745-E, 19751-E, 19752-E, 19753-E, 19754-E, 19757-E, 19758-E, 19783-E, 19784-E, 19787-E, 19789-E, 19790-E, 19791-E, 19792-E, 19799-E, 19920-E," 20257-E.

General Caption 23

"19917-C, 19919-C, 20017-C, 20020-E, 20120-E, 20124-E, 20129-E," 20131, 20136.

General Caption 24

"20021-D, 20023-C, 20094-C, 20095-C, 20096-C, 20097-E, 20098-C, 20100-C, 20101-C, 20102-C, 20103-C, 20105-C, 20134-E, 20229-E, 20236-E, 20239-E."

General Caption 26

"Klamath County . . . 20721-E, 20722-E, 20924-C, 20723-E, 20902-D, 20922-D, 20921-C."

"Yakima County . . . 20308-E, 20310-E, 20315-E, 20322-E, 20336-E, 20349-E, 20350-E, 20352-E, 20357-E, 20399-C, 20404-C, 20417-C, 20420-C."

General Caption 27

"20279-E, 20287-E, 20288-E, 20289-E, 20297-E, 20300-E, 20301-E, 20376-C, 20382-C, 20390-C, 20402-C," 20290, 20297, 20298, 20295, 20299, 20230, 20370.

General Caption 28

"20371-C, 20380-C, 20389-C, 20393-C," 20286, 20285, 20291, 20292, 20397.

General Caption 29

"20329-E, 20330-E, 20331-E, 20332-E, 20333-E."

General Caption 31

"20760-C, 20761-C."

General Caption 33

"20755-C, 20756-C, 20757-C, 20758-C, 20883-D, 20885-D, 20887-D."

General Caption 34

"20779-E, 20780-E, 20783-E, 20785-E, 20786-E, 20789-E, 20867-E, 20869-E, 20872-E, 20873-E, 20874-E, 20875-E."

General Caption 35

Deserted homesteads: "20824-E, 20827-E, 20831-E, 20829-E. 20832-E, 20890-C, 20899-C, 20416-C, 20421-C, 20424-C, 20427-C."

Ament: "20792-E, 20793-E, 20794-E, 20795-E."

General Caption 36

Michigan Hill: "20833-E, 20839-E, 20840-E, 20847-E, 20853-E, 20856-E, 20460-E, 20554-D, 20598-D."

Arnold family: "20552-D, 20809-E, 20810-E, 20813-E, 20814-E, 20815-E, 20834-E, 20842-E, 20843-E, 20844-E, 20845-E, 20858-E, 20861-E, 20862-E, 20863-E, 20864-E, 20868-E."

Kytta family: "20847-E, 20851-E, 20853-E, 20854-E, 20855-E."

General Caption 39

"20463-E, 20518-E, 20524-E, 20551-C, 20555-C, 20560-C, 20561-C, 20563-C, 20564-C," 20565, 20566.

General Caption 41

"20539-E, 20540-E, 20549-E, 20571-C, 20588-D, 20545-E, 20430-C, 20435-C, 20439-C, 20576-C, 20573-C, 20572-C, 20568-C, 20567-C, 20550-E."

General Caption 43

Siskiyou County, California: "20405, 20321, 20660-E, 20661-E, 20662-E, 20664-E, 20665-E, 20667-E, 20913-C, 20917-C."

Napa County, California: "18797-E, 18801-E, 18800-E, 18799-E, 18795-E."

General Caption 44

"20712-E, 20718-E, 20719-E, 20724-E, 20970-E."

General Caption 45

1. Picking hops: "20898-C, 20680-E, 20679-E, 20677-E, 20673-E, 20672-E, 20638-E, 20631," 20650.
2. Housing for hop pickers: "20689-E, 20698-E, 20692-E, 20709-E, 20713-E, 20745-C, 20748-C, 20940-E, 21065-E, 21059-E."
3. Miscellaneous: "20280-E, 20607-E, 20609-E, 20634-E, 20635-E, 20637-E, 20639-E, 20674-E, 20678-E, 20684-E, 20685-E, 20686-E, 20688-E, 20690-E, 20708-E, 20744-E, 20752-C."

General Caption 46

"20472-E, 20476-E, 20478-E, 20481-E, 20482-E, 20490-E, 20495-E, 20497-E, 20500-E, 20501-E, 20530-E, 20531-E, 20532-E, 20534-E, 20535-E, 20575-C, 20579-C, 20580-C, 20581-C, 20582-C, 20583-C, 20584-C, 20585-C, 20586-C, 20589-D, 20591-D, 20599-D, 20901-D, 20903-D, 20904-D, 20907-D, 20908-D, 20909-D, 20910-D."

General Caption 47

"The following negatives were made on August 23: 20902-D, 20922-D, 20921-C—Note rabbits in back of house. The following negatives were made on September 29: 21000-E . . . 21002-E, 21038-C."

General Caption 48

1. Views: "21509-E . . . 21512-E . . . 21514-E . . . 21515-E . . . 21519-E . . . 21514-C . . . 21549-C . . . 21552-D . . . 21644-C . . . 21606-C . . . 21608-C . . . 21609-C . . . 21617-C . . . 21620-C . . . 21621-C . . . 21634-C . . . 21640-C . . . 21644-C . . . 21645-C . . . 21652-C . . . 21655-C . . . 21656-C."

2. Members of cooperative: "21504-E . . . 21528-E . . . 21530-E . . . 21531-E . . . 21614-C . . . 21622-C . . . 21633-C . . . 21635-C . . . 21643-C . . . 21647-C . . . 21658-C."
3. Mill: "21541-C . . . 21503-E . . . 21507-E . . . 21543-D . . . 21546-D . . . 21559-D . . . 21588-D . . . 21589-D . . . 21591-D . . . 21624-C . . . 21639-C . . . 21641-C . . . 21560-D . . . 21626-C . . . 21653-C."

General Caption 49

Although Lange did not list negative numbers for this general caption, her individual captions for the following photographs refer to general caption 49: 21665-D, 21668-D, 21669-D, 21673-C, 21676-C, 21677-C, 21678-C, 21681-C, 21682-C, 21683-C, 21688-C, 21689-C, 21699-C, 21704-E, 21712-E, 21714-E, 21723-E, 21731-E, 21736-E, 021748-D, 21749-C, 21753-C, 21756-C, 21758-C, 21765-C, 21767-C, 21768-C, 21770-C, 21774-C, 21776-C, 21779-C, 21789-C, 21792-C, 21798-C, 217800-C, 21852-D, 21853-D, 21854-D, 21855-D, 21856-D, 21857-D, 21873-D, 21876-D, 21880-D, 21881-D.

General Caption 50

"21675-C, 21717-C, 21719-E, 21785-C, 21801-C, 21881-D, 21879-D, 21963-C, 21966-C, 21969-C, 21970-C, 21971-C, 21980-C."

General Caption 51

"21664-D, 21705-E, 21788-C, 21790-C."

General Caption 52

"21755-C, 21757-C, 21759-C, 21760-C, 21761-C, 21764-C, 21766-C, 21771-C, 21772-C, 21884-D."

General Caption 54

"21661-D, 21665-D, 21667-D, 21673-C, 21729-E, 21741-D, 21745-D, 21747-D."

General Caption 55

"21724-E, 21726-E, 21858-D, 21862-D, 21867-D, 21869-D, 21871-D, 21940-D."

General Caption 56

"21897-E, 21702-E, 21752-C, 21762-C, 21777-C, 21780-C, 21795-C," 21697.

General Caption 57

Yamhill Farms: "21896-E."

Granger: "21116-E, 21154-E . . . 21157-E, 21895-C, 21896-C."

General Caption 58

Chopper cooperative: "21073-C, 21080-C, 21081-C, 21082-C, 21085-C, 21086-C, 21096-C, 21142-E, 21893-C, 21894-C, 21897-C, 21898-C, 21901-C."

Helping Hand club: "21099-C, 21110-C, 21111-C, 21150-E, 21151-E."

General Caption 59

"21077-C, 21078-C, 21087-C, 21095-C, 21125-E."

General Caption 60

"21075-C, 21088-C, 21149-E, 21153-E, 21158-E."

General Caption 62

1. The mobile camp: "20977-E, 20997-E, 20998-D, 21005-E, 21816-E, 21825-E, 21826-E, 21886-D, 21889-D, 21903-E, 21911-E, 21912-E, 21914-E, 21915-E, 21965-C, 21967-C, 21968-C, 21972-C, 21979-C, 21982-C, 21983-C, 21984-C."
2. The Agricultural Workers Medical Association: "21824-E, 21829-E, 21830-E, 21832-E, 21833-E, 21834-E, 21837-E, 21921-E, 21924-E, 21938-E, 21949-C, 21951-C, 21952-C, 21953-C, 21957-C, 21961-C, 21962-C, 21989-C."
3. People in camp: "20974-E, 20975-E, 20976-E, 20980-E, 20981-E . . . 21819-E, 21917-E, 21820-E, 21922-E, 21823-E, 21956-C, 21902-E, 21974-C, 21986-C, 21987-C."

General Caption 63

1. Camp across from the potato sheds: "20944-E, 20955-E, 20956-E, 20958-E, 20959-E, 20960-E, 20961-E, 20963-E, 20964-E, 20967-E, 20969-E, 21003-E, 21014-C, 21016-C, 21023-C, 21025-C, 21031-C, 21034-C, 21040-C, 21042-C, 21841-E, 21843-E, 21846-E."
2. Potato sheds across from the camp: "21013-C, 21022-C, 21026-C, 21033-C, 21035-C, 21041-C, 21943-D, 21945-D."

General Caption 64

"21018-C, 21019-C, 21021-C, 21027-C, 21028-C, 21029-C."

General Caption 65

"20985-E, 20987-E, 20991-E, 20992-E, 20993-E."

General Caption 66

Although Lange did not list negative numbers for this general caption, her individual captions for most of the following photographs refer to general caption 66: 21774-E, 21273-E, 21260-E, 21263-E, 21292-C, 21301-E, 21339-E, 21346-C, 21347-C, 21353-C, 21354-C, 21355-C, 21357-C, 21358-C, 21359-C, 21360-C, 21361-C, 21362-C, 21363-C, 21556-D, 21585-D, 21595-D, 21596-D, 21603-D.

General Caption 67

1. The landscape: "21182-E, 21248-E, 21278-C, 21279-C, 21290-C, 21293-C, 21362-C, 21556-D, 21582-D, 21598-D."
2. The church: "21181-E, 21367-C, 21368-C, 21373-C, 21375-C, 21456-E."
3. Seven families (E. D. Wardlaw, M. M. Hull, Franklin Schroeder, Charles E. Free, Williams, Browning, and Emmet Smith; the latter five are reproduced in appendix E).

Wardlaw: "21377-D, 21378-D, 21389-D, 21404-D, 21460-E, 21461-E, 21462-E, 21463-E, 21464-E, 21466-E, 21469-E."

Hull: "21176-C, 21177-E, 21178-E, 21179-E, 21180-E, 21255-E, 21256-E, 21258-E, 21271-E, 21273-E."

General Caption 69

"21211-E, 21212-E, 21213-E, 21214-E, 21215-E, 21216-E, 21217-E, 21220-E."

General Caption 70

"21392-D, 21396-D, 21496-E, 21407-E, 21421-E, 21422-E, 21477-E, 21479-E, 21480-E, 21485-C, 21487-C, 21496-C, 21498-C, 21596-D."

General Caption 72

"21234-E, 21235-E, 21240-E, 21241-E, 21242-E, 21243-E, 21264-E, 21265-E, 21267-E, 21269-E, 21274-E."

General Caption 73

"21222-E, 21223-E, 21225-E, 21227-E, 21228-E, 21238-E."

APPENDIX E

Additional General Captions from 1939

The following general captions include all those Lange wrote in 1939 that do not appear in Part Two. The negatives, like those associated with general captions included in the text (see appendix D), are in the collection of the Library of Congress, catalogued by the numbers listed below (with the prefix LC-USF34-0).

GENERAL CAPTION NO. 3
[May 1939, Visalia, California]

Ten families have been established by Farm Security Administration on the Mineral King Cooperative Farm, an old ranch of 500 acres, which they will operate as a unit, raising cotton, alfalfa, and dairy products for cash crops. Modern structures, suitable for community farming, will soon replace old buildings. Purpose: Rehabilitation. Three directors were elected by the ten families from among themselves.

[Although Lange does not list any negative numbers, the following individual captions make reference to general caption 3: 19637, 19649, 19650, 19675, 18368. She also photographed this project in fall 1938.]

GENERAL CAPTION NO. 10
DATE: July 4, 1939
LOCATION: At Olive Hill on Highway 57, Person County
MAP CODE: Person 12
SUBJECT: The tobacco barn, which is a distinctive American architectural form

These barns, in the same field, show two types—with and without front shelter. Barn with shelter, has small shelters in rear and at sides. The doors are open showing that the barns are being cleared and cleaned preparatory to priming, which will begin next week.

Refer to negatives 19990-C, 19966-C, 20028-C, 20031-C.

GENERAL CAPTION NO. 11
DATE: July 3, 1939
LOCATION: Turn east from Highway 144 at sign saying "To Hurdle Mills" two miles northeast of Bushy Fork; turn right in two and seven tenths mile. Go three tenths of a mile, turn around, and the half mile is taken from here back toward the highway.
SUBJECT: One half mile along a country road in Person county

Notes on subjects of photographs (L. and R. for left and right side of road).

House No. 1. A "shotgun," weather board house with car in yard. This house was built in 1925 and is occupied by the son of the widow of the next house.

Refer to negative 19773-E–L.

SUBJECT: Looking down the road photographed.

Note light sandy soil. These photographs were made on a rainy day. Refer to negative 19775-E.

Tobacco barn with shed in back belongs to house No. 1, refer to negative 19774-E–R.

SUBJECT: Tobacco Barn with bottom part of a log and top boxed, belongs to house No. 1, refer to negative 197723-E–R.

SUBJECT: Pack house, where tobacco is stripped, refer to negative 19771-E–L.

SUBJECT: Mail box, refer to negative 19781-E. House No. 2, the one and one half story part of this house (a story and a jump) was built fifty to sixty years ago; the two story part was built in 1900. It is owned by a widow

whose husband died seventeen years ago. She says, I run the place myself, and it's a po' run!" She has lived here ever since she has married, but her husband's people came when the big white oaks in the front yard were so small "you could drag a wagon over them." Her sons lived in the houses nearest on either side, and another married son and a widowed daughter lived with her. She told us about the Negro church below, and was very interested in our purposes. Refer to negatives 20036-C–L, 20034-C–L.

SUBJECT: Road, with two women walking on it, going to see a sick neighbor. The older woman is the widow of house No. 2, and the younger is her sister-in-law, also a widow. They "lived together for thirteen years without a cross word." When asked to let us take pictures, the older said "you must want an old sea hag," and the younger "whose hair was rolled up in curlers" said "I look like the bad man's baby doll." Refer to negative 20041-E.

House No. 3, story and a half, weather board. Note China berry trees, common for shade. Note erosion of soil in foreground. Note corner of tobacco field. Refer to negative 20035-C-L.

SUBJECT: Negro church called Young's Chapel, a Negro Baptist Church. The corner stone says "organized May, 1887," Rev. C. J. Springfield. A cross in the yard has an inscription, this stone marks the place where J. W. Bradsher professed faith in Christ October 1891. Refer to negatives 19763-E, 19906-C, 20042-E, 19761-E.

GENERAL CAPTION NO. 12
[Dorothea Lange with Margaret Jarman Hagood]
DATE: July 8, 1939
LOCATION: Siler City, Fayetteville Street, Chatham County
MAP CODE: Chatham 4

Notes: Photograph of Fayetteville Street showing crossing of Raleigh Street and Chatham Bank is of same area as the photograph bought from salesman at the drug store, which was taken 25 years ago. The old photograph shows "the old town well." This photograph is affixed. Various people were asked to estimate the date when the old photograph was taken. An older man who was mayor of Siler City for four years about that time

thinks it was taken about 25 years ago. See photograph of the ex-mayor looking at the photograph. The hotel showing in both pictures was built in 1907. The bank building has been brick veneered since the first picture was taken.

Refer to negatives:

20139-E: Subject, Man who was mayor of Siler City 25 years ago studies the photograph (attached) to ascertain when it was made. "The old town well right there in the center—let me see now, that was fixed—I was mayor at the time, and I been married 30 years—it was before I was married, and before we put in the macadam. See the flagpole we put down there?"

20215-E: Same as 20139-E.
20137-E: Contrast with photograph showing same crossing about 25 years ago.
20208-E, 20218-E, 20217-E, 20216-E.

GENERAL CAPTION NO. 13
[Dorothea Lange with Harriet L. Herring]
DATE: July 5, 1939
LOCATION: Two miles south of Wheeley's Church
MAP CODE: Person 23
SUBJECT: Negro topping tobacco

Elderly negro man. He says he is so practiced in topping tobacco, swinging from right to left that he can carry two rows as fast as he can walk. And top it to either ten, twelve, fourteen, leaves as he chooses. Has a big family—three boys, two girls, and a wife—and tends twelve acres of tobacco, works four mules. "Best tobacco land in this whole country." Makes one thousand to one thousand one hundred per acre. He is a tenant.

Refer to negatives 19759-E, 20223-E, 20232-E, 20246-E, 20266-E, 20268-E.

GENERAL CAPTION NO. 16
[Dorothea Lange with Margaret Jarman Hagood]
DATE: July 1, 1939
LOCATION: Highway 55, 12 miles from Chapel Hill, Chatham County
MAP CODE: Chatham 3
SUBJECT: White sharecropper—family, house, and tobacco patch

This tenant farm is representative of the small holdings in the region. This is a "settled" community and there is much kinship and intermarriage. The owner has 12 acres of tobacco and three families live on the place, the owner's family, his son's, and this tenant. The sharecropper's wife is 25 years old. They have been married three years. She put a sun suit on the baby to have its picture taken and went back to the house and combed her hair. They are all Chatham county people. The house shows barrenness, lack of shade, lack of yard and flowers or decoration of any sort. It has three rooms built four years ago. Note that the tobacco grows up to the front porch. The tobacco is fairly good, about three weeks before priming stage.

Refer to negatives 19838-E, 19891-E, 19893-E, 19894-E.

GENERAL CAPTION NO. 25
Panaceas

On the edges of small towns in Oregon and Washington, where the insignia of business and patriotic societies usually line the highways, there appear the advertisements of panaceas. Home made, crudely painted signs proclaim the Townsend plan, a device for full employment and prosperity as well as a help to the aged. Even Technocracy, with tri[?] metal sign as befits an organization based on engineering principles, is advertised to meet weekly at the town library.

Refer to negatives 20277-E, 20711-E, 20704-E, 20703-E, [20505-E].

[General caption 30. In her captions for five negatives (20312-E, 20313-E, 20314-E, 20318-E, 20319-E), Lange wrote: "August 10, 1939, Toppenish, Yakima Valley, Washington. Family who traveled by freight train. Refer to general caption 30." Lange did not submit text for the general caption. The following is taken from her daybooks: "Family, travelling by freight train. Left Spokane where had been on relief, to come to Yakima Valley for the hop season. No work started and no camp open. Came last year in old jalopy 'and made good,' had 22.50 at end of the season, over his living expenses. Hop season lasts about 4 weeks. *Toppenish*."]

GENERAL CAPTION NO. 32
DATE: August 11, 1939
PLACE: Yakima, Yakima County, Washington

In shacktown, 2 miles east of Yakima south of the fairgrounds. Refer also to General Caption No. 26 on Shacktowns.

Photograph shows tent in which this young family have lived, shack where they live now, and concrete basement of new house which they are building. The basement is finished and they plan to live in it until they can progress further. Note vegetable garden (corn) in rear of lot. They have two small children. The price of the lot is $650 for a half acre. They pay $10 per month. Husband age 30 works in mill in town and earns $75 per month.

Wife says "We're putting up a little every pay day. We've got our payments to where we can keep it in case anything comes up. We're independent minded people, this is all we've got, but we *feel* we're independent. We never *will* forget what we went through to get this."

Refer to negatives 20417-C, 20769-E.

GENERAL CAPTION NO. 37
DATE: August 14, 1939
PLACE: Tenino, Thurston County, western Washington
SUBJECT: Western Washington small town

Tenino lies in a valley clearing. Photograph 20457-C shows view of the town from hill above. Note surrounding second growth timber. Population 938. U.S. 99 runs through the town. A trading center for farmers (see General Caption No. 36 on Thurston County), and is a railroad junction. The lumber mill has closed.

For photographs made driving down the main street from North to South, refer to negative numbers 20504-E, 20505-E, 20506-E, 20507-E, 20508-E, 20509-E, 20510-E, 20511-E, 20512-E, 20513-E, 20514-E, 20515-E.

GENERAL CAPTION NO. 38
DATE: August 15, 1939
PLACE: Elma, Grays Harbor County, western Washington
SUBJECT: Another western Washington town

Negative 20567-D shows another western Washington town looking down from the surrounding hills (refer to General Caption No. 37). Population 1,545. Refer also to General Caption No. 39 for photographs of the Mumby

mill at Malone, upon which this town has depended. The mill closed down after 35 years operation. Clippings attached tell the present story of this town.

Elma is surrounded by 20,000 acres of farm land, serves 4 rural mail routes out of its post office. 13 districts are consolidated in Elma schools. The question which faces this town and many others in western Washington is, "How can the loss of the lumber mills be absorbed?"

Refer to negative numbers 20428-C, 20429-C, 20441-C, 20443-C, 20444-C, 20521-E, 20522-E, 20594-D, 20597-D.

GENERAL CAPTION NO. 42
DATE: August 16, 1939
PLACE: Longview, Coulitz county, western Washington
SUBJECT: Longview homesteads (F.S.A.)

Longview Homesteads is a subsistence homestead project of 60 units designed for low-income industrial families who are employed in the lumbering and wood processing plants in the vicinity. Its purposes are to provide better housing and living conditions and to give the project residents an opportunity to lower their living costs by the production of home-grown fruit and vegetables.

At the present time (August 1939) practically all the heads of families are employed in one large mill. There is no unemployment among the homesteaders. They earn from $90 to $125 per month. There is no vacancy on the project. There is no payment delinquency. Payments on individual homesteads vary from $19 to $22 per month.

Story of one family: This family have been able to weather disaster because they had a home which was a sound unit. Husband was saw-filer in the mill when the family moved onto the project. They have three children. Since then he became ill, was hospitalized for one year's care with tuberculosis. Mother was granted $42 a month under Public Assistance, Aid to Dependent Children. During the time that he was ill she was able to hold the family together, meet the payments on their home ($17 a month). They were able to grow practically all their own food on their 2 acres. She raised vegetables, chickens, rabbits for meat, cow and calf (butchered the calf and quartered it), pig, and berries, of which they

sold some to market. The husband is now recovered, goes back to work next week. Home shown in photographs, husband repainted his house.

Refer to negatives 20448-C, 20550-C.

GENERAL CAPTION NO. 53
DATE: October 21, 1939
PLACE: Bonner and Boundary Counties, Northern Idaho Refer to General Caption No. 49 for information on these counties
SUBJECT: Water supply on cutover farms

Another problem of the cutover area is that of securing an adequate water supply. In some places plenty of water is available from natural springs but in other places the cost of drilling a well two or three hundred feet is prohibitive.

Refer to negatives 21680-C, 21737-E.

GENERAL CAPTION NO. 61
DATE: September 30, 1939
PLACE: Keno, Klamath County, Oregon
SUBJECT: Small lumber mill, representative of many in the Northwest

The Mill is situated on the Klamath River about 18 miles from Klamath Falls, owned by the Ellingson Lumber Company. It has been operating continuously since 1922, and employs about forty men.

Refer to negatives 20945-E, 20946-E, 20947-E, 20952-E, 20951-E, 20953-E, 20994-E, 21172-E.

GENERAL CAPTION NO. 67
DATE: October 11–17, 1939
SUBJECT: Dead Ox Flat, Malheur County, Southeastern Oregon

Refer to General Caption No. 66 on Malheur County

[See the main text, page 248, for the first sections of this general caption.]

III
This group shows the homes of seven families who are establishing farms on Dead Ox Flat.

Name: Franklin Schroeder (FSA borrower)

An example of a successfully adjusted and relocated family. Came from a South Dakota farm three years ago. Worked in a lumber mill in Klamath Falls when first came west in 1936, but was laid off "because I was the last one on." Wife had been a school teacher. Have three small boys, two born on this farm. Has 80 acres, 70 irrigable. No cash crop yet, land must be built up.

He says:
"I had no reason to stay in South Dakota—I was through . . ."
"We're getting along all right here, but it's slower than I thought."
"Got along all right with irrigation, but it was hard to make the ditches hold at first." (This is a problem of new land).
"My place looks kind of barren now. I didn't put in my trees right away. Now I know where I want them—west of the house."

Wife says:
"FSA is fine for us, but there's lots of rules and things you can't do that would help you get along faster, but they have to have them to suit the average, I guess."
"Sometimes I think we're not getting along fast enough and we get discouraged, we've done such a lot of work on this land. I'd like to go back to South Dakota to visit with all my folks, but I wouldn't want to stay."

Refer to negatives 21184-E, 21194-E, 21195-E, 21196-E, 21197-E, 21198-E, 21277-C, 21283-C, 21286-C, 21582-D, 21583-D.

Name: Charles E. Free (FSA borrower)

See information regarding this family, attached.

This family live on a 40-acre farm, one-half mile east of the church, in a basement dugout house, with a dirt floor. Permission not granted to photograph interior. They had lived for thirty years in Beaver County, Oklahoma, and heard of this land through correspondence with church people. Had $20.00 cash when they landed.

"If a person has money they can fix things up quicker."
"This land is for people younger than us. We're too old

for it, but we had to come some place."
"My husband shouldn't work so hard. He's not well enough, but there's too much for me and the boy (17) to do."

Boy, 10 years old: "I wish I could climb a tree."

Refer to negatives 21380-D, 21381-D, 21386-D, 21387-D, 21390-D, 21391-D.

[Lange attached an FSA office report on the Free family, not reprinted here.]

Name: Williams (FSA borrower)

Another basement dugout home. Family plans on the sale of turkeys as cash crop. Note Rural Electrification. Family not home on this day.

Refer to negatives 21186-E, 21187-E, 21199-E.

Name: Browning (FSA borrowers)

This family left North Dakota in 1929, and went to Washington. Father had been on W.P.A. there. They have seven children, the oldest thirteen. Out of his W.P.A. earnings ($55.00 per month) they saved $100.00 and moved here, rented this place in April, 1939. "I could do that out of what we had because I have a good wife." Have had a loan of $782.00 from FSA. "Having trouble meeting the full payment this year, haven't made a cent." Lost a horse during the summer. Hope to move to a better place on the flat shortly.

"It takes two years to get this land in shape to grow. The first year maybe you can feed your livestock."

Refer to negatives 21193-E, 21250-E, 21251-E, 21252-E, 21253-E, 21254-E, 21275-C, 21281-C.

Name: Emmett Smith (FSA borrower)

The Smith family "took their land out of the sage brush three years ago." They have 160 acres. See office report attached.

"I reckoned on three years to get this place in shape, but more likely it will take five. There's lots of work getting

a place like this so the water will run right, filling in the gullies, and after you get it done you see where it's still ain't right. But I like farming about the best kind of a way there is—if prices would come up. 40 cents for wheat and $4 for hay ain't very good."

Refer to negatives 21190-E, 21191-E, 21192-E.

[Lange attached an FSA office report on the Smith family, not reprinted here.]

IV
This group of photographs shows some of the children of newly settled families going to school from their homes on Dead Ox Flat. The bus pulls up the hill at seven-thirty in the morning, makes a wide circle on the top of the bench, from one farm to the next, and descends at eight-thirty bound for the school in Ontario, about six miles away.

Note to R.E.S. [Roy Stryker]: Could not follow the bus, the dust was excessive, could not precede it because of the speed at which the driver traveled over rough road.

Refer to negatives 21205-E, 21206-E, 21207-E, 21208-E, 21210-E, 21259-E, 21276-C, 21287-C, 21282-C.

GENERAL CAPTION NO. 68
DATE: October 12, 1939
PLACE: Outskirts of Vale, Malheur County, southeast Oregon
SUBJECT: Migrant family

Man and wife, four children, have come from northern Idaho to look for work in onion harvest. Then they plan to put the children in school in Nyssa "for a little while", while parents work in the beets. Have an old Dodge car, team, saddle, skis, goats in the back of the wagon. Mother patching overalls.

Refer to negatives 21397-D, 21399-D, 21402-D.

GENERAL CAPTION NO. 71
DATE: October 13, 1939
PLACE: Nyssa Heights, Malheur County, Oregon
SUBJECT: John Bartheloma, FSA borrower

Refer to General Caption No. 66 and Office Report attached.

Photographs show Mrs. Bartheloma dipping water from irrigation ditch for home use. "Every year we stay here we think we'll be rich enough to have a well, but we don't."

"I've been discouraged this year. I think we ought to be getting to make something, but—we've got our hardest years behind us. My husband had to go back to Nebraska—a death in the family—and he's been satisfied since he came back. He says if I could just go back and see Nebraska I'd be right satisfied."

They have been here for three years. Haul drinking water from town four miles over rough road.

Refer to negatives 21303-E, 21304-E, 21305-E, 21307-E.

[Lange attached an FSA office report on the Bartheloma family, not reprinted here.]

GENERAL CAPTION NO. 74
DATE: October 12, 1939
PLACE: Warm Springs District, Malheur County, Oregon
SUBJECT: Daugherty family, FSA borrowers
Refer to Office Report Attached
See General Caption No. 66

Family of seven, oldest boy 11, baby 2 months old born in this house. Came to Malheur County from Tillamook, Oregon, where he had been a dairy farmer. Came in March, 1939, and are establishing a 120-acre farm under the Irrigation Homestead Act.

The children have helped grub out the sage brush. They have built a semi-basement house with a sod roof. Have an acre of garden, fruit trees set out, canned food for the winter. Have no car. When they come to town, they ride in the hay wagon.

Boy: "My father went to the War, but only the World War, not the Civil War. The Battle of France was the only battle he fought in."

Refer to negatives 21308-E, 21309-E, 21311-E, 21313-E, 21488-C, 21494-C, 21562-D, 21572-D, 21577-D, 21578-D.

[Lange attached an FSA office report on the Daugherty family, not reprinted here.]

GENERAL CAPTION NO. 75
DATE: October 16, 1939
PLACE: Homedale District, Malheur County, Oregon
SUBJECT: The Dazey family, FSA borrowers
See General Caption No. 66

Family came from Colorado a year and a half ago. Dry farmers there for 16 years. Moved on this farm in April, 1939. Bought a house in Homedale and moved it to the farm. Have five children, three boys in high school. The soil is poor, "the garden didn't grow much." Rabbits took their beans and peas "when we needed it so bad." "The rabbits were just like a herd of sheep." A year ago the family worked in beets and in hops. "Think we'd be all right if we could get it started." They have a 120-acre farm. Haul drinking water 9 miles. To drill a well would cost 50 cents a foot, and they don't know how deep they would have to dig.

Refer to negatives 21442-E, 21443-E, 21445-E, 21446-E, 21447-E, 21449-E, 21450-E, 21451-E.

GENERAL CAPTION NO. 76
DATE: October 26, 1939
PLACE: Gilchrist, Oregon
SUBJECT: New style company lumber town and housing

This mill village has just been completed, modern architecture employed, by company from Laurel, Mississippi. They have operated there for many years, cut out last year, and have moved their operations into the Oregon woods. They have brought forty millworkers from Mississippi with them, for whom they built this town. Oregon timber supply on their property is estimated to last 60 years.

Refer to negatives 21806-E, 21807-E, 21811-E, 21812-E, 21840-E, 21849-E, 21850-E, 21977-C, 21988-C.

NOTES

Prologue

1. Dorothea Lange, interview by Suzanne Riess (October–December 1960, January 1961, and August 1961), in *Dorothea Lange: The Making of a Documentary Photographer* (Berkeley: Regional Oral History Office, Bancroft Library, University of California, 1968), 144.

2. Ibid., 149.

3. Dorothea Lange, interview by Richard Doud, New York City, May 22, 1964, Archives of American Art, Smithsonian Institution, http://www.aaa.si.edu/collections/oralhistories/transcripts/lange64.htm.

4. Lange, in Riess, *Dorothea Lange*, 145.

5. Ibid.

6. Lange, Doud interview, 1964.

7. Ibid.

8. Dorothea Lange, audiotape recorded by KQED, San Francisco (cassette tape 16, side A), November 8, 1962, or August 11, 1964, Dorothea Lange Collection, Oakland Museum of California (hereafter cited as Lange Collection). Quotations from the KQED audiotapes were transcribed by Anne Whiston Spirn.

9. Lange, KQED (tape 6, side B), September 27 or October 15, 1964, Lange Collection.

10. Lange, KQED (tape 15, side A), September 10, 1965, Lange Collection.

11. Lange, in Riess, *Dorothea Lange*, 145–46.

12. Ibid., 216.

13. Lange, KQED (tape 15, side A), September 10, 1965, Lange Collection.

14. Lange, KQED (tape 16, side B, and tape 17, side A), August 11, 1964, Lange Collection.

15. Lange, KQED (tape 3, side A), August 28, 1964, Lange Collection.

16. Lange, Doud interview, 1964.

One. Dorothea Lange and the Art of Discovery

1. See John Steinbeck, *Their Blood Is Strong* (San Francisco: Simon J. Lubin Society of California, 1938), a reprint of his 1936 articles for the *San Francisco News*. Steinbeck spent several days looking through the Farm Security Administration files to prepare this. See also F. Jack Hurley, *Portrait of a Decade: Roy Stryker and the Development of Documentary Photography in the Thirties* (New York: Da Capo, 1977), 140; Carol Schloss, "John Steinbeck and Dorothea Lange," in *In Visible Light: Photography and the American Writer, 1840–1940* (New York: Oxford University Press, 1987). Pare Lorentz, "Dorothea Lange: Camera with a Purpose," *US Camera* 1 (1941): 96.

2. Dorothea Lange, interview by Richard Doud, New York City, May 22, 1964, Archives of American Art, Smithsonian Institution, http://www.aaa.si.edu/collections/oralhistories/transcripts/lange64.htm.

3. Dorothea Lange, interview by Suzanne Riess (October–December 1960, January 1961, and August 1961), in *Dorothea Lange: The Making of a Documentary Photographer* (Berkeley: Regional Oral History Office, Bancroft Library, University of California), 174.

4. Dorothea Lange, *Dorothea Lange Looks at the American Country Woman* (Fort Worth: Amon Carter Museum, 1967), 12.

5. Lange was critical of those who merely depicted conditions without portraying the underlying phenomena of cause and effect: "When they present this story of agricultural labor, people don't really see the big story which is behind it, which is the story of our natural resources." Lange, in Riess, *Dorothea Lange*, 159, 164. Lange's reference to "people in their relations . . ." is from her fellowship application to the John Simon Guggenheim Memorial Foundation, 1940, Dorothea Lange Collection at the Oakland Museum of California (hereafter cited as Lange Collection).

6. Clifford Geertz, "Thick Description: Toward an Interpretive Theory of Culture," in *The Interpretation of Cultures* (New York: Basic Books, 1973).

7. Rondal Partridge, interview by Anne Whiston Spirn,

Berkeley, California, March 28, 2005. Lange, in Riess, *Dorothea Lange*, 158, 206.

8. There is also a set of the 1939 general captions and individual captions in the Lange Collection at the Oakland Museum of California.

9. Annette Melville, "Farm Security Administration Historical Section: A Guide to Textual Records in the Library of Congress" (Washington, D.C.: Library of Congress, 1985). Lange's general captions were filed separate from her photographs, which were, however, filed with their individual captions. Milton Meltzer, in *Dorothea Lange: A Photographer's Life* (New York: Farrar, Straus and Giroux, 1978), reproduces one general caption (the same one Lange used in *The American Country Woman*) but mentions no others. Karen Tsujimoto refers to Lange's general captions and includes an excerpt from one on "migratory single workers" in her *Dorothea Lange: Archive of an Artist* (Oakland: Oakland Museum of California, 1995). Karin Becker Ohrn's fine book, *Dorothea Lange and the Documentary Tradition* (Baton Rouge: Louisiana State University Press, 1980), alludes only briefly to them (103, 106). Howard Levin and Katherine Northrup's edited volumes, *Dorothea Lange, Farm Security Administration Photographs, 1935–1939* (Glencoe, Ill.: Text-Fiche Press, 1980), incorporate excerpts from several general captions, but within individual photograph captions and without comment. Lange's longer texts were not omitted because of limited space; Levin and Northrup include two speeches on migrant labor by Lange's husband, Paul Taylor, as well as other reports Taylor wrote. (Lange's photographs are, in effect, missing too—they do not appear in the book itself but only on accompanying microfiches.) In Linda Gordon's recent article, "Dorothea Lange: The Photographer as Agricultural Sociologist," *Journal of American History* 93, no. 3 (December 2006): 698–727, one general caption is provided as an example of how Lange attempted to "control the meanings of her pictures." Meltzer and Gordon's texts do not note, however, that Lange was not the sole author of the texts each reproduced. These particular captions were coauthored with staff of the University of North Carolina's Institute for Research in Social Science, under whose auspices Lange was working in July 1939. Gordon's article appeared after the completion of the manuscript for *Daring to Look*.

10. Beaumont Newhall, "The Questing Photographer: Dorothea Lange," in Dorothea Lange, *Dorothea Lange Looks at the The American Country Woman*, (Fort Worth: Amon Carter Museum, 1967), 7. On July 29, 1965, fewer than three months before her death, Lange wrote to the curator and critic Beaumont Newhall to entrust him with a manuscript on the theme of "The American Country Woman" in the hope that it would be "safeguarded." Newhall added an introductory essay and a note from Lange and arranged for the book's publication.

11. This practice was not unusual in the 1930s either. For information on how the popular press used the FSA photographs, see Cara A. Finnegan, *Picturing Poverty: Print Culture and FSA Photographs* (Washington, D.C.: Smithsonian Books, 2003).

12. Time-Life Books, *Great Photographers* (New York: Time-Life, 1971), 184.

13. Nicholas Natanson, *The Black Image in the New Deal: The Politics of FSA Photography* (Knoxville: University of Tennessee Press, 1992), 217–19. Natanson reports that Lange's photographs of blacks, when she was working in states where she was likely to encounter them, comprised about 31 percent of her total photographs, a significantly greater proportion than for any other FSA photographer apart from Gordon Parks. Natanson, 72.

14. William S. Powell, *North Carolina through Four Centuries* (Chapel Hill: University of North Carolina Press, 1989), 494.

15. Henry James, *The American Scene* (New York: Harper, 1907). This quotation from James was a favorite of photographer and author Wright Morris, who was a contemporary of Lange.

16. Images with no people make up only 13 percent of the plates in the 1966 MOMA catalogue that accompanied the retrospective exhibition of her work (New York: Museum of Modern Art, 1966), 17 percent in *Photographs of a Lifetime* (New York: Aperture, 1982), 7 percent in *Dorothea Lange: A Visual Life*, ed. Elizabeth Partridge (Washington, D.C.: Smithsonian Institution Press, 1994), 6 percent in *Dorothea Lange: The Heart and Mind of a Photographer*, ed. Pierre Borhan (Boston: Bulfinch Press, 2002). In Lange's own books and essays, the proportion of photographs without people is much higher and more representative of the actual range of her work: more than half in "Death of a Valley," coauthored with Pirkle Jones (*Aperture* 8, no. 3 [1960]: 127–65), and a third in both *American Country Woman* and Dorothea Lange and Paul S. Taylor, *An American Exodus:*

A Record of Human Erosion (New York: Reynal and Hitchcock, 1939).

17. Daniel Dixon, in *Dorothea Lange: A Visual Life*, a film by Meg Partridge (Pacific Pictures, 1994). Dorothea Lange, audiotape recorded by KQED, San Francisco (cassette tape 19, side A), September or October 1964, Lange Collection.

18. The word *landscape* in Nordic languages and Old English combined the root *land* (both a place and the people living there, as in country or nation) with a suffix related both to the verb *to shape* and to the quality of association or partnership. The modern definition of landscape as "a picture representing a view of natural scenery . . . a portion of land that the eye can comprehend in a single view" has lost that deeper meaning. See Anne Whiston Spirn, *The Language of Landscape* (New Haven: Yale University Press, 1998); *Webster's New Universal Unabridged Dictionary* (New York: Simon and Schuster, 1983).

19. Lange's protest can be heard in a KQED audio recording (tape 2, side A) from August 1964, found in the Lange Collection. Robert Coles's essay for the 1982 monograph *Photographs of a Lifetime* calls the photograph of a road "a rare picture for Lange, one without people" (41). Judith Fryer Davidov is rare among scholars and critics for her attention to Lange's landscapes; see her book, *Women's Camera Work: Self/Body/Other in American Visual Culture* (Durham, N.C.: Duke University Press, 1998), 366–75.

20. John Benson, "The Dorothea Lange Retrospective, The Museum of Modern Art, New York," *Aperture* 12, no. 4 (1965).

21. Borhan, *Dorothea Lange*, 255. Lange, "The American Farm Woman," *Harvester World* 51, no. 11 (1960): 2–9. *American Country Woman* predated a genre prompted by the women's movement of the 1960s, by which time Lange had been taking such photographs and writing such captions for two decades and more. In 1939, Lange was searching for "distinctive" or "original" "American forms" and found them in signs, highways, and building types. In later years, as she assembled portraits of the fifteen women, Lange defined "women of the American soil" as "*themselves* a very great American style."

22. Robert Taylor, "The Roving Eye: Dorothea Lange's Legacy," *Boston Herald*, November 8, 1966.

23. Dorothea Lange, Doud interview, 1964.

24. A photograph by Edward Weston had also previously sold for the same amount; see *Photo Techniques* 27, no. 1 (2006): 5.

25. Lange quoted in Daniel Dixon, "Dorothea Lange," *Modern Photography* 16, no. 12 (1952): 73.

26. Paul S. Taylor and Norman Leon Gold, "San Francisco and the General Strike," *Survey Graphic* 23, no. 9 (September 1934). *Survey Graphic* interpreted social problems for a broad audience. In the early 1930s, it had a then impressive circulation of more than twenty-five thousand. See Finnegan, *Picturing Poverty*, 69.

27. Paul S. Taylor, "Nonstatistical Notes from the Field," *Land Policy Review* 5, no. 1 (January 1942): 13.

28. Paul S. Taylor, interview by Suzanne B. Riess, in *Paul Schuster Taylor: California Social Scientist, Volume I. Education, Field Research, and Family* (Berkeley: Regional Oral History Office, Bancroft Library, University of California, 1973), 127. Lange and Maynard Dixon were divorced in the fall of 1935, as were Paul Taylor and his wife, Katherine Page Whiteside.

29. Lange, Doud interview, 1964.

30. Paul S. Taylor, "Establishment of Rural Rehabilitation Camps for Migrants in California," March 15, 1935, Prints and Photographs Division, Library of Congress; Lange, in Riess, *Dorothea Lange*, 162. Dorothea Lange, Daybooks, March–April 1935, Imperial Valley, California, Lange Collection.

31. Paul Schuster Taylor, in Janus and MacNeil, *Photography within the Humanities*, 29. Taylor, in Riess *Paul Schuster Taylor*, 140, 145. Taylor's role in the migratory camp program was described by Jonathon Garst, San Francisco, in a letter to Roy Stryker, November 21, 1939, Roy E. Stryker Papers, University of Louisville, Louisville, Kentucky (hereafter cited as Stryker Papers).

32. Taylor, "Camps for Migrants."

33. Paul S. Taylor, "Migration of Drought Refugees to California," April 17, 1935, Prints and Photographs Division, Library of Congress.

34. Dorothea Lange, "First Rural Rehabilitation Colonists, Northern Minnesota to Matanuska Valley, Alaska," May 1935, Prints and Photographs Division, Library of Congress (reproduced in the online catalogue). Lange also produced another report that spring, "Cottage Gardens," her first story of shacktowns, Lange Collection.

35. Taylor, in Riess, *Paul Schuster Taylor*, 129. Hewes had been office manager of the Rural Rehabilitation Division of California's Emergency Relief Administration.

36. Meltzer, *Lange*, 102–3. Meltzer interviewed Hewes on May 17, 1976. The reports in question are probably those of March 15, 1935, and April 17, 1935, as well as the Alaska report of May; these three are now part of the Farm Security Administration/Office of War Information Collection, Prints and Photographs Division, Library of Congress (hereafter cited as FSA/OWI Collection).

37. Lange, in Riess, *Dorothea Lange*, 177, 174; Lange to Stryker, April 27, 1937, Stryker Papers; Lange, in Riess, *Dorothea Lange*, 177.

38. Partridge, Spirn interview, 2005. Rondal Partridge quoted in Meg Partridge's film, *A Visual Life*.

39. Partridge, Spirn interview, 2005.

40. Figure 9c (LC-USF34-021049-C) appeared in *An American Exodus*. Lange submitted this photograph several months later than the others in this sequence and gave it a different caption adapted from the one she had used in the book: "February 23, 1939. Brawley, Imperial County, Calif. In FSA Migrant Labor camp during pea harvest. Family from Oklahoma with eleven children. Father, eldest daughter, and eldest son working. She: 'I want to go back to where we can live happy, live decent, and grow what we eat.' He: 'I've made my mistake and now we can't go back. I've got nothing to farm with.'"

41. "I'm not a one-camera person," Lange said in the early 1960s. "I would take with me a 4x5 long bellows extension Graflex on any trip, provided I had the strength and heft to manage it because it's about as awkward a camera as can be, heavy and bulky and awkward. It curtails your freedom" (in Riess, *Dorothea Lange*, 195, 197). By the late 1930s, Lange was using three cameras: the Graflex (twelve sheets of film connected by paper), the Zeiss Juwel (fitted with a special back that took twelve sheets of film at a time rather than a single sheet), and the Rolleiflex (roll film with twelve exposures). The negatives of the Juwel (3.25 inches by 4.25 inches) and Graflex (4 inches by 5 inches) are, respectively, close to three and four times larger than those of the Rolleiflex (2.25 inches by 2.25 inches) and so can capture more detail, but the Rolleiflex is much lighter and less cumbersome. Lange said that she used the three for different purposes, but, in practice, she took close-up details, portraits, and broad panoramas with all three; fearing camera failure she tended to use two cameras to make backup photographs. Lange did not work with a 35-millimeter camera until she was much older and found the larger cameras more burdensome.

42. Lange to Stryker, February 24, 1936, Stryker Papers.

43. Partridge, Spirn interview, 2005; Lange, Doud interview, 1964.

44. Partridge, Spirn interview, 2005. Sometimes the collaboration was explicit. After Glen Wardlaw of Malheur County, Oregon, told Lange that he did his homework at the kitchen table, she asked him to sit there and write while she photographed him (see LC-USF34-021404-D); Wardlaw, interview with Anne Whiston Spirn, Nampa, Idaho, August 1, 2006. This collaborative method, whether implicit or explicit, was apparently not always followed. Florence Thompson, the subject of "Migrant Mother," objected years later that Lange had never asked whether she could take the photograph.

45. Lange, Doud interview, 1964.

46. Lange, KQED (tape 15, side A), probably September 10, 1965, Lange Collection; Partridge, Spirn interview, 2005.

47. Christina Gardner, Lange's assistant beginning in 1942, told me that Lange called these notebooks her "daybooks" (Gardner, interview by Anne Whiston Spirn, Petaluma, California, March 31, 2005). See Daybooks, October 12, 1939, Lange Collection.

48. Lange, Doud interview, 1964.

49. Taylor, in Riess, *Paul Schuster Taylor*, 133–34.

50. Lange, in Riess, *Dorothea Lange*, 177. Taylor's handwriting in Lange's daybook for August 13, 1939, matches that in his handwritten correspondence to her about the proofs of *An American Exodus* in late September and early October 1939, Lange Collection.

51. Lange to Stryker, October 6, 1937, and October 20, 1937, Stryker Papers.

52. Dorothea Lange, General caption 1, "US 99," FSA/OWI Collection. Roy Stryker must have asked the other three FSA staff photographers—Arthur Rothstein, Russell Lee, and Marion Post—to do the same. All four began to submit general captions in 1939, though the captions supplied by the other three were fewer and much briefer than Lange's. Shahn listed negative numbers under each of his general captions, a practice Lange began only after her trip to Washington, D.C., in June 1939, when she may have seen Shahn's captions from the previous summer. I am indebted to Beverly Brannan for telling me about

Shahn's captions (Ben Shahn, 1938, FSA/OWI Collection). Stryker issued a memorandum on general captions, probably in early 1940, since format and font are similar to dated memoranda of that period (Paul Vanderbilt Papers, Archives of American Art, Washington, D.C.). Previously, in 1937, Russell Lee had provided background to certain photographs from Williams County, North Dakota, referring to the text as a "general caption" (Lee to Stryker, n.d., Stryker Collection).

53. There are conflicting reports over when and how Lange was first appointed to the Resettlement Administration in 1935. Her biographer, Milton Meltzer, says that she was working as "field investigator, photographer" for the Resettlement Administration's Information Division by June, following the Resettlement Administration's absorption of the Federal Emergency Relief Administration's Rural Rehabilitation Division (Lange and Taylor had been working for the state office in California); Meltzer, *Dorothea Lange,* 102. Robert Doherty gives a similar account in his introduction to Leven and Northrup, *Dorothea Lange,* 27. In 1970, Paul Taylor told Suzanne Riess that it was he who first showed Lange's photographs to Roy Stryker and that Lange transferred directly from the Emergency Relief Administration for the State of California to Stryker's Historical Section at the Resettlement Administration in August 1935, but Taylor confused several dates and details in these interviews. Taylor, in Riess, *Paul Schuster Taylor,* 149.

54. Stryker, then a forty-two-year-old doctoral student, had worked the previous summer, in 1934, for the Information Division of the Agricultural Adjustment Administration, staying in Tugwell's home in Washington, D.C. Back at Columbia University that fall, he was teaching and working on a photographic sourcebook on American agriculture with the help of photographer Lewis Hine, whom he had met while assembling the photographs for Tugwell's book *American Economic Life and the Means of Its Improvement* (New York: Harcourt Brace, 1930). Stryker elected to be credited as coauthor of *American Economic Life* in lieu of payment, but the copyright is in Tugwell's name alone. The third edition, published in 1930, incorporated many photographs by Hine; the other illustrations were mostly a hodgepodge of undistinguished photographs from corporations and government agencies. Stryker gave up his doctoral studies

when he took the job with the Resettlement Administration.

55. See Robert J. Doherty, "Introduction," in Levin and Northrup, *Dorothea Lange,* 27.

56. Ben Shahn, interview by Richard Doud, Roosevelt, N.J., April 14, 1964, Archives of American Art, Smithsonian Institution, http://www.aaa.si.edu/collections /oralhistories/transcripts/shahn64.htm.

57. Shahn, Doud interview, 1964. Bernarda Bryson Shahn's comment was reported by Beverly Brannan, curator of photography, Prints and Photographs Division, Library of Congress, in a conversation with Anne Whiston Spirn, Washington, D.C., January 24, 2005.

58. Lynd and his wife Helen M. Lynd were the authors of *Middletown,* a classic of sociology. Stryker to Arthur Rothstein, 1939, "General Photographic Notes, Sheep Ranching," Stryker Papers. See also Stryker to Rothstein, August 26, 1939, and Stryker to Rothstein, 1939, "Some general things to watch for during summer travels," Stryker Papers. In 1939, Stryker at times sent Lange more specific instructions than he had earlier, including a long "Shooting script for Dorothea" from FSA staff member Edwin Rosskam, Stryker to Lange, September 16, 1939, Stryker Papers.

59. Lange to Stryker, November 16, 1937, Stryker Papers. Ben Shahn, who also "didn't trust the government facilities for . . . developing," sent his film to New York for processing (Shahn, Doud interview, 1964).

60. Lange to Edwin Locke, September 10, 1936, Stryker Papers.

61. Stryker to Lange, October 7 and August 26, 1936, Stryker Papers.

62. Evans was on leave working with James Agee. Shahn had left to work on another project but returned to the FSA for short periods, such as the summer of 1938.

63. Lange to Stryker, November 19, 1936, Stryker Papers.

64. John Dixon, quoted in Elizabeth Partridge, "Introduction," in Partridge, *Dorothea Lange,* 10.

65. See the caption for LC-USF34-020902-D, FSA/OWI Collection; and the transcript of a conversation in New York City with Lange, Roy Stryker, Arthur Rothstein, and John Vachon, 1952, 42, Lange Collection.

66. Lange to Stryker, February 24, 1936; Stryker to Lange, October 7, 1936 and November 11, 1936; all in Stryker Papers. Lange may have been right about the problems caused by heat and humidity. Ansel Adams,

who had agreed to develop Lange's film in summer 1938, reported that the film she sent from the South reeked of mildew and was "damaged by humidity," which could explain why Lange's negatives were muddy and gray. "The film was broken down. . . . Obviously it had suffered heat. . . . It was just the conditions" (Theresa Heyman, "Ansel Adams Remembers Dorothea Lange: An Interview by Theresa Heyman," in Partridge, *Lange*, 155–56). It was also due to Lange's preference for prints with a broad range of grays.

67. Lange to Stryker, November 16, 1937, Stryker Papers.

68. Taylor, in Riess, *Paul Schuster Taylor*, 217–18.

69. Lange to Stryker, December 1938; Stryker to Lange, December 22, 1938; both in Stryker Papers.

70. Hurley, *Portrait of a Decade*, 106.

71. Perhaps this difficulty explains why more than half of the photographs in *An American Exodus* were from periods when Lange was not on the FSA payroll. Some may well have been culls that Stryker had instructed her to eliminate from her submissions, from before 1939, when she was developing her own negatives.

72. Stryker to Lange, October 6, 1939, Stryker Papers.

73. Stryker to Rothstein, October 28, 1939, Stryker Papers.

74. Jonathon Garst, San Francisco, to Stryker, November 21, 1939, Stryker Papers.

75. Stryker to Garst, November 30, 1939; Stryker to Lange, November 1939 (n.d.); both in Stryker Papers.

76. Stryker to Jack Delano, March 2, 1940; Delano, New Bedford, Mass., to Stryker, January 19, 1940; both in Stryker Papers.

77. Lange, Doud interview, 1964.

78. In 1942, Stryker and the FSA files moved to the Office of War Information, but he stayed only until the files were transferred to the Library of Congress in 1943, whereupon he resigned (Hurley, *Portrait of a Decade*, 167–68).

79. Roy E. Stryker and Nancy Wood, *In This Proud Land: America 1935–1943 as Seen in the FSA Photographs* (Greenwich, Conn.: New York Graphic Society, 1973), 19.

80. Pirkle Jones, *California Photographs* (New York: Aperture, 2001), 36. Lange proposed that they pool their photographs and publish without attribution, and they did so, though both later published their own work separately, Pirkle in *California Photographs*, Lange in *American Country Woman*.

81. Taylor, in Riess, *Paul Schuster Taylor*, 223–27.

82. Lange, "Aspen Conference 1950," Lange Collection. Evidence that "White Angel Breadline" was the last of a series comes from Rondal Partridge, who said that Lange had borrowed the camera and that that particular image had been left in the camera when she returned it (Partridge, Spirn interview, 2005). Karin Becker Ohrn implies the sequence by Lange's numbering of the photographs of "Migrant Mother" (Ohrn, *Lange and the Documentary Tradition*, figures 31–35).

83. Roy Stryker, interview by Richard Doud, Montrose, Colorado, October 17, 1963, Archives of American Art, Smithsonian Institution, http://www.aaa.si.edu /collections/oralhistories/transcripts/stryke63.htm.

84. For a discussion of Stryker's practice of "killing" negatives, see Carl Fleischauer and Beverly W. Brannan, *Documenting America, 1935–1943* (Berkeley: University of California Press, 1988), 339. Some scholars have suggested that the final straw that persuaded Stryker to fire Lange came in 1939 when she reportedly deleted from the negative of "Migrant Mother" an out-of-focus thumb on a tent pole in the foreground. F. Jack Hurley asserts that this occurred when Lange borrowed that negative to produce a print for *An American Exodus*, but that photograph is not in the book. As evidence, Hurley cites three letters on the subject between Stryker and Lange, but two of these letters contain no reference to the alleged incident, and the third is not among the correspondence in the microfilm edition of the Stryker Collection. Arthur Rothstein had stirred public outrage three years before when he inserted a skull into several photographs and, again, when he staged one of his most famous photographs, the "dust storm" scene of a man and boy leaning forward as if into the wind. Stryker took those uproars in stride and did not fire Rothstein. Removing a blurry thumb, as Lange is said to have done, and staging a photograph are not deceptions of the same order. The first would be akin to cropping, the other is sheer fabrication. It seems unlikely that this was why Stryker fired Lange. Lange described her own approach as "Hands off! Whatever I photograph, I do not molest or tamper with or rearrange." Daniel Dixon, "Dorothea Lange," *Modern Photography* 16, no. 12 (1952): 68.

85. Newhall, "Questing Photographer," 7. Newhall attributed the phrase "the third effect" to Wilson Hicks,

the editor of *Life* magazine. However, Hicks, in *Words and Pictures: An Introduction to Photojournalism* (New York: Harper, 1952), defines "the principle of the third effect" as the result of juxtaposing two pictures, where "their individual effects are combined and enhanced by the reader's interpretive and evaluative reaction" (p. 34). Lange's work exemplifies "the third effect" in both Newhall's and Hicks's use of the term.

86. Lange, KQED (tape 15, side A), September 10, 1965, Lange Collection.

87. Eleanor Roosevelt, "My Day," *New York World Telegram*, April 10, 1940; Carey McWilliams, "American Exiles," *New Republic*, 219; Margaret Jarman Hagood, "An American Exodus," *Social Forces* 18, no. 4 (May 1940): 598–99.

88. Taylor, in Riess, *Paul Schuster Taylor*, 219.

89. Coleman, "Dust in the Wind: The Legacy of Dorothea Lange and Paul Schuster Taylor's *An American Exodus*," in Borhan, *Dorothea Lange*, 157, 160, 163.

90. Lange's photographs of 1939 are not likely to have influenced these photographers directly, since only a few from that year had been published.

91. Lange's approach in these series has a cinematic quality, and she may have been influenced by the documentary films of Pare Lorenz, himself an admirer of Lange. She would have known Lorenz's *The Plow That Broke the Plains* (1936) and *The River* (1937), since both were made under the auspices of the Resettlement Administration. For this observation, I am grateful to Finis Dunaway. See Dunaway, *Natural Visions: The Power of Images in American Environmental Reform* (Chicago: University of Chicago Press, 2005), in which he argues that Lorenz (and Robert Flaherty, too), used a panoramic view to capture the relationships between people and land.

92. Lange, "Home Is Where," undated manuscript, included among papers for a class Lange taught at the California School of Fine Arts in spring 1958, Lange Collection. In "Theory," the poem by Stevens to which Lange refers, the poet describes places and things as portraits of the people to whom they belong. *The Collected Poems of Wallace Stevens* (New York: Knopf, 1991), 86–87.

93. After leaving the FSA, Lange worked on a per diem basis in 1940 as head photographer for the U.S. Bureau of Agricultural Economics. She continued to submit general captions along with photographs and individual captions.

94. Dorothea Lange, fellowship application to John Simon Guggenheim Memorial Foundation, 1940, Lange Collection.

95. William Stott, *Documentary Expression in Thirties America* (New York: Oxford University Press, 1973), 9. A few of Lévi-Strauss's photographs were published in his *Triste Tropiques* (which first appeared in French, in 1955); many others were published more recently in *Saudades do Brasil* (Seattle: University of Washington Press, 1995). Gregory Bateson and Margaret Mead, *Balinese Character: A Photographic Analysis* (New York: New York Academy of Sciences, 1942). Lange to Homer Page, when he was living in New York in 1949, courtesy of Christina Gardner, who was Page's first wife.

96. Bateson and Mead, *Balinese Character*, xi, 49–54. Bateson's "photographic analysis" was organized into one hundred groups, each on a different topic, from "Agriculture" and "Sharing and Social Organization" to "Hand Postures in Daily Life" and "The Father-Child Relationship."

97. Dorothea Lange, "Aspen Conference 1950," unpublished manuscript, Lange Collection. Despite her criticism, Lange may well have been influenced to photograph certain themes by the scripts Stryker sent out to all the photographers.

98. Lange, Daybooks, August 8, 1953, St. George, Utah, Lange Collection; Lange, "Aspen Conference," Lange Collection.

99. Lange and Taylor, *An American Exodus*, 6. Caldwell and Bourke-White were straightforward about their invention: "The legends under the pictures are intended to express the authors' own conceptions of the sentiments of the individuals portrayed; they do not pretend to reproduce the actual sentiments of these persons." *You Have Seen Their Faces* (New York: Viking, 1937).

100. According to William Stott, Riis and Hine "became photographers" "in order to effect social reform," *Documentary Expression*, 30. Lange, in Riess, *Dorothea Lange*, 155.

101. Lange's comments to the Newhalls are reproduced in Lange, *American Country Woman*, 70. Her comment to Szarkowski about using doubles was transcribed by Anne Whiston Spirn from a KQED tape (tape 8, side A), December 8, 1964, Lange Collection.

102. Lange, KQED (tape 8, side A), December 8, 1964, Lange Collection. "I think that's a good statement, agreed?"

asked Lange. Szarkowski did not sound convinced, but he did include the pair in the exhibit catalogue (MOMA, *Lange*, 52–53).

103. Lange, KQED (tape 6, side B), September 27 or October 15, 1964, Lange Collection.

104. Lange, KQED (tape 8, side A), December 8, 1964, Lange Collection.

105. Rachel Carson, *Silent Spring* (Boston: Houghton Mifflin, 1962).

106. Lange and Jones, "Death of a Valley."

107. Lange, Guggenheim application, 1940, Lange Collection.

108. Dorothea Lange, undated manuscripts included among papers for a class Lange taught at the California School of Fine Arts in spring 1958, Lange Collection.

109. Lange and Taylor, *American Exodus*, 6; Lange, KQED (tape 15, side A), September 10, 1965, Lange Collection.

110. Dorothea Lange, "Toward a Great Society," undated manuscript, Lange Collection.

111. Gardner, Spirn interview, 2005; "City of Richmond Photographs," caption number 29, Lange Collection. Beginning in 1942, on assignment to document the wartime evacuation of Japanese Americans to internment camps, Lange employed Christina Gardner as an assistant and a "caption-taker." Gardner remained a close friend of Lange and helped with *American Country Woman*, finished a few months before Lange's death in 1965. In the 1940s, Gardner's job was to take notes, draft captions, help carry equipment, and keep Lange supplied with film. Lange trusted her judgment, asking, "How does this sound?" as she wrote captions, and often incorporated Gardner's suggestions. Partridge, Spirn interview, 2005.

112. Dorothea Lange, "Documentary Photography," reprinted in *Photographers on Photography*, ed. Nathan Lyons (Englewood Cliffs, N.J.: Prentice-Hall, 1966), 68. Taylor, in Riess *Paul Schuster Taylor*, 238–38a. Occasionally, texts attributed to Lange probably were mostly Taylor's. The 1940 general captions for the Bureau of Agricultural Economics were likely Taylor's, considering their abstract language, academic tone, and absence of quotations from the people photographed.

113. William Stott, *Documentary Expression and Thirties America* (New York: Oxford University Press, 1973), 12. Stott devotes the book's last two chapters to *Let Us*

Now Praise Famous Men and promotes Walker Evans to the pinnacle of documentary photography, but much of his praise for Evans could also be applied to Lange. She too avoids "the spectacular, the odd, the piteous, the unseemly." She too "records people when they are most themselves, most in command," and "seeks normal human realities" "that speak beyond their immediate existence" (269). She too finds beauty in the ordinary, makes "art of commonplace reality," and knows "that the world can be improved and yet must be celebrated as it is" (273, 276, 314). If Lange's work lacks the cool distance of Evans's, it is nevertheless often disciplined and understated. "Coolness" is a word Stott uses frequently and equates with art, as in "the coolness of art" (230).

114. Lange and Dixon, "Photographing the Familiar," *Aperture* (1952), 5–15. The term "artist" in this article is significant. Dixon would write more than forty years later, "My mother never described herself as an artist. . . . By temperament and instinct, however, an artist is what Dorothea Lange truly was." Daniel Dixon, "Afterword," in Partridge, *Dorothea Lange*, 164. In the 1960s interviews with Suzanne Riess, Lange's references to "the artist" imply that she considered herself one. Lange discusses documentary photography with Riess, but the KQED tapes are particularly valuable for her insights on the documentary approach, see especially KQED (tape 12, side A), December 14, 1964, and KQED (tape 15, side A), September 10, 1965, Lange Collection.

115. Carbon copies of the general captions Lange submitted to the OWI are in the Dorothea Lange Collection at the Oakland Museum of California.

116. Dorothea Lange, notes for "Great Society" project, Lange Collection.

117. Dorothea Lange and Ansel Adams, "Three Mormon Towns," *Life*, September 6, 1954, 91–100; Dorothea Lange, "Irish Country People," *Life*, March 21, 1955, 135–43. *Life* decided not to use the public defender story.

118. Lange, KQED (tape 16, side A), November 8, 1962; (tape 12, side B), December 14, 1964; and (tape 16, side A), November 8, 1962; all in Lange Collection. Lange's comments to the Newhalls are quoted in Newhall, "Questing Photographer," *American Country Woman*, 8. Paul Taylor told Suzanne Riess that "photographing in the United States was what she wanted to do. But of course I had agreed that *this* was what

I was going to do, and I guess I had the main lever-
age and she had to come in tow." Riess, *Paul Schuster
Taylor*, 277. In 1960 and 1961, Lange spoke with
Suzanne Riess about "the difference between the
role of the woman as artist and the man. There is
a sharp difference, a gulf. The woman's position is
immeasurably more complicated. . . . I would like
to have one year . . . just one, when I would not
have to take into account anything but my own
inner demands. . . . but I can't." Riess, *Dorothea Lange*,
219–20. Lange's foreign work, from 1958 on, con-
stituted nearly a quarter of the photographs in the
MOMA retrospective of 1966, perhaps because Lange
did so little work in the United States during the last
seven years of her life. (Of the fifty-two photographs
exhibited from that period, only four were from her
own country.)

119. Dixon, in Partridge, *Dorothea Lange*, 165.

120. Dorothea Lange and Margaretta Mitchell, *To a Cabin*
(New York: Grossman, 1973), 2–3. Mitchell produced
the book on the cabin and its setting, with Lange's
photographs and texts as well as her own.

121. Meltzer, *Lange*, 345.

122. Meltzer, Lange, 340. John Szarkowski's letter to Lange,
February 28, 1964, is quoted in Meltzer, 341.

123. Checklist for the exhibit, Museum of Modern Art file,
Lange Collection.

124. Frank Getlein, "Paintings and Photographs," *New
Republic*, March 19, 1966. The photograph described
as a man stepping off a streetcar was actually
entitled "Man Stepping from Curb, 1956."

125. George Elliott, *Dorothea Lange* (New York: Museum of
Modern Art, 1966). Only eighty-eight of the exhibit's
214 photographs are reproduced in this catalogue.
For a description of the exhibit as it appeared at
MOMA, see Judith Fryer Davidov, *Women's Camera
Work*, 216ff.

126. Elliott, "On Dorothea Lange," in *Dorothea Lange*, 10–11.

127. For example, the MOMA catalogue for a 1947 exhibit
of Henri Cartier-Bresson describes photographs
"seized in the middle norm of a run of action" as
"works of art within their own radical aesthetic," and
Cartier-Bresson himself as a leader in the movement
to formulate "a new approach to deliberate pho-
tography." Lincoln Kirstein, "Henri Cartier-Bresson,
Documentary Humanist," in *The Photographs of Henri-
Cartier-Bresson* (New York: Museum of Modern Art,
1947), 7, 8. John Szarkowski, Massimo Mussini, Arturo

Carlo Quintavalle, *Dorothea Lange* (Parma. Istituto di
storia dell'arte, Università di Parma, 1972).

128. Ibid., 11.

129. Lincoln Kirstein, "Photographs of America: Walker
Evans," in *Walker Evans: American Photographs* (New
York: Museum of Modern Art, 1938), 191, 194.

130. Ben Shahn's Norton Lectures at Harvard were pub-
lished as *The Shape of Content* (Cambridge, Mass.:
Harvard University Press, 1957).

131. Philippe de Montebello, "Director's Foreword," in
Maria Morris Hambourg et. al., *Walker Evans* (New
York: Metropolitan Museum of Art, 2000), vii; Earl
A. Powell III, "Foreword," in *Robert Frank*, ed. Sarah
Greenough and Philip Brookman (Washington, D.C.:
National Gallery of Art, 1994), 20; interview with
Robert Frank, in *Photography within the Humanities*, ed.
Eugenia Parry Janus and Wendy MacNeil (Danbury,
N.H.: Addison House, 1977), 65. In this interview,
Frank added that he also liked the work of Emmet
Gowin.

132. Catherine Preston documented this process in her
dissertation, "In Retrospect: The Construction and
Communication of a National Visual Memory" (PhD
diss., University of Pennsylvania, 1995).

133. Peter Galassi, *Walker Evans & Company* (New York:
Museum of Modern Art, 2000), 24–25. Lange does
appear briefly in the introductory essay, represented
by a small photograph in the margin and a para-
graph contrasting her work and Evans's. There is no
mention of Lange's influence on Evans, nor on the
many other photographers in the book whose work
is indebted to hers. Sally Stein calls such caricatures
of Lange's work "a gendered discourse of thermal
effects." Sally Stein, "Peculiar Grace: Dorothea Lange
and the Testimony of the Body," in Partridge, *Dorothea
Lange*, 63.

134. In 1936, after first seeing Lange's photographic essays
in fall 1935, Evans created two albums of sequenced
photographs with captions, a preliminary draft of
the photographic essay later published in *Let Us Now
Praise Famous Men*. He presented these albums to Roy
Stryker; they are now in the Prints and Photographs
Division, Library of Congress. I am grateful to Beverly
Brannan for showing me these albums.

135. Hilton Kramer, *New York Times*, January 28, 1971,
quoted in Stott, *Documentary Expression*, 267.

136. Trachtenberg, *Reading American Photographs* (New
York: Hill and Wang, 1989). Trachtenberg's title is a

tribute to Evans's 1938 book, *American Photographs*. Galassi, *Walker Evans & Company*, 24–25.

137. Coleman, "Dust in the Wind," 160.

138. Arthur Goldsmith, "A Harvest of Truth: The Dorothea Lange Retrospective Exhibition," *Infinity*, March 1966.

139. Partridge, Spirn interview, Berkeley, California. Partridge also showed me a Weston negative that was nearly impossible to print. The son of photographer Imogen Cunningham and himself a photographer, Partridge worked as Lange's assistant off and on from 1934 to 1939.

140. Jacob Deschin, "Dorothea Lange and Her Printer," *Popular Photography* 59, no. 1 (July 1966): 28–30, 68–70; Lange, KQED (tape 14, side A), September 10, 1965, Lange Collection.

141. Beaumont Newhall, "Cartier-Bresson's Photographic Technique," in *The Photographs of Henri-Cartier-Bresson* (New York: Museum of Modern Art, 1947), 12, 14.

142. KQED's two films on Lange's life and work were *Under the Trees* and *The Closer for Me*. Meg Partridge also drew from the KQED tapes in her fine 1994 film, *Dorothea Lange: A Visual Life*.

143. Alan Trachtenberg, *Reading American Photographs* (New York: Hill and Wang, 1989); Colin Westerbeck and Joel Meyerowitz, *Bystander: A History of Street Photography* (Boston: Bulfinch, 1994).

144. Lange, Doud interview, 1964.

145. Linda Gordon states that Lange documented housing "only from the outside"; Lange actually took dozens of photographs of domestic interiors in 1939 and hundreds before and after that year. Gordon, "Lange: Agricultural Sociologist," 715.

146. Lange, KQED (tape 15, side A), probably September 10, 1965, Lange Collection.

147. Lange, KQED (tape 6, side B), September or October 1964, Lange Collection.

148. Dorothea Lange, "Proposed Guggenheim Project," 1963, Lange Collection.

149. Hurley, *Portrait of a Decade*, 52.

150. Lange on Evans and Cartier-Bresson, KQED (tape 16, side B; 17, side A), August 11, 1964; Lange on her own approach (tape 17, side A), August 11, 1964; both in Lange Collection.

151. Lange, KQED (tape 17, side A), August 11, 1964, Lange Collection.

152. Lange and Dixon, "Photographing the Familiar."

153. Daniel Dixon, Dorothea Lange," *Modern Photography* 16, no. 12 (1952): 68.

154. Lange, KQED (tape 19 side B), September or October 1964, Lange Collection.

155. Lange, KQED (tape 10 side A), December 10, 1964, Lange Collection.

156. Lange, KQED (tape 17, side A), August 11, 1964, Lange Collection.

157. Partridge, Spirn interview, 2005.

158. Katherine Lee Bates, "America the Beautiful," 1895, revised in 1913.

159. Harriet L. Herring, memorandum on "Annual Cleaning-up Day at Wheeley's Church," July 5, 1939, Lange Collection. Lange deleted this phrase from the general caption.

160. Lange, KQED (tape 13, side B), January 13, 1965, Lange Collection.

161. Lange, KQED (tape 16, side A), November 8, 1962, or August 1964, Lange Collection.

162. Lange, "Home Is Where," Lange Collection.

163. Lange, KQED (tape 16, side A), November 8, 1962, or August 1964, Lange Collection.

Two. Photographs and Reports from the Field

1. Richard F. Weingroff, "Creating the Interstate System," *Public Roads* 60, no. 1 (summer 1996).

2. Dorothea Lange, field notes, May 24, 1939, Dorothea Lange Collection, Oakland Museum of California (hereafter cited as Lange Collection).

3. Dorothea Lange to Roy Stryker, March 13, 1939, Roy E. Stryker Papers, University of Louisville, Louisville, Kentucky (hereafter cited as Stryker Papers). Lange suggested to Stryker that "in our files and talking of California's situation in agriculture . . . we do not narrow the classification to migratory labor. Migratory labor is part of it. We have 1. industrialized agriculture, 2. agricultural labor, 3. migratory labor."

4. Dorothea Lange and Paul S. Taylor, *An American Exodus: A Record of Human Erosion* (New York: Reynal and Hitchcock, 1939), 130, 135.

5. Ibid., 130.

6. Dorothea Lange, caption for LC-USF34-019296, Farm Security Adminsitration/Office of War Information Collection, Prints and Photographs Division, Library of Congress (hereafter cited as FSA/OWI Collection).

7. Lange, caption for LC-USF34-019472-C, FSA/OWI Collection.

8. Herbert Klein and Carey McWilliams, "Cold Terror in California," *Nation* 141, no. 3655 (July 24, 1935): 97.

9. Paul S. Taylor and Norman Leon Gold, "San Francisco

and the General Strike," *Survey Graphic* 23, no. 9 (September 1934); Klein and McWilliams, "Cold Terror," 97–98.

10. Lange to Stryker, April 27, 1937, October 13, 1938, and February 16, 1937; all in Stryker Papers. In her April letter, Lange described her concern about traveling alone to document conditions of Texas tenant farmers.

11. See, for example, Paul S. Taylor, "Establishment of Rural Rehabilitation Camps for Migrants in California," March 15, 1935, Prints and Photographs Division, Library of Congress.

12. John Steinbeck, *Their Blood Is Strong* (San Francisco: Simon J. Lubin Society of California, 1938); FSA administrator, quoted in Carol Schloss, *In Visible Light: Photography and the American Writer, 1840–1940* (New York: Oxford University Press, 1987), 216, 227. McWilliams and Klein reported that the growers, with the aid of state social service agencies and "stool pigeons," had investigated the workers' "individual histories" as a way to intimidate them ("Cold Terror," 97–98).

13. Rondal Partridge, interview by Anne Whiston Spirn, Berkeley, California, March 28, 2005; Lange to Stryker, November 11, 1938, Stryker Papers.

14. See Lange photographs: Lange, LC-USF34-019036, LC-USF34-019104, FSA/OWI Collection.

15. See Lange photographs: LC-USF34-019627, LC-USF34-019631, LC-USF34-019635, LC-USF34-019636, FSA/OWI Collection.

16. Memo from Rosskam to Stryker, "Shooting Script for Dorothea," enclosed in Stryker to Lange, September 16, 1939, Stryker Papers. For more detail on the innovations in site planning and prefabricated buildings, see Greg Hise, *Magnetic Los Angeles* (Baltimore: Johns Hopkins University Press, 1997), 86–116.

17. Dorothea Lange, interview by Suzanne Riess (October–December 1960, January 1961, and August 1961), in *Dorothea Lange: The Making of a Documentary Photographer*, (Berkeley: Regional Oral History Office, Bancroft Library, University of California, 1968), 172.

18. Howard W. Odum and Harry Estill Moore, *American Regionalism: A Cultural-Historical Approach to National Integration* (New York: Henry Holt, 1938).

19. Margaret Jarman Hagood, *Mothers of the South: Portraiture of the White Tenant Farm Woman* (Charlottesville: University of Virginia Press, 1996), 224. Origi-

nally published by University of North Carolina Press in 1939.

20. Pamphlet announcing national conference, "Population Research, Regional Research, and the Measurement of Regional Development," held at the University of North Carolina, spring 1940, FSA/OWI Collection.

21. Harriet L. Herring, "Notes and Suggestions for Photographic Study of the 13 County Subregional Area," n.d., FSA/OWI Collection.

22. Herring, "Notes and Suggestions."

23. After Marion Post took over this assignment from Lange, Stryker passed Lange's opinion on to her; see Roy E. Stryker to Marion Post, Stryker Papers.

24. Herring, "Notes and Suggestions"; Harriet L. Herring, "Family group eating watermelon," July 5, 1939, Lange Collection.

25. Hagood, *Mothers of the South:*, 245.

26. The term "tenant farmer" was sometimes used to describe anyone who did not own the farms they operated, including sharecroppers. The description of tenant farmers and sharecroppers is drawn from Arthur F. Raper and Carl C. Taylor, "Landowners and Tenants," in *Rural Life in the United States*, ed. Carl C. Taylor et al. (New York: Knopf, 1949), 264, 269.

27. Hagood, *Mothers of the South*, 12.

28. Ibid., 172.

29. Margaret Jarman Hagood, "Farm house and farm landscape of Negro tenant cotton farmer; Negro family," July 8, 1939, Lange Collection.

30. Linda Gordon reproduced one of these general captions ("Putting in Tobacco"), attributing it to Lange alone, in "Dorothea Lange: The Photographer as Agricultural Sociologist," *Journal of American History* 93, no. 3 (December 2006). "Putting in Tobacco" was drafted by an author with initials WGB; Lange crossed out one sentence of the draft and used the rest verbatim. The detailed description of specific harvesting methods is not representative of general captions for which Lange is sole author.

31. Harriet L. Herring, "Family group eating watermelon" and "Rail fence with barbed wire fence and telephone or electric line," July 5, 1939, Lange Collection.

32. Margaret Jarman Hagood, "Negro small-owner—house, yard, and wife," July 1, 1939, Lange Collection.

33. Lange, caption for LC-USF34-020207-E, FSA/OWI collection.

34. This photograph is reproduced widely and often incorrectly labeled "Alabama, 1937." See, for example,

Museum of Modern Art, *Dorothea Lange* (New York: Museum of Modern Art, 1966), 49. This catalogue may be the source of the confusion, since the photograph is properly captioned in the FSA/OWI Collection.

35. The Farm Security Administration's Rural Rehabilitation Program made loans to farmers for the purchase of seed, fertilizer, livestock, and equipment. Lange mixed up the ages of the two daughters: Colene was the eldest; Dorothy Lee was three.

36. Once known as the "furniture capital of America," Grand Rapids, Michigan, has been a center for furniture manufacturing since the mid-nineteenth century.

37. A plug mule is "basically a worthless mule, without much spirit. A plug mule won't run away, but you won't get much work done." Randolph Hester, interview by Anne Whiston Spirn, Berkeley, California, March 24, 2005.

38. Primitive Baptist churches are independent congregations that regard the text of the Bible as literally true and "the sole rule of faith and practice" and are opposed to missionary societies and church schools.

39. James E. Sidel, "Rubber Tramps in the Hop Fields," *American Child* 21, no. 1 (January 1939): 1. Rubber tramps were migrants who traveled by car, in contrast to the hoboes or "bindle-stiffs" who walked or rode the rails. Lange enclosed this article, published by the National Child Labor Committee, with her general caption on hops in her mailing to the home office in Washington, D.C.; see FSA/OWI Collection.

40. Jill Livingston, *That Ribbon of Highway III: Highway 99 through the Pacific Northwest* (Klamath River, Calif.: Living Gold Press, 2003), 38.

41. Sidel, "Rubber Tramps," 3.

42. Paul H. Landis and Melvin S. Brooks, "Farm Labor in the Yakima Valley, Washington," Rural Sociology Series in Farm Labor No. 1, *Bulletin No. 343* (Pullman, WA: State College of Agriculture, Agricultural Experiment Station, December 1936), 64. Lange enclosed this report with her general captions on the Yakima Valley; see FSA/OWI Collection.

43. Carleton H. Parker, "The Hop Fields' Report," in *The Casual Laborer and Other Essays* (New York: Harcourt, Brace and Howe, 1920), 171–72, 176–89.

44. Parker, "The Casual Laborer," in *Casual Laborer*, 72. This chapter was originally published as an article in 1915.

45. Richard L. Neuberger, "Who Are the Associated Farmers?" *Survey Graphic* 28, no. 9 (September 1939): 517; Carey McWilliams, *Factories in the Field* (Boston: Little, Brown, 1939), 261.

46. Herbert Klein and Carey McWilliams, "Cold Terror in California," *The Nation* 141, no. 3655 (July 24, 1935): 98.

47. Dorothea Lange, General caption 31, "The stockade in the center of town," August 10, 1939, FSA/OWI Collection.

48. George B. Herington, "Drouth Migrants and Seasonal Agricultural Workers of the Pacific Northwest" (undated mimeographed paper, Farm Security Administration, Portland, Ore.), 5. This paper was received September 21, 1938, by the library of the University of California at Berkeley. Herington was a labor relations advisor for the Farm Security Administration.

49. Sidel, "Rubber Tramps," 3. By the late 1930s the plight of migrant farm laborers had been the focus of numerous studies. The FSA's regional office reported in 1938 that about thirty-eight thousand farm families had come to the Northwest since 1930, many of them "dependent on seasonal agricultural work for their livelihood"; it estimated that there were eighty thousand temporary migrant workers, and nineteen thousand families, many destitute yet ineligible for state relief because of residency requirements. These migrants were "one of the most acute yet least recognized of the Pacific Northwest's major social and economic problems." Herington, "Drouth Migrants," 1–2, 4.

50. U.S. Department of Agriculture, Farm Security Administration, "Mobile Camps for Migrant Farm Families," September 13, 1940, 8pp.

51. Dorothea Lange, caption for LC-USF34-019550, May 1939. FSA/OWI Collection.

52. In Washington, a fishing and hunting license for nonresidents cost twenty-five dollars in 1939; for state residents, the fee was three dollars. "Finger-tip Tours, U.S. 99 and 100 in Oregon and Washington" (Shell Touring Service, 1939), 23. These photographs are in the online catalogue of the Library of Congress, Prints and Photographs Division (http://www.loc.gov/rr/print/); add the prefix LC-USF34-0 to the negative numbers given in Lange's text.

53. Francis Townsend, a retired physician, proposed a plan to provide a monthly pension to those sixty years and older on the condition that they give up their jobs and spend the monthly benefit within thirty days. The funds were to be raised by a tax on

transactions of goods and money. Many viewed the Townsend Plan as a racket, but it became popular in the late 1930s. See William E. Leuchtenburg, *Franklin D. Roosevelt and the New Deal* (New York: Harper and Row, 1963), 132.

54. James Gray Maddox, "The Farm Security Administration" (PhD diss., Harvard University, 1950), 85.

55. Dorothea Lange, in Riess, *Dorothea Lange*, 172.

56. Lucile Reynolds, "Planning with Farm Families on Low Income" (undated report). This document was received January 5, 1939, by the library of the University of California at Berkeley. Reynolds was chief of the Home Management Unit, Rural Rehabilitation Division, Farm Security Administration.

57. Maddox, "Farm Security Administration," 170.

58. Sidney Baldwin, *Poverty and Politics: The Rise and Decline of the Farm Security Administration* (Chapel Hill: University of North Carolina Press, 1968), 200; Barbara Leibhart Wester, "Land Divided: Yakama Tribal Land Use in the Federal Allotment Era," in *Northwest Lands, Northwest Peoples*, edited by Dale G. Goble and Paul W. Hirt (Seattle: University of Washington Press, 1999), 205–25.

59. Maddox, "Farm Security Administration," 104. Some farmers criticized rural rehabilitation programs, and not all were appreciative of the farm and home supervisors: "Good Old Grandma Government sent home economics experts to teach us women how to make underwear and aprons out of flour sacks, when we were already making everything possible out of them, from table cloths to sheets." Annie Pike Greenwood, *We Sagebrush Folks* (1934; reprint, Moscow: Idaho University Press, 1988), 68.

60. Dorothea Lange and Paul S. Taylor, *An American Exodus: A Record of Human Erosion* (New York: Reynal and Hitchcock, 1939), 155.

61. Lange enclosed a report "for use with Northwest photos," entitled "The Drought Farmer Adjusts to the West," Bulletin no. 378, State College of Washington, Agricultural Extension Station, July 1939.

62. Lange enclosed an illustrated pamphlet entitled "Live—Farm—Play," published by Weyerhaeuser Forest Products, on which she wrote: "To be attached to General Caption #36—Lange." She also included a report on the Arnold family with a handwritten note, "Please add to General Caption #36." The latter document is in appendix C.

63. Humbird Lumber Company, "A Naturally Timbered Country Is the Best for the Farmer" (Sandpoint, Idaho, n.d.), FSA/OWI Collection.

64. Ibid.

65. John Blanchard (under the direction of the Northwest Regional Council), *Caravans to the Northwest* (Boston: Houghton Mifflin, 1940), 54.

66. Dorothea Lange, General caption 38, FSA/OWI Collection; Charles McKinley, "Five Years of Planning in the Pacific Northwest," (Portland: Northwest Regional Council, 1939), 7. McKinley was chairman of the Portland Planning Commission.

67. McKinley, "Five Years of Planning," 6.

68. Pacific Northwest Regional Planning Commission and the National Resources Committee, *Forest Resources of the Pacific Northwest* (Washington: Government Printing Office, 1938), 1–6.

69. Nelle Portrey Davis, *Stump Ranch Pioneer* (1942; Moscow: University of Idaho Press, 1990), 28 , 44–45.

70. U.S. Farm Security Administration, "Suggestions for Prospective Settlers to Idaho, Oregon and Washington" (Portland: U.S. Department of Agriculture, Region XI, November 1938), 3, 16.

71. Davis, *Stump Ranch Pioneer*, 136.

72. Ibid., 116.

73. Susan Hendricks Swetnam, "Introduction," in Davis, *Stump Ranch Pioneer*, ix.

74. Walter A. Duffy, "Westward Migration of Farm Families," manuscript, Lange Collection.

75. This brief general caption can be found appendix E.

76. Lange noted, "Pamphlet attached," but no pamphlet is included in that file in the FSA/OWI Collection.

77. The figures in Lange's original add up to 110 percent, so there is obviously an error in one or more of the numbers.

78. Richard L. Neuberger, "The Columbia Flows to the Land," *Survey Graphic* 28, no. 7 (July 1939), http://newdeal.feri.org/survey/39a08.htm.

79. William E. Smythe, *The Conquest of Arid America* (Seattle: University of Washington Press, 1969), x. Reprint of revised edition of 1905, published by Macmillan. Smythe convened the first National Irrigation Congress in Salt Lake City in 1891. He saw irrigation as "a religious rite" that brings man "into partnership with God" and promoted irrigating arid lands in the West as a way to provide homesteads for the landless, whether city dwellers or farmers. Forty years

later, Neuberger and others were making the same appeal.

80. National Reclamation Act of 1902, http://www.ccrh.org/comm/moses/primary/newlands.html.

81. The Public Land Survey System, beginning in 1785, had determined how unsurveyed land in the United States was to be surveyed and described: land was to be divided into townships, each township six miles on a side, each further divided into thirty-six sections of one square mile (640 acres). Sections were subdivided further into half sections (320 acres), quarter sections (160 acres), and so on.

82. D. W. Meinig, *The Great Columbia Plain* (1968; Seattle: University of Washington Press, 1995) 372.

83. Lewis A. McArthur, *Oregon Geographic Names* (Portland: Oregon Historical Society Press, 2003).

84. Richard L. Neuberger, *Our Promised Land* (New York: Macmillan, 1938), 361–62.

85. Neuberger, "Columbia Flows."

86. Carl P. Heisig and Marion Clawson, "New Farms on New Land: A Study of the Economic Situation of Settlement on the Vale and Owyhee Reclamation Projects, Malheur County, Oregon," undated report, U.S. Bureau of Agricultural Economics, FSA/OWI Collection. Lange enclosed this report with her general caption for Malheur County.

87. Eric A. Stene, "The Owyhee Project" (Denver, Colo.: Bureau of Reclamation History Program, 1996), http://www.usbr.gov/dataweb/projects/oregon/owyhee/.

88. Heisig and Clawson, "New Farms."

89. The Hulls' farm was in the Ontario Heights portion of the Dead Ox Flat division of the Owyhee Project. Dead Ox Flat itself is east of Ontario Heights.

90. Northwest Regional Council, *Pacific Northwest Problems and Materials: An Introduction*, Know Your Northwest Series (Portland: Northwest Regional Council, 1940), 79–80.

91. Neuberger, "Columbia Flows."

92. Dorothea Lange, General caption 35, "Columbia Basin, near Quincy, Grant County, Washington," August 13, 1939, FSA/OWI Collection.

93. Lange and Taylor, *American Exodus*, 153–54.

94. The Vale Project also receives water from the Owyhee River via the Malheur Siphon.

95. Lange attached a newspaper clipping, "Beet Harvest Gets Started over Valley," which estimated employment and payroll for the 1939 season of the Amalgamated Sugar Company.

Three. Then and Now

1. Oregon Trail Coordinating Council, "The Oregon Trail 1843–1993: A Self-Guiding Tour of the Oregon Trail across Oregon," 3rd ed., 1993.

2. Bob Evans, *Traces of the Trails: A Guide to Historic Trails and Wagon Road Sites on Public Lands in Eastern Oregon* (Baker City, Ore.: Trail Tenders, 1998).

3. Dale Maharidge and Michael Williamson, *And Their Children after Them: The Legacy of Let Us Now Praise Famous Men* (New York: Pantheon, 1989); Bill Ganzel, *Dust Bowl Descent* (Lincoln: University of Nebraska Press, 1984).

4. Carlton Elementary School Bicentennial Club, *Reflections on Carlton* (Carlton: Yamhill-Carlton School District, 1999).

5. Edwin Rosskam, memorandum enclosed in Roy Stryker to Dorothea Lange, Roy E. Stryker Papers, University of Louisville, Louisville, Kentucky (hereafter cited as Stryker Papers). The FSA's claims are somewhat overblown. The Sears, Roebuck catalogue had featured houses and garages from 1908, which shipped complete with precut parts and nails; by 1940 more than 100,000 houses had been sold, http://www.searsarchives.com/homes/.

6. Dorothea Lange, audiotape recorded by KQED, San Francisco (tape 6, side B), September or October 1964, Dorothea Lange Collection, Oakland Museum of California.

7. Isabel Valle, *Fields of Toil: A Migrant Family's Journey* (Pullman: Washington State University Press, 1994).

8. The Dead Ox Flat division of the Owyhee Irrigation District includes both Ontario Heights (northwest of Ontario) and Dead Ox Flat (north of Ontario). Lange referred to both areas as "Dead Ox Flat."

9. U.S. Census Bureau, Census 2000, http://censtats.census.gov/data/OR/1604153750.pdf.

10. Ralph Cammack, interview with Anne Whiston Spirn, Ontario, Oregon, July 27, 2006; Ralph and Charlotte Cammack, interview with Anne Whiston Spirn, Ontario, Oregon, September 22, 2006.

11. Glen Wardlaw, interview with Anne Whiston Spirn, Nampa, Idaho, August 1, 2006.

12. David Igler, *Industrial Cowboys: Miller & Lux and the Transformation of the Far West, 1850–1920* (Berkeley:

University of California Press, 2001), 4, 36, 60–61. Igler cites the California State Board of Agriculture biennial report from 1870 and 1871.

13. Lange to Stryker, March 13, 1939, Stryker Papers.

14. Carey McWilliams, *Factories in the Fields: The Story of Migratory Farm Labor in California* (Boston: Little, Brown), 22, 325.

15. Dorothea Lange, interview by Suzanne Riess (October–December 1960, January 1961, and August 1961), in *Dorothea Lange: The Making of a Documentary Photographer*, (Berkeley: Regional Oral History Office, Bancroft Library, University of California, 1968), 174.

16. Dorothea Lange, General caption 49, "Recent settlement of cutover lands in northern Idaho."

17. Richard White's influential books include *Land Use, Environment, and Social Change: The Shaping of Island County, Washington* (Seattle: University of Washington Press, 1980); *"It's Your Misfortune and None of My Own": A New History of the American West* (Norman: University of Oklahoma Press, 1991); and *The Organic Machine* (New York: Hill and Wang, 1995).

18. Nelle Portrey Davis, *Stump Ranch Pioneer* (1942; Moscow: University of Idaho Press, 1990), 219; Susan Hendricks Swetnam, "Introduction," in ibid., ix.

19. http://www.priestlake.com.

20. Valle, *Fields of Toil*.

21. Lange, in Riess, *Dorothea Lange*, 205.

22. Sheldon Rampton, "Fish out of Water: Behind the Wise Use Movement's Victory in Klamath," Center for Media and Democracy, http://www.prwatch.org /prwissues/2003Q2/fish.html.

23. William deBuys and Joan Myers, *Salt Dreams: Land and Water in Low-down California* (Albuquerque: University of New Mexico Press, 1999), 165.

24. Dorothea Lange, quoted in Beaumont Newhall, "The Questing Photographer: Dorothea Lange," in *Dorothea Lange Looks at the The American Country Woman*, (Fort Worth: Amon Carter Museum, 1967), 7. This is an adaptation by Lange of a statement written by Paul Taylor, which was quoted in the catalogue edited by Edward Steichen, *The Bitter Years, 1935–1941* (New York: Museum of Modern Art, 1962), vii.

Appendix B

1. Anthony J. Badger, *The New Deal* (Chicago: Ivan Dee, 2002); Sidney Baldwin, *Poverty and Politics: The Rise and Decline of the Farm Security Administration* (Chapel Hill: University of North Carolina Press, 1968), 188.

2. John A. Salmond, *The Civilian Conservation Corps, 1933–1942* (Durham, N.C.: Duke University Press, 1967); *The CCC at Work* (Washington, DC: U.S. Government Printing Office, 1941).

3. Baldwin, *Poverty and Politics*.

4. William E. Leuchtenburg, *Franklin D. Roosevelt and the New Deal* (New York: Harper and Row, 1963), 132.

5. Donald S. Howard, *The WPA and Federal Relief Policy* (New York: Russell Sage Foundation, 1943); Works Projects Administration, "Final Report on the WPA Program 1935–1943" (Washington, D.C.: Government Printing Office, 1947).

ESSAY ON SOURCES

There is no single biography adequate to the significance of Dorothea Lange, her work and times. Two brief essays by Henry Mayer—"Dorothea Lange: A Life in Context" and "The Making of a Documentary Book"—sketch her life in historical perspective and give a glimpse of how important Mayer's biography of Lange would have been had he lived to write it. Both essays appear in books edited by Sam Stourdzé, *Dorothea Lange: The Human Face* (Paris: NBC Editions, 1998) and a facsimile edition of *An American Exodus* (Paris: Jean-Michel Place, 1999). Two biographies are complementary: Milton Meltzer's *Dorothea Lange: A Photographer's Life* (New York: Farrar, Straus, and Giroux, 1978) emphasizes Lange's life, and Karin Becker Ohrn's *Dorothea Lange and the Documentary Tradition* (Baton Rouge: Louisiana State University Press, 1980) focuses on her work. Elizabeth Partridge's *Restless Spirit* (New York: Viking, 1998) and several essays in her edited book, *Dorothea Lange: A Visual Life* (Washington, D.C.: Smithsonian Press, 1994), offer an intimate perspective, as does Meg Partridge's film *Dorothea Lange: A Visual Life* (Pacific Pictures, 1994), which features Lange's own voice and those of Ron Partridge and her son Daniel Dixon.

There exists no comprehensive presentation and assessment of Lange's work and influence. There are instead numerous individual articles, chapters, and exhibition catalogues. Daniel Dixon's "Dorothea Lange" (*Modern Photography* 16, no. 12 [1952]) remains an important source. *Dorothea Lange: American Photographs* (San Francisco: San Francisco Museum of Modern Art and Chronicle Books, 1994), with essays by Sandra Phillips, Therese Heyman, and John Szarkowski, is also excellent, as is Judith Fryer Davidov's discussion in *Women's Camera Work: Self/Body/Other in American Visual Culture* (Durham, N.C.: Duke University Press, 1998). Judith Keller's *Dorothea Lange* (Los Angeles: J. Paul Getty Museum, 2002) is a compact and compelling introduction to Lange and her work as represented in the Getty's

own collection. Sally Stein offers a perceptive view in "Peculiar Grace: Dorothea Lange and the Testimony of the Body," in Partridge's *Dorothea Lange*, and Charles Shindo's *Dust Bowl Migrants in the American Imagination* (Lawrence: University Press of Kansas, 1997) includes a discussion of the important role of Lange's field notes, drawn from Zoe Brown's "Dorothea Lange: Field Notes and Photographs, 1935–1946" (master's thesis, John F. Kennedy University, 1979). Linda Gordon provides a good introduction to Lange as critic of agricultural practices and politics in "Dorothea Lange: The Photographer as Agricultural Sociologist" (*Journal of American History* 93, no. 3 [December 2006]: 698–727). Yet these and other publications yield only a partial and, sometimes, contradictory picture of Lange and her work.

For a fuller view, there is Lange herself. Her own publications are essential, particularly *American Exodus: A Record of Human Erosion*, with Paul Taylor (New York: Reynal and Hitchcock, 1939; not the 1969 Yale University Press edition, which was radically altered after her death); *Dorothea Lange Looks at the American Country Woman* (Fort Worth: Amon Carter Museum, 1967); "The American Farm Woman," *Harvester World* 51, no. 11 (1960): 2–9; "Death of a Valley," with Pirkle Jones, *Aperture* 8, no. 3 (1960): 127–65; as well as "Photographing the Familiar" (1950), with Daniel Dixon, and "Documentary Photography" (1940), both reprinted in *Photographers on Photography*, edited by Nathan Lyons (Englewood Cliffs, N.J.: Prentice-Hall, 1966). Lange describes life with Maynard Dixon in *The Thunderbird Remembered: Maynard Dixon, the Man and the Artist* (Seattle: University of Washington Press, 1994), which she coauthored with Daniel Dixon, John Dixon, and Edith Hamlin. But Lange's publications represent only a tiny fraction of what she wrote and said; her unpublished writings, interviews (some published), and recorded conversations are revealing.

The Dorothea Lange Collection at the Oakland

Museum of California, the primary archive for Lange's life and work, has published two guides: Therese Thau Heyman, *Celebrating a Collection* (1978), and Karen Tsujimoto, *Dorothea Lange: Archive of an Artist* (1995). Most important, for me, were the field notes, the photographic essays of 1935, Lange's copies of individual and general captions, 1939 memoranda by researchers at the University of North Carolina, unpublished manuscripts, clippings, transcripts of interviews with Lange and others, her Guggenheim proposals, and KQED's audio recordings of Lange in the 1960s (the raw material for two films: *Under the Trees* and *Closer for Me*). The unedited KQED audiotapes are extraordinary. The excerpts I have quoted here represent only a tiny fraction of the material, selected from more than forty hours of recordings. I verified Lange's words by listening to the audiocassettes (a transcript exists, but it is not a complete and faithful reproduction). Recordings from several dates are sometimes compiled on a single cassette, making precise dates difficult to determine. Access to the collection is by appointment, and limited by chronic understaffing.

The Paul S. Taylor Papers at the Bancroft Library, University of California at Berkeley, include significant material on Lange, especially the interviews by Suzanne Riess and Malca Chall for the library's Regional Oral History Project, published as *Paul Schuster Taylor: California Social Scientist*, volume 1, *Education, Field Research, and Family* (1973) and volumes 2 and 3, *California Water and Agricultural Labor* (1975). Riess also interviewed Lange for the Bancroft during October–December 1960, January 1961, and August 1961; the product, *Dorothea Lange: The Making of a Documentary Photographer* (1968), is an important source. Taylor's publications provide insight into his and Lange's mutual influence; see his writings during periods of their fieldwork, including *Labor on the Land: Collected Writings 1930–1970* (New York: Arno Press, 1981) and *On the Ground in the Thirties* (Salt Lake City: Peregrine Smith, 1983). In the latter, see especially his 1942 "Non Statistical Notes from the Field."

The Farm Security Administration/Office of War Information (FSA/OWI) Collection in the Prints and Photographs Division of the Library of Congress, an indispensable resource, includes Lange's FSA photographs, captions, and supplementary material, three of her 1935 photographic essays, and Walker Evans's 1936 albums of his work with James Agee. All of Lange's FSA photographs are on the Library of Congress Web site (http://www.loc.gov/rr/print), and much of her writing and related material is on microfilm; see Annette Melville, *Farm Security Administration Historical Section: A Guide to Textual Records in the Library of Congress* (Washington, D.C.: Library of Congress, 1985). Also in the collection are books that Roy Stryker recommended to the FSA photographers and publications of FSA photography from the 1930s and since.

Among the many books on photography and the FSA, several are key. *Documenting America, 1935–1943* (Berkeley: University of California Press, 1988), edited by Carl Fleischauer and Beverly Brannan, curator of the FSA/OWI Collection, with essays by the editors, Lawrence Levine, and Alan Trachtenburg, is the best introduction. Michael Lesy, *Long Time Coming: A Photographic Portrait of America, 1935–1943* (New York: W. W. Norton, 2002), shows daily life as depicted by FSA photographers, interspersed with excerpts from Roy Stryker's letters, shooting scripts, and readings. F. Jack Hurley, *Portrait of a Decade: Roy Stryker and the Development of Documentary Photography in the Thirties* (New York: Da Capo, 1972), and Roy E. Stryker and Nancy Wood, *In This Proud Land: America 1935–1943 as Seen in the FSA Photographs* (Greenwich, Conn.: New York Graphic Society, 1973), present Roy Stryker's perspective. Stryker's own correspondence with FSA photographers is more revealing, however. Both his letters and those written to him by the photographers (including Lange) are among his papers at the University of Louisville; the Library of Congress has the microfilm edition: see David G. Horvath, ed., *Roy Stryker Papers, 1912–1972: A Guide to the Microfilm Edition* (Microfilming Corporation of America, 1982). Stryker's section was not the only one producing documentary photographs. For a discussion of FSA's documentary film program, see Finis Dunaway, *Natural Visions: The Power of Images in American Environmental Reform* (Chicago: University of Chicago Press, 2005).

The papers of Paul Vanderbilt, who organized the FSA/OWI Collection at the Library of Congress, include FSA "gossip sheets" and 1930s memoranda that give an appreciation for the bureaucratic context within which Lange worked in 1939. The Vanderbilt papers are in the Archives of American Art in Washington, D.C., which also has transcripts of Richard Doud's invaluable 1960s interviews with Stryker, Lange, and other FSA photographers, including Ben Shahn, Walker Evans, Marion Post Wolcott, Jack Delano, Gordon Parks, and Arthur Rothstein.

Lawrence Levine's essays in *Documenting America* and William Stott's *Documentary Expression in Thirties America* (New York: Oxford University Press, 1973) put the FSA photography into cultural context, as does Alan Trachtenburg's *Reading American Photographs* (New York: Hill and Wang, 1989) and Nicholas Natanson, *The Black Image of the New Deal* (Knoxville: University of Tennessee Press, 1992). But Stott and Trachtenburg give pride of place to Walker Evans and do not provide insight into Lange's works and contributions; Trachtenburg ignores Lange entirely. Catherine L. Preston traces the cultivation of Evans's reputation, at the expense of Lange, in "In Retrospect: The Construction and Communication of a National Visual Memory" (PhD diss., University of Pennsylvania, 1995). A. D. Coleman's "Dust in the Wind: The Legacy of Dorothea Lange and Paul Schuster Taylor's *An American Exodus*," is an important critical review; it appears in *Dorothea Lange: The Heart and Mind of a Photographer*, edited by Pierre Borhan (Boston: Bulfinch Press, 2002). Despite Coleman's essay and the excellent contributions of others, the full picture of Dorothea Lange's place in the FSA and in the history of photography remains to be written.

My principal guides to the political context of Lange's 1930s work were William E. Leuchtenburg, *Franklin D. Roosevelt and the New Deal, 1932–1940* (New York: Harper and Row, 1963), and Anthony J. Badger, *The New Deal: The Depression Years, 1933–1940* (New York: Hill and Wang, 1989). Sydney Baldwin's *Poverty and Politics: The Rise and Decline of the Farm Security Administration* (University of North Carolina Press, 1968) elucidates the shifting priorities and internal politics affecting Stryker's section of the agency. James Gray Maddox, "The Farm Security Administration" (PhD diss., Harvard University, 1950), gives an insider's view of the conditions and programs Lange photographed, as do reports and memoranda by FSA staff and numerous other sources, such as monographs sponsored by public and quasi-public agencies. (Libraries at the University of California at Berkeley and Harvard University have ample collections of these 1930s documents.) Especially valuable for the Northwest are publications of the Northwest Regional Council on population, industry, and natural resources, including a book by John Blanchard, *Caravans to the Northwest* (Boston: Houghton Mifflin, 1940), illustrated with Lange's photographs from 1939.

The Franklin and Eleanor Roosevelt Institute maintains the New Deal Network (http://newdeal.feri.org),

an online resource of primary materials for the 1930s, including articles from *Survey Graphic* and an essay by Cara A. Finnegan, whose *Picturing Poverty: Print Culture and FSA Photographs* (Washington, D.C.: Smithsonian Books, 2003) describes the role of such journals in the 1930s. Taylor and Lange published in *Survey Graphic* and read the *Nation*; articles in those journals informed what and how Lange saw, as did the books she cited, including Arthur Raper, *Preface to Peasantry* (Chapel Hill: University of North Carolina, 1936); Rupert Vance, *Human Geography of the South* (Chapel Hill: University of North Carolina Press, 1932); J. Russell Smith, *North America* (New York: Harcourt Brace, 1925); Carleton H. Parker, *The Casual Laborer and Other Essays*, introduction by Cornelia Stratton Parker (New York: Harcourt, Brace and Howe, 1920); Carey McWilliams, *Factories in the Field: The Story of Migratory Farm Labor in California* (Boston: Little, Brown, 1939); and Richard L. Neuberger, *Our Promised Land* (New York: MacMillan, 1938).

Other books published during that period provide background information essential to understanding the people Lange was working with. For North Carolina, see especially Howard W. Odum and Harry Estill Moore, *American Regionalism* (New York: Henry Holt, 1938), and Margaret Jarman Hagood, *Mothers of the South: Portraiture of the White Tenant Farm Woman* (Chapel Hill: University of North Carolina Press, 1939). For the Northwest, two memoirs reprinted by the University of Idaho Press describe the lives Lange was photographing: Nelle Portrey Davis, *Stump Ranch Pioneer* (1942; Moscow: University of Idaho Press, 1990), and Annie Pike Greenwood, *We Sagebrush Folks* (1934; Moscow: University of Idaho Press, 1988). The Shell guides to U.S. 99 in California and to Washington and Oregon published in 1939 (collection of Bancroft Library, University of California at Berkeley) provide a sense of what it was like to travel along that highway, as do maps of 1938 and 1939 distributed by Standard Oil Company, Conoco, and Shell (Pusey Library, Harvard University); these served as the basis for reconstructing the routes Lange traveled.

A rich literature on the social and environmental history of the American West helped me understand what Lange was seeing (and not seeing). Three books by Richard White, *"It's Your Misfortune and None of My Own": A New History of the American West* (Norman: University of Oklahoma Press, 1991), *The Organic Machine* (New York: Hill and Wang, 1995), and *Land Use, Environment, and Social Change: The Shaping of Island County,*

Washington (Seattle: University of Washington Press, 1980), provide valuable background to the changes that preceded 1939, as do Donald Worster, *Dust Bowl* (1979; New York: Oxford University Press, 2004); Clyde A. Milner II, Carol A. O'Connor, and Martha Sandweiss, eds., *Oxford History of the American West* (New York: Oxford University Press, 1996); William Cronon, *Nature's Metropolis: Chicago and the Great West* (New York: Norton, 1991); D. W. Meinig, *The Great Columbia Plain* (Seattle: University of Washington Press, 1995); David Igler, *Industrial Cowboys: Miller & Lux and the Transformation of the Far West, 1850–1920* (Berkeley: University of California Press, 2001); and Carlos Arnaldo Schwantes, *The Pacific Northwest* (Lincoln: University of Nebraska Press, 1996).

Finally, my own work in the history and culture of landscapes and the practice of design and planning and the sources from which that work draws, inevitably have informed my reading of Lange and her work. These are described in my books *The Granite Garden: Urban Nature and Human Design* (New York: Basic Books, 1984) and *The Language of Landscape* (New Haven: Yale University Press, 1998).

LIST OF ILLUSTRATIONS

The titles below are abbreviated. Except as noted, all photographs are by Dorothea Lange. Photographs with the designation "LC" are in the FSA/OWI Collection in the Prints and Photographs Division, Library of Congress. The photographs that Lange noted as "killed" were likely ones rejected by Roy Stryker, her boss at the Farm Security Administration; "killed" was his term. Photographs marked "reject" are probably ones Lange herself edited out.

First frontispiece. See figure 115.
Second frontispiece. See figure 130.
Third frontispiece. "Reject." LC-USF34-021526-E (compare figure 144).

36. Tent interior in labor contractor's camp near Westley, California. 1939. LC-USF34-019499-E.

37. Laundry facilities at Westley Camp for migratory labor. 1939. LC-USF34-018745-D.

38. Meeting of camp council. 1939. LC-USF34-019524-C.

39. Map of North Carolina. Places photographed by Lange in 1939.

40. Single tobacco flower. 1939. LC-USF34-019913-C.

41. Sharecropper and wage laborer priming tobacco. 1939. "Reject." LC-USF34-019996-E.

42. Mr. Taylor [or] wage laborer slide tobacco to the barn. 1939. "Reject." LC-USF34-020059-E.

43. Handing up strung tobacco in the barn. 1939. LC-USF34-019998-E.

44. Ten-year-old son of tobacco tenant. 1939. LC-USF34-020088-E.

45. Tobacco people take it easy. 1939. LC-USF34-020087-E.

46. Farm boy in doorway of tobacco barn. 1939. LC-USF34-019715-E.

47. Tobacco barn ready for "putting in." 1939. LC-USF34-019707-E.

48. Building a tobacco barn. 1939. LC-USF34-019880-E.

49. White sharecropper family. 1939. "Reject." LC-USF34-019796-E.

50. Corner of tobacco farmer's front room. 1939. LC-USF34-019713-E.

51. Corner of the Whitfield kitchen. North Carolina. 1939. LC-USF34-019735-E.

52. Wife of tobacco sharecropper bathes baby in kitchen. 1939. "Reject." LC-USF34-019728-E.

53. "Knee baby" comes in from outside. 1939. LC-USF34-019733-E.

54. Sharecropper and the littlest girl work in field. 1939. LC-USF34-019787-E.

55. Home from the field for dinner. 1939. LC-USF34-019799-E.

56. Tobacco barns on the Stone place. 1939. LC-USF34-019900-E.

57. Young sharecropper and child. 1939. LC-USF34-020258-E.

58. Negro sharecropper's house. 1939. LC-USF34-019971-C.

59. View of a hillside farm. 1939. LC-USF34-019995-C.

60. Colored tenant. 1939. LC-USF34-019849-E.

61. Tenant farmer reads his paper. 1939. LC-USF34-020162-E.

62. The older boys go off visiting. 1939. LC-USF34-020174-E.

63. House of Negro tenant family. 1939. LC-USF34-019915-C.

64. Grandson of Negro tenant. 1939. LC-USF34-020125-E.

65. Feeding the little pigs. 1939. LC-USF34-020121-E.

66. Noon time chores. 1939. "Reject." LC-USF34-020181-E.

67. Sharecropper's children on the porch. 1939. LC-USF34-019935-E.

68. Sharecropper's child playing. 1939. LC-USF34-019947-E.

69. Caroline Atwater tells about her church. 1939. LC-USF34-019902-E.

70. Colored owner's home. 1939. LC-USF34-019808-E.

71. Sick father and family. 1939. LC-USF34-020221-E.

72. Shopping in town. 1939. LC-USF34-019859-E.

73. Shopping and "visiting" in town. 1939. LC-USF34-019846-E.

74. Ever-present CSA monument. 1939. "Reject." LC-USF34-019857-E.

75. Church yard on annual cleaning-up day. 1939. LC-USF34-020120-E.

76. Member of congregation named "Queen." 1939. LC-USF34-019917-C.

77. Women of the congregation. 1939. LC-USF34-020017-C.

78. Wheeley's church and grounds. 1939. LC-USF34-020021-C.

79. Congregation after church. 1939. "Reject." LC-USF34-020224-E.

80. Map of Pacific Northwest. Places photographed by Lange in 1939.

81. Sign on service station, U.S. 99. 1939. LC-USF34-020280-E.

82. On road off main highway. 1939. LC-USF34-020674-E.

83. Migratory boy. 1939. LC-USF34-020650-E.

84. Hop picker with her children. 1939. LC-USF34-020686-E.

85. Deputy sheriff stationed at paymaster's window. 1939. LC-USF34-020685-E.

86. Hop kiln ready for firing. 1939. LC-USF34-020688-E.

87. Children in bean pickers camp. 1939. LC-USF34-020481-E.

88. Unemployed lumber worker and wife at bean harvest. 1939. LC-USF34-020908-D.

89. Picking pears, Pleasant Hill Orchards. 1939. LC-USF34-020868-E.

90. Harvesting pears. 1939. LC-USF34-020785-E.

91. Roza Irrigation Canal. 1939. LC-USF34-020753-C.

92. Yakima County small town. 1939. LC-USF34-020388-C.

152. Weeds crowd the barn door. 1939. LC-USF34-020827-E.
153. Chris Ament, on dry land wheat farm. 1939. LC-USF34-020793-E.
154. World's longest siphon. 1939. LC-USF34-021359-C.
155. Family moved to three different places in one year. 1939. LC-USF34-021263-E.
156. Basement dugout house and excavation for new house. 1939. LC-USF34-021353-C.
157. Daugherty home. 1939. LC-USF34-021562-D.
158. Newly reclaimed benchland. LC-USF34-021598.
159. Mrs. Wardlaw, after church service. 1939. LC-USF34-021369-C.
160. Mr. Wardlaw, a drought farmer. 1939. LC-USF34-021460-E.
161. The Wardlaw couple and basement dugout home. 1939. LC-USF34-021389-D.
162. Mrs. Hull, in one-room basement dugout home. 1939. LC-USF34-021271-E.
163. The Hull family haul drinking water. 1939. LC-USF34-021178-E.
164. Entrance to Lincoln Bench School. 1939. LC-USF34-021214-E.
165. Girls of Lincoln Bench School. 1939. LC-USF34-021217-E.
166. Entrance to Amalgamated Sugar Company factory. 1939. LC-USF34-021480-E.
167. Mr. Roberts. 1939. LC-USF34-021225-E.
168. Mrs. Soper tells how it was when they first came. 1939. LC-USF34-021269-E.
169. Mrs. Soper with youngest child at well. 1939. LC-USF34-021267-E.
170. Exterior of Soper house. 1939. LC-USF34-021264-E.
171. Corner of the Soper kitchen. 1939. LC-USF34-021241-E.
172. Soper grandmother, who lives with family. 1939. LC-USF34-021235-E.
173. Old bank building, now the Bureau of Reclamation office. 1939. LC-USF34-021421-E.
174. Old bank building, now the Owyhee Irrigation District office. 2005. Anne Whiston Spirn.
175. Onions drying in the sacks. 1939. LC-USF34-021540-D.
176. Negro Church called Young's Chapel. North Carolina. 1939. LC-USF34-020042-E.
177. Country store on dirt road. North Carolina. 1939. LC-USF34-019911-C.
178. Person County courthouse. 2006. Anne Whiston Spirn.
179. Homedale District, Malheur County, Oregon. 1939. LC-USF34-021450-E.
180. The irrigated and the dry. 2006. Anne Whiston Spirn.
181. Congregation after Sunday morning service. 1939. LC-USF34-021368-C.
182. Glen Wardlaw and his wife, Mary. 2006. Anne Whiston Spirn.
183. Terry Oft and his mother, Betty. 2006. Anne Whiston Spirn.
184. Michigan Hill, Thurston County, Washington. Land cleared and planted. 1939. LC-USF34-020814-E.
185. Michigan Hill, Thurston County, Washington. Land reclaimed by forest. 2005. Anne Whiston Spirn.

INDEX

Italicized page numbers indicate photographs and maps.

children as workers; farm facto-
ries; growers; industrialized agri-
culture; Industrial Workers of the
World (IWW, Wobblies); migrant
workers; strikes and demonstra-
tions; unemployment
labor contractor: role of, 74
labor contractor camps: conditions,
75; grandmother in, 84, 85; tent in-
terior in, 86, 87
Landis, Paul H., 331n42
landowners: acreage owned by, 94,
106; agricultural subsidies for,
93; black tenant farmers as, 94;
California patterns of, 290, 295–97;
tobacco barns of, 104, 105, 112, 114.
See also farmers; growers
landscape: deep context of, 280,
281; definition, 322n18; as form
of language, xi; in formulating
captions, 26; Lange's photographs
of, ignored, 8–9, 13–14, 321–22n16;
past and present in, 268–72, 274;
as portrait, 14, 280; present-day
remaking of, 295–97; qualities of,
xi; sources on, 338; time, space,
and story in, 14, 280–81. See also
photographs (Lange): of landscape
landscape architects, 274–75, 278
Lange, Dorothea, 2, 21, 23, 24; chro-
nology of life, 299–301. See also
American Country Woman, The
(Lange); American Exodus, An
(Lange and Taylor); captions for
specific photographs; documents;
field notes (Lange); fieldwork
(Lange and Taylor); general cap-
tions (Lange); photographic essay
(Lange); photographs (Lange); por-
traits (Lange); working methods
(Lange)
—career: as artist, 48, 49, 50,
327n114; BAE position, xii, 49,
326n93; daybook and handwriting
of, 24–25, 26, 43–44; education,
15; enthusiasm and ideas, 34–36;
erasure and neglect of, 9, 51–55;
Evans compared with, xiii, 52,

53, 328n133; as field investigator,
photographer, 16, 20; focus on
present, 269; FSA assignments,
28–29; FSA firing of, 26–27, 29, 30,
31, 33, 34; Guggenheim fellowship,
42, 49; intuitive and metaphorical
approach, 14; OWI position, xii, 49;
people skills, 23–24; political con-
text, 337; portrait photographer,
15, 16, 18; professional identity, 15–
20; purpose, 11, 13, 38, 42, 49, 52,
323n41; RA position, 16, 20, 26–27,
187; self-criticism, 29–30; sources
on, 335–36; street photographer,
17–18, 48; themes, 10, 47, 54, 55,
290, 297, 321n10; travels abroad,
75–76, 330n10; voice, 39–40; War
Relocation Authority position, 49;
writing style, 48
—exhibitions: "The Bitter Years:
1935–1941," 50; "Family of Man,"
50; MOMA retrospective, 15, 44–
45, 50–55, 56–57, 321–22n16, 327–
28n118
—personal life: abandoned by father,
15, 299; characteristics, 35; death,
50; family, 15, 50, 54, 299; first
marriage and divorce, 15, 322n28;
illness, 49, 50; second marriage, 17,
28; travels, 49
—views on: audience, 57–58;
cameras, 47, 323n41; captions,
12, 25; changing images in print-
ing, 325n84; daring to look, 5,
8; distinctive American forms,
322n21; documentary photogra-
phy, 44–45, 327n114; the familiar,
48–49, 56, 57; grouping of photo-
graphs, 25, 36, 44–45; home, 41;
hostility, 25, 56; instincts, 20; land-
scapes, 14; natural light, 108, 109;
pairs, 36, 44–45; people, place, and
time, 41, 56–57; photograph as act
of love, 58; photography and ca-
reer, 3–5; portraits, 41, 45; poverty,
5; shooting scripts, 43–44; social
erosion, 4; Stryker, 34; subjects, 56;
themes, 297; tones and tonality,

55–56; tree, on photographing, 56;
visual life, 4; working as "wholly
free individual," 42
—works: "Cottage Gardens," 322n34;
"Death of a Valley" (with Jones),
35, 45, 46, 49, 321–22n16; "Docu-
mentary Photography," 48; "Estab-
lishment of Rural Rehabilitation
Camps for Migrants in California"
(with Taylor), 18, 19; "First Rural
Rehabilitation Colonists, Northern
Minnesota to Matanuska Valley,
Alaska," 18, 19; "Home Is Where,"
326n92; "Migration of Drought
Refugees to California" (with
Taylor), 18; "Photographing the
Familiar" (with D. Dixon), 48–49
laundry facilities, 87, 261
law enforcement, 75, 152
Lee, Russell, 29, 32, 33, 35, 323–24n52
lettuce fields, 74, 77
Let Us Now Praise Famous Men (Agee
and Evans), 270, 324n62, 327n113,
328n134
Levin, Howard, 321n9
Lévi-Straus, Claude, 42
Lewis County (Wash.): bulldozer
contractor in, 210, 211
Library of Congress: Lange's docu-
ments in, 10, 12, 54, 61–62, 321n9,
336
Life magazine, 12, 49
Lincoln Bench School, 254–55, 312
Locke, Edwin, 29
logging. See cutover lands; lumber
companies
Longview Homesteads (FSA), 316
Lorenz, Pare, 8, 33, 326n91
lumber companies: bulldozer con-
tractor and, 210, 211; cutover land
sales, 204–5, 206, 212; sawmill and
town abandoned, 208, 209–10;
town and housing of, 319
lumber mills: abandoned, 204, 205,
208, 209–10, 218, 315–16; bulldozer
contractor and, 210, 211; coopera-
tive, 188, 192–93, 194–95, 311
Lux, Charles, 290

Lynd, Helen M., 324n58
Lynd, Robert, 28, 324n58
Lyons, Zollie, 33, 94, 112, 113, 114

Magritte, René, 50–51
Maharidge, Dale, 270
mail delivery, 246
Malheur County (Ore.): character of land, 232–33; children's activities, 323n44; day-to-day activities, 261–62; description, 244, 248, 250, 252, 256, 258, 260, 316–19; documents concerning, 232, 233, 306–8, 333n86; farm size, 233, 244; fieldwork in, 259; Friends church, 248, 249, 250, 285, 286; housing, 246–47, 251, 262–63, 282, 318–19; land division and sale, 232–33; negatives related to, 312; onion harvest, 272, 273; present-day appearance, 281, 282, 283–88, 286, 289; residents, 249, 250, 253, 264, 318; road near, 249; school, 254–55; siphon (pipeline), 245, 281, 282; sugar company, 256, 257, 333n95; water supplies, 245, 252, 318–19. See also Dead Ox Flat (Ore.)
Malin (Ore.): potato camps, 170, 171; present-day appearance, 271, 294
Malone (Wash.): abandoned lumber mill, 208, 209–10
Manoa (film), 42
maps: California places photographed by Lange, 64; North Carolina places photographed by Lange, 90; Pacific Northwest places photographed by Lange, 142; past and present, navigating by, 272
Marion County (Ore.): migrant families, 154, 155
Martinez, Maria Elena, 281
Martinez, Raul, 280–81
Marysville (Calif.): migratory labor camp, 75, 76
Masters of Photography (Newhall and Newhall), 44, 55
McBryde, Amy, 272, 274

McKinley, Charles, 205
McNally, Marcia, 279
McWilliams, Carey, 36, 38, 75, 290, 330n12
Mead, Margaret, 42–43
Meloland (Calif.): carrot harvest, 80
Meltzer, Milton, 321n9
Merrill (Ore.): present-day appearance, 294
Merrill Farm Family Labor Camp: description, 181, 184; facilities, 182; migrant farm worker, iii, 145–46, 184; sick child, 183
Michelangelo, 51
Michigan: family from, 200
Michigan Hill (Wash.): family's resettlement in, 199–200, 201–3; present-day appearance, 271, 292, 293
"Migrant Mother," 9; classical art compared with, 51; in context of photographic series, 35, 325n82; fame of, 15; as icon, 8; making prints of, 29; negative of, 325n84; Stryker on, 35; subject's later comments on, 323n44
migrant single workers: description, 161; gear, 162; in Napa Valley, 162, 163; travels, 83. See also bindlestiffs (hoboes)
migrant workers: cause and effect in conditions of, 320n5; daring to look at, 5, 8, 17–18; on dust storms, 4; ethnicity and race of, 80, 81, 143–44, 161, 176–77, 290; health care for, 187; in Imperial Valley, 17, 18, 19; labor division among, 77; Lange's exchanging places with, 24; larger context of, 280–81; number of, 331n49; persistence of, 292; seasonal circuit of, 84, 271, 280; strikes of, 74; U.S. 99 used by, 66, 67–73, 143. See also agricultural crops; farm factories; housing; migrant single workers
"Migratory Cotton Picker, Eloy Arizona, 1940," 51

migratory labor camps (FSA): budget for, 187; camp council meeting at, 88; description, 145, 181, 184, 185; development, 18, 75–76, 164; emergency mobile and permanent types, 76; family groups in, 84; Lange's approach to, 21–22, 56; for migrant hops pickers, 145, 186; revisiting, 271; size and facilities of, 87, 181, 182, 186
Miller, Henry, 290
Mineral King Cooperative Farm, 271, 313
Minnesota: refugees from, 18, 19
Mitchell, Margaretta, 328n120
Montebello, Philippe de, 52
Monterey County (Calif.): lettuce fields, 74, 77
Moore, Hugh, 138
Moore, Marianne, 52
Morris, Wright, 321n15
Morrow County (Ore.): description, 235; hay derrick, 239; hay forks, 240; negatives related to, 312; railroad tracks and station, 231, 236–37; sweet potato harvest, 238
Mullins, Nellie, 156. See also Pleasant Hill Orchards (Ore.)
Mumby Lumber Mill (Wash.): context, 204, 208; dismantling of, 209; neighboring village abandoned, 210
Museum of Modern Art (N.Y.), 50–52, 328n127. See also Dorothea Lange (MOMA retrospective)
Mydans, Carl, 28, 29

Nanook of the North (film), 42
Napa Valley: bindlestiff, 162, 163
narrative of photographs and texts: concept underlying, xi–xii, 11–12, 47; curators' views of, 13; multiple stories in, 57; rhetorical and compositional strategies in, 39–41; substituting words in, 12–13, 24; "third effect" of, 36–41; time, space, and story in, 280–81
Natanson, Nicholas, 321n13

story," 40, 171; of the West, 291. *See also* Lange, Dorothea: career

Stott, William, 48, 326n100, 327n113

Strand, Paul, 50

strawberry fields, 199, *201–3*, 270

strikes and demonstrations: growers' response to, 74–75, 144–45, 330n12; Lange's response to, 75–76; 1934 photographs of, 17; Yakima stockade and, 39, 145, *160*, 304

string bean harvest: camp for pickers, *154, 155*; description, 27, 39, 154; negatives related to, 311

Stryker, Roy: background of, 324n54; "credo" of, 35; Hagood's relationship with, 48; instructions from, 187–88, 323–24n52; on Lange and Taylor's book, 30–31; Lange fired by, 26–27, 29, 30, 31, 33, 34; Lange's correspondence with, 31–33, 76, 290, 329n3; Lange's relationship with, 34–36; mentioned, xii, 25; negatives "killed" by, 36, 325n84; photographers under, 28–29, 33; photographs as perceived by, 35–36; on quality of Lange's photographs, 29–30; resignation from FSA, 35, 325n78; shooting scripts of, 28; works: *In This Proud Land* (with Wood), 35

stumplands. *See* cutover lands

sugar beets, 256, 257, 284, 333n95

"Suggestions for Prospective Settlers to Idaho, Oregon and Washington" (FSA), 205–6

Survey Graphic (journal), 17, 230, 241, 304, 322n26

sweet potato harvest, 238

Szarkowski, John: on Lange as artist, 50, 51; Lange's discussion with, 44–45, 54, 57, 326–27n102

tax system, 204–5, 220, 241

Taylor (tobacco worker), 97, 98, 100

Taylor, Paul S. See also *American Exodus, An* (Lange and Taylor); fieldwork (Lange and Taylor)

—career: documents donated by, 10–11; field methods, 17; handwriting, 26, 323n50; as Lange's collaborator, 25, 35, 47, 48, 327n112; mentioned, xii; migratory camp program, 18, 33–34; sources on, 336; travels, 49, 327–28n118; Washington contacts of, 34; writing style, 48

—personal life: first marriage and divorce, 322n28; second marriage, 17, 28

—views on: Lange's working methods, 25; migrant labor, 321n9; San Francisco general strike of 1934, 75

—works: "Establishment of Rural Rehabilitation Camps for Migrants in California" (with Lange), 18, 19

Tehachapi Ridge: U.S. 99 over, 67

tenant farmers: agricultural programs and, 13; income, 93, 118; relationships among, 100; on thirds and fourths, 84; tobacco crop and, 96, 97–99; use of term, 93, 330n26; white women as, 92–93. *See also* sharecroppers

—Negro: children, *122–25*; chores, 123; description, 56, 93, 118, 120, 122; housing of, 94, *120*; in Piedmont region, 93, 118, *119*; visiting and reading among, 121

Tenino (Wash.): abandoned lumber company, 205; description, 315; present-day appearance, 271

Texas: refugees from, 18, *37*, 164, *177*

thick description, 11

Thompson, Florence, 323n44. *See also* "Migrant Mother"

Thurston County (Wash.): abandoned lumber company, 205; family's resettlement in, 199–200, *201–3*; present-day appearance, 271, 292, *293*; town in, described, 315

tobacco: barns, 98, *102, 103, 104, 105*, 112, 114, 313; children's help in, 99, 100, *101, 103, 110, 111*; cultivation

process described, 93, 96, 98, 112, 314; fields, *97, 111*; Herring's project outline and, 92; processing of, 96, *97–99*; reminiscences of, 274–75, 278; resting after "putting up," 100, *101*; yields per acre, 115, 118

Toppenish (Wash.): bindlestiff gear near, *162*; migrant children, *159, 166–67*

Townsend, Francis, 331–32n53

Townsend Plan, 184, 315, 331–32n53

Trachtenberg, Alan, 52

Treaty of Guadalupe Hidalgo (1848), 290

Tsujimoto, Karen, 321n9

Tucker, W. B., 306

Tuck's Filling Station, 116

Tugwell, Rexford, 20, 27–28, 34, 324n54

Tulare County (Calif.): migratory labor camp, 76, 88; present-day appearance, 271, 288

Tulelake (Calif.): description, 168; magazine's mislabeling of, 12; migrant family, *172–73*; negatives related to, 311, 312; potato harvest, 168, *169–70*; present-day appearance, 294

Under the Trees (film), 329n142

unemployment: due to illness, 128; in Imperial Valley, 74, 80, *81–83*; persistence of, 292; in Yakima Valley, 156

Union Pacific Railroad, 244, 256

University of North Carolina: Institute for Research in Social Science, 91–92, 321n9

Unruh family, 224, 311

Upchurch (N.C.): black sharecropper family, 112, *113–14*

U.S. 15, 130

U.S. 54, *37*, 53

U.S. 99: abandoned lumber company along, 205; camping and accommodations, *72–73*; family groups along, *37, 68, 69*; first caption written for, 12;